Dada & Surrealism Matthew Gale

P9-DFC-461

ART&IDEAS

Φ

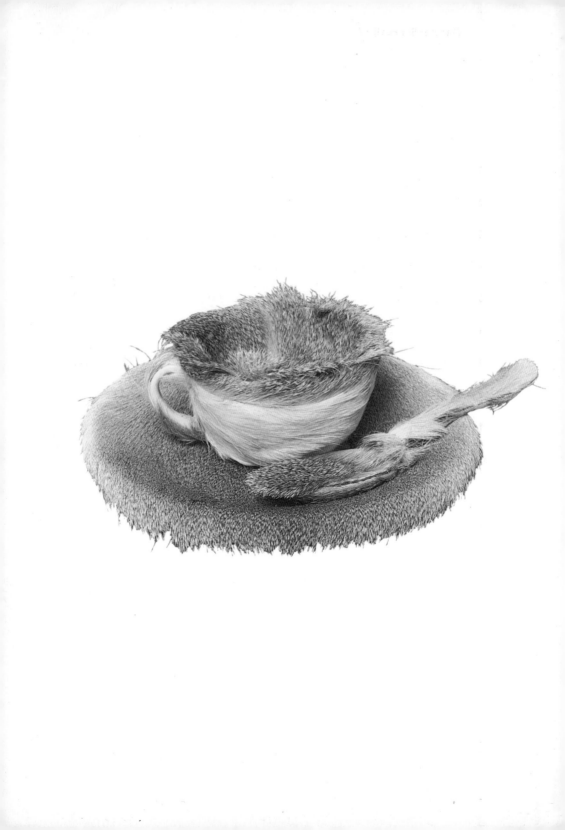

Dada & Surrealism

**Opposite
Meret
Oppenheim**,
*Fur Covered Tea
Cup, Saucer and
Spoon*; 1936.
h.7·5 cm, 3 in.
Museum of
Modern Art,
New York

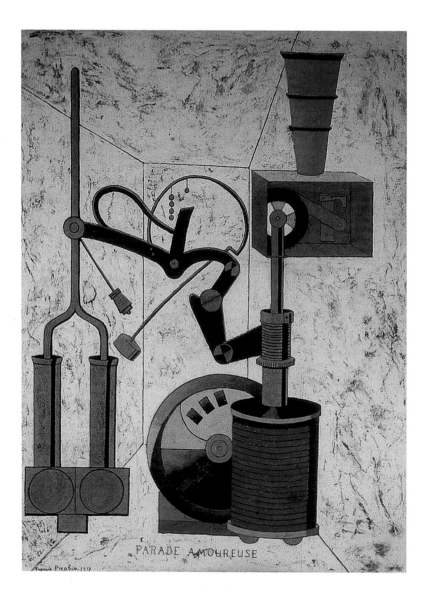

The idea that Dadas and Surrealists, first active three-quarters of a century ago, can still have a radical message may appear perverse. They belonged to a period now embalmed in black-and-white photographs and films in which people strut with staccato strides. It was a period of crisis between empires and revolutions, between the outwardly self-confident patriarchy and the seething unconscious desires exposed by Sigmund Freud's psychoanalytic theories. However, like the German Dada George Grosz, those few artists were willing to stand up and say 'No!' to the stultifying materialism of Western civilization. Philosophers had, in different ways, already condemned the inequalities of this existence, just as anarchists had tried to bomb out the old order. Both were overtaken by the unparalleled slaughter of World War I (1914–18), which raised doubts for those in all walks of life about the merits of progress if this was the result.

More than deploring the war, the Dadas and those subsequently grouped around the banner of Surrealism took an ideological stand. They did not simply hold up a mirror to society: they demanded attention. They exposed its moral decay with a ferocity and wit unprecedented for the arts. Theirs was an assault on the complacency of their audience, an introduction of chaos into a life in which carnage was being carefully regulated between warring nations. Their position emerged from the cultural radicalism of the prewar avant-garde (the roots of which are traced in Chapter 1), but they distinguished themselves by sustaining their attacks despite the pressures of conformity and nationalism.

The audacity of the Dadas' protest, which also proved productive, continues to make a study of it uplifting. In cities as dissimilar as Zurich, New York, Berlin and Paris, they embarked upon a

1
**Francis
Picabia**,
*Parade
Amoureuse*,
1917.
Oil on canvas;
96·5 x 73·7 cm,
38 x 29 in.
Morton
Neumann
Collection on
loan to the
National
Gallery of Art,
Washington,
DC

total reconsideration of the basis of art. They embraced the new in whatever form seemed most suitable to their target and their personal aims. In this emphasis on the freedom of individuals to find their own means of expression lies a key characteristic of Dada. As such, it was a grouping not easily linked by other means. Although a number of poets and artists tended to dominate – Hugo Ball and Tristan Tzara in Zurich, Richard Huelsenbeck and Raoul Hausmann in Berlin, Francis Picabia and André Breton in Paris – there was no consistent style in the usual sense. Artists and poets produced like 'fruit on trees' as Hans Arp said, rather than to a predetermined formula. Any account of their disparate activities is necessarily a compromise, like an account of a firework display, but a considerable flavour of what may now be recognized as Dada can be attained.

From the mid-1920s Surrealism pursued a different strategy. The Surrealists still assaulted all fondly held political, social and artistic conventions, but did so as a definitely constituted movement, with a recognized and charismatic leader, André Breton. Their programme was relatively carefully planned, offering a more coherent direction than Dada. Breton committed the movement to the reconciliation of the rational and the irrational sides of existence. In the individual this was represented by the conscious and unconscious mind, so Surrealists explored the imagery of dreams, trances and automatism, which took them (in the words of one of René Magritte's titles) to the 'Threshold of Liberty' (2). The Parisian group around Breton was dominant, but other groups emerged – in Brussels, Prague and elsewhere – and maintained a certain independence, enriching the movement in its later years. International co-ordination became more important as nationalism became increasingly prevalent in the 1930s. Surrealism was committed to the politics of the radical left in the face of the rising tide of Fascism and the repressions of Stalinist Communism. If politics proved internally disruptive to the movement, this commitment helped to sustain its integrity and productivity for two decades and more.

2
René
Magritte,
On the
Threshold of
Liberty, 1930.
Oil on canvas;
115 × 146 cm,
45½ × 57½ in.
Museum
Boymans-van
Beuningen,
Rotterdam

The fact that some of the same figures were involved in both Dada and Surrealism has encouraged the habit of seeing them as fundamentally linked, but only a minority of Surrealists arrived by that route. However, the central continuity provided by Tzara and Breton, Paul Éluard and Louis Aragon, Max Ernst and Man Ray lends this approach some justification. As the diversity explored here shows, it would be possible to produce quite another assessment of the long history from Dada to Surrealism. After all, the nature of each group within these wider movements was as diverse and contradictory as its individual members, by turns experimenting with automatism, modern technology, anarchism, oriental philosophy, ritual, Freudian psychoanalysis, chance, Jungian psychoanalysis, eroticism, Marxist dialectics and many other approaches. The path chosen here between these points cannot, therefore, be considered definitive, but an attempt has been made to trace some of these continuities and to show how they lie at the heart of this network of individuals.

If it is the anarchic humour and iconoclasm that still makes Dada attractive, it has become almost impossible to isolate the influence of Surrealism in Western culture. The joke 'How many Surrealists

does it take to change a light bulb?' (answer: 'A fish') can be overheard at bus-stops. The fundamental strangeness achieved through the conjunction of unrelated objects has become the everyday language of advertisements, and 'surreal' has come to be equated with anything unexpected and often humorous. It might be argued, without too much exaggeration, that we live (in the 'West' at least) in a post-Surrealist culture, in which a visual vocabulary of forms has become so common as to pass unrecognized. This enrichment of everyday culture may be seen as a positive legacy, although sceptics might say that it is merely an advertising gimmick. Whatever the case, its everyday presence is justification enough for the study of Surrealism's rich and troubled history. Just as it has passed into the mainstream, so it has become a source for subsequent artists, who acknowledge their debt without needing to embrace it wholeheartedly. Surrealism sought to let everyone explore its liberating processes, taking a cue from the saying of the poet Isidore Ducasse: 'Poetry should be made by all.'

Merdre Dada's Roots in the Avant-Garde

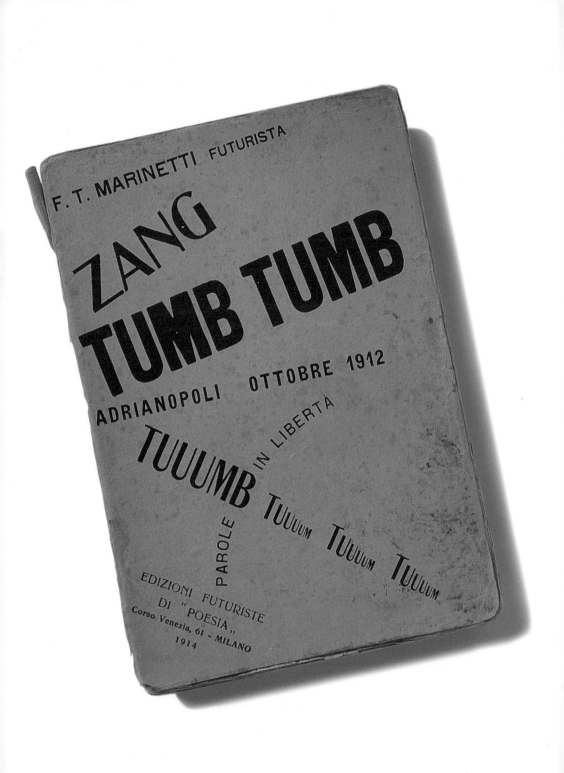

Dada emerged – energetic and anarchic – in the middle of
World War I. Its participants formed groups openly opposed
to the establishment values that had helped to bring about mass
slaughter. However, the roots of Dada's cultural protest lay in
the prewar activities of those artists subsequently identified
as 'modernists'. They introduced new materials and techniques
and depicted subjects that reflected the rapidly changing
conditions of modern life. The most radical of them came to be
seen as the avant-garde, whose experimental methods reflected
their fundamental questioning of the political and philosophical
assumptions underlying art. A brief overview of some of the
important issues arising from these prewar activities can provide
the context from which Dada emerged. It serves to highlight
Dada's roots in the experimentation and internationalism
of avant-garde art, and touches upon the crucial philosophical,
psychological and mystical ideas by which it was influenced.

3
Filippo
Tommaso
Marinetti,
Zang Tumb
Tuum, 1914.
Private
collection

These prewar activities were seen in cities from Moscow to
Munich and Milan, but above all in Paris. Here the Impressionists
had emerged in the 1870s and an artistic avant-garde had
established itself in a series of provocative and iconoclastic
movements ranging from Symbolism in the 1880s and 1890s
to Fauvism and Cubism in the decade leading up to the war.
The avant-garde did not constitute a homogeneous body
– indeed its members divided stylistically, philosophically
and politically as each generation extended the achievements
of the last. However, most avant-garde artists were individualistic
and experimental in their work, believing that all arts needed
to be renewed by a response to the times.

For some time official French culture had served conservative
political ends. Governments of the late nineteenth century

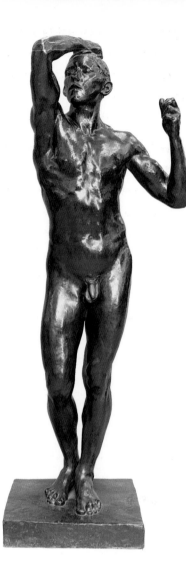

4
Auguste
Rodin,
The Age of
Bronze, 1875–6.
Bronze;
h.175 cm, 71 in.
Victoria &
Albert
Museum,
London

recognized culture and especially the visual arts as a means
of sustaining foreign influence. They actively promoted the
Academies of Art in Paris, which perpetuated the Classical
Academic tradition handed down from the Renaissance and
of which the sculptor Auguste Rodin (4) came to be regarded
as a major exponent. The avant-garde formed among those
promoting new ideas and offering a critique of the system.
While working outside the culturally and politically conservative
establishment, they also benefitted from the vitality of the arts
in the city. Many artists, like the Impressionists, had revolted

against conventions primarily on artistic grounds, seeking freedom to explore new subjects and techniques. Others embraced radical politics as an extension of their artistic radicalism, and the process of unmasking the hypocritical establishment came to be associated with the ideas of artistic experimentation.

This link was strengthened by the scandal of the Dreyfus Affair. In 1894, Alfred Dreyfus, a colonel in the French Army, was sent to the tropical penal colony of Devil's Island for selling secrets to the enemy. With the famous article 'J'Accuse' (1898), the novelist Émile Zola campaigned for his release, asserting that the innocent Dreyfus had been made a scapegoat because he was Jewish. The appeal, at which Dreyfus was exonerated, confirmed an institutionalized anti-Semitism at the very heart of the French establishment. The Dreyfus Affair divided a whole generation on pro- and anti-Dreyfus lines.

Although not all avant-garde artists supported Dreyfus, the outcome reinforced the perception of artists and intellectuals as defenders of ideals and moral positions irrespective of conventions. In social terms artists and intellectuals had little to lose. They were already outside the establishment and were associated with the 'demi-monde' of entertainment, like the artists of Giacomo Puccini's romantic opera *La Bohème* (1890).

While exhibitions of avant-garde art led to conflicts with the establishment in general and the middle classes in particular, avant-garde theatrical and musical performances provoked especially sharp hostility among audiences devoted to the 'divine' actress Sarah Bernhardt or the rising operatic tenor Enrico Caruso. When Alfred Jarry's satirical play *Ubu Roi* (1896) opened with an extended cry of 'Merdre' (shit; intentionally misspelled in the script and mispronounced to avoid censorship), it caused a riot of legendary vehemence. The new Russian and French music introduced through the performances of Serge Diaghilev's company, the Ballets Russes, was greeted with a similar response. The jagged power of Igor Stravinsky's *Rite of Spring* (1913) and the sexuality of Nijinsky's dancing in Claude Debussy's *Prélude*

à l'après-midi d'un faune (1894; ballet, 1912) both provoked vocal first-night protests.

In many cases professional critics opened the way to public ridicule. Louis Vauxcelles condemned the works of Henri Matisse (6), André Derain, Raoul Dufy and their associates who exhibited together in 1905 as those of 'fauves' (wild beasts). He took exception to their energetic use of unmixed colour taken straight from the tube to convey the intensity of sensual experience. Some four years later the same critic (actually echoing Matisse) dismissed Georges Braque's work as 'cubisme', a caricature of the painter's attempt to reconstruct reality on his canvas by using simplified planes (5). The painters, however, adopted such terms as Cubism as a proud acknowledgement of their radicalism. The Italian Futurists led by the poet Filippo Tommaso Marinetti met such ridicule and bemusement head-on. Their exhibitions were accompanied by combative public performances or soirées in which the audience was deliberately provoked to the point

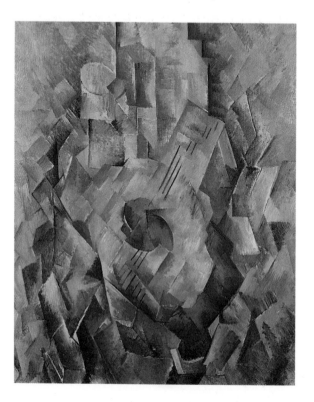

5
Georges Braque.
Mandora,
1909–10.
Oil on canvas;
71·1 x 55·9 cm,
28 x 22 in.
Tate Gallery,
London

6
Henri Matisse,
Landscape at Collioure, 1905.
Oil on canvas;
46 × 55 cm,
18⅛ × 21⅝ in.
Statens Museum for Kunst,
Copenhagen

of riot. In some artistic circles the desire to *épater la bourgeoisie* (shock the bourgeoisie) became an end in itself, but as audiences became harder to shock, more controversial effects were required.

In the years immediately preceding the war, a greater understanding of the new art, and a better balance between shock and appreciation, was achieved as avant-garde critics infiltrated the ranks of the professionals. Articulate young poets – such as Guillaume Apollinaire, André Salmon and Max Jacob – were close to the painters and musicians of the new generation, and Apollinaire (7) in particular was a pivotal figure. Inspired and charismatic, he championed Cubism and counted the painters Braque, Pablo Picasso, Juan Gris and Fernand Léger among his friends. He also supported the Fauves, as well as younger artists such as Robert Delaunay, Alexander Archipenko, Giorgio de Chirico, Marcel Duchamp and Francis Picabia. The diversity of these artists, a list which reads like a roll-call of prewar modernism, shows that his wider purpose was to encourage innovation of all types. Apollinaire had an astonishingly eclectic experience of culture; of mixed Polish and Italian ancestry, he composed some of the most remarkable poems in the French language and also catalogued the Bibliothèque Nationale's collection of pornographic literature. He was also the only

person arrested when Leonardo da Vinci's *Mona Lisa* was stolen from the Louvre in 1911. The fact that he could be suspected in this way speaks for the power of avant-garde propaganda against such symbols of tradition.

There were similar concentrations of experimental artists across Europe and further afield. A fertile exchange of ideas was established through an international network. Apollinaire had contacts in Prague; the poet Blaise Cendrars travelled to New York and Rio de Janeiro; Marinetti took Futurism on a tour of Europe. News of activities was quickly spread through periodicals such as Apollinaire's *Les Soirées de Paris*, Herwarth Walden's Berlin-based *Der Sturm* and Alfred Stieglitz's New York-based *Camera Work*.

The periodicals provided a platform for new writers, just as independent exhibiting organizations allowed artists to show their work without submitting to the rules of the official Salons. In Paris, the springtime Salon des Indépendants and the Salon d'Automne had selection committees made up of modernists, and the impetus towards freedom of expression was repeated across Europe. The suppression of an exhibition of Edvard Munch's work in 1892 because of the charged eroticism of the paintings led to the formation of the Berlin Secession by artists determined to break away from the academic establishment. The Vienna Secession was formed by Gustav Klimt, Carl Moll and others who likewise rejected the conservative attitude of the official establishment, favouring a more modern experimental approach. Die Brücke (The Bridge) was formed in Dresden in 1905 around Ernst Ludwig Kirchner and others, who saw their highly coloured and energetic art, later dubbed Expressionist, as a bridge to the future. However, even such progressive groups splintered. In 1912 Wassily Kandinsky felt bound to resign from the Neue Künstler Vereinigung (New Artists' Association), which he had founded in Munich in 1909, because of attempts by fellow-artists to restrict his showing of abstract works. As a result he founded a new group called Der Blaue Reiter (The Blue Rider), named

7
Louis Marcoussis,
Portrait of Guillaume Apollinaire,
1912. Drypoint engraving;
49 × 27 cm,
19¼ × 10⅝ in.
Philadelphia Museum of Art

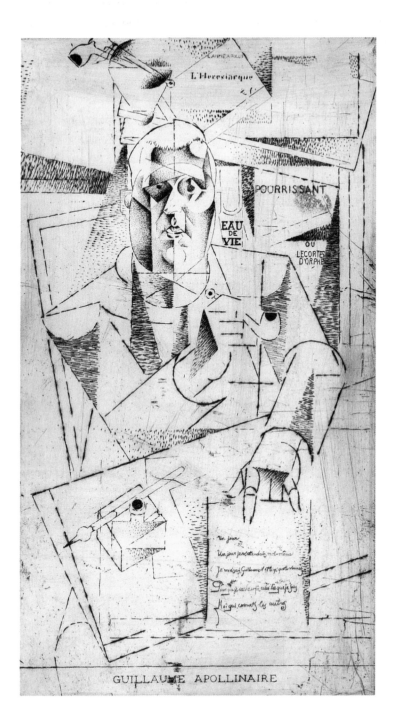

GUILLAUME APOLLINAIRE

after one of his paintings. With Franz Marc, Kandinsky edited *Der Blaue Reiter Almanach* (1912), a publication that promoted the avant-garde and their own near abstraction.

This upsurge of international avant-garde experimentation coincided with a revolution in political and philosophical ideas and social changes brought about by rapid urbanization and developments in science and technology. The writings of the Communists Karl Marx and Friedrich Engels and the Anarchists Mikhail Bakunin and Petr Kropotkin challenged the view of progress fostered by industrial capitalism. The radical works of such writers and playwrights as Oscar Wilde and Henrik Ibsen, Leo Tolstoy and Fyodor Dostoyevsky exposed the social and moral dilemmas associated with materialism. The French Symbolist poets, including Stéphane Mallarmé and Arthur Rimbaud, concentrated on the 'idea in art' at the expense of realism, establishing a pattern from which the world of the imagination became a source of spiritual renewal.

Friedrich Nietzsche in his masterpiece *Thus Spake Zarathustra* (1883–5) proclaimed the coming of a superman, mentally and physically more evolved than was then imaginable. The consequences of such propositions – and Nietzsche never shrank from the unacceptable – were to be seen in the bastardization of his ideas in Nazi Germany in the 1930s. Most widely read especially among artists was his philosophical autobiography *Ecce Homo* (1888, published 1908), because it summarized the course of his thought in an easily digestible form. Nietzsche initially relied on Arthur Schopenhauer's proposition that the true nature of things lay behind surface reality. Such metaphysical ideas were distinct from the positivist view of progress gained through observation. However, Nietzsche soon developed his own world-view of a 'Will to Power', emphasizing that every expression of this Will strove to increase its power.

Richard Wagner's intense music, performed with dramatic staging and near-religious effects, captured a massive audience. He was also important for his development of the *Gesamtkunstwerk* or

total art work. Wagner believed that art should aspire to an all-encompassing experience, in which music, costumes, sets, lighting, even the design of the theatre should be integrated. Musicians, notably Alexander Scriabin in St Petersburg in 1910, attempted to link the arts quite literally by building 'light pianos', so that when the keyboard was played the music was accompanied by projected coloured lights each attuned to a note. Kandinsky and his colleagues in Der Blaue Reiter were also concerned with the potential role of painting in the *Gesamtkunstwerk*. Calligraphic forms and strong saturated colours filled canvases, such as Kandinsky's *Painting with Black Arch* (8), which retained only vestiges of a subject. These artists sought a visual equivalent to the power of music and in the process established the validity of pictorial abstraction, often using musical analogies, as in Marc's *Composition III* (9).

In Paris the ideas of the philosopher Henri Bergson were especially influential. He proposed that the nature of experience was in a constant state of flux, and that this was perceived by the individual not as a series of rational moments selected by the conscious mind but as a multiplicity of perceptions and memories. His lectures at the Sorbonne on the 'simultaneity of experience' were attended by some Cubist painters in the 1910s, and his *Introduction to Metaphysics* (1903) was widely read. The theory seemed to confirm the new urban reality, which was cacophonous and complex in its impact on the senses. It fitted the results of technological progress experienced on the streets, and promoted the idea of the 'living city', with a rhythm and life of its own.

For many artists this Bergsonian instability was a stimulant, offering a new challenge. The fact that it could be a subject for art was a measure of how far artists had broken with traditional forms and notions of reality. The fragmentary perception of contemporary existence was exemplified in the work of Delaunay, who celebrated the Eiffel Tower (10) as a symbol of modern technological achievement. (Constructed for the 1889 Universal Exposition, the Eiffel Tower remained until 1910 the highest

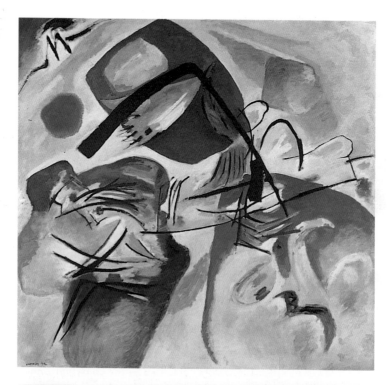

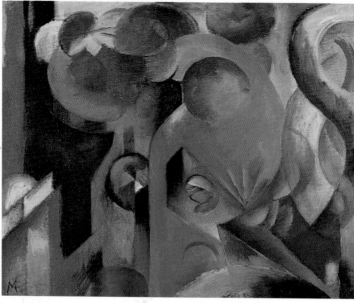

**8 Left
Wassily
Kandinsky**,
*Painting with
Black Arch*,
1912.
Oil on canvas;
188 × 196 cm,
74 × 77¼ in.
Musée National
d'Art Moderne,
Centre
Georges
Pompidou,
Paris

**9 Below left
Franz Marc**,
Composition III,
1914.
Oil on canvas;
45·5 × 56·5 cm,
17⅞ × 22¼ in.
Karl Ernst
Osthaus-
Museum,
Hagen

**10 Right
Robert
Delaunay**,
Eiffel Tower,
1910–11.
Oil on canvas;
130 × 97 cm,
51¼ × 38¼ in.
Museum
Folkwang,
Essen

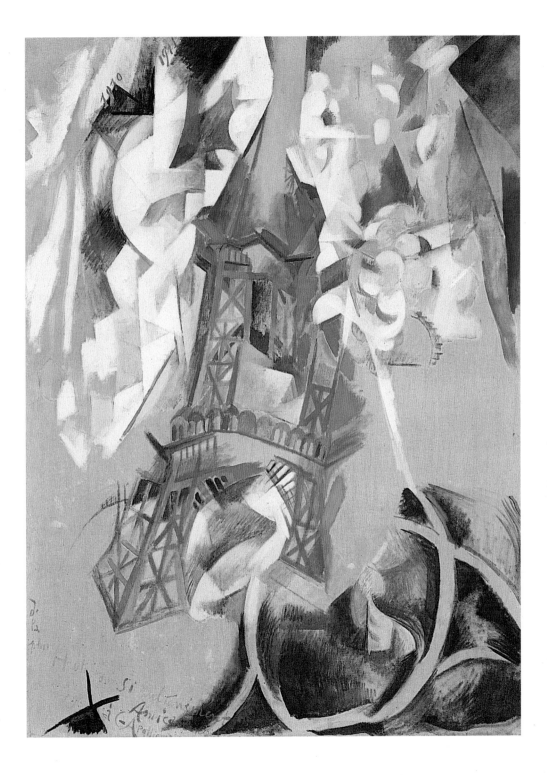

11
**Umberto
Boccioni**,
*States of Mind
II: Those Who
Go*, 1911.
Oil on canvas;
70·8 x 95·9 cm,
27⅞ x 37¾ in.
Museum of
Modern Art,
New York

structure in the world.) In a series of canvases, it buckles in
writhing angular forms and kaleidoscopic colour.

For the Futurists in Milan, simultaneity was inextricable from
modern urban life, and mechanization was a marvellous
intervention into Italian cities embalmed for the benefit of
tourists. In a manifesto, showered on Venice from the top
of the Campanile of San Marco, they proposed filling in the
city's canals, both as an objection to its genteel decay and as an
expression of faith in the new culture of the motor car. Umberto
Boccioni's paintings of Milan railway station, for example *States
of Mind II: Those Who Go* (11), celebrated this new industrial
and technological Italy, just as Marinetti's *Manifesto of Futurism*
(1909) famously alluded to a Greek sculpture in the Louvre
when proclaiming the motor car to be 'more beautiful than
the *Victory of Samothrace*'. Perhaps their ultimate expression
of optimism was Luigi Russolo's transformation of music
through his manifesto *Art of Noises* (*Arte dei rumori*; 1913). With
specially built machines called *intonarumori* (noise intoners), he
created whistles, hisses and sirens which enacted a mechanized
utopia in such orchestrated pieces as *The Awakening of a Great
City* (1913). These were given – to varied success – in concerts
across Europe.

The idea of simultaneity brought two startling innovations in the poetry of Apollinaire. He was enthusiastic about Delaunay's work (one of the *Eiffel Tower* series was dedicated to him; 10) and the more rigorous Cubist paintings of Picasso and Braque. In his poem *Lundi rue Christine* (1913) he captured the simultaneity of experience simply by using fragments of overheard conversation, thus rejecting the role of the versifier and becoming a reporter of the poetry of the street. The effect is comparable to the unexpected conjunctions of commercial material in Cubist collages, where slices of reality – ranging from newspapers to wallpapers – were served up together to demonstrate the diversity of experience (12). The poet was to push this idea even further with the invention of 'Calligrammes'. Undoubtedly indebted to Marinetti's Words in Freedom ('parole in libertà', 1912), in which free-form typographic innovations enhanced the impact of the words, the Calligrammes set words in pictorial

12
Pablo
Picasso,
Guitar, Sheet-
music and Glass,
1913. Charcoal,
gouache and
collage;
121·9 × 91·4 cm,
48 × 36 in.
McNay Art
Institute, San
Antonio

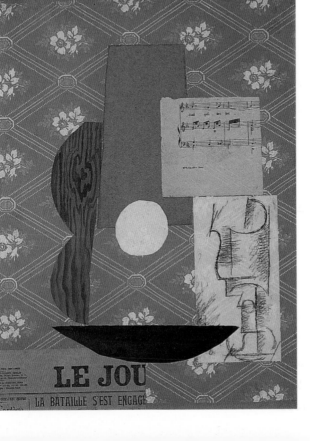

form. The simplest were literal, such as the tumbling letters of 'Il pleut' (1914). However in 'Lettre-Océan' (1914), in the guise of a letter to his brother in Mexico, Apollinaire conveyed complex ideas of telegraphic transmission, journeying, and Old and New Worlds in the rotating structures of words.

Artists in Central Europe appeared to have a greater distrust of scientific and technological progress. They nurtured a concern with the relationship between nature and emotion. In Dresden, the Expressionist artists of Die Brücke, including Kirchner (13), had retreated periodically into the countryside where they made energetically worked and coloured paintings suggesting a return

to savagery. In Munich, Marc's recurring depictions of animals were concerned with the relation of the spirit to natural forces. The anxieties about loss of contact with nature reflected wider concerns, which also stimulated an interest in the irrational. In the Viennese theatre, Arthur Schnitzler showed that sexuality united all strata of society in the chain of lovers in his controversial *Reigen* ('The Roundelay', 1896), while the Swedish dramatist August Strindberg exposed the repressed forces in the human psyche in such plays as *Miss Julie* (1888). This delving into the irrational power of the imagination and sexual drive achieved particular

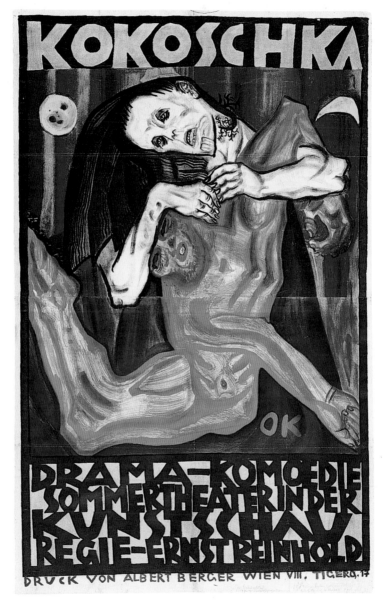

14
Oskar
Kokoschka,
Murderer, Hope
of Women,
1909.
Lithographic
poster;
118·1 × 76·2 cm,
46½ × 30 in.
Museum of
Modern Art,
New York

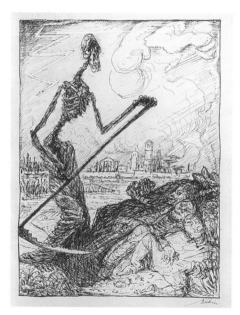

15
Alfred Kubin,
*Death the
Reaper*, 1918.
Ink on paper;
28 x 21 cm,
11 x 8¼ in.
Städtische
Galerie im
Lenbachhaus,
Munich

force among the Expressionists. **Of these, the play by the Austrian
painter Oskar Kokoschka, *Murderer, Hope of Women* (14),
in which brutal rape and murder are treated mesmerically,
epitomized the frenzy and violence that could be unleashed.**

**These works drew support from scientific propositions, of which
the most persuasive study was Sigmund Freud's *The Interpretation
of Dreams* (1900). He proposed that unacceptable desires were
repressed and lodged in the unconscious mind. In a few people
these desires received their outlet in irrational behaviour, but
in all they were expressed in dreams. This theoretical text
transformed the general understanding of human behaviour as it
suggested that behind all rational façades lurked suppressed
insecurities and desires determining every response – the world
of nineteenth-century propriety thus was exposed as a sham.
The establishment greeted these ideas with scepticism not least
because, like Schnitzler's play, they proposed that such desires
knew no class boundaries. It was not until 1911 that Freud's
theories began to reach a wider German-reading public. *The
Interpretation of Dreams* was translated into English in 1913 but,
significantly, not into French for another decade.**

These ideas gained currency in a period in which emotional expression in art had generally gained ascendency over realism. Representation had, in any case, been taken over by mechanical reproduction: photography, moving pictures, gramophone recordings and Gugliemo Marconi's wireless transmission were facilitated by the arrival of electricity. In place of these lost utilitarian functions for painting and theatre, Expressionist artists experimented with more hallucinatory approaches, such as found in the draughtmanship of the Munich-based artists Paul Klee or Alfred Kubin (15). They explored a fusion of myth and dream comparable with the dark writings of Franz Kafka and the more humorous and mystifying poems of Christian Morgenstern, whose Gallows Songs (Galgenlieder, 1905) included a composition made up of dots and dashes.

These approaches also contributed to the simultaneous development of abstract painting in different centres: by the Russians Kandinsky in Munich and Kasimir Malevich in Moscow, the Czech František Kupka in Paris, and the Dutchman Piet Mondrian. In his study of culture Abstraction and Empathy (1907) Wilhelm Worringer had discussed the abstract in contrast with the empathetic. However, painters turned to other sources. Kandinsky and Mondrian were among those attracted by the mystical doctrines of the Theosophical Society and Annie Besant and C W Leadbetter's book Thought Forms (1905). With notions of a world scheme of balanced polarities (male/female, vertical/horizontal, etc.) and a belief that initiates could perceive coloured auras or 'thought forms' that reflected states of mind, these theories offered an anti-materialist counterpoint to European positivism.

Mixed in with such mystical notions was an interest in the so-called 'Fourth Dimension', derived through serious studies such as Henri Poincaré's Science and Hypothesis (1902) and Elie Jouffret's Elementary Treatise on Fourth Dimensional Geometry (1903), and which gained popularity through writings such as Gaston de Pawloski's Journey to the Land of the Fourth Dimension (1912).

The French artist and theorist Marcel Duchamp speculated that if a three-dimensional object cast a two-dimensional shadow, that object could be considered the three-dimensional 'shadow' of a four-dimensional object. Such arguments had little connection with Albert Einstein's contemporary *Theory of Relativity* (1905; in which time is regarded as the fourth dimension), but they generated widespread mystical speculations, from the writings of Rudolf Steiner in Germany to *Tertium Organum: A Key to the Enigmas of the World* (1911) published by Petr Uspensky in Petrograd. In conjunction with technological developments, such as the X-ray which allowed an actual glimpse of the unseen, these ideas vastly enriched avant-garde pictorial experiments.

The mysticism of Theosophy and related systems encouraged aspirations toward a morally and socially responsible art. Avant-garde theorists sought precedents in the art of the so-called

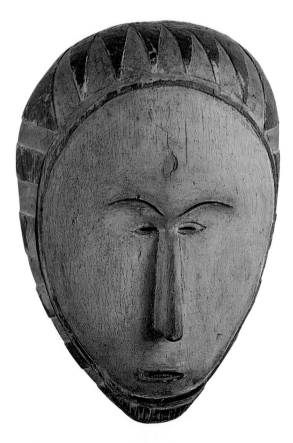

16
Mask made by the Fang people of Gabon. Wood; h.48 cm, 18⅞ in. Musée National d'Art Moderne, Centre Georges Pompidou, Paris

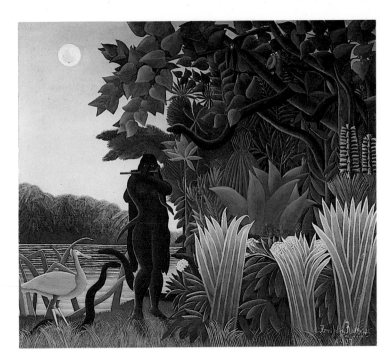

17
Henri Rousseau, *Snake Charmer*, 1907. Oil on canvas; 169 × 190 cm, 66½ × 74⅞ in. Musée d'Orsay, Paris

'Italian primitives' of the fourteenth century, such as Giotto, whose work responded to the emotional demands of their audience in a way matched in the twentieth century only by folk art or the art of untutored painters such as the 'Douanier' Henri Rousseau (17). Such work, with its simple drawing and lively colour, offered a direct emotional response to the subject untainted by high culture. A similar honesty was also found in arts outside the European tradition, such as African masks (16) and Oceanic sculptures – grouped as 'L'Art Nègre' (Negro art) – and the ancient arts of Egypt and Cycladic Greece. The study of these cultures became a means of liberation from conventions and drew an explicit equation between the avant-garde and those exploited by contemporary civilization.

This tendency encouraged some – like the Expressionists – to follow the painter Paul Gauguin's retreat from civilization in order to find a moral basis for the production of art that rejected established codes and the contamination of money and power. The setting up of independent artists' colonies, often associated with radical politics, became a viable proposition.

At Monte Verità near Ascona in Switzerland, for example, artists from across the continent established an intellectual anarchistic colony, to which the Zurich Dadas also retreated to regain strength for their assault on contemporary values.

The euphoria of the revolution in the arts between 1900 and 1914 disguised the seriousness of the European political crisis precipitated by the increasing industrial power and ambition of Germany. United as an empire in 1871 at the end of the Franco-Prussian War, Germany gained Alsace-Lorraine from France as a result, and subsequently sought 'spheres of influence' in North Africa and the Near East at the expense of the crumbling Ottoman Empire. To strengthen this position it formed alliances with Austria-Hungary and Italy. Ranged against them were France, Britain and Russia, who sought to defend their own interests and those of smaller states such as Belgium and Serbia.

These alliances were formed in the mistaken belief that any war would be geographically contained and short-lived. In retrospect, the 'Agadir Crisis' of 1911 can be seen as the first slip towards the wider conflict. The Germans objected to the French annexation of Spanish Morocco and sent a gunship to protect the one German citizen in Agadir. An arms race followed British support for the French. Under cover of these distractions the Italians invaded Libya – then still nominally part of the Ottoman Empire – accompanied by a diversionary attack on Turkey itself in the following year (1912). The Balkan nations saw their opportunity to free fellow nationals ruled by Turkey. Greece, Montenegro, Serbia and Bulgaria united and, with unparalleled carnage, swept to within hailing distance of Constantinople itself. When these allies fell out, and Bulgaria attempted to claim more territory in 1913, Serbia and Greece united with Romania in a brief, punitive campaign.

The apparently closed world of the avant-garde looked on the exceptionally bloody Balkan wars and invasion of Libya with a horror and amazement. Somewhat bizarrely, Marinetti signed up as a journalist for the Parisian newspaper *L'Intransigeant* (of

which Apollinaire was the art critic) on the Libyan campaign in order to grasp this ultimate modern experience. In 1912 he witnessed the Bulgarian siege of the Turks at Adrianople, later producing his extraordinary onomatopoeic text *Zang Tumb Tuum* (3) which conveyed the crashing conflict with the use of revolutionary typography. His celebration of war now seems tasteless, but his courage in putting theory into practice is unquestionable. A quite different response appeared in Picasso's use of newspaper cuttings of Balkan war reports in his collages (12). They relate invariably to the human cost of the conflict and offer an open criticism of its inhumanity.

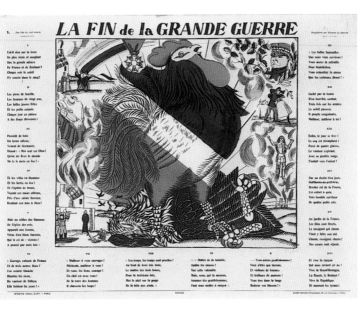

18
Raoul Dufy,
*The End of the
Great War*, 1915.
Ink and gouache
on paper;
43·3×55 cm,
17×21⅝ in.,
Musée
d'Histoire
Contemporaine,
Hôtel National
des Invalides,
Paris

These events were the preamble to the wider European conflict. The establishment of stronger Balkan states made Austria-Hungary, with its closely related national minorities, understandably nervous. On a good-will tour of Sarajevo in June 1914, the heir to the throne of the Austro-Hungarian Empire, Archduke Franz Ferdinand, was assassinated by a Serbian anarchist. Austria-Hungary refused to accept calming diplomatic efforts and mobilization brought a reciprocal move from Russia, Serbia's traditional protector; German mobilization followed, with France and Britain drawn in within days. Of the major powers

31 Dada's Roots in the Avant-Garde

only Italy remained neutral in August 1914. With the difficult terrain and the massive inefficiency of the Austro-Hungarian and Russian armies, the crucial encounters took place far from the trigger of the conflict. In August and September the German armies swept through Belgium, outflanking France's border defences and coming within artillery range of Paris. The expectation of a brief campaign foundered as the troops dug in for the first of four winters of systematized killing in unimaginable squalor (20).

Propaganda in France characterized the war effort as a defence of French – and therefore European – culture against 'barbarism' (18). Conservative elements seized the opportunity to attack the internationalist avant-garde by linking Cubism to German culture, making all aspects of modernism effectively 'consorting with the enemy'. Under the pressure of patriotism, such ploys proved effective: the 45-year-old Matisse attempted to join up, as did the tubercular Amedeo Modigliani. Among others who felt the call of patriotism were French and German artists who had shared tables in Parisian cafés. Many took up arms for a system they had been opposing from within and, although the issues and motives were far more complex, it is clear that this commitment had a divisive effect over the ensuing years. Of the artists from all sides who went to the trenches, most experienced a rapid disillusionment at the profligate waste of human life and the power of the military to crush the spirit of the survivors. Some turned to Dada, in which they found an expression of disgust with cultural nationalism and an attempt at a radical revision of all conventions.

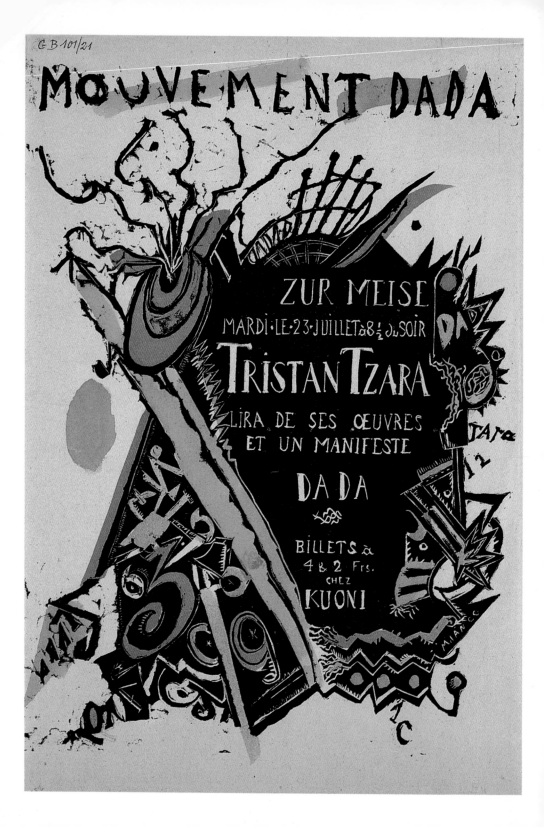

Zurich, where Dada was founded, lay at the margins of avant-
garde developments but at the heart of a Europe torn by war.
The Swiss Federation of several nationalities remained intact,
a prosperous, politically neutral state isolated by its mountains
from the storms raging outside. The war gave Switzerland a
new and highly cosmopolitan role; while its cities teemed with
diplomats and spies trying to outdo the enemy, it also became
a bolt-hole for intellectuals escaping the conflict. It was the site
of Socialist Peace Congresses in 1915 and 1917, news of which
was suppressed abroad. Swiss tuberculosis sanatoria – memorably
described in Thomas Mann's *The Magic Mountain* (1924) –
were filled with writers and intellectuals, and revolutionaries
filled the cafés. Among them were such differing figures as
the novelists Hermann Hesse and James Joyce, the poet Rainer
Maria Rilke, and the psychoanalyst Carl Jung. Vladimir Ilyich
Ulyanov (Lenin) lived for a time in the artistic quarter of Zurich,
at 21 Spiegelgasse, in the same street as the Dadas' cabaret at
no. 1. He must have been within earshot of their cacophonous
soirées, although his reaction remains unrecorded.

The founding of the Cabaret Voltaire in February 1916 is the
focal point of Zurich Dada. It was there that the group of Arp,
Tristan Tzara, Marcel Janco and Richard Huelsenbeck formed
around the guiding influence of Hugo Ball and Emmy Hennings.
Their individual experiences came together to create an unex-
pected fusion of ideas in an unlikely place, and they determined
the distinctive mixture in Dada of French and German culture,
which elsewhere was being nationalistically divided.

Arp was from Alsace and his origins explain his alternative first
names, Jean and Hans. He wrote eccentric, humorous poems in
both French and German, and his belief in the spiritual potential

19
Marcel Janco,
*Mouvement
Dada*, 1918.
Woodcut
poster;
23 × 14·7 cm,
9 × 5¾ in.
Kunsthaus,
Zurich

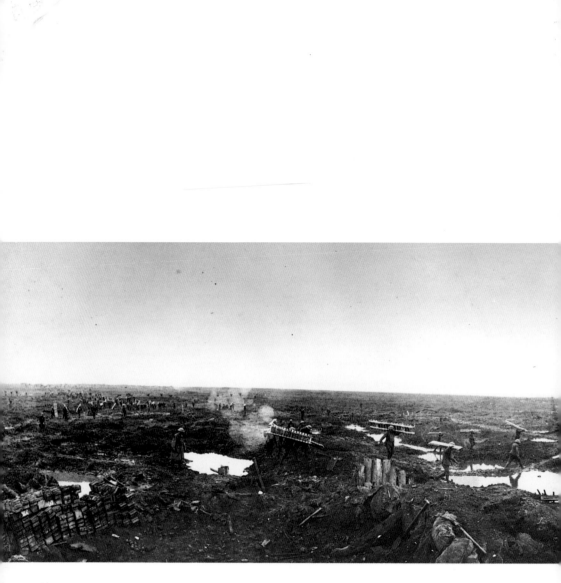

20
Battlefield of
Passchendaele,
France, 1917.
Imperial War
Museum,
London

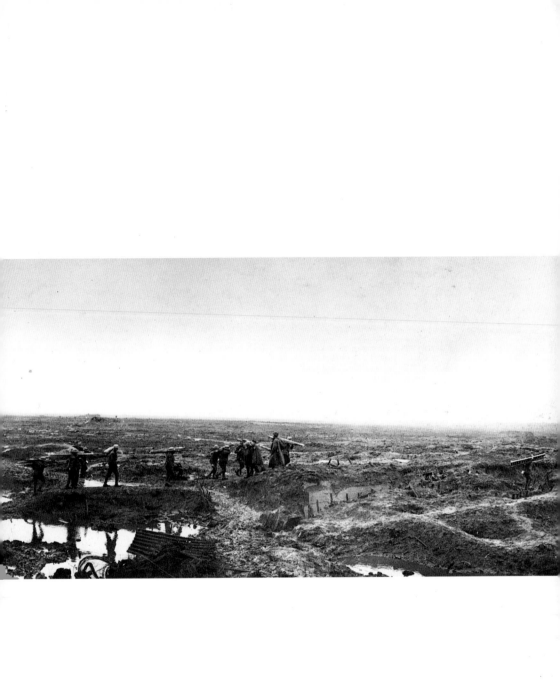

of art emerged in both his painting and his artistic contacts. In 1911 he and the Expressionist painters Walter Helbig and Oscar Lüthy had established the Moderne Bund (Modern League) at Weggis near Luzern, and in the following year Arp was in Munich where he contributed to the *Blaue Reiter Almanach* edited by Kandinsky and Marc. Kandinsky's most recent writings – *Concerning the Spiritual in Art* (1911) and the poems *Sounds* (*Klänge*, 1912) – convinced Arp of the expressive potential of abstraction, with which he had already begun to experiment. In 1914 he arrived in Paris, where he was in contact with leading avant-garde artists including Picasso, under whose influence he made his first collages.

Dodging the war, Arp arrived in Zurich in September 1915 with the Dutch abstract painters and anarchists Otto and Adya van Rees. At this stage all three were using the rich colour of the Blaue Reiter circle but with a tendency towards geometric formality. This can be seen in the designs for geometric tapestries, dominated by squares and rectangles, which they exhibited at the Galerie Tanner in November (21). Tzara later described this show as marking the inception of Dada activity in Zurich, and it certainly had two immediate consequences. At the gallery Arp met the dancer and painter Sophie Taeuber, with whom he developed an artistic and personal relationship of immense

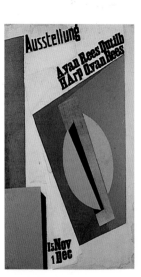

21
Otto van Rees, Design for Galerie Tanner exhibition poster, 1915. Collage. Centraal Museum, Utrecht

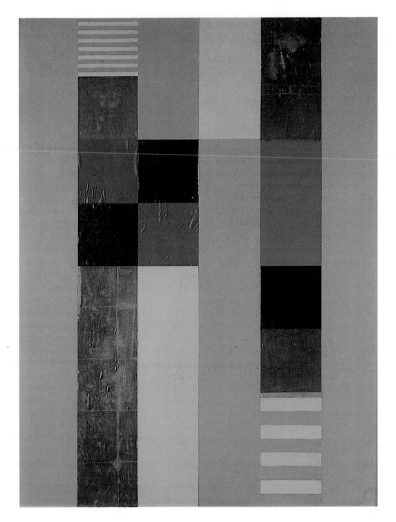

22
Hans Arp,
Geometrical Collage, 1916.
Coloured paper and cardboard;
89 × 69 cm,
35 × 27⅛ in.
Hans Arp and Sophie Taeuber Arp Foundation,
Rolandseck

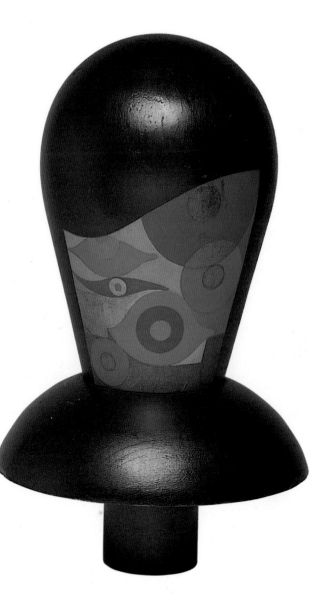

23
Sophie Taeuber,
Dada Head (Portrait of Hans Arp), 1918.
Painted wood;
h.34 cm, 13⅜ in.
Musée National d'Art Moderne, Centre Georges Pompidou, Paris

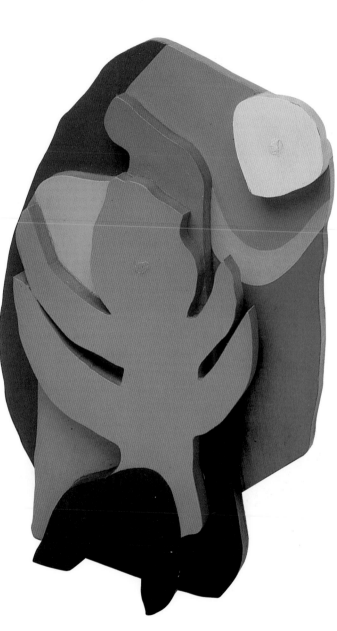

24
Hans Arp.
Forest,
Terrestrial
Forms, 1916.
Painted wood
relief;
32·5 × 19·5 cm,
12¾ × 7⅝ in.
Fondation Arp,
Clamart

intuitive strength. Arp's abstraction (22) was reflected in Taeuber's paintings and painted objects (23, 25), and her dance movements seem to have inspired the rhythms of his wooden reliefs (24). As a result of the exhibition, the art dealer Han Corray recommended that his daughter's school in Zurich should commission decorations from Arp and Otto van Rees. They produced the first abstract murals in Switzerland but, following objections from parents who regarded abstraction as corrupting, these were painted over in 1919.

It was probably also through the Galerie Tanner that the four artists met Ball and Hennings (26). They had come to Zurich from Germany with a background in the experimental Expressionist theatre of Berlin and Munich, where Ball had been a director at the Kammerspiele theatre in 1912. Ball became aware of the parallels between Kandinsky's interest in the *Gesamtkunstwerk* and his own theatrical experiments, and he helped to organize an exhibition of avant-garde paintings from the Expressionist Galerie Der Sturm. He also co-founded the politically radical periodical *Die Revolution* (1913–14).

Hennings was a poet, dancer and singer, specializing as a *diseuse* or reciter of poetry. She had met Ball in Munich, and became his companion and wife. At the outbreak of war she forged passports for those seeking to escape German military conscription, for which she was briefly imprisoned. For his part, Ball had volunteered and, on being rejected by the army on medical grounds, travelled to Belgium in November 1914 to see the war for himself. Repelled by what he found, he returned to Berlin

25 Left
Sophie
Taeuber.
Vertical,
Horizontal,
Square,
Rectangle,
1917. Gouache
on paper;
23 × 15·5 cm,
9 × 6⅛ in.
Kunsthaus,
Zurich

26 Above
Marcel Janco.
Portraits of
Emmy
Hennings and
Hugo Ball.
Woodcut
illustrations for
Cabaret Voltaire
(June 1916)

27
Marcel
Slodki,
Woodcut
illustration for
Cabaret Voltaire
(June 1916)

and began anti-war activities inspired by his reading of the
Anarchist theorists Bakunin and Kropotkin; in this he was joined
by Huelsenbeck, a medical student with literary aspirations.
On 12 May 1915 Ball and Huelsenbeck organized an Expressionist
soirée ('Expressionistenabend'), which adopted Italian Futurist
techniques of audience provocation. This turned out to be a
dangerous move, as ten days later Italy became a national
enemy by declaring war on Germany's ally Austria-Hungary.
Fearing that he would be drafted, Ball and Hennings used her
forged passports to cross into Switzerland. Here Hennings's
experience as a performer helped them to scrape a living with
the Maxim-Ensemble travelling cabaret, and in February 1916
they proposed to Jan Ephraim, the owner of a back-street Zurich
cabaret, that he could sell more beer by opening it as the
Cabaret Voltaire.

The cabaret was a recent innovation in the city, brought by the
influx of German exiles. These included the writers Hugo Kersten,
Emil Szittya, Conrad Milo and Walter Serner, who together
had founded the Cabaret Pantagruel and launched two anti-war
periodicals, *Der Mistral* and *Sirius*. This was the formula adopted
for the Cabaret Voltaire, and despite a certain rivalry there were
those who participated in both groups.

The artist Marcel Slodki, for example, provided illustrations for *Sirius* and contributed regularly to the Cabaret Voltaire. He made posters using woodcuts, the quintessential Expressionist medium, in which the contrasting black and white helped to capture the claustrophobic mood (27). The paintings of Arthur Segal (28) and Max Oppenheimer – like Slodki among the few artists from Austria-Hungary involved in the Cabaret Voltaire – were more Cubist in approach. Oppenheimer had escaped from Vienna after supporting the Socialists' rejection of the war, and was an early adviser to Ball and Hennings on the formation of the cabaret.

Ball's press announcement for the Cabaret Voltaire on 2 February 1916 invited contributions from 'the young artists of Zurich'. Three days later, on the day of the opening, Ball recorded in his diary *Flight Out of Time* (1927):

while we were still busy hammering and putting up futuristic posters, an Oriental-looking deputation of four little men arrived with portfolios and pictures under their arms … They introduced themselves: Marcel Janco the painter, Tristan Tzara, Georges Janco, and a fourth gentleman whose name I did not quite catch. Arp happened to be there also, and we were able to communicate without too many words.

28
Arthur Segal,
Red Houses II,
1918.
Oil on canvas;
51 x 61·5 cm,
20 x 24¼ in.
Museo
Comunale
d'Arte
Moderna,
Ascona

The work of these Romanian students was immediately accepted; and Tzara performed that evening. Disarmingly youthful, he had arrived in Zurich in the previous autumn to study literature and philosophy. In place of his given name, Sami Rosenstock, he had already assumed the pseudonym Tristan Tzara, translatable as 'sad in country', as a disguised protest at the discrimination against Jews in Romania. In 1912, while still in Bucharest, he and the poet Ion Vinea founded the periodical *Simbolul*, which reflected the influence of French Symbolist poets and affirmed their desire to follow such compatriots as the sculptor Constantin Brancusi into the international avant-garde. Ironically, Tzara's parents had sent him to Zurich to get away from these distractions, but his encounter there with Marcel Janco ensured quite the opposite. Janco, who had contributed to *Simbolul*, was studying architecture, but Tzara encouraged the painting that he was working on in private. When they presented themselves to Ball, they were already a team.

The forceful Huelsenbeck was the last of the founders of the Cabaret to arrive. Spared active service in Germany because of his medical studies, he was nevertheless required to do military service. This convinced Huelsenbeck of the futility and sense-lessness of the conflict against which he had protested in Berlin alongside Ball. Learning of the Cabaret, he used the pretext of completing his medical studies in Switzerland to join the group and immediately became a vociferous participant, Ball's most ardent supporter and a furious partner and rival of Tzara.

The choice of the name Voltaire, after the French Enlightenment philosopher and author of the satirical novel *Candide* (1759), was significant in German-speaking Switzerland. It suggested the cross-cultural links embodied by the Cabaret. In the periodical *Cabaret Voltaire*, published in June 1916, Ball wrote: 'To avoid a nationalist interpretation the editor of this review declares that it has no relation with the "German mentality".' He listed the contributors – who included Apollinaire, Kandinsky and Marinetti – by country, thus confirming the polyglot nature

of the enterprise. From the first the Dadas proclaimed their moral stance in relation their own countries' activities more openly and critically than other groups of exiles. Refusing to be national representatives, they became self-styled internationalists, gleaning from the wreckage of war the gems of contemporary avant-garde production. Coupled with their assault on the complacency of the Swiss (notable by their absence from the list of contributors), this marked Dada's residence in Zurich as that of a rebellious lodger rather than a grateful guest.

The name 'Dada' was devised on 18 April, between the founding of the Cabaret in February and the periodical published in June, and was adopted as a banner by all concerned. Ball concluded his Introduction to the periodical with the promise of another: 'The review will appear in Zurich and will bear the name "DADA" Dada Dada Dada Dada.'

The two accounts of the word's origins reflect the subsequent rivalry between Tzara and Huelsenbeck. While Tzara later asserted that he invented it, his writings at the time do not make this claim but play instead on the attempts of others to read meaning into the name. In his *Dada Manifesto 1918* he states:

DADA DOES NOT MEAN ANYTHING … We read in the papers that the Negroes of the Kroo race call the tail of a sacred cow: dada. A cube, and a mother, in certain regions of Italy, are called: dada. The word for a hobby-horse, a children's nurse, a double affirmative in Russian and Rumanian, is also: DADA.

By contrast, Huelsenbeck's account in *En Avant Dada: A History of Dadaism* (1920) states that he made the discovery with Ball when seeking a stage name for a certain Mme Le Roy by the simple method of plunging a knife into a dictionary. The assault on logic embodied in this random approach was to typify Dada. What Huelsenbeck and Ball shared with Tzara, however, was their emphasis on the word's applications in many languages. A word that had no common currency between languages effectively stood outside them rather in the way that the Dadas

found themselves outside contemporary events. The name 'DADA', adopted publicly for the group with the publication of *Cabaret Voltaire*, was meant to irritate. It succeeded.

The first performances of the Cabaret introduced the international avant-garde to Zurich (29). The participants on the opening night, 5 February 1916, included Ball and Hennings, Mme Leconte, Janco and Tzara, Oppenheimer, Slodki and Arp. Pictures by the last three hung on the walls, alongside works by Otto van Rees and Segal, a print by Picasso and a drawing by the sculptor Eli Nadelmann. Ball read from Voltaire, from his own works and those of his friend the playwright Frank Wedekind; Tzara read his own Romanian poems. Hennings sang and the programme's musical element included pieces by Rachmaninov and Camille Saint-Saëns, and the presence of a Russian balalaika orchestra. Thus the Dadas were equally artists in their own right and a medium through which the works of others were presented, and their blending of arts and languages encouraged unexpected resonances.

Some flavour of the Dadas' own work may be gained from Arp's poem *kaspar is dead* (1912). It opens:

alas our good kaspar is dead.
who will conceal the burning banner in the cloud's pigtail now and blackly
thumb his daily nose
who will run the coffee grinder in the primeval cask now
who will entice the idyllic deer out of the petrified bag
who will blow the noses of ships umbrellas beekeepers ozone-spindles and
bone pyramids
alas alas alas our good kaspar is dead. goodness gracious me kaspar is dead.

The tone parodies funeral orations (Kaspar is a German puppet equivalent to Mr Punch) and yet retains a true sense of loss. Such revisions of standard responses became a hallmark of Dada.

After the first hasty French translations of his romantic Romanian verse, Tzara developed more daring and collaborative schemes. On 31 March 1916 the 'Dance *Soirée* with Cabaret Programme'

included the first public performance of 'simultaneous poems' in which several parts were spoken at once. Tzara not only included examples by the French poets Henri-Martin Barzun and Ferdinand Divoire but also gave an example of his own, 'L'amiral cherche une maison à louer' ('The admiral looks for a house to rent'). Its three unrelated texts were spoken simultaneously by Huelsenbeck in German, Janco in English and Tzara in French, accompanied by drum, whistle and rattle. The effect was deliberately cacophonous, an assault on the very nature of poetry, even of communication, that went beyond such prewar experiments as Barzun's *Voix, rythmes et chants simultanés* ('Simultaneous Voices, Rhythms and Songs', 1913), Apollinaire's conversational poems or Marinetti's Words in Freedom. The languages – all given voice but about different things – provided a parody of the wartime conflict of national propagandas.

Arp's description in 'Dadaland' (1948) of Janco's lost painting *Cabaret Voltaire* gives some idea of how such performances were greeted:

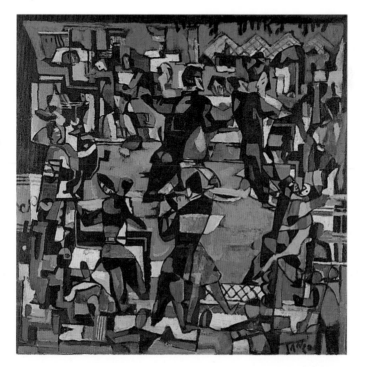

29
Marcel Janco,
Zurich Ball,
1917.
Oil on canvas;
99 x 101·5 cm,
39 x 40 in.
Israel Museum,
Jerusalem

On the stage of a gaudy, motley, overcrowded tavern there are several weird and peculiar figures representing Tzara, Janco, Ball, Huelsenbeck, Madame Hennings, and your humble servant. Total pandemonium. The people around us are shouting, laughing, and gesticulating. Our replies are sighs of love, volleys of hiccups, poems, moos, and miaowing of medieval Bruitists … We were given the honorary title of Nihilists.

The audience of 31 March was treated to a further baffling première. Tzara and Huelsenbeck devised various *Chants Nègres* ('Negro songs'; 30) from genuine African poetry collected in libraries, which they recited in the original languages to the accompaniment of the rhythmic beating of Huelsenbeck's great drum. In their raw state, like the simultaneous poems,

30
Marcel Janco,
Sketch for
Chant Nègre,
1916. Charcoal
on paper;
73 × 55 cm,
28¾ × 21⅝ in.
Kunsthaus,
Zurich

the *Chants Nègres* were without meaning for the audience and were simply provocative. More seriously, they also proposed a revitalization of a tired European tradition through the adoption of something unspoiled and pure, a radical – if still essentially colonial – view of Africa.

Over the next couple of months came *Dances Nègres* ('Negro dances'), characterized by violent limb movements and contortions. The accompanying costumes used primary colours and geometric forms and were completed by astonishing masks. While true African masks were well known among avant-garde

31
Marcel Janco,
Mask, 1919.
Gouache,
pastel, paper,
cardboard and
twine;
h.45 cm, 17¾ in.
Musée National
d'Art Moderne,
Centre
Georges
Pompidou,
Paris

circles (16) – in Paris they influenced the paintings of Matisse, Derain and Picasso in 1906–7 (105) – the Dadas' masks were recast in modernist terms by Janco. The humblest of materials – cardboard, paper, string, paint – were infused with power by using simple shapes and strong colour (31), paralleling the immediacy of rhythm. In these masks Janco used African art as a means of breaking with the European tradition and indicated that art could be conjured up even from the crudest materials.

At the end of May 1916 an equally important 'Grand Evening of the Voltaire Art Association' was held. It included a 'concert

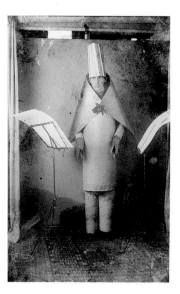

bruitiste' by Ball entitled 'Eine Krippenspiel' ('a nativity play'), probably inspired by the Futurist Luigi Russolo's *Art of Noises*. Ball's approach to language was different. He believed that journalism and politics had irredeemably debased the meaning of words and that this was symptomatic of the wider decay of Western civilization. As a solution he proposed the deconstruction of language by reducing words to sounds. Ball called the results 'Lautgedichte' (sound poems). On 23 June he read *Elephant-caravan (Elefantenkarawane)*, in which, reciting a series of syllabic sounds, he was able to convey in their rhythm, pronunciation

and volume an element of meaning, universally intelligible on an emotional level. His account in *Flight Out of Time* of the début remains immediate. Despite the seriousness of his intent, Ball deliberately presented a comic aspect in his appearance (32):

I had made myself a special costume for it. My legs were in a cylinder of shiny blue cardboard, which came up to my hips so that I looked like an obelisk. Over it I wore a huge coat cut out of cardboard, scarlet inside and gold outside. It was fastened at the neck in such a way that I could give the impression of winglike movement by raising and lowering my elbows. I also wore a high, blue-and-white-striped witch doctor's hat … I could not walk inside the cylinder so I was carried on to the stage in the dark and began slowly and solemnly:

> gadji beri bimba
>
> glandridi lauli lonni cadori
>
> gadjama bim beri glassala
>
> glandridi glassala tuffm i zimbrabim
>
> blassa galassasa tuffm i zimbrabim …

The stresses became heavier, the emphasis was increased as the sound of the consonants became sharper. Soon I realized that, if I wanted to remain serious (and I wanted to at all costs), my method of expression would not be equal to the pomp of my staging … The heavy vowel sequences and the plodding rhythm of the elephants [in *Elephant-caravan*] had given me one last crescendo. But how was I to get to the end? Then I noticed that my voice had no choice but to take on the ancient cadence of priestly lamentation … I was carried down off stage like a magical bishop.

Although this single surviving account is laced with Ball's retrospective revisions, the recital must indeed have been extraordinary. Its apparent meaninglessness had a long-term impact beyond controversy, as it became a weapon against convention and opened the possibility of a total revision of accepted values. Arp, Tzara and Huelsenbeck were soon writing and performing their own sound poems; Huelsenbeck's *Phantastische Gebete* ('Fantastic Prayers', 1916) was published in the summer. On receiving a copy, his mother is said to have burst into tears, fearing he had gone mad.

**At the final performances of the summer of 1916, the group
began to read Dada manifestos, initially indebted to Marinetti.
Tzara excelled at the subtle blend of theory, direct insult and
unctuous apology – skills that presaged his increasingly central
role within the group. The first Dada *soirée* on a larger scale
than the Cabaret Voltaire could accommodate was held at
the Zunfthaus zur 'Waag' on 14 July 1916. Both Ball and Tzara
read manifestos that appeared to explain Dada but deliberately
evaded any answer. They were classics of audience frustration
and confusion. Ball's manifesto introduced further sound poems
and, dispensing with conventional language, assumed some
of their character. He explained:**

Words emerge, shoulders of words, legs, arms, hands of words. Au, oi, uh.
One shouldn't let too many words out. A line of poetry is a chance to
get rid of all the filth that clings to this accursed language, as if put there
by stockbrokers' hands, hands worn smooth by coins. I want the word
where it ends and begins. Dada is the heart of words.

**Tzara's *Monsieur Antipyrine's Manifesto* (1916) was more
directly combative. It opened with apparently inconsequential
claims, which on further consideration clearly challenge all
conventions:**

dada is life with neither bedroom slippers nor parallels; it is against and
for unity and definitely against the future; we are wise enough to know
that our brains are going to become flabby cushions, that our antidogmatism
is as exclusive as a civil servant, and that we cry liberty but are not free …
dada remains within the framework of European weaknesses, it's still shit,
but from now on we want to shit in different colours so as to adorn
the zoo of art with all the flags of all the consulates … This is Dada's balcony,
I assure you. From there you can hear all the military marches, and come
down cleaving the air like a seraph landing in a public bath to piss and
understand the parable.

**The stridency of Tzara's assault was more than justified
by the horrors in the outside world, as General Erich von
Falkenhayn's strategy of 'bleeding the French army to death'**

at Verdun had been in progress throughout the existence
of the Cabaret itself.

The manifestos exposed the widening gap between the two
authors. Ball's performance of the sound poems reawakened
a dormant spiritual need, and he recognized it as a farewell.
He and Hennings withdrew to Ascona in Switzerland for
the rest of the year. *Monsieur Antipyrine's Manifesto* marked
the transfer of leadership to Tzara, who increasingly relished
the role of lion-tamer in Dada's circus.

In June 1916, however, the Cabaret closed definitively, as the
participants retired to the country for the summer. The only
public sign of life over the following months was the production
of three volumes in the 'Collections Dada': Tzara's *La Première
Aventure céleste de M. Antipyrine* (*The First Celestial Adventure
of M. Antipyrine*) with woodcuts by Janco, and Huelsenbeck's
Schalaben schalabai schalamezomai and *Phantastische Gebete,* both
illustrated by Arp (33). Woodcuts had the advantage of being
cheap and robust (using the same technology as the
type, they could also appear in more than one publication).
As a medium the woodcut was particularly associated with
the angst-laden imagery of the Expressionists, but both Arp
and Janco deliberately avoided this, moving instead towards
personal abstract forms. Like the verses they accompanied,
their images were without direct equivalent in the outside
world but retained an idea of nature through the impression
of the rough wood grain.

These publications served to establish a definable public identity
for Dada. Under Tzara's guidance it was to be an avant-garde
movement with its own periodical, although without a predeter-
mined programme – an anti-movement for anti-art. It already
constituted a loose association of independent artists who agreed
nothing other than a general rejection of existing values.
Ball believed that the Cabaret had allowed them to break
with the expectations of contemporary culture. Tzara saw this
as a strength but while pushing for ever more radical iconoclasm

he was willing to step back into the cultural current in order to challenge it. For this he was roundly criticized by Huelsenbeck, who recognized his raw ambition. Like Ball, Huelsenbeck had doubts about forming a movement and prepared to return to Berlin, although he did not leave until the end of 1916.

The Dadas' attack on all conventions and their refusal to participate in the patriotic calls of the war were not easy positions to hold. They were accused of nihilism, anarchism and neutrality, which had become pointed terms of abuse. As the cultural establishment attempted to protect itself from Dada, pressure fell heavily on the group's collaborators abroad who feared to be associated with its dubious internationalism. This was particularly the case in Paris, where both Apollinaire and the dealer Paul Guillaume felt they could contribute only to 'pro-Ally' events in Zurich.

During the summer of 1916 the configuration of Zurich Dada changed. The original group had split, and the entry of Romania into the war on the side of Britain, France and Russia, on 28 August, immediately transformed Tzara and Janco into potential conscripts. In November Tzara was called for examination by a panel ascertaining fitness to fight. He successfully feigned mental instability and received a certificate to that effect. (Arp had been similarly successful before a German panel, whose questions he had answered by writing down his date of birth several times in a column and adding them into an immense total.) By the winter a joint Austrian–German campaign had overrun Romania, and this severing of national ties must have determined the renewed energy that Tzara channelled into Dada.

Other participants also began to have an impact on Dada in mid-1916. At the end of September Taeuber held a 'Fête Littéraire', which confirmed a growing proximity between the Dadas and the dancers of the Laban school, followers of the innovative choreographer Rudolf von Laban. New collaborators arrived from the Front, including the young German Expressionist painter Hans Richter and his writer friends Albert Ehrenstein

33
Hans Arp,
Cover of
*Phantastische
Gebete*, 1916.
Woodcut;
23 x 14.7 cm,
9 x 5⅞ in.
Kunsthaus,
Zurich

Für Tristan Tzara

Hans Arp

[signatures]

Phantastische Gebete

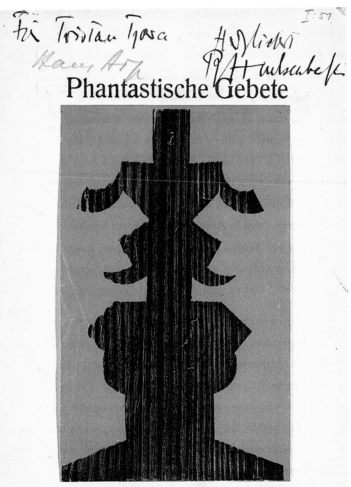

Verse von RICHARD HUELSENBECK mit 7 Holz-
schnitten von HANS ARP Colection DADA Zürich im
Semptember 1916

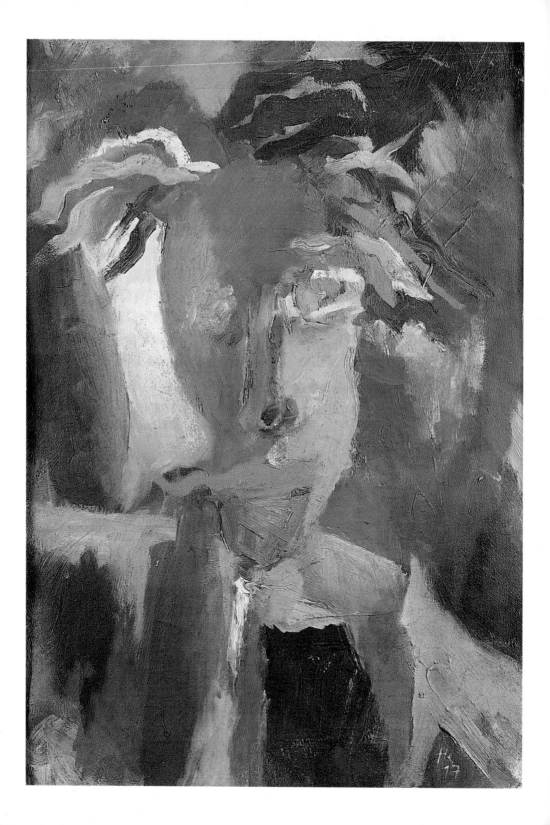

of the outside world or its material conventions. In this he was also clearly indebted to Arp, who had an important influence on the exhibition, and whose ideas on the subject were noted by Ball in *Flight Out of Time* a year before:

Arp speaks out against the bombast of the gods of painting (the expressionists) … He would like to see things more ordered and less capricious, less brimming with colour and poetry. He recommends plane geometry rather than painted versions of the Creation and the Apocalypse. When he advocates the primitive, he means the first abstract sketch that is aware of complexities but avoids them. Sentiment must go, and so must analysis when it occurs only on the canvas itself. A love of the circle and of the cube, of sharply intersecting lines. He is in favour of the use of unequivocal (preferably printed) colours (bright paper and fabric); and he is especially in favour of the inclusion of mechanical exactness … If I understand him correctly, he is concerned not so much with richness as with simplification.

For Ball, the theorist, such order was associated with a Germanic rationality for which he criticized his country. For the artist, it represented a stripping away of the emotion of Expressionism in search of an order higher than that imposed by man. Arp's work during 1916 had continued his earlier simplification, using unexpected geometries and textures, allowing for the echoing of forms across the composition (22). This geometry was embodied in Arp's use (in a collage reproduced in *Dada* 2, December 1917) of approximately square pieces of paper, which were set side to side so that the composition could grow into a progression of forms from this slight irregularity. The use of commercial papers also relieved the artist of decisions over colour and tone.

In the piece on Arp that accompanied this collage, Tzara laid the emphasis on the magical elements of growth marshalled by the artist: 'But the artist is a creator: he knows how to make a form that becomes organic. He decides. He makes man better. He cultivates the garden of intentions, commands.'

34
Hans Richter,
Visionary Self-portrait, 1917.
Oil on canvas;
53·5 x 38 cm,
21 x 15 in.
Musée National d'Art Moderne, Centre Georges Pompidou, Paris

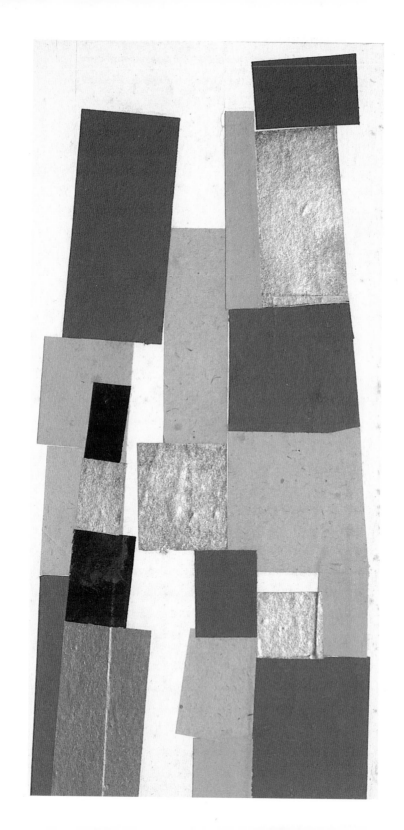

The most revolutionary of Arp's collages were those made 'according to the laws of chance' (35, 36). In these works the papers were glued where they had been allowed to fall. Richter recalled that the discovery of this technique, which came to seem quintessentially Dada, grew out of frustration at composing by more orthodox methods. Arp simply tore up the work and threw it on the ground, later finding in the random arrangement a freer and more suggestive method that dispensed with the dexterity and judgements of the finely tuned eye of the artist. If Dada was to be considered as 'anti-art', then this was one of the purest and most provocative of such gestures, even if the results were also of great formal and aesthetic value. By letting chance intervene so directly, the artist's role was startlingly reduced in a way that commented upon the state of the world in which fate had overtaken the determination of human plans. The rationalism of Western society had been shown to be worthless, and Arp became interested in alternatives in Eastern philosophy. His method has obvious parallels with the Taoist book of divination, the *I Ching*, which involved the casting of yarrow stalks in order to read the future, and suggests that chance alignments could reflect a universal order.

The use of chance in these collages could also be applied to poetry, as Arp recalled in 'Wegweiser' ('Signpost', 1953):

Often I shut my eyes and chose words and sentences in newspapers by underlining them with a pencil. I called these poems 'Arpaden' … We thought to penetrate through things to the essence of life, and so a sentence from a newspaper gripped us as much as one from a prince of poets.

The *Arpaden* match the recipe offered by Tzara in his later *Manifesto of Feeble Love and Bitter Love* of December 1920:

TO MAKE A DADAIST POEM
Take a newspaper.
Take some scissors.
Choose from this paper an article of the length you want to make your poem.

35
Hans Arp,
*Collage Made
According to the
Laws of Chance*,
1916.
25·3 × 12·5 cm,
10 × 4⅞ in.
Kunstmuseum,
Basle

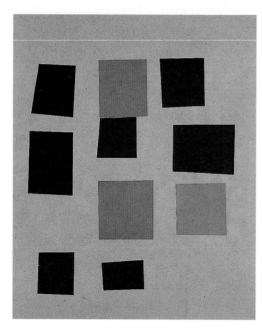

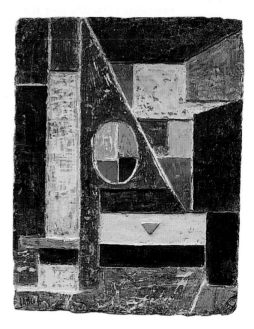

Cut out the article.

Next carefully cut out each of the words that makes up this article and put them all in a bag.

Shake gently.

Next take out each cutting one after the other.

Copy conscientiously in the order in which they left the bag.

The poem will resemble you.

And there you are – an infinitely original author of charming sensibility, even though unappreciated by the vulgar herd.

It is not surprising that Arp was interested in the concealed patterns in nature, which also existed outside rational systems. He had begun to explore the geometries of plant growth through new woodcuts featuring shapes reminiscent of micro-organisms. These assumed an almost hieroglyphic quality, distilling fundamental biomorphic signs – bottle, leaf, navel – until their essence achieved a compelling simplicity.

Janco's woodcuts were also increasingly organic, and their complex forms can be related to his contemporary carved plaster reliefs, a further exploitation of unorthodox but cheap

Arp had made some reliefs by early 1917 which, although of quite a different order, share with Janco's the use of shallow layering and strong colour. As with the prints, Arp used planks of wood cut in biomorphic forms. The layers were progressive planks held by clearly visible screws and differentiated by bright colours, so that the effect was of a pile of disparate objects with an unexpected but organic relationship (24, 38). True to his conviction in the importance of chance, Arp had the pieces cut and assembled by a carpenter, allowing him a certain freedom of interpretation.

Richter made drawings and woodcuts close to Janco's, although his painting for a time retained recognizably Expressionistic traits: heightened colour, energetic brushwork, emotional distortion of the human figure. His need to reduce his controlling role in this response came with the *Visionary Portraits* (34, 39), which were painted at twilight, so that colour and form were determined more by chance. His transformation towards a more restrained form of abstraction is remarkable and linked to his encounter with the reclusive Swedish painter, Viking Eggeling (40). Together with Arp and Janco they definitely swung Dada towards abstraction, and drew support from other artists such as Augusto Giacometti (44) and Baumann, who were instrumental in promoting abstract art in Switzerland.

The closure of Galerie Dada at the end of May 1917 curtailed these opportunities. Ball and Hennings withdrew definitively as Ball turned to politics and contributed to the left-wing Bern newspaper *Die Freie Zeitung*. As in 1916, activities in the summer months again relied on publication: *Dada 1* came out in July 1917 followed by *Dada 2* the following December. The periodical supported Tzara's claim that a Dada Movement had been launched, and highlighted his determination to make a mark on the international stage. That its publication coincided with the intervention of the United States in the war may suggest that he was already anticipating the opening up of the postwar era.

36 Far left
Hans Arp,
*Collage Made
According to the
Laws of Chance*,
1916.
40·4 × 32·2 cm,
15⅞ × 12⅝ in.
Kunstmuseum,
Basle

37 Left
Marcel Janco,
*Prière, éclair du
soir (Prayer,
Evening
Lightning)*,
1918.
Painted plaster;
47·7 × 37·5 cm,
18¾ × 14¾ in.
Kunsthaus,
Zurich

From this point Tzara strengthened ties with France and Italy at the expense of those with Germany. Contacts in Paris included the writers Pierre Albert-Birot and Pierre Reverdy, whose contributions later appeared in *Dada 3* (December 1918) and who publicized Dada activities in their own periodicals, *SIC* and *Nord–Sud* respectively. The fact that *Dada* appeared so irregularly (due to lack of funds) meant that Tzara had to keep up a consistent correspondence to maintain these contacts.

Links with Italy were also diversified, and this was reflected in the high proportion of Italian contributors to the first two issues

38 Left
Hans Arp,
The Entomb-
ment of the
Birds and
Butterflies
(Head of Tzara),
1916–17.
Painted
wooden relief;
40 x 32·5 cm,
15¾ x 12¾ in.
Kunsthaus,
Zurich

39 Right
Hans
Richter,
Blue Man,
1917.
Oil on canvas;
61 x 48·5 cm,
24 x 19⅛ in.
Kunsthaus,
Zurich

of *Dada*. None of these belonged to the orthodox Futurists who had appeared in *Cabaret Voltaire*, but they included artists of what became known as the Metaphysical Art (Arte Metafisica) group such as the musician and writer Alberto Savinio, his brother Giorgio de Chirico and the ex-Futurist Carlo Carrà. The work they produced was rooted in de Chirico's melancholic and mysterious imagery of disrupted urban spaces (squares and arcades) and unexpected juxtapositions; an illustration of his Parisian painting *The Evil Genius of a King* appeared in *Dada 2* (41). The enigmatic mannequins with which he subsequently peopled these spaces

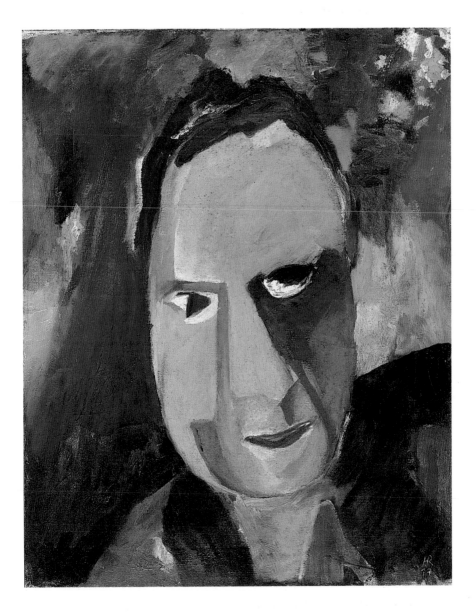

40
Viking Eggeling.
Composition,
c.1916.
Oil on canvas;
50 × 35·5 cm,
19¾ × 14 in.
Kunstmuseum,
Basle

41
Giorgio de Chirico,
The Evil Genius of a King,
1914–15.
Oil on canvas;
61 × 50·2 cm,
24 × 19¾ in.
Museum of
Modern Art,
New York

became de Chirico's most resonant – and copied – invention
as a metaphor for the dehumanizing experience of the war.

As well as sending texts to Tzara, Savinio acted as a link to
Francesco Meriano's and Bino Binazzi's Bolognese periodical
La Brigata. Meriano's poems were read at a Zurich *soirée* in May
1917, and in the following month Tzara invited him to launch
the Dada movement in Italy. Events conspired against this first
attempt at an off-shoot from the Zurich group: financial
difficulties forced the closure of *La Brigata* and Meriano was
soon called up. He did take time, however, to recommend the
newly established Roman periodical *Noi* edited by Prampolini,
notorious for the manifesto *Let's Bomb the Academies* (1913),
which simultaneously had him expelled from the Rome Academy
and embraced by the Futurists. An enthusiastic exchange followed,
with Prampolini's prints appearing in the first three issues of *Dada*,
and Tzara publishing 'Froid Jaune' ('Cold Yellow') alongside
woodcuts by Janco and Arp in *Noi 1* (June 1917). However,

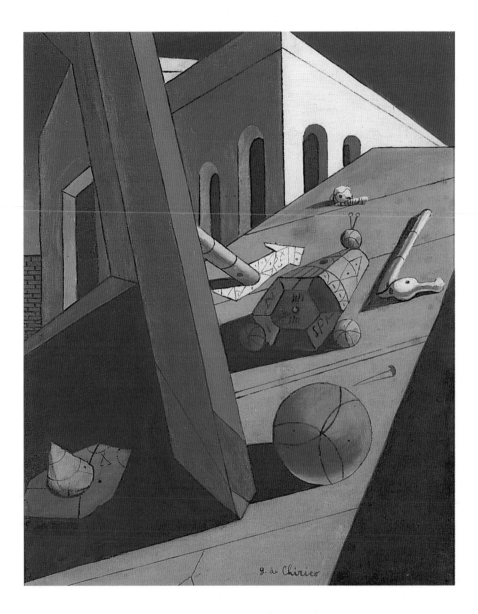

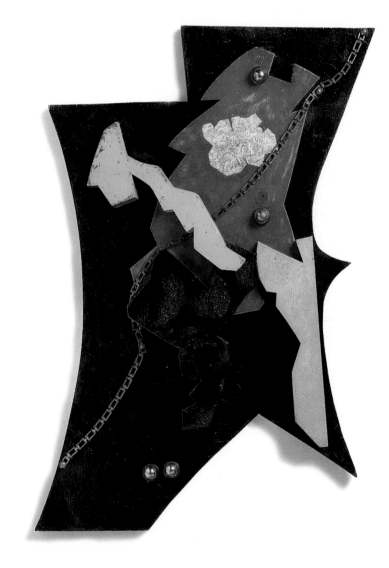

these caught the attention of nationalists in Italy suspicious of neutrality, encouraging the critic Margheritta Sarfatti to write:

Why publish empty things without construction … such as the Bois n.1 by H Arp from … Zurich? M Arp is politically neutral. In art he appears to be like the Boches of which I say one should: 1st be suspicious and 2nd defend oneself against their infiltration.

Prampolini's unwillingness to defend Dada publicly, and open hostility from the Futurists, convinced Tzara that nurturing links with Italy was more trouble than it was worth. The difficulties were greatly increased in the autumn by the upsurge of patriotism in reaction to the devastating defeat at Caporetto, in which Italy temporarily lost huge swathes of the north to the Austrians. During 1918, exchanges between Dada and Italy were extremely muted.

New collaborations were forthcoming from within Switzerland. In late 1917 Walter Serner, the former editor of *Sirius*, established contact with Tzara. He had spent much of his time in Geneva where Christian Schad was working and exhibiting and, through Serner, Schad also temporarily adhered to Dada. Like Arp, Schad was experimenting with painted reliefs, although his were made up of disparate materials (42). They were mechanomorphic in inspiration, having parallels with the still realistic 'peinto-sculptures' of Alexander Archipenko, with whom Schad shared an exhibition in Geneva in December 1919.

Perhaps more important were Schad's photographic experiments: the 'Schadographs' (43). By laying objects on light-sensitive photographic paper and exposing them to light, a camera-less photograph was achieved. Because contact ensured a white surface, negative images of the objects were fixed with their forms fading into darkness. The composition and effect were largely determined by chance, and they hovered on the borders between the abstract and unexpected illusionism. Like X-rays, and with similar effects, the Schadographs appeared to fix an unseen world. The reduction of the mechanics of photography for Dada ends was a triumph over the rational world, although

42
Christian Schad,
Composition in M, 1920.
Painted wood and metal relief;
h.70 cm, 27⅝ in.
Kunsthaus, Zurich

43
**Christian
Schad**,
Untitled, 1918.
Schadograph;
16·4 x 12·7 cm,
6½ x 5 in.
Kunsthaus,
Zurich

it was to be Dadas elsewhere – in France and Germany – who explored it fully. Schad remained at a remove, participating only in the few Dada activities in Geneva.

The commitment of the Zurich artists to abstraction was confirmed at the end of 1917 in the illustrations of *Dada 2* by such artists as Delaunay, Kandinsky and Prampolini and, among the local contributors, Otto van Rees, Arp and Janco. This tendency brought the formation, in April 1918, of a new alignment of abstract artists working in Switzerland, which can be seen as a parallel group to Dada. Called Das Neue Leben (New Life) it saw Arp, Taeuber, Janco and Lüthy join Baumann, Giacometti (44) and others to exhibit together in Zurich and Basle. Even if the works carried the same message, the aims of Das Neue Leben to promote and exhibit abstract art lay within conventional commercial means usually avoided by Dada.

That this outlet was necessary reflected the fact that, once again, Dada activity had all but collapsed due to lack of funds and Tzara's nervous illness. At this point the centre of Dada activity switched to Germany, where Huelsenbeck began to form Berlin Dada in

April 1918. That summer, however, Tzara made two attempts to secure lost ground. He published *Vingt-cinq poèmes* (*Twenty-five Poems*, 1918) with woodcuts by Arp, and held the seventh *soirée*, under the defiant title '*Soirée* Tristan Tzara', at the Zunfthaus zur Meise on 23 July (19). His *Dada Manifesto 1918*, subsequently published in *Dada 3*, is a lengthy, explosive and aggressive text asserting that '**DADA was born, out of a need for independence, out of mistrust for the community.**' The assault was brilliantly sustained. He began with quick-witted irony:

I am writing a manifesto and there's nothing I want, and yet I'm saying certain things, and in principle I am against manifestos, as I am against principles (quantifying measures of moral value of every phrase – too easy; approximation was invented by the impressionists).
I am writing this manifesto to show that you can perform contrary actions at the same time, in one single, fresh breath; I am against action; as for continual contradiction, and affirmation too, I am neither for nor against them, and I won't explain myself because I hate common sense.

Having lulled his audience into a false sense of security with this wit, he increased the pace and sharpness of his attacks. Under the guise of a discussion of art, he questioned all fondly held principles, implicitly acknowledging how they had been exposed by the conditions of the war:

The principle: 'Love thy neighbour' is hypocrisy. 'Know thyself' is utopian, but more acceptable because it includes malice. No pity. After the carnage we are left with the hope of a purified humanity …
A painting is the art of making two lines, which have been geometrically observed to be parallel, meet on the canvas, before our eyes, in the reality of a world that has been transposed according to new conditions and possibilities. This world is neither specified nor defined in the work, it belongs, in its innumerable variations, to the spectator. For its creator it has neither cause nor theory. *Order = disorder; ego = non-ego; affirmation = negation:* the supreme radiations of an absolute art. Absolute in the purity of its cosmic and regulated chaos, eternal in that globule that is a second which has no duration, no breath, no light and no control.

Tzara ended his tirade with a section entitled 'Dada Disgust', in which actively iconoclastic definitions are offered in a series of rhythmic phrases, concluding with Dada defined as 'the roar of contorted pains, the interweaving of contraries and of all contradictions, freaks and irrelevancies: LIFE'. In contrast with Ball's liturgical sound poems, Tzara had evolved a hymnic form, piling phrase upon phrase in a dizzying accumulation of images which overwhelmed the audience under its sheer weight of negation. With this text all was cast aside.

The energy of this manifesto did not quite come out of the blue. By the summer of 1918 the war had moved into its final phases and, although the killing had not stopped, the prospects for its conclusion were brighter. Following the success of the Russian Revolution in 1917 and with signs of civil unrest in Germany, widespread social revolution seemed imminent. Whole sectors of society suddenly seemed in tune with Dada's 'disgust' at its established orthodoxies.

Tzara had set his sights on Paris as the next goal for Dada expansion, when he was contacted by Picabia. Although unknown in Zurich, Picabia must have seemed like the embodiment of Dada. His experimentation, irony, playful and sexual punning seemed to epitomize an anti-art, to which he added a masterful command of the teasingly abusive publication and, above all, the scandalous provocation. His links within the prewar Parisian avant-garde were impressive, as an abstract painter and collaborator of Apollinaire and Duchamp; his wartime activities were astonishing, as he travelled between New York and Barcelona organizing exhibitions and publishing his own itinerant periodical, *391*. These activities (discussed in Chapter 3) were in the same spirit as Dada although this was the first direct link between the groups.

In the spring of 1918 Picabia and his wife Gabrielle Buffet arrived in Switzerland, so that he might recuperate from nervous exhaustion at Bex-les-Bains, near Lausanne. During the summer he came across Tzara's *Vingt-cinq poèmes*. Through a lively correspondence

44
Augusto
Giacometti,
May Morning,
1910.
Oil on canvas;
133×133 cm,
52³⁄₈ × 52³⁄₈ in.
Kunstmuseum,
Basle

limbo in Zurich, while the Berlin group was intensely active and there were further developments elsewhere.

The realization of the international scope of Dada and the need to match Picabia's nihilism sharpened Tzara's philosophy of disgust. This was evident at the riotous eighth Dada *soirée* held at the Saal zur Kaufleuten (9 April 1919). Inspired by Eggeling's symphonic abstractions exhibited at the Galerie Wolfsberg, two 15-m (50-ft)-long paintings by Arp and Richter and by Alice Bailly and Giacometti provided a backdrop. Against this Tzara's simultaneous poem for twenty voices, *Le Fièvre du mâle* (*Male Fever*), was performed to considerable disturbance in the audience. Arp's *Wolkenpumpe* (*Cloud Pump*) poems hardly served to placate them but the audience exploded when Serner addressed them with his back turned for his nihilist manifesto *Letzte Lockerung* (*Final Dissolution*); the stage was attacked and he was chased from the building. Richter recalled that not only 'Serner's provocations, but also the rage of those provoked, had something inhuman', through the recognition of which 'the public had gained in self-awareness'. When they returned for the final part of the programme, Tzara issued his *Proclamation without Pretension*, also from *Dada 4–5*: 'We are in search of the force that is direct pure sober UNIQUE we are in search of NOTHING.'

This was the swan song of Zurich Dada. Peace allowed freedom of movement and Tzara's publishing ambitions became international, building to his unrealized *Dadaglobe* anthology of the following year. Instead Serner was the driving force behind the one-off periodical, *Der Zeltweg* (November 1919), which he edited with Tzara and the writer Otto Flake. Arp, Janco and Richter had already joined Baumann and Eggeling in founding a new pan-European grouping of abstract artists in May 1919 called Radikalen Künstler/Groupe des artists radicaux (Group of Radical Artists). In December, Serner and Schad launched the independent Geneva Dada, but it was not sustained beyond the Grand Dada Ball in March 1920.

46
Julius Evola.
Interior Landscape at 10.30, 1919–20.
Oil on canvas; 70×54 cm, 27½×21¼ in. Galleria Nazionale d'Arte Moderna, Rome

Tzara's travels during the summer of 1920 from his new base in Paris reflected the diminishing activities in Zurich. He returned to Bucharest for the first time in five years, to be reunited with Vinea and with Janco, who had preceded him. Their partnership had deteriorated with Janco's increasing conviction in an idealistic abstraction (related to his subsequent return to architectural practice). Despite his inclination towards anarchism, Tzara seems to have taken an interest in his friends' periodical *Contimporanul* (1920–30), although its scope was much broader than Dada.

Tzara also visited Italy, where interest in Dada re-emerged in the unlikely setting of Mantua. There the painters Gino Cantarelli and Aldo Fiozzi edited the periodical *Procellaria* (1917 and 1919) on the fringes of Futurism, before declaring in favour of Dada in their new periodical *Bleu* (1920), to which Tzara contributed. On meeting them in Venice, Tzara came into contact with the abstract painter Julius Evola, who took to Dada with unbridled enthusiasm, launching a Rome Dada exhibition at the Galleria Bragaglia in April 1921. Although his paintings (46) and the accompanying reading of his own idealist theories of abstraction and of Tzara's *Dada Manifesto 1918* caused a gratifying disturbance, his declaration of the death of Futurism unleashed sustained hostility. The brief Rome Dada season – during which he produced the volume *Arte Astratta* (*Abstract Art*) – brought Evola to a point of personal crisis before he abandoned Dada for philosophical speculation.

The ambitions for a global Dada that Tzara appeared to nurture in 1920 lay in the balance. A need was felt to turn outwards from Zurich once the restricting conditions of war were lifted. This opened the way to the artistic centres of Berlin and Paris, but it was also a response to the sudden knowledge – exposed by contact with Picabia – that Zurich Dada had not been an isolated protest, but part of a larger assault hatched simultaneously by other groups in other neutral cities.

Although Dada is firmly associated with Zurich, not all avant-garde artists sought refuge from the war in Switzerland. Different – if parallel – new approaches in avant-garde practice and theory emerged in other exiled artistic communities. Links between Paris and both Barcelona and New York were especially important, and these can be traced back to the productive decade preceding the war (see Chapter 1). Three figures in particular – Picabia, Duchamp and Apollinaire – contributed important developments that took place outside the orbit of Zurich Dada but which converged with it after 1918.

47
Francis
Picabia,
*Dances at the
Spring II*, 1912.
Oil on canvas;
251·8 ×
248·9 cm,
99¼ × 98 in.
Philadelphia
Museum of Art

Like many exiles, Picabia and Duchamp, who both left Paris having been relieved of active service, chose the more distant potential of the New World. Their activities in New York during 1917 were certainly parallel in spirit to Dada – as Tzara was to recognize – but there were differences too. Gabrielle Buffet, Picabia's then wife and collaborator, emphasized the 'perfect gratuitousness of the "demonstrations", which ... issued spontaneously from the most trivial circumstances and gestures'. This casualness contrasted with the urgent note of Zurich Dada, reflecting New York's much greater distance, both geographical and psychological, from the war.

It was Buffet, too, who named the prewar period of collaboration between Picabia, Duchamp and Apollinaire 'pre-Dada', a term that highlights the roots of their shared attitude between 1912 and 1914. The first sign of this may be recognized in Apollinaire's singling out of Duchamp and Picabia in his book *Aesthetic Meditations: The Cubist Painters* of 1912. He discerned a psychological motivation in their choice of subjects that distinguished them from the more formal concerns of their Cubist colleagues. In such paintings as Duchamp's *Sad Young Man on a Train* (1911) or Picabia's

Dances at the Spring II (47), they used Cubist fragmentation
to evoke mental states within different environments.
Apollinaire dubbed this more lyrical Cubist approach 'Orphism',
after the mythical Orpheus, considering it to be a poetic response
to Bergson's ideas of flux. Their themes of eroticism and
mechanization, coloured by a stance of ironic distance,
can already be seen as heralding Dada.

**48
Marcel
Duchamp,**
*Nude
Descending a
Staircase
(No. 2),* 1912.
Oil on canvas;
146 × 89 cm,
57½ × 35 in.
Philadelphia
Museum of Art

Together with the pianist Buffet, the two painters formed a fertile
friendship with Apollinaire. In 1912 they were inspired by a
performance of Raymond Roussel's bizarre play *Impressions of
Africa*, in which elaborate and improbable machines are
invented by the shipwrecked characters; Duchamp later
described these as 'the madness of the unexpected'. Roussel's
punning word-play was adopted by the painters for the titles of

their works. **The linguistic possibilities also suggested parallels with Apollinaire's approach in the contemporary poem *Zone*, where he superimposed images of Paris, popular culture and an ironic view of religion:**

Even the automobiles here seem to be ancient

Religion alone has remained entirely fresh religion

Has remained simple like the hangers at the airfield

You alone in all Europe are not antique O Christian faith

The most modern European is you Pope Pius X

And you whom the windows look down at shame prevents you

From entering a church and confessing this morning

You read prospectuses catalogues and posters which shout aloud

Here is poetry this morning and for prose there are the newspapers

There are volumes for 25 centimes full of detective stories

Portraits of famous men and a thousand assorted titles.

The poet's extraordinary blend of lyricism and iconoclasm infected the work of his friends. Picabia adapted the rich colouring of his earlier post-Impressionism to his increasingly abstract paintings, which culminated in *Dances at the Spring II*. References to the figure were almost lost within its broad planes of colour. Instead, the fragmentation and balance conveyed the essence of the dance brought together in memory. Appropriately this reflected contemporary Synthetist theories in music – about the holding of the piece in the memory – to which Buffet introduced Picabia.

Through his older brothers, the painter Jacques Villon and the sculptor Raymond Duchamp-Villon, Duchamp was more closely linked to Cubism. They held regular discussions at their Puteaux studios, which were attended by the painters Albert Gleizes and Jean Metzinger, authors of the major theoretical text *Du Cubisme* (1912). Duchamp, however, broke with Cubist orthodoxy in 1912: in *Nude Descending a Staircase (No. 2)* (48) he attempted to convey progressive movement by overlapping planes related to the blurred effect in contemporary photographic studies of motion. The Cubists considered the painting uncomfortably close to Futurism when it was submitted to

the Salon des Indépendants, and tried to persuade Duchamp to change the title. Instead he withdrew the painting, confirming his divergence from Cubism towards a concentration on psychological transformations. These he conveyed with tubular forms and diagrammatic line, until the interior of the human body offered mechanical analogies. This served as a reflection of modern man, and opened possibilities for the ironic treatment of a sexually charged atmosphere.

Duchamp's redefinition of art took the form of 'denying the possibility of defining art'. He believed that art should exercise the intellect rather than simply indulge the eye. He soon found

**49
Marcel
Duchamp,**
*The Bride
Stripped Bare by
Her Bachelors,
Even,* 1915–23.
Oil and lead
wire on glass;
227·5 x
175·6 cm,
109¼ x 69⅛ in.
Philadelphia
Museum of Art

oil painting too limited, and developed the sexual imagery of his painting *The Bride* (1912) by other means. Through diagrammatic studies he envisaged a series of imaginary mechanisms, reminiscent of Roussel's, which he executed in metal and paint on glass so that the background might change. The preparatory works made in Paris were preliminary to the major work – in all taking a decade – which Duchamp began in New York in 1915, *The Bride Stripped Bare by Her Bachelors, Even*, also known as *The Large Glass* (49). Its central subject is the unconsummated passion of the nine uniformed bachelors for the stripped bride. The bachelors are mechanical in appearance and constricted to the lower zone with their 'bachelor machine'; the bride floats seductively above. The elaborate techniques of the work's manufacture were matched by the conceptual complexity, as Duchamp attempted to embody in mechanized form the futility of human passion. In his preparatory notes he envisaged the bride as

an apotheosis of virginity ie ignorant desire. blank desire. (with a touch of malice) and if it (graphically) does not need to satisfy the laws of weighted balance nonetheless a shiny metal gallows could simulate the maiden's attachment to her girl friends and relatives … her timid-power … is a sort of automobiline, love gasoline that, distributed to the quite feeble cylinders, within reach of the sparks of her constant love, is used for the blossoming of this virgin who has reached the goal of her desire.

While this kind of conceptual approach was very different from the spontaneity that characterized Zurich Dada, Duchamp did accommodate the use of chance. He dropped a metre of thread from the height of a metre, and used the resulting curve to make a customized ruler for constructing part of *The Large Glass*, repeating this operation to create the *Three Standard Stoppages* (1913–14).

The conquest of New York by Picabia and Duchamp began before the war with the Armory Show of 1913, a large international exhibition including such prominent members of the European avant-garde as Picasso, Braque, Matisse and Brancusi. At that

time contemporary art in the United States was still dominated on the one hand by the Impressionism of Winslow Homer and Maurice Prendergast, and on the other by the gritty realism of the Ash Can School of Robert Henri and George Bellows. The last two taught at the anarchist Ferrer Center in New York, where their students included Max Weber, Man Ray and Adolf Wolff. Few people in America were aware of Cubism in 1913, and the Armory Show was a public sensation. From New York it travelled to Chicago and Boston, and was seen by almost 75,000 people. The most-mocked work on display was Duchamp's *Nude Descending a Staircase (No. 2)*, which ensured him overnight notoriety and was bought by the San Francisco dealer Frederick Torrey 'sight unseen'.

The arrival of Picabia and Buffet for a five-month stay in America served to stoke up the scandal. The public were by turns convinced and goaded by their provocative pronouncements, and their visit also allowed them to sample life in the world's greatest metropolis, with its skyscrapers and illuminated advertisements for which there were no equivalents in Europe. In the newspaper article 'How New York Looks to Me', Picabia declared:

Your New York is the cubist, the futurist city. It expresses in its architecture, its life, its spirit, the modern thought … Because of your extreme modernity, therefore, you should quickly understand the studies that I have made since my arrival … They express the spirit of New York as I feel it, and the crowded streets of your city as I feel them, their surging, their unrest, their commercialism and their atmospheric charm.

Such paintings as *New York* (50) express this excitement in jostling abstract forms. They were shown at the Photo Secession gallery run by Alfred Stieglitz, who was one of the few to introduce America to artistic photography and the European avant-garde. His sense of a social purpose for art clashed with the commercialism of the Armory Show, but he welcomed the Picabias into his circle, which included other photographers such as Edward Steichen and Charles Sheeler, the painters

50
Francis
Picabia,
New York, 1913.
Watercolour
on paper;
54·7 x 74·7 cm,
21½ x 29½ in.
Musée National
d'Art Moderne,
Centre
Georges
Pompidou,
Paris

Arthur Dove and (subsequently) Georgia O'Keeffe, and the Mexican caricaturist Marius De Zayas.

Inspired by New York, Picabia returned to Paris to paint the enormous canvas *I See Again in Memory My Dear Udnie* (51). Its title hinted at his association with the American dancer Isadora Duncan (whose initials are combined with 'nue', naked, to form 'Udnie'), but any figurative reference was dissolved into abstract pneumatic forms. A more permanent transatlantic link was promised with the arrival in France of De Zayas. He set up collaborations between the Galerie Paul Guillaume and Stieglitz's gallery and contributed abstracted caricatures to Apollinaire's periodical *Les Soirées de Paris*. On returning to New York, De Zayas persuaded Stieglitz to back a similarly radical periodical in 1915. Called *291*, after the Photo Secession's address, it was a showcase for the new transatlantic links; its typography was indebted to Apollinaire's Calligrammes, and it featured work by him as well as by Picasso and Savinio.

51
**Francis
Picabia**,
*I See Again in
Memory My
Dear Udnie*,
1914.
Oil on canvas;
250·2 ×
198·8 cm,
98⅝ × 78⅜ in.
Museum of
Modern Art,
New York

All these factors made New York an attractive place of exile. After a year as an army driver, Picabia arrived there in June 1915 under the pretext of a French government commission (secured through family influence) to buy sugar in Cuba. He immediately absconded, visiting Cuba only after Buffet's arrival in the autumn. In the same month Duchamp, who was unfit for active service, also arrived in New York. They were joined by the French composer Edgar Varèse, who championed both modernist and popular black American music. Already enthusiastic about the syncopated piano of ragtime, he found Jazz – which did not reach Europe until the 1920s – sweeping through wartime New York.

The exiles spent 1915 and 1916 enjoying their renewed freedom and establishing contacts with like-minded artists. Picabia rejoined Stieglitz's friends, while Duchamp was introduced to the circle centred around a wealthy writer of symbolist-inspired poetry, Walter Arensberg, and his wife Louise, who would form an unrivalled collection of his work over the next forty years. Among the Arensbergs' friends were the poets William Carlos

Williams and Margaret Anderson, editor of the literary periodical *The Little Review*, and Alfred Kreymborg, with whom they formed the avant-garde 'Others' group. They held fashionably left-wing political views, although Robert Coady's Washington Square Gallery (1914–21) and periodical *The Soil* offered more explicitly radical arenas for new American work. Among the associated artists, Joseph Stella reflected an awareness of Futurist dynamism through his canvases of Brooklyn Bridge (52), while others responded more to the ironic vision of the world that the Frenchmen had developed. These included Morton Schamberg, the eccentric German Baroness Elsa von Freytag-Loringhoven and Man Ray. Duchamp and Picabia found themselves at the centre of artistic gatherings, especially at the Modern Gallery opened by Stieglitz and De Zayas in October 1915. However, these remained essentially casual in nature. There never appeared to be an ambition to create a 'movement'; had there been, it would have been hampered by Picabia's frequent absences – and his addiction to opium – and Duchamp's general insouciance as he gradually built *The Large Glass*.

52
Joseph Stella,
Brooklyn Bridge,
1918–20.
Oil on canvas;
214·5 x 194 cm,
84½ x 76½ in.
Yale University
Art Gallery,
New Haven

Further arrivals in New York aided the re-creation there of a Parisian avant-garde in exile. Turning to pacifism on being discharged from the army, the Cubist Albert Gleizes arrived with his wife Juliette Roche in late 1915. They joined the similar group in Barcelona for several months in the following year, but returned to New York in 1917. In a way comparable with Stella, Gleizes's *In the Port* (53) – which combines features of Barcelona and New York – is a celebration of the metropolis and the excitement of modern life. Gleizes's Cubism, however, was of a utopian kind, which became as much a target for his iconoclastic friends Picabia and Duchamp as conservative art. For the Swiss painter Jean Crotti, the New York period brought a profound transformation in style as he adopted Duchamp's mechanistic analogies to his more spiritual outlook (54).

The exiles' influence on their American friends is seen in the sudden prevalence of mechanical imagery and materials.

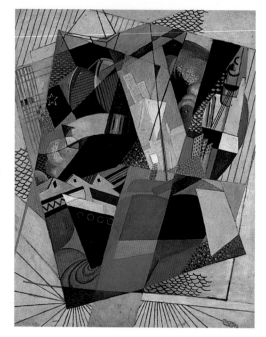

53
**Albert
Gleizes**,
In the Port,
1917. Oil and
sand on canvas;
153·3×120·6 cm,
60³⁄₈×47½ in.
Fundación
colección
Thyssen-
Bornemisza,
Madrid

Responding to Duchamp's studies for *The Large Glass*, Picabia called a number of his mechanomorphic works (in which machine parts replace those of the body) *Daughter Born Without a Mother* to emphasize ironically both man's invention of the machines and their quasi-human (specifically female) qualities. He lifted images from technical illustrations, appropriately adapting a diagram of a camera for the 'portrait' *Ici, c'est ici Stieglitz* (55). This had extraordinary consequences on Picabia's oil paintings, in which brushwork was given a 'machine' finish within diagrammatic formats. The titles and inscriptions of subsequent works such as *Parade Amoureuse* (see 1) indicate the implicit sexuality of mechanical functions even as the mechanisms depicted are shown as soulless – perhaps as much a reflection of Picabia's difficulty with his relationships as a comment on the human condition.

The mechanomorphic approach was taken up by Schamberg and Man Ray in 1916. Where Picabia used the machine to draw scurrilous sexual parallels, Schamberg was more concerned with a new compositional order. Abstract paintings such as *Painting IX* (56), though derived from stripped-down stitching machinery

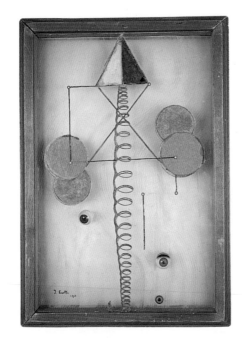

54
Jean Crotti.
Clown, 1916.
Lead, glass eyes
and paper on
glass;
36·8 x 25·4 cm,
14½ x 10 in.
Musée d'Art
Moderne de la
Ville de Paris

55
**Francis
Picabia**.
*Ici, c'est ici
Stieglitz*, 1915.
Ink and collage;
76 x 51 cm,
30 x 20 in.
Metropolitan
Museum of
Art, New York

made by Schamberg's family firm, suggested a straightforward equation between new technology and new art. Man Ray's approach reflected his close friendship with Duchamp. They met shortly after the American had produced his one-off periodical *The Ridgefield Gazook* (1915), which in parodying his literary and anarchist friends set the standard for the subsequent witty publications associated with the New York group. Man Ray mastered photography in order to reproduce his own paintings, but the two processes soon became interwoven. Photography's procedures matched the new mechanical emphasis, while his paintings – like Picabia's – took on the slick sheen of machines in their finish. This is especially evident in *The Rope Dancer Accompanies Herself with Her Shadows* (57), which in both its abstract form and allusive title acknowledged a debt to Duchamp's *The Large Glass*.

56
Morton Schamberg,
Painting IX or
Machine, 1916.
Oil on canvas;
76·5×57·9 cm,
30⅛×22⅞ in.
Yale University
Art Gallery,
New Haven

In ways that clearly relate to – but were not directly connected with – the avant-garde developments in Zurich, these works challenged material and technical conventions as well as the social and aesthetic status of art. The displacement of the human by the machine – the 'daughter born without a mother' – and the various degrees of ironic comment that this entailed, served particularly to undermine accepted ideas of material progress. The intricately punning inscriptions and the sexual imagery added a thinly disguised assault on bourgeois propriety.

A further, more radical challenge to the idea of the work of art was unveiled in New York in 1916. This was Duchamp's invention of the 'readymade'. The term itself was coined in America (taken from the innovation of ready-made – as opposed to tailor-made – clothes), but Duchamp had, in fact, made this revolutionary leap in Paris three years earlier, when he had simply upturned a wheel on a stool to create *Bicycle Wheel* (58). The devastating idea that mass-produced commercial objects could be considered as artworks simply 'through the choice of the artist' took the Cubists' use of newspaper fragments in their collages to the logical extreme. The modification of a common French

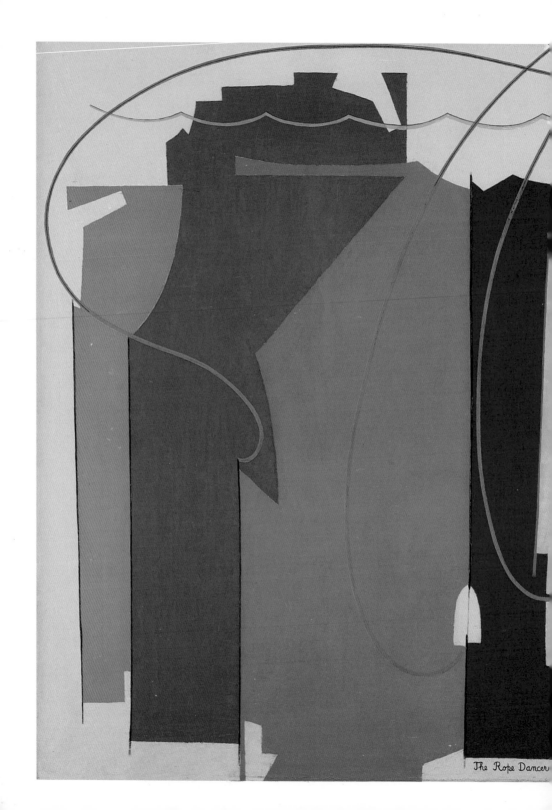

The Rope Dancer

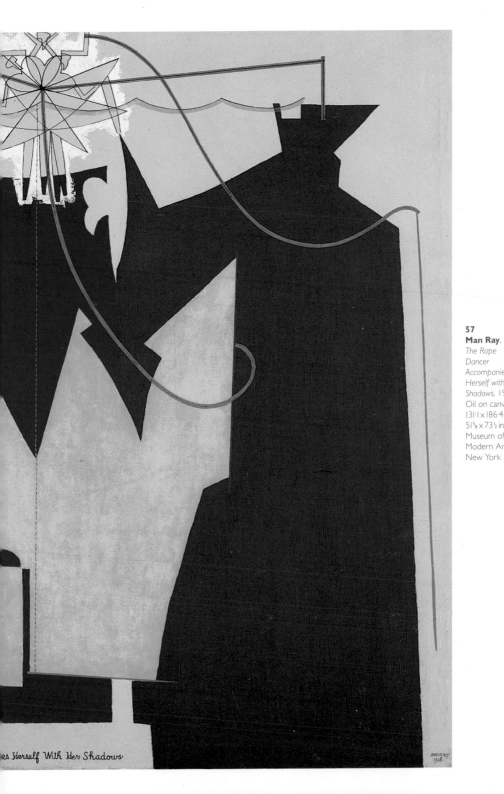

es Herself With Her Shadows

Dada & Surrealism

58
Marcel Duchamp,
Bicycle Wheel,
1913; replica,
1951. Bicycle
wheel and
stool;
h.126·5 cm,
49¾ in.
Museum of
Modern Art,
New York

piece of equipment for draining bottles, *Bottlerack* (1914), only by the inscription and signature of the artist, confirmed that Duchamp was challenging the foundations of art. His actions undermined the assumption that skill and uniqueness were necessary qualities of a work of art, and they also exposed the hidden cultural transformation of 'works of art' when they are placed in a gallery or museum.

Partly, perhaps, because such consequences took some time for Duchamp himself to accept, readymades were not shown publicly until his arrival in the United States, a country he believed was able to throw off the past more easily than Europe. With considerable intellectual rigour, Duchamp set down guidelines for his selection of readymades, which were primarily to be 'an-aesthetic' – objects free from potential aesthetic value – in order to guard against conventional notions of beauty. They were first exhibited at the aptly named Bourgeois Gallery in April 1916.

Although the exhibition was generally ignored, it set the tone for the New York group's more aggressive stance towards the definition of art and its accepted values. The industrial object, with ironic or critical titles, was soon taken up by others. Crotti made a *Portrait of Marcel Duchamp* (1915–16; now lost but recorded in a drawing) with a bent wire profile and plaster forehead, showing a related use of unorthodox materials. Most significant was the plumbing trap held in a carpenter's mitre-block, entitled *God* (59); it was photographed by Schamberg and was probably conceived together with von Freytag-Loringhoven. Many such objects, subjected to varying degrees of intervention, were ephemeral. Most notable was another lost *Portrait of Marcel Duchamp* (c.1921) by von Freytag-Loringhoven, which was an assemblage of feathers, wire and other elements in a wine glass. Man Ray produced some of the most interesting objects, with his suspended and unravelled *Lampshade* (1919), teasing the viewer as to its function and status as art.

During 1917 these various private experiments came to public fruition in the gratuitous and controversial 'demonstrations' recalled by Buffet. Duchamp caused a real scandal at the Society

59
Else von Freytag-Loringhoven and **Morton Schamberg**, *God*, 1918. Mitre-block and cast-iron plumbing trap; h.26·7 cm, 10½ in. Philadelphia Museum of Art

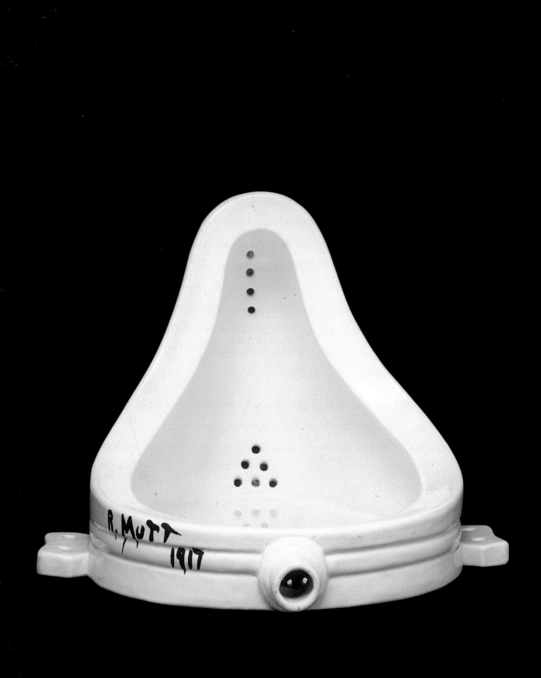

of Independent Artists' exhibition of April that year. This progressive organization was supposed to show all works submitted, with only their hanging being decided by the committee on which Duchamp served. He determined to test its will by submitting a readymade; for this he selected a urinal and laid it on its back, inscribing it *Fountain* (60) and signing it with the pseudonym 'R Mutt'. This provocative gesture met with predictable consternation, and the committee, unable to reject the piece, resolved to place it behind a curtain. A true *succès de scandale* was achieved when Duchamp made public the committee's sleight of hand and Walter Arensberg purchased Mr Mutt's work. The deception was reported in the specially produced and provocatively titled *The Blind Man* (April 1917), which Duchamp edited with the writers Henri Pierre Roché and Beatrice Wood. After an intervening publication called *Rongwrong* (April 1917), a second issue of *The Blind Man* carried a photograph of *Fountain* by Stieglitz and Duchamp's defence of the piece:

Whether Mr Mutt with his own hands made the fountain or not has no importance. He CHOSE it. He took an ordinary article of life, placed it so that its useful significance disappeared under the new title and point of view – created a new thought for the object.

The exhibition was the target for a further assault planned by Duchamp with Picabia, who had returned to New York after six months in Barcelona just in time for the opening. They recommended that Arthur Cravan, a writer and critic from Paris, should give a lecture on the state of modern art. Cravan, who claimed to be the nephew of Oscar Wilde (his real name was Fabian Lloyd), announced himself as 'the poet with the shortest haircut in the world'. His Parisian reputation had been established by his insulting periodical *Maintenant* (1912–14), in which he mercilessly exposed the pretensions of the avant-garde, and his arrival in New York followed a period in Barcelona where his activities had already taken a Dadaistic turn. He turned up for his lecture in a state of drunkenness,

60
Marcel
Duchamp,
Fountain, 1917,
replica 1963.
Porcelain;
h.33·5 cm, 14 in.
Indiana
University Art
Museum

left for Buenos Aires, followed by Dreier. He made a *Sculpture for Travelling* out of rubber bathing caps for the journey. Although his plans for a Cubist exhibition in Argentina came to nothing, he did complete his third glass, mockingly inscribed with the words *A Regarder (L'autre côté du verre) d'un oeil, de près, pendant presque une heure (To be Looked at [from the Other Side of the Glass] with One Eye, Close to, for Almost an Hour; 61).*

After the war, avant-garde artistic activity was rekindled in New York in March 1919 by Man Ray's periodical *TNT*, edited with Wolff and Adon Lacroix. Its publication was announced in *Dada 4–5*. Wolff's modernist sculpture appeared on the cover, while his anarchist views inspired the 'explosive' title. There were contributions from Walter Arensberg and Philippe Soupault. Man Ray confirmed his continuing interest in mechanical forms with a reproduction of the ironically titled *My First Born* (1919), an 'aerograph' or airbrush painting. He used the near photographic finish of this technique in the important *Admiration of the Orchestrelle for the Cinematograph* (62). A wider recognition of the similarity of approach between Zurich Dada, Barcelona and New York had to wait, however, until 1920–1.

Duchamp returned to France, where he spent the second half of 1919 in Paris, staying with Picabia and witnessing the preparations for Paris Dada. On leaving again for New York, he made a 'rectified' readymade by adding a moustache and beard to a reproduction of Leonardo's *Mona Lisa*, the revered masterpiece whose theft had landed Apollinaire in prison eight years earlier. Duchamp inscribed it *LHOOQ* (63), which when pronounced individually in French composes the scurrilous joke *'elle a chaud au cul'* (she has a hot ass). The additions threw up a multiplicity of sexual, iconoclastic and humorous associations for the painter, his model and the regard in which the work was generally held. Few gestures of such economy of means have been so widely admired.

Back in America, Duchamp resumed activities with Man Ray. In 1920 they made the motor-driven construction *Rotary Glass Plates (Precision Optics)*, which gave the optical illusion of

concentric circles when rotated. They also helped Dreier establish the first public collection of international modern art. Called the Société Anonyme collection (and subsequently given to Yale University), it reflected Duchamp's and Dreier's connections in France and Germany, and did much to promote the modernist cause in the United States before the founding of the Museum of Modern Art in New York. Perhaps because of this activity, it was

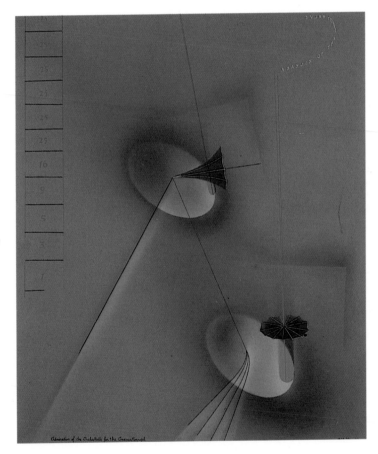

62
Man Ray,
Admiration of the Orchestrelle for the Cinematograph,
1919.
Aerograph (oil paint applied by spray) on canvas;
66 × 54·6 cm,
26 × 21½ in.
Museum of Modern Art,
New York

not until April 1921 that Duchamp and Man Ray produced the single issue of *New York Dada*, which carried articles by Tzara and von Freytag-Loringhoven but was notable for the importation of the term 'Dada'. Shortly after both editors left for Paris.

There were other Dada-related developments in the New World, and specifically Latin America, where the experience of European

avant-garde ideas matched an already developing cultural reassessment. There was a particularly fluid and vital situation in Mexico, which had just emerged from its bloody revolution, and the need for a cultural revolution was widely felt. Parallels with Dada were shown by the poet Manuel Maples Arce in Mexico City, who was also in touch with De Zayas, and who launched the Estridentismo movement in December 1921. Taking into account the approaches developed by Cubism, Futurism and Dada, Maples Arce favoured a 'quintessential synthesis' in his manifesto *Actual*:

Man is not a systematically balanced clockwork mechanism. Genuine emotion is a form of supreme arbitrariness and specific chaos. The whole world is conducted like an amateur band.

The poets Germán List Arzubide and Luis Quintanilla and the American-trained composer Silvestre Revueltas joined Estridentismo, which looked to local examples, from the satirical prints of José Guadalupe Posada to the Calligrammes of José Juan Tablada. Jean Charlot's *Mental Portrait of Maples Arce* (64) shows how a modernist fragmentation matched the movement's fervent desire for change. The painters Ramon Alva de la Canal and Fermín Revueltas also responded to Cubism, while the masks made by Germán Cueto shifted between caricature and abstraction of the structure of the head. Sharing many of the anti-conventional and anti-bourgeois aspirations of the European avant-garde, Estridentismo offered a more optimistic view than Dada, with a strong element of political commitment. It may be seen as typical of a number of groups that reassembled aspects of the European movements in a new way appropriate to local circumstances.

While Estridentismo must be regarded as a modified echo of Dada, Barcelona was soon recognized, along with Zurich and New York, as its third major centre. A richly cultured city, it rivalled Madrid as a centre for the arts, and its position as the Spanish gateway to Paris and Europe gave it incomparable importance. The reaffirmation of Catalan pride at the end of the nineteenth century had brought urban expansion and an upsurge in artistic

63
Marcel
Duchamp.
LHOOQ, 1919:
artist's replica,
1964. Rectified
readymade:
30·1 x 23 cm,
11⅞ x 9 in.
Private
collection

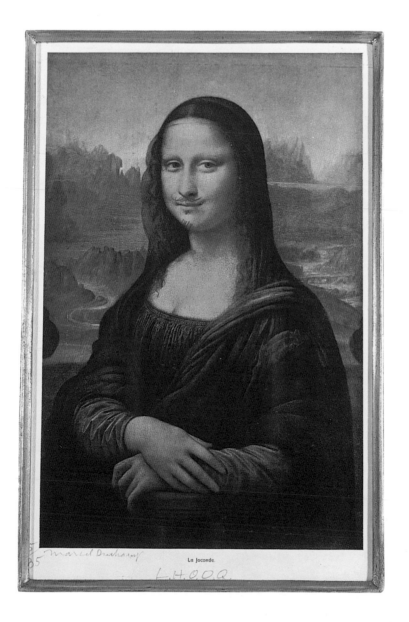

La Joconde.

activity as an expression of national identity. Public buildings became symbols of the city's confidence: from Lluis Domènech's exquisite Palau de la Musica (1908), which paraded busts of local composers across its façade, to Antoni Gaudí's astonishingly organic but unfinished church of the Sagrada Familia (begun 1901). In painting there was a similar outpouring of inventiveness, and the ease of communication with Paris allowed for the growth of a local avant-garde which, in the work of Joaquim Sunyer and others, inclined towards a Mediterranean classicism dubbed Noucentisme. These developments were principally supported by the gallery run by Josep Dalmau. In 1912 he arranged the first Cubist show outside Paris, gathering paintings from that year's Salon des Indépendants and including Duchamp's *Nude Descending a Staircase (No. 2)*, which in raising relatively little comment showed the sophistication of the Catalan audience.

There was also a familiarity with Italian Futurism. The painters Rafael Sala and Enric Cristòfor Ricart published Futurist material in their periodical *Themis* (1915), and the Uruguayan Rafael Pérez Barradas had met Marinetti in Milan before settling in Barcelona in 1916. With his compatriot Joaquín Torres García he contributed to Joan Salvat Papasseit's periodical *Un Enemic*

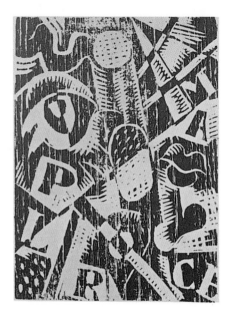

64
Jean Charlot,
*Mental Portrait
of Maples Arce*,
1922.
Woodcut;
University of
Hawaii,
Honolulu

del Poble (1917–19), named after Ibsen's political play *An Enemy of the People* (1882) and trumpeted as a 'paper of spiritual subversion'. The Uruguayans' approach was distinguished by a geometrical structure that compartmentalized mechanical and urban detail (65). In his manifesto *Art-Evolution* (1917) Torres García concluded with a sentiment comparable with those expressed by Tzara: 'Our motto must be: individualism, the here and now, inter-nationalism.' An example of their approach, which they termed 'vibrationism of ideas', was found in the illustrations made by Torres García for Salvat Papasseit's *Poema en ondes hertzianes* (*Poems in Hertzian Waves*, 1919).

Artists from elsewhere in Europe had escaped the hostilities by moving to Barcelona in late 1915 and 1916. Marie Laurencin, who had had a tempestuous affair with Apollinaire, was already there, having left Paris at the outbreak of war because of her marriage to the German, Otto van Watjen. Gleizes and Roche visited from New York. Together they constituted a loose group from the fringes of Cubism, who were encouraged by Dalmau to continue their Parisian experiments. Gleizes's exhibition at the gallery in December 1916 proved especially influential on the local avant-garde (including Barradas and Torres García). Robert and Sonia Delaunay passed through on their way to Portugal. They had a joint show at Dalmau's in April 1916, which was followed by an exhibition of abstract work by Serge Charchoune and his sculptor wife Hélène Grunhof. This group would become the vehicle for Barcelona Dada.

There were tensions and conflicts between them, not least because of the presence of the provocative Cravan prior to his departure for New York. The memories of his acerbic comments in *Maintenant* in prewar Paris about both Laurencin and Sonia Delaunay were still fresh; he had been challenged to a duel by Apollinaire over the former, and had served a week in jail for libelling the latter. His witticisms had the cutting honesty of Dada, but were combined with a tragic bitterness. Writing to the collector André Level in January 1916, he reflected that in Paris:

65
Joaquín
Torres
García,
Composición
vibracionista,
1918.
Oil on canvas;
50 × 35 cm,
19¾ × 13¾ in.
Private
collection

art only exists by theft, by deception, and by intrigue, where ardour is calculated, where tenderness is replaced by syntax and the heart by reason and where not a single noble artist breathes and where a hundred people make a living by novelty.

In the same letter he admitted the 'irrational passion' to go to Brazil to see the butterflies. Cravan's elusiveness and adventures were legendary – he is said to have crossed Europe in wartime without a passport – and his work as a boxer led to one of his most extraordinary exploits when, on 23 April 1916, he entered the ring against the American World Champion Jack Johnson. Despite doing it for his share of the purse – which supplied the transatlantic fare – the defiant futility of this bout seemed an essentially Dadaist gesture.

What little coherence this group had was galvanized by the arrival from New York of Picabia and Buffet in August 1916. Picabia immediately assumed his usual combination of provocateur and philanderer (beginning an affair with Laurencin), but despite his Spanish blood he was barely interested in local contacts. When Dalmau helped him to launch *391* in January

1917, it addressed audiences in New York – where it was accepted in the summer, as we have seen – and Paris (66). The four opening issues of *391* constituted the main focus of Dadaist activity in Barcelona. Picabia displayed in it the combination of mechanical and erotic – often covertly obscene – imagery established in his American work. His writings were combative and mocking of artistic conventions, especially those newly accepted by fellow members of the Parisian avant-garde under political pressure during the war. The contributions of others, who included Buffet, Laurencin, the writer Max Goth and most of the Barcelona exiles, proved less obscure and acerbic. As in New York, the influence of Apollinaire remained potent although his militarism was mocked; his Calligramme 'L'Horloge de demain' ('Tomorrow's Clock'), hand-coloured by Picabia, appeared in *391*, no. 4 (March 1917). Picabia was himself much occupied with poetic writing, and in the same issue he published *Bossus* (*Hunchbacks*) which approaches the layering of Zurich Dada:

66
Francis
Picabia,
Novia
(cover of *391*,
no. 1, 1917)

Many fruits are lost if the self-conceit guards its treasure of old rats but in a fashion of order contrary to Napoleon unique synthesis of circumstances. For the greeting always ready from the disappointments of honest men beholden to the papacy degenerate and spoiled fruit makes war for revolutionaries

After Picabia's return to New York in March 1917 the summer saw two important cultural events in Barcelona. The first was the massive Exhibition of French Art (23 April–5 July), which presented the Parisian avant-garde from Impressionism to Fauvism, rather like the Armory Show of 1913 in New York. Diaghilev's Ballets Russes arrived for rehearsals soon after. Performances of the new ballet *Parade*, conceived by Jean Cocteau, with a score by Erik Satie and sets by Picasso, were given in Madrid (in October) and Barcelona (November). Picasso's love for the ballerina Olga Koklova ensured his triumphal return to Spain with the company. His designs combined towering Cubist costumes with a classicizing drop-curtain. Set to Satie's whimsical and fragmentary music – including such instruments as a typewriter and a siren – these produced a humorous effect comparable with Dada but without the cutting edge.

Picabia, who again passed through the city in October, seemed to have timed his visit to avoid Picasso, whose new classicism he lampooned in *391*. The month-long stay allowed Picabia to collect his fantastic poetry in the volume *Cinquante-deux miroirs* (*Fifty-two Mirrors*, 1917) before he pressed on to Switzerland in a state of nervous collapse. With his departure, collaboration among the exiles faded under increasing political pressures as Catalan nationalism was widely equated with pro-French sentiments, and pro-German feelings were associated with centrist Spanish politics. Nevertheless, the example of the exiles, however fleeting, left an immense impact on the younger generation of Catalan artists, as demonstrated by the formation of the Agrupació Courbet in 1918–19 by Sala, Ricart and Joan Miró.

The Spirit of the Age Dada in Central Europe 1917–1922

4

67
George
Grosz,
The Engineer
Heartfield,
1920.
Watercolour
and photo-
montage on
paper;
41·9 x 30·5 cm,
16½ x 12 in.
Museum of
Modern Art,
New York

During the war, Dada's artistic revolt took shape in the relative
security of Zurich with echoes in neutral New York and Barcelona,
where avant-garde artists found it possible to continue with
and develop their work. This sense of physical and psychological
distance did not apply to Dada in central Europe, where the
immediate postwar period continued the traumas and dislocations
of the conflict. In Berlin, in particular, Dada was coloured by the
brutal social realities of the time. German Dada was also closer
to developments in eastern Europe, where a vigorous artistic
avant-garde had existed before the war, and where the Soviet
state that emerged after the Russian Revolution of 1917 adopted,
at least initially, a progressive and wide-ranging policy involving
the arts.

For Germany and Austria-Hungary, a war fought on two fronts
had proved debilitating, as the hostile encirclement that had been
feared before the war became a reality. The sense of despondency
was embodied in Wilhelm Lehmbruck's *The Fallen Man* (68).
In the Austro-Hungarian Empire the diversity of nationalities,
using eighteen official languages, exaggerated the inefficiency
of the system, the absurdity of which was satirized by the Czech
writer Jaroslav Hašek in *The Good Soldier Sweijk* (1921–3).
The German Army, meanwhile, maintained its Prussian discipline
despite the horrifying loss of life, which was largely concealed
from the wider public. Many German intellectuals saw the
hostilities as a betrayal of the ideals of the previous century.
Hermann Hesse chronicled the plight of Germany in 'If the
War Goes On Another Two Years' (1917), in which he foresaw
an interminable war, in which everything – material, moral,
mortal – was geared to the military effort. By 1917 this was
not far from the truth, and as the situation became increasingly
grim more fundamental opposition became widespread.

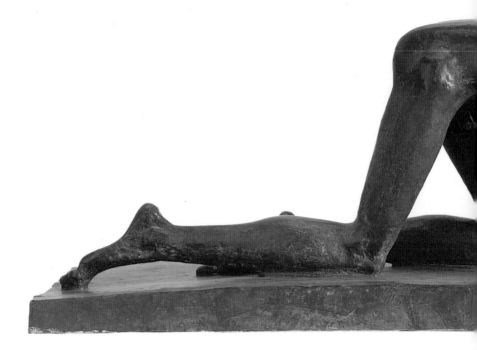

In his *Memoirs of a Dada Drummer*, Huelsenbeck recounted his return to Berlin from Zurich in early 1917:

The situation, which hadn't been very good when I had left the city in 1916, had turned tragic. The war had done its work, many of my friends had been killed in action, the desperate problem of food occupied everyone, theoretically and practically. What would become of Germany? And I asked myself: What's to become of man? The Negativist feeling, the resentment toward our civilization was surprisingly confirmed … It was as if somebody had said: 'Here is the proof of everything you people have said.'

In his article 'The New Man', published in the left-wing periodical *Neue Jugend* (23 May 1917), Huelsenbeck looked forward to the promise of a postwar existence which would sweep away the establishment. In the 'new man' of the title, the divisions of class, power and nationalism were to be reconciled: 'He thinks: Everything shall live, but one thing must end – the burgher, the overfed philistine, the overfed pig, the pig of intellectuality, this shepherd of all miseries.' This assault on all remaining hierarchies reintroduced Huelsenbeck as a cultural activist in the capital, anticipating his launch of Berlin Dada in the following spring.

68
Wilhelm Lehmbruck,
The Fallen Man,
1915–16.
Bronze;
h.78 cm, 30¾ in.
Bayerische
Staatsgemälde-
sammlungen,
Staatsgalerie
Moderner Kunst,
Munich

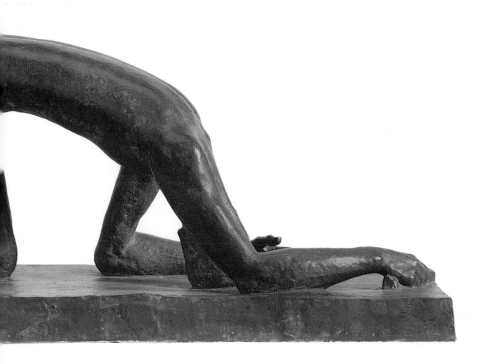

In the meantime events both inside and outside Germany escalated the need for a change of direction. The entry of the United States into the war in the spring of 1917 threatened to prolong the conflict, while the success of the Bolshevik Revolution in Russia opened up the possibility that rule by the proletariat might be exported to the industrialized West. Inevitably such a prospect had a mixed reception. Those in power in the Western alliance viewed the possibility with trepidation, and actively supported the 'White' conservative forces in the Russian civil war that followed. However, to workers and left-wing intellectuals, international revolution offered a means for remaking postwar society. Lenin's withdrawal of Russia from the war in early 1918 seemed to confirm a solidarity between workers of all nations against the military ambitions of their masters. Indeed, the example of the Russian Revolution triggered mutinies in the German Army and Navy, and strikes in Berlin, which contributed to the ending of the war.

This combination of despair and hope fuelled Berlin Dada, which emerged as an act of revulsion and revolt in the first months of

1918. The national situation determined its dominant political concerns, which set it apart from the Zurich group. As Huelsenbeck recalled: 'There is a difference between sitting quietly in Switzerland and bedding down on a volcano, as we did in Berlin.'

Dada thrived on this turmoil. It drew its energy from the real prospect of revolution and its audience from those overcome by events. In Berlin, more than anywhere outside the Soviet Union, a direct equation could be made between political reform and artistic radicalism. Despite the seeming absurdity of some of their activities, the Dadas' reinvention of poetic language and artistic form could be seen as a prelude to reforming the whole of the decayed social system.

The situation was indeed volcanic. When military defeat came in November 1918, accompanied by the abdication of the Kaiser and followed by vengeful postwar sanctions imposed by France and Belgium in the form of reparations, domestic political strife intensified. Stories of industrialists and generals profiting at the expense of the ordinary soldier were widespread. For those who survived the conflict, the suffering was continued by the financial crisis that swept the country bringing the now legendary levels of inflation; abandoned by the state, mutilated ex-servicemen begged on the streets to survive. Popular discontent with the establishment boiled over in late 1918 in the Spartacist Revolution in Berlin and the revolt of the workers' commune in Munich. Despite their popular support, they were too idealistic and disorganized to survive, and in 1919 they were brutally suppressed by the authorities. The leaders of the Berlin revolution, Rosa Luxemburg and Karl Liebknecht, were murdered. From the armistice to well into 1920, under the liberal but ineffectual Weimar Republic, Germany remained on the brink, lurching between political crises.

The Berlin Dadas shared much with the left-wing revolutionaries. They railed against the same hypocrisies and injustices, although the politicians viewed their more eccentric activities with derision (at best) and suspicion (at worst). These activities reflected the

purity of Dada's position, which was closer to anarchism in its recognition of the rights of the individual than the systems and expediencies of the politicians. So the Dadas were politically vocal but marginalized, causing a stir but not formulating policies. Their self-appointed role was to react to the contemporary crisis, to seize the moment and to open people's eyes through their provocative imagery and words, which might indeed influence wider decisions.

If the politicians found it difficult to take Dada seriously, the artistic avant-garde, dominated by Expressionism, also had its reservations. Huelsenbeck launched the Berlin movement in February 1918 at an artistic *soirée* at the Galerie Neumann. He read from his collection of sound poems *Phantastische Gebete* and in an impromptu speech attacked Expressionism, which he accused of both self-indulgent ideals and of compromise with the establishment. The other speakers, taken by surprise by this assault, objected to having the evening hijacked by a controversy-seeker. As so often before, scandal proved powerful publicity and the evening led to the formation of Club Dada in April. In his contemporary *Dadaist Manifesto* (1918) Huelsenbeck renewed his attack on Expressionism, stressing the immediate experience of reality in the street, as opposed to the soul-searching anguish associated with the Expressionists, and called for an art

which in its conscious content presents the thousandfold problems of the day, the art which has been visibly shattered by the explosions of the last week, which is forever trying to collect its limbs after yesterday's crash. The best and most extraordinary artists will be those who every hour snatch the tatters of their bodies out of the frenzied cataract of life, who, with bleeding hands and hearts, hold fast to the intelligence of the time.

Club Dada was a loose association. Its most prominent members included the writers Walter Mehring, Franz Jung and Gerhard Preiss, the brothers Wieland Herzfelde and John Heartfield (the latter Anglicized his name to protest against the nationalism of the war), and other artists such as George Grosz, Johannes Baader, Hannah Höch and Raoul Hausmann. Others – such as Grosz's

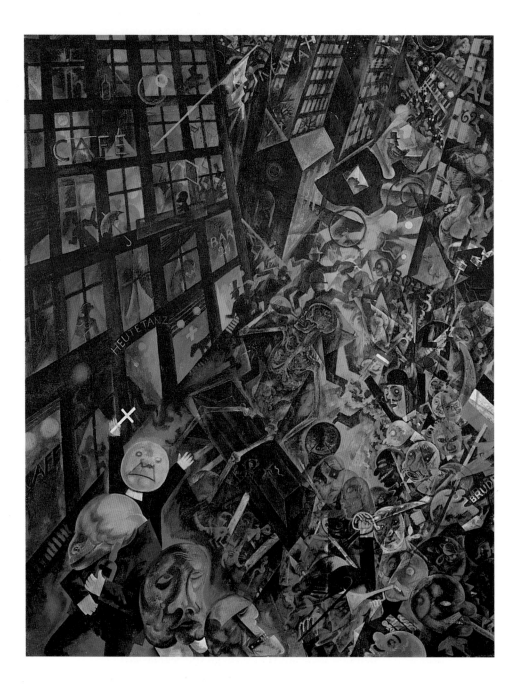

brother-in-law Otto Schmalhausen or the critic and writer
Carl Einstein – passed through, contributing memorably
before moving on to other concerns. The members selected for
themselves humorous pseudonyms that suggested something
of their roles within the Club. Thus the engineer–artist
Heartfield (67) was 'Monteur Dada', his brother 'Progress-Dada'
and Grosz the 'Marshall', while the philosophical Hausmann
was 'Dadasoph' and the monomaniac Baader was
'Oberdada' (Superdada).

The writers had already collaborated on earlier political–satirical
periodicals such as Franz Jung's *Die freie Strasse* launched

**69 Left
George
Grosz**,
*Homage to
Oskar Panizza*,
1917–18.
Oil on canvas;
140 × 110 cm,
55⅛ × 43⅜ in.
Staatsgalerie,
Stuttgart

**70 Right
Carlo Carrà**,
*The Funeral of
the Anarchist
Galli*, 1911–12.
Oil on canvas;
198 × 266 cm,
78 × 104¾ in.
Museum of
Modern Art,
New York

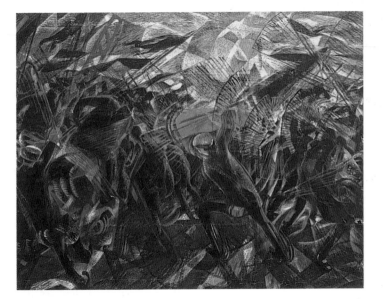

in May 1916 and *Neue Jugend*. Heartfield had also contributed
illustrations to these periodicals and for Herzfelde's Communist
publishing house, Malik Verlag. The brothers believed in the
justice and internationalism of the class struggle. They were
among the only Dadas (with Jung and Grosz) to join the German
Communist party when it was founded in December 1918, and
they would maintain their position through the repressions of
Naziism to see the establishment of a Communist government
in East Germany.

of their articles ensured that many of these periodicals were banned by the authorities after only one issue, so that the contributors had to assume a new title for each publication. In early 1918, Huelsenbeck, Jung and Hausmann together edited *Club Dada*, a special issue of *Die freie Strasse*. They used random orientations and sizes of letters and combinations of typefaces on the cover (72) and in the titles. In this they were following the lead set by Heartfield's experiments in *Neue Jugend* (June 1917), where mixed type and picture blocks had been used to advertise Grosz's *Kleine Grosz Mappen* (*Little Grosz Portfolios*)

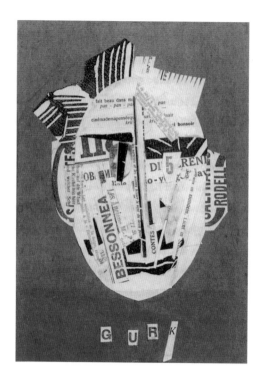

71
Raoul Hausmann,
Gurk, 1919.
Collage:
27 x 21·5 cm,
10⁵⁄₈ x 8½ in.
Kunstarchiv
Arntz, Haag

lithographs. By 1919, *Der blutige Ernst* edited by Carl Einstein and carrying satirical cartoons by Grosz introduced more adventurous typography. Its headlines were set at angles in contrasting type or printed over other images or texts. While this distorted the readers' expectations, it also served to reflect the confusion of information and imagery in any city street (shop signs, advertisements, posters, newspapers).

72
Raoul
Hausmann,
Typography
from the cover
of *Club Dada*,
1918.
26·5×19 cm,
10½×7½ in

73
Raoul
Hausmann,
Poeme
phonétique-
affiche, 1918.
32·5×47·5 cm,
12¾×18¾ in.
Musée National
d'Art Moderne,
Centre
Georges
Pompidou,
Paris.
Left
OFF
Right
fmsbw

These periodicals reflected an essentially urban existence. In this the Dadas set themselves apart from their Expressionist predecessors, who had found the city an oppressive and disturbing place. Even for those Expressionist painters who had dealt with the city, it was either a site of alienation, as in the work of Kirchner, or of the apocalyptic destruction of civilization, as in Ludwig Meidner's visionary landscapes (74). The Dadas were among the first to seize on the city itself as a subject in German art, showing the diversity and intensity of its visual impact.

The means to capture the pace and spirit of the city was the photograph, and in the development of the hybrid photomontage the Berlin Dadas invented an invaluable tool. In essence, photomontage was close to the Dadas' typographic practices, in that it brought together disparate parts to create an

unconventional new whole. It was also related to the Cubist experiments with collage and, perhaps rather less so, to those of Arp in Zurich. Where photomontage differed from both typography and collage was in the immediacy of the end image, which resulted from the photographs' direct relation to reality.

Grosz, Heartfield and Hausmann had already produced collages using such contemporary materials as headlines and text from newspapers, but in ways that subverted their original meaning. Photomontage could also serve such political/satirical purposes and broader social commentaries. The raw material of photographs was flexible and realistic, but avoided the use of discredited pictorial realism. In the process of experimentation it became clear that, even when severely distorted or cropped, photographs remained convincing as slices of reality and as such demanded the observer's attention. The adaptation of the mechanical process also added an element of the Russian machine aesthetic that had attracted their attention.

Through photomontage Dada periodicals could make use of all aspects of contemporary life. The images could be subverted to expose the hypocrisies and idiocies of that existence by using the same advertisements or pictures of political leaders put out by the official press. The Dadas added to these their own photographs, including a range of self-portraits, thus trumpeting their cause for all to see and taking the self-publicity of the Futurists and of the Zurich Dadas on to another plane.

In later years the Berlin Dadas acrimoniously debated claims over the invention of photomontage. Grosz claimed that he and Heartfield invented the technique as a device to circumvent political censorship. In different accounts he placed its invention as early as 1915 or 1916 for postcards they had made and supposedly sent from the Front; this subsequently led to an idea that the technique had arisen spontaneously among the anonymous soldiers in the trenches. Heartfield's experience in film-making during these years may well have contributed to his appreciation of the manipulation of the photographic process.

Hausmann and Höch also claimed to have invented the technique and, again, their approach reflected their concerns. Their accounts place the discovery on a holiday in mid-1918, when they came across a composite image of the Kaiser and his ancestors, among which their hotel landlord had added his own face. This would indicate that their discovery of photomontage was not politically motivated, and that their subsequent work derived, in any case, from a type of image already present in the popular domain. None of the early works remembered in these accounts has survived.

One of the earliest photomontages is that by Heartfield used on the cover of *Jedermann sein eigner Fussball* (*Every Man is his Own Football*; 75). This shows the technique at its simplest, with the transformation of the body of a masthead figure into the football of the title, and the assembly of heads of the major ministers across a fan, below the heading 'Who is the prettiest of them all?' Such satire is typical of Heartfield's approach, which was to make him the prime exponent of political photomontage. His images attacking the brutality and lies of the Nazi regime in

Einzelnummer: 30 Pf., zugestellt 40 Pf.,
Abonnement: Quartal (6 Nummern incl.
Zustellung) 2 Mark. Vorzugs-Ausgabe:
100 numm. Exemplare 1-20 sign. auf echt
Zanders Bütten à 10 M., 21-100 à 3 M.

Preis 30 Pf.
Durch Post und Buchhandel
40 Pf.

Anzeigenpreise: 1 Quadratzenti-
meter 0,50 Mark, einmal wiederholt 10%
Rabatt, zweimal wiederholt 20% Rabatt.
Exzentrischer Satz: 1 Quadratzentimeter
1,00 Mark, bei gleichen Rabattsätzen.

"Jedermann sein eigner Fussball"

Jllustrierte Halbmonatsschrift

1. Jahrgang Der Malik-Verlag, Berlin-Leipzig Nr. 1, 15. Februar 1919

Sämtliche Zuschriften betr. Red. u. Verl. an: Wieland Herzfelde, Berlin-Halensee, Kurfürstendamm 76. Sprechst.: Sonntags 12–2 Uhr

Preisausschreiben!
Wer ist der Schönste??

Deutsche Mannesschönheit 1

(Vergl. Seite 4)

Die Sozialisierung der Parteifonds
Eine Forderung zum Schutze vor allgemein üblichem Wahlbetrug

(Diese Ausführungen sollen den Unfug unserer Nationalversammlung
selbst vom Gesichtspunkt der Demokraten aus illustrieren, jener Leute,
die meinen, ein Volk dürfe keine Regierung besitzen, deren Niveau dem
seines eigenen Durchschnitts überlegen ist.)

Man mag Demokrat sein, deutsch-sozialistischer Untertan oder Kommu-
nist, man mag mit Schiller sagen: Verstand ist stets bei wenigen nur ge-
wesen oder behaupten auf jede Stimme komme es (sogar mit Recht) an —
die Tatsache wird man nicht bestreiten: Wahlen gehören zu den ge-

the 1930s have become some of the best-known of the twentieth century (166). They use distortion to expose truth, a paradox not lost on their creator. By simple conjunctions on different scales or cutting together disparate details, a single work could create an explosive image which spoke volumes. This facility had grown out of Heartfield's Dada experiments and drew upon the practical lessons learnt during that period.

By contrast, Höch's works responded to everyday life with a sly humour. They often contain figures composed of parts differing radically in scale, but whose unity is undeniable. The effect of unexpected leaps in scale is particularly powerful – heads are overwhelmed by enormous eyes or beautiful smiles become distressingly large on tiny figures (76). By these means, the superficiality of much of the source material is exposed, the simple acceptance of the seductive surface of reality that the photograph advances is shown to be mistaken, and the possibility of new realities (literally new combinations of thought) is offered up to the viewer. In her *Cut with the Cake Knife* (77), these means were used to give a perplexing view of the city, a place of infinite choice and variety in its activities, whose varied inhabitants crowd between the wheels and cogs on which it runs.

75
John
Heartfield,
Cover of
*Jedermann sein
eigner Fussball,*
no. 1
(15 February
1919)

Apart from Höch's work, most Dada photomontages and collages remained on the intimate scale of the book page. This had as much to do with the scale of the source material as with the desired impact. Hausmann's collages tended to crush together words to make a condensed version of reality which, in such works as the collage *Gurk* (71), is all located in the head of an individual. To an extent, condensation is also typical of his photomontages. This compression of experience is more eloquent and focused in such works as *The Art Critic* (79), which combines text (in this case part of an optophonetic poem) with composite figures. It satirizes both the subject of the title and Grosz who is recognizable as the main figure. In all their works the Dadas stressed the ephemeral nature of the sources and the results; the photomontage is to be valued for its image and message rather than its craftsmanship

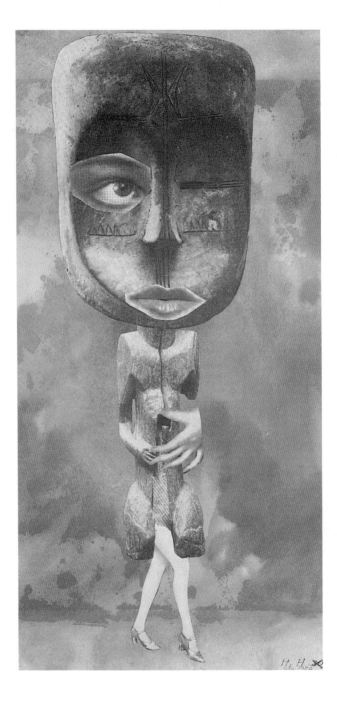

**76 Left
Hannah
Höch**,
*From the
Ethnographical
Museum: The
Flirt*, 1926.
Photomontage;
30 x 15·5 cm,
11⁷⁄₈ x 6⅛ in.
Collection Eva-
Maria Rössner
and Heinrich
Rössner

**77 Right
Hannah
Höch**,
*Cut with the
Cake Knife*,
c.1919. Collage;
114 x 89·8 cm,
44⁷⁄₈ x 35³⁄₈ in.
Staatliche
Museen, Berlin

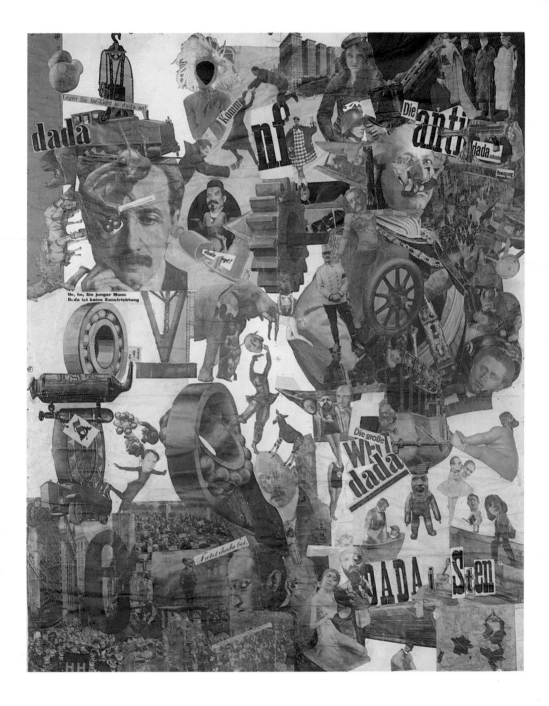

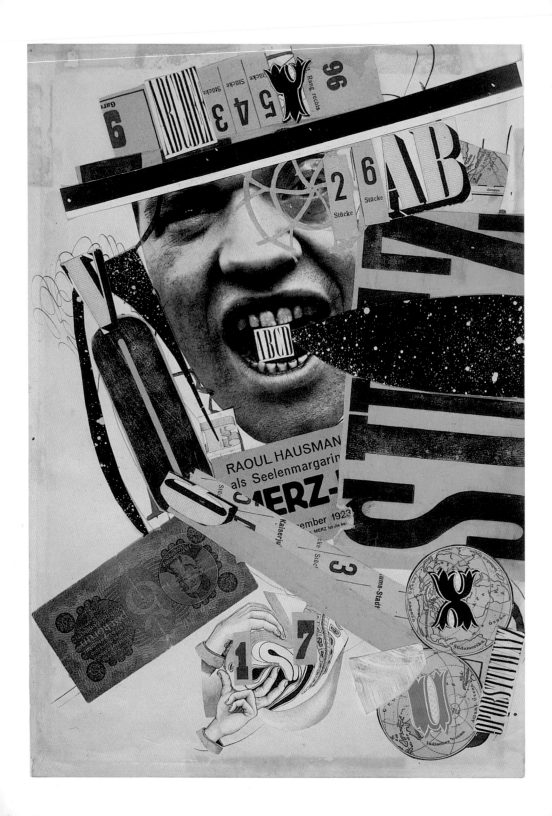

or status as a work of art. Hausmann was among those who extended this practice into three dimensions by assembling disparate objects. His conjunction of a hatter's dummy head, a wallet, tape-measure, collapsible cup and other items to make *Mechanical Head (Spirit of the Age)* epitomizes his ironic stance in relation to bourgeois material concerns (81).

Dada's rise in Berlin coincided with that of the radical left, and Dada provided an active voice of opposition when the revolution of the left was suppressed by the Socialist Weimar government. In February 1919, *Jedermann sein eigner Fussball* had been confiscated immediately on publication for urging renewed

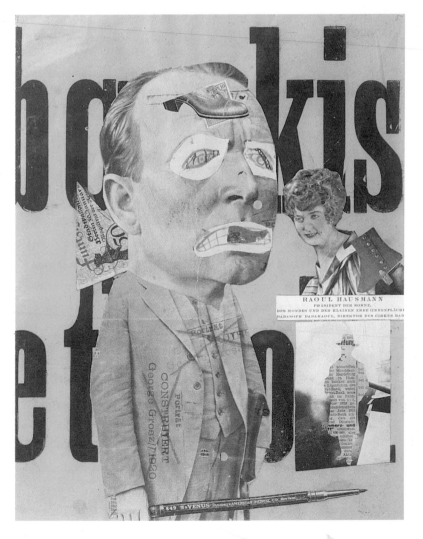

78 Left
Raoul
Hausmann,
ABCD, 1923–4.
Collage;
40·7 × 28·5 cm,
16 × 11¼ in.
Musée National
d'Art Moderne,
Centre
Georges
Pompidou,
Paris

79 Right
Raoul
Hausmann,
The Art Critic,
1919–20.
Photomontage;
31·8 × 25·4 cm,
12½ × 10 in.
Tate Gallery,
London

revolutionary activities. Other gestures in response to the suppression of the revolution included those by Baader (80). However, his 'psychotic exhibitionism and impulsiveness' (as Huelsenbeck would recall it) disconcerted his associates who feared, with some justification, that he distracted from Dada's wider political and artistic purpose. His response to the suppression of the revolution was an absurdist pamphlet *Dadas Against Weimar* (February 1919) bearing the signatures of major Dadas including Tzara and Huelsenbeck and proclaiming Baader President of the Earth. This was not his first foray into politics as he had already stood for Parliament. By means never ascertained, he had also managed to penetrate the inauguration ceremony of the new Republic, distributing the leaflet *Das Grüne Pferd* (*The Green Horse*) which nominated him for President.

In February 1920, the climactic year of Berlin Dada, Baader accompanied Huelsenbeck and Hausmann on a Dada performance tour beginning in Leipzig and leading to Prague. These performances, which recalled the Futurist and Zurich Dada *soirées*, proved to be a tremendous *succès de scandale*. As Huelsenbeck recalled, the programme relied on readings of sound poems by the performers, but the aim was largely anti-rational: to defy the expectations of the audience. This usually took the form of provocations from the stage, which were greeted with anger before a general riot ensued among those incensed at the lack of any sort of orthodox entertainment. It must be suspected that some, at least, of the audience must have gone in the expectation of such a conflict.

The tour coincided with a broadening of Berlin Dada activities to make contact with artists and others outside the city. In part, this seems to have grown out of a rivalry between Tzara and Huelsenbeck. Tzara transferred to Paris in January 1920 and was being hailed there as the originator of Dada. Whatever the case, national and international contacts were strengthened during the year; work by Picabia, for instance, was published in the third issue of Hausmann's periodical *Der Dada* (April 1920).

80
Johannes
Baader,
*The Author in
His Home*,
c.1920.
Photomontage;
21·6 x 14·6 cm,
8½ x 5¾ in.
Museum of
Modern Art,
New York

81
Raoul
Hausmann,
*Mechanical
Head (Spirit of
the Age)*,
c.1920.
Assemblage;
h.32·5 cm,
12¾ in.
Musée National
d'Art Moderne,
Centre
Georges
Pompidou,
Paris

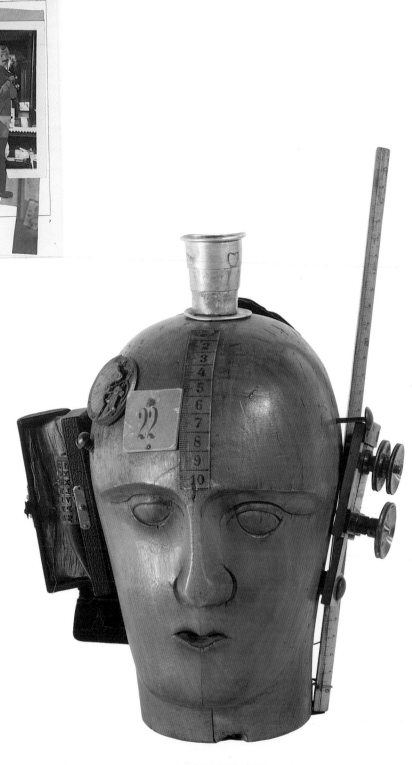

The culmination of this tendency, and indeed of Berlin Dada itself, was the First International Dada Fair (June 1920; 82), a large exhibition which included participants from other German cities as well as Switzerland and France. The dominant note, however, was that of Berlin Dada; although drawings and paintings (by Grosz and Dix) were shown, collages and photomontages, assemblages and posters covered the walls, producing an effect of saturation as colliding images and words assaulted the viewer. In the centre of one room Baader built his *Plastic-Dada-Dio-Drama*, a large assemblage of found objects and Dada publications. Elsewhere a uniformed dummy with a pig's head was suspended from the ceiling (with a notice 'Hanged by the revolution'), causing Grosz and Heartfield to be fined for defaming the military. The press expressed their outrage in terms anticipated by Hausmann's parody in the accompanying *Dada Almanac*, which asserted that 'these individuals spend their time making pathetic trivia from rags, debris and rubbish. Rarely has such a decadent group, so totally void of ability or of serious intention, so audaciously dared to step before the public as the Dadaists have done here'.

Huelsenbeck's *Dada Almanac* also included contributions from Zurich, Barcelona and Paris Dada and thus provided an overview of the movement's newly emerging international character. That it included Tzara is remarkable, as Huelsenbeck bitterly attacked his ambitions in his contemporary *En Avant Dada*. The *Dada Almanac* simultaneously confirmed the movement's wide range and its fragmentation into different groups and individuals.

The Berlin group was not primarily looking to the West, however, as the celebration of the Russian Constructivist Vladimir Tatlin at the Dada Fair confirmed. This did not focus on Tatlin's work itself (which they probably knew largely through rumours about the *Monument to the Third International*, 1919–20) but on the idea that it represented, summed up in Grosz and Heartfield's poster *'Art is dead! Long live the machine art of Tatlin!'* of 1920. It confirmed the Dadas' continuing interest in a revolutionary art that was in some way mechanical, and may have suggested

parallels with the Dada technique of photomontage, embodied in Hausmann's *Tatlin at Home* (83). It was not until the First Soviet Art Show in Berlin in 1922 that more information about the art of the Russian Revolution would emerge, but the Dadas were aware that art was taking an active part in the transformation of society in the new Soviet Union, and here they saluted that achievement.

Shortly after the Dada Fair, personal conflicts led to the Berlin group's fragmentation. Herzfelde, Heartfield and Grosz moved closer to the Communist Party, while Huelsenbeck increasingly withdrew into his medical practice. Nevertheless, the development of wider contacts considerably extended Dada in Germany during the 1920s: Hausmann and Höch undertook fruitful collaborations with Kurt Schwitters and the Dutch artist Theo van Doesburg, while the Dada Fair had included important contributions from German Dadas based in Cologne.

In the postwar years, the political situation in the Rhineland was less volatile than in the capital, and Dada developed independently in Cologne in an atmosphere of repressed calm. The Western allies had occupied the Rhineland and divided it into zones, with Cologne falling under British rule (it continued under occupation into the 1920s). The French had reclaimed the west-bank provinces of Alsace and Lorraine, ceded in the treaties following the Franco-Prussian War, and were anxious to secure this land by establishing an independent state in the coal-rich Saar region and demilitarizing the east bank of the Rhine. When Germany failed to pay reparations for war damage to France and Belgium, the French invaded the industrial heartland of the Ruhr (January 1923), thus seizing the nation's wealth at its point of production with devastating economic results.

Culturally, the Rhineland had long reflected its pivotal position between Germany and France. In 1912, the year before the New York Armory Show, the Sonderbund exhibition in Cologne had brought together avant-garde art from eastern and western Europe in unprecedented strength. The Young Rhineland association of artists, of which Macke and Heinrich Campendonk

were members, capitalized on this exchange and became an important prewar bridge between Paris and Munich. However, following the carnage of the war, their mystical Expressionism no longer seemed appropriate, and its rejection in favour of a more political and critical art became a central feature of Dada in Cologne in 1918–19. Although the Cologne group gained impetus from the example of Berlin Dada, its members were determined to maintain their independence, and had important links with Tzara and Arp in Zurich. As a result, Cologne Dada established a distinctive character of its own.

The participants were all painters and may be divided roughly into those inclined more towards artistic subversion and those committing their art to political action. The most important figure was Max Ernst. A philosophy and art history graduate from Bonn University, he had become interested in Freud's psychoanalytic theories prior to serving in the trenches. On leave from the army in 1916 he encountered Grosz and Herzfelde, who were already agitating against the war. This combination of intellectual stimuli informed the deliberately referential nature of Ernst's postwar work, which subverted

the standard themes and techniques of Western art. In his photomontage self-portrait, *The Punching Ball or the Immortality of Buonarotti* (84), he irreverently undermines Michelangelo's exalted position in art history. That those traditional values were admired by his domineering father, who was an amateur painter, added a personal gloss to this revolt.

Ernst's main collaborator was Alfred Grünwald, whom he met in 1918 and who used the pseudonym 'Johannes Baargeld' (85). This surname (translatable as 'bags of money') derived from his banker father, but was also a teasing provocation in times of rampant inflation. After some inclination towards political activity he finally found an outlet for his personal revolt in Dada – a conversion that was so much a relief to his unsuspecting father that he financed his son's publications. With this background of shared filial revolt, Ernst's and Baargeld's collaborative works and publications, beginning with the periodical *Der Ventilator* (1919), were largely anarchic and absurdist in their attacks on the status quo.

In this they were joined by more serious-minded artists, including Franz Seiwert, Anton Räderscheidt, Marta Hegemann, and Heinrich and Angelika Hoerle. These artists were ardent supporters of the Spartacist uprising, which they saw as offering the chance of social renewal. Their communism had to be disguised under the Allied occupation, although their contributions to *Der Ventilator* reflected a spirit of revolt. The Hoerles set out to capture the internal and external disfiguration of humanity by the times, and sought inspiration for their nightmarish graphic style in the more eccentric works of Kubin (15) and Klee. This shared interest was reflected in Ernst's visit to Klee in Munich in 1919, where he also discovered the first illustrated monograph on de Chirico. His paintings, with their atmosphere of mysterious alienation, had an immediate impact on all members of the Cologne group; the emotionless mannequin figures in spaces composed through distortions of orthodox perspective were widely adopted, especially in Ernst's graphic portfolio *Fiat Modes – Pereat ars* ('Make Fashion – Let Art Perish', 1919).

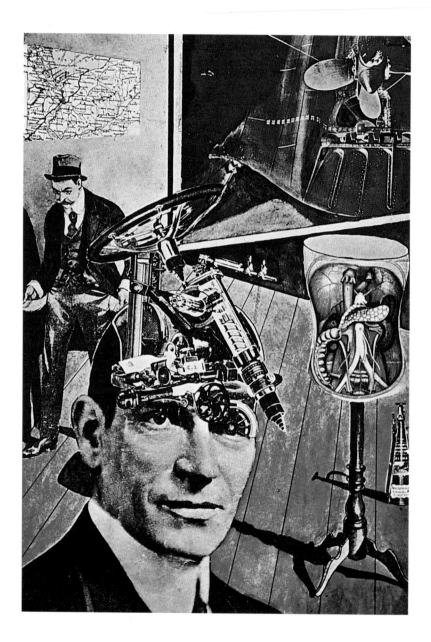

In late 1919 the Cologne Dadas were invited to contribute to the otherwise largely Expressionist exhibition at the Kunstverein, and produced an accompanying catalogue, *Bulletin D*. Hoerle and Seiwert collaborated on the publication, but showed their growing exasperation with their colleagues by withdrawing from the exhibition, which they saw as a compromise with commercialism, even declaring, 'Dada is bourgeois art marketing.' In this they clearly viewed the anarchic approach of Ernst and Baargeld as essentially apolitical, while failing to appreciate its subversive potential.

The submissions of Ernst and Baargeld to the Kunstverein, together with those of Otto Freundlich, caused considerable

83 Left
Raoul
Hausmann,
Tatlin at Home,
1920.
Photomontage;
40.9 x 27.9 cm,
16⅛ x 11 in.
Moderna
Museet,
Stockholm

84 Right
Max Ernst,
The Punching
Ball or the
Immortality of
Buonarotti (self-
portrait), 1920.
Collage;
17.5 x 11.4 cm,
6⅞ x 4½ in.
Arnold H
Crane
Collection,
Chicago

85 Far right
Johannes
Baargeld,
Self-portrait,
1920.
Photomontage;
37.1 x 31 cm,
14⅝ x 12¼ in.
Kunsthaus,
Zurich

controversy. Not only were their works humorously, often aggressively, anti-conventional, but also they were executed in the most insubstantial and quintessentially Dada techniques of collage, photomontage and found objects. They stood in direct opposition to the established canons of art, but their apparent flippancy obscured their more searching criticism. Ernst and Baargeld further signalled their identification with those outside the artistic mainstream by including works by amateurs and mental patients.

Ernst, in particular, developed unusual Dada techniques. During February 1920, when seeing *Die Schammade* through publication,

86
Max Ernst,
Self-constructed
Little Machine
by Minimax
Dadamax,
1919. Collage;
49·4 x 31·5 cm,
19½ x 12⅜ in.
Peggy
Guggenheim
Foundation,
Venice

he collected rejected proofs from the printers. The chance
conjunction of material from different sources on the same
sheet prompted his embellishments and gave the letters a life
independent of literary meaning. The results, such as *Self-*
constructed Little Machine by Minimax Dadamax (86), were
deliberately mystifying accumulations comparable with Picabia's
mechanomorphic works in *391*. They subverted the dominant
position of the machine, so important for the war, by creating
suggestive hybrid armoured figures. Reality, as recognized
through pictorial conventions, was undermined in other ways.
Ernst collected engravings and photographs from nineteenth-
century encyclopaedias, romantic novels and histories of art,
which he transformed by cutting and covering to produce
marvellous agglomerations of unseen worlds (87). The images'
small scale allowed Ernst, joined in this practice by Baargeld, to
produce vast amounts of provocative works from these familiar
sources, to which they added poetic and nonsensical titles.

After the Kunstverein exhibition Arp arrived in Cologne where
he had met Ernst six years earlier. The two artists had remained

in sporadic contact while the experience of Dada separately transformed their work. As a result of Arp's contacts, Ernst and Baargeld began to look to an international audience, and they constituted a core group, calling themselves Dada West Stupidia 5 or W/5 (after their address). They set about questioning the importance allotted to the individual in art through their collaborative collages, which were termed *Fatagaga* (from 'Fabrication de tableaux garantis gazo-métriques', roughly 'Fabrication of pictures guaranteed as gasometric'). These bore elaborate titles that overpowered the images.

These artists' relation with the more politically committed wing of Cologne Dada broke down in 1920. Räderscheidt, Seiwert and Angelika Hoerle had published a folio of linocuts entitled *Lebendige* (*The Living Ones*, 1919), which portrayed the political martyrs of recent revolutions, including Rosa Luxemburg. Both in its serious content and in its adoption of an Expressionist print style, the folio contrasted with Ernst and Baargeld's approach. This split was confirmed in mid-1920, when the Hoerles, Seiwert and Räderscheidt formed the separate 'Stupid' group and published a catalogue of their work entitled *Stupid 1*. The self-parodying English name was, in part, a response to their exclusion from Dada West Stupidia 5 (whose name they echoed), and in part a provocation for the occupying British authorities.

87
Max Ernst,
*The Hairy-
hoofed Horse,
He's a Little
Sick*, c.1920.
Collage;
14·5 x 21·5 cm,
5³⁄₄ x 8½ in.
Museo Civico,
Galleria d'Arte
Moderna, Turin

Under Seiwert's guidance the Stupids sought a directly proletarian art, taking its models from the art of children, prehistoric pictographs and local medieval painting (all subjects of contemporary debate). With the honesty of these works as examples, they depicted factory workers in a modern idiom (88), comparable with that of Fernand Léger but remaining indebted to de Chirico's sense of alienation and melancholy. Although the name Stupid was not used again, the alliance later developed into the Gruppe Progressiver Künstler (Group of Progressive Artists), which maintained a left-wing art into the 1930s until crushed by Nazism.

Where the Stupids were searching for local sources of ideological renewal, Ernst was more nihilistic, using reproductions of details of Renaissance paintings in iconoclastic conjunctions. In the photomontage *The Massacre of the Innocents* (89), an angel above the fleeing figures seems to be combined with a wartime aircraft. The equation of physical destruction with a loss of spiritual value is seen in the devastation of the city below (it has been identified as Soissons, the destruction of which Ernst witnessed as a soldier). More disturbing is the way in which the centre of the composition opens to put the viewer in the place of the attacking pilot.

The break with the Stupids (though not definitive) and the publication of *Die Schammade* ensured that 1920 was the pivotal and, as it turned out, culminatory year of Cologne Dada. The periodical included contributions from Huelsenbeck in Berlin and Breton and Aragon in Paris, beginning a process of turning outwards confirmed in the departure of Arp and, eventually, of Ernst himself (in 1922). The undoubted high point came with Ernst and Baargeld's exhibition of April 1920, entitled Dada Early Spring (Dada Vorfrühling).

The two artists had been excluded from the Cologne Artists Committee, and for their independent exhibition they hired a back room at the Winter Brewery. The poster read: 'This is the beloved Dada Baargeld, this is the feared Dadamax Ernst.' Provocation was piled on provocation: visitors to the exhibition

88
Franz Seiwert,
The Workmen,
1920.
Oil on canvas;
69×90 cm,
27⅛×35½ in.
Kunstmuseum,
Düsseldorf

had to pass the public lavatories where – according to some accounts – a girl in First Communion clothes sang obscene songs. Alongside the photomontages and collages on show was an Ernst sculpture that visitors were invited to destroy; the axe provided was well used. Rumours of pornographic works brought a threat of police closure, until it was revealed that the offending item was a reproduction of Albrecht Dürer's famous engraving of *Adam and Eve* of 1504. The obscurity of most of the references made in the collages protected them from further accusations.

The scandal of the Winter Brewery exhibition brought attention from other Dadas and an invitation to contribute to the Berlin Dada Fair two months later. However, the disintegration of group activity in Berlin coincided with that in Cologne. Arp's movements between Berlin and Zurich (he was still unable to obtain a visa for France) left Baargeld and Ernst to their own devices, with the latter inclining towards more substantial paintings. He continued to use illustrations from encyclopaedias and

associated with Huelsenbeck. (Despite the relative simplicity of the technology, the production of these films was a financial and physical strain and led to Eggeling's premature death in 1925.)

Eggeling and Richter had also found others who were working on similar projects. These included the Frankfurt-based artists Ludwig Hirschfeld-Mack, who made light projections, and Walter Ruttmann, who made the series of abstract films *Opus I–IV* (1920–4). The work of all four was shown at an extraordinary screening by the avant-garde November Group in Berlin in May 1925.

Beyond the avant-garde the films received few public viewings and met with general incomprehension. The very idea of an abstract film ran counter to commercial cinema, which had developed from a basis in narrative and drama. This remains the case even in the visually stylish marvels of the German commercial cinema of the day: Robert Wiene's *The Cabinet of Dr Caligari* (1919) and Fritz Lang's *Metropolis* (1926). Significantly, even a progressive writer such as Blaise Cendrars

LE MASSACRE DES INNOCENTS MAX ERNST

criticized *Dr Caligari* because he saw in the conjunction of Expressionist sets and the murderous narrative an implicit equation of modernism with 'degenerate' elements, foretelling subsequent official prejudices in Nazi Germany. Compromises were found, as Ruttman showed in the rhythmic and abstract elements in his imaginative documentary *Berlin, Symphony of a Great City* (1927). This approach was influenced by the Soviet director Serge Eisenstein, whose films, including *Battleship Potemkin* (1925), introduced innovations such as montage, superimpositions, split-screen, even negative sequences. Although lacking the official (and propagandizing) finances of the Soviet directors, Eggeling, Richter and Ruttman were part of this important exchange between eastern and western Europe.

Other channels of exchange more specifically related to Dada were opened by Berlin-based periodicals such as *Perevoz Dada* and *Broom*. The former was published by Serge Charchoune, who had been in Barcelona and Paris with Picabia. During his brief stay in Berlin in 1922, he used *Perevoz Dada* to translate

significant material on Dada into Russian. The English-language *Broom* of which Josephson was an editor moved from Rome to Berlin in 1922 and was an important vehicle for introducing Dada material to America. Pieces by Huelsenbeck and Arp were translated into English for the first time, and *Broom* also drew interesting parallels between the new arts of the Soviet Union and Western Europe, bringing together, for instance, Man Ray's Rayograms and El Lissitzky's photograms (91) and his discussion of new photography.

Alongside these associates of Berlin Dada in the 1920s must be considered the independent master of collage and poetry, Kurt Schwitters, who was based in the conservative northern city of Hanover. Here he had established himself as an Expressionist painter and poet in the circle of Der Sturm before becoming friendly with Hausmann and Höch in 1918, and turning to collage (93). To the use of photomontage in Berlin and printers' proofs in Cologne he added the use of waste paper. His response to Dada emerged equally in his art and poetry, as part of his unexpectedly popular *On Anna Bloom* (1919) can demonstrate:

Blue is the colour of your yellow hair,
Red is the whirl of your green wheels,
Thou simple maiden in everyday dress,
Thou small green animal, I love thine!
Thou thee thee thine! I thine, thou mine, we?
That (by the way) belongs to the glowing brazier!

Together with its brilliant combination of tongue-in-cheek romanticism and absurdity, Schwitters' work was characterized by tight control. This already carried the seeds of his subsequent sound poetry, performed throughout the 1920s. Just as the rhythms in the poem were carefully balanced against their meaning, the disposition of his collage elements found by chance (bus and theatre tickets, chocolate wrappers and other waste paper) was carefully conceived. Most of his work was made with plain, printed or painted papers but like Ernst (whom he visited

in 1920) Schwitters also used collage to 'modernize' such Old Master paintings as Raphael's *Sistine Madonna* of 1513 in *Mz 151 (Knave Child)* (92).

There are several stories of Schwitters' attempts to join Club Dada, from which he was excluded by a distrust of his political commitment. Huelsenbeck apparently disliked his 'bourgeois face', and at their only meeting Grosz irascibly lied to him, 'I am not Grosz,' to which Schwitters replied, 'I am not Schwitters.' Something of a feud opened with Huelsenbeck, whose objection to *On Anna Bloom* (which he believed pandered to bourgeois taste) was heightened when 'dada' appeared on the cover of Schwitters's 1919 anthology of poems. Schwitters had the measure of the situation as, in January 1920, he simply launched his own movement, named 'Merz' from part of 'Commerzbank' visible in one of his collages. Although he remained the sole member of the movement, Merz effectively served Schwitters as a surrogate Dada. Initially, the difference lay in the political field, which Schwitters never allowed to overcome aesthetics; increasingly, however, a difference between the abstraction of Merz and the aggressive realism of Berlin Dada also became apparent.

The exclusion of Schwitters from Dada was far from watertight. He was in contact with Tzara, who published a collage in *Der Zeltweg* (1919) and named him as one of the 'Presidents of Dada' in *Dada No. 6 (Bulletin Dada)* the following year. In Berlin, Hausmann and Höch readily saw the marvellous quality of his collages, and were impressed by his claim not to paint but to nail his pictures together (95). From this emerged productive friendships, and the three artists took an Anti-Dada Merz Tour to Prague in 1921. Hausmann's readings of his phonetic poem *fmsbw* (1918) inspired Schwitters's subsequent expansion of the phonetic poem in the *Ur Sonata*. This symphonic piece, which was only published in 1932 with typography by Jan Tischold (*Merz 24*), began:

91
El Lissitzky,
Self-portrait: The Constructor,
1924. Double-
exposure
photograph;
11·3 × 12·5 cm,
4½ × 5 in.
Collection van
Abbemuseum,
Eindhoven

Fümms bö wö tää zää Uu,

pögiff,

kwii Ee.

Oooooooooooooooooooooooooooooooooo,

dll rrrrrr beeeee bö,

dll rrrrrr beeeee bö fümms bö,

rrrrrr beeeee bö fümms bö wö,

beeeee bö fümms bö wö tää,

bö fümms bö wö tää zää,

fümms bö wö tää zää Uu:

Schwitters's performance of this and other sound poems is reported to have had a mesmeric and cathartic effect on even his most conservative audiences, achieved both through his serious persistence and their laughter. His practice of reordering the ordinary – whether sounds or collage items – suggested a redemption of a fragmented world (94). This reflected an

**92
Kurt
Schwitters**
*Mz 151 (Knave
Child)*, 1921.
Collage;
17·1 x 12·9 cm,
6¾ x 5 in.
Sprengel
Museum,
Hanover

**93
Kurt
Schwitters**,
*Zeichnung A2,
Hansi*, 1918.
Collage;
18·1 x 14·6 cm,
7⅛ x 5¾ in.
Museum of
Modern Art,
New York

ideological position in which the undervalued was revealed in art
as beautiful, just as, in the political sphere, the contribution of
the ordinary worker was recognized for its full worth. Though
lacking the cutting edge of Dada satire, this more optimistic
approach had much in common with the idealism of Construc-
tivism, to which Schwitters and his companions were drawn.

The West viewed Constructivism as the art of the Bolshevik
Revolution and associated it with the functionalism of
engineering. Detailed information was not widely available until
the important First Russian Exhibition in Berlin in 1922. As the
term suggested, Constructivism set art at the service of the
reconstruction of society, often performing an educational or
propagandist role similar to that of the new cinema. Everything
from housing to clothing came into the domain of such art-

workers as Alexander Rodchenko and Varvara Stepanova, but the theoretical divisions between their commitment to 'productivism' and those artists retaining aesthetic considerations were less apparent in the West. However, the artistic conservatism of the Soviet leadership brought increasing restrictions which encouraged many Constructivists to move to Germany in the 1920s. They included Ivan Puni (96), Lissitzky and the Hungarian László Moholy-Nagy, who were drawn into the orbit of the Bauhaus, the pioneering art school at Weimar.

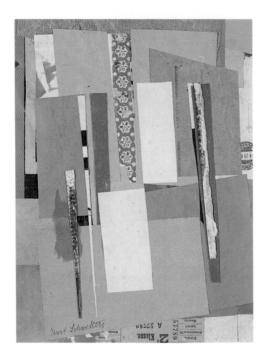

94
Kurt
Schwitters,
Collage, 1923.
31·4 × 24·5 cm,
12 × 9¾ in.
Private
collection

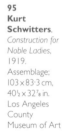

95
Kurt
Schwitters,
Construction for
Noble Ladies,
1919.
Assemblage;
103 × 83·3 cm,
40½ × 32⅞ in.
Los Angeles
County
Museum of Art

The Constructivists and Dadas broadly shared political beliefs in the imminent triumph of the proletariat over the decayed bourgeois societies of the West. Grosz's satirical drawings were published in the USSR as examples of this sympathy, before he was profoundly disenchanted by his visit in 1924. More active in the exchange of ideas were Richter and Arp, as well as Hausmann, Höch and Schwitters, who established some common

ground with Constructivists on issues of formal explorations and methods. In this process, which came to fruition in 1922, a crucial role was played by Schwitters's friend Theo van Doesburg, a founder of the Dutch Constructivist group De Stijl. For a time active on the fringes of the Bauhaus, van Doesburg promoted a geometrical abstraction through his work and writing in the periodical *De Stijl*. What made him exceptional, however, was his parallel interest in the anarchic side of Dada, which gave birth to his Dada persona 'I K Bonset'.

Van Doesburg's contact with Dada began at the first of a series of international artistic congresses: the International Congress of Progressive Art in Düsseldorf in May 1922. Set up to re-establish the unanimity of the European avant-garde fragmented in the war, it served mainly to prove this impossible. Attending on behalf of Berlin Dada, Hausmann rejected such quasi-official schemes by declaring 'that he was no more international than he was a cannibal', while van Doesburg, Lissitzky and Richter objected to the financial focus of the organizers and their failure to define

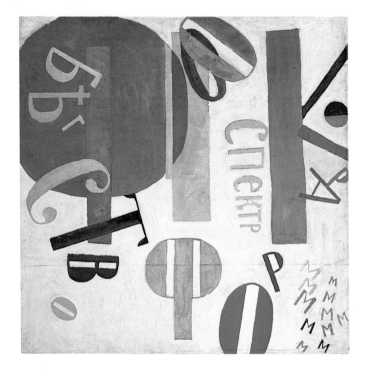

96
Ivan Puni,
*La Fuite des
Formes*
(sketch), 1919.
Watercolour
on paper;
129·7 x 130·8 cm,
51⅛ x 51½ in.
Museum of
Modern Art,
New York

the term 'progressive artist'. These three founded an independent International Faction of Constructivists, which had an underlying inclination towards Dada, although Lissitzky's related periodical *Viesheh – Gegenstand – Objet* (1922, edited with Ilya Ehrenberg) was emphatically Constructivist, disseminating Soviet art in anticipation of the First Russian Exhibition.

The exchanges of the second half of 1922 successfully blurred the distinctions between Dada and Constructivism. In September, Schwitters, Arp, Hausmann and Richter attended the Dada/ Constructivist Congress in Weimar (98). Other Berlin Dadas stayed away, but Tzara came from Paris, where Dada was by this date in the process of disintegration. With van Doesburg playing a dual role (although without revealing the identity of Bonset), the Constructivists, headed by Lissitzky and Moholy-Nagy, appeared to be rather outnumbered, and the assertion that the Congress was a Dada provocation has some truth. It was Tzara's only assault on Germany, and he gave lectures on Paris Dada in Weimar, Hanover and Jena, accompanied by Arp reading from *Wolkenpompe* (*Cloud Pump*). A community of ideas between Dada and Constructivism, seen most clearly in the language of abstract art, had existed since the Zurich years and was resumed by Richter and Arp. While Richter moved towards a stricter Constructivism in his publication of the periodical *G* (standing for *Gestaltung*, 'form') in 1923–4, Arp and Hausmann signed 'A Call for an Elementarist Art' in *De Stijl* in October 1922. This document, co-signed by Moholy-Nagy and Puni, embodied both the aspirations and limitations of these exchanges. Its vague wording, calling for an art 'built of its own elements alone', revealed a divergence of approaches and ideas.

Early in the following year, Theo and Nelly van Doesburg undertook a disruptive 'Dada Campaign' in Holland (97). At a given moment, his lectures on art were interrupted by barking from a member of the audience; this turned out to be Schwitters who, thus introduced, recited phonetic poems. Shared with the De Stijl painter Vilmos Huszár, these *soirées* established a hybrid

combination of mechanization and chance which was promoted by Bonset in the periodical *Mecano* and by Schwitters in *Merz 1; Holland Dada* (January 1923).

Arp's contacts in Germany yielded interesting results on the borders of Dada and Constructivism. In 1925 he wrote *Kunstismen (Isms of Art)* with Lissitzky, a volume which traced (though not without irony) the different groupings of the twentieth-century avant-garde. In the previous year he and Taeuber shared the commission to decorate the Aubette Cinema in Strasbourg with van Doesburg. Arp created rooms filled with organic forms

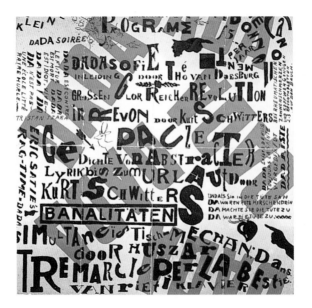

97
Theo van Doesburg,
Dada Poster,
1922.
Black and red letterpress;
30·5 x 30·5 cm,
12 x 12 in.
Centraal Museum,
Utrecht

in primary colours, Taeuber used restrained rectangular patterns and van Doesburg produced diagonal grids. It was one of the first public interiors in the West to be decorated wholly by avant-garde painters, although the almost simultaneous advent of the Art Deco style as a result of the Paris 1925 Exposition of Decorative and Industrial Arts placed it in the context of the work of more commercial artists. The Aubette commission allowed Arp and Taeuber to establish themselves in Paris where Arp moved into the orbit of Surrealism, although his continuing collaboration with Schwitters maintained a Dada spirit.

For his part, Schwitters produced what may be seen as the ultimate Dada monument, the structure known as the *Merzbau* (99). This was a work full of contradictions, produced by an artist excluded from Dada after its apparent demise (in the 1920s–1930s) and in the relative isolation of Hanover. It began in one room of Schwitters's house and eventually towered into the rooms above through holes cut in the ceiling. In the accumulation of objects within an ever-growing structure the *Merzbau* maintained the Merz paradox of making art from the ephemeral. Parts revealed Schwitters's darker side: the

'Cathedral of Erotic Misery' contained disturbing reworkings of sadistic sex crimes, which were profoundly shocking to visitors. Other parts had a memorial aspect, for in addition to found materials some items for inclusion were hair, cigarette ends and pencils given by Richter, Ludwig Mies van der Rohe, Arp and van Doesburg. Like the growth of a coral reef, the compartments were built over as the *Merzbau* grew, and the result had an eccentric architectural potential. When Schwitters was forced to flee Germany by the Nazis in 1937,

it was abandoned and later destroyed by Allied bombing. A further *Merzbau* in Norway was also destroyed, and only the beginnings of a third, made in the England, remain. It was appropriate that such a monument to the ephemeral should have vanished (although a reconstruction has been attempted), for it is now perhaps more marvellous in photographs.

The eastern Europeans who had attended the 1922 Dada/Constructivist Congress in Weimar were hardly ignorant of Dada activity. The Russians had the material translated by Charchoune and the legacy of their own prewar Cubo-Futurist poets, who had invented phonetic poetry quite independently. The collaboration of the poet Aleksei Kruchenykh with the tonal composer Mikhail Matyushin on the performance of the opera *Victory over the Sun* in St Petersburg in 1913 epitomized their total restructuring of language and music. The central theme was man's new ability to overthrow nature, a thinly disguised political allegory. Kasimir Malevich's sets included the austere Suprematist *Black Square* on the drop curtain, which uncoupled art irrevocably from imitative realism. The poetic position reached by Kruchenykh's declaration of 'the word broader than sense' was developed further in collaboration with Velimir Khlebnikov, who invented a 'trans-rational language' called 'zaum' in which phonetics dictated the form of a language of supposedly international scope.

There were considerable parallels between the Russians' work and that made subsequently by Dadas. Many of the most important developments took place before the war cut their lines of communication with Der Blaue Reiter group in Munich and the Futurists in Milan, and it remains unclear whether news of these developments reached Ball in Zurich. In any case, the Russians embodied a sophisticated anticipation of aspects of Dada, although they remained closely involved with Constructivism and the assertive abstraction of Malevich's Suprematism, and the political consequences of their theories. Both Lissitzky, a colleague of Malevich, and Moholy-Nagy were fully aware of these precedents by the time of their encounter with Dada

99
Kurt
Schwitters,
Interior of
Merzbau,
Hanover,
begun 1923
(destroyed
1943)

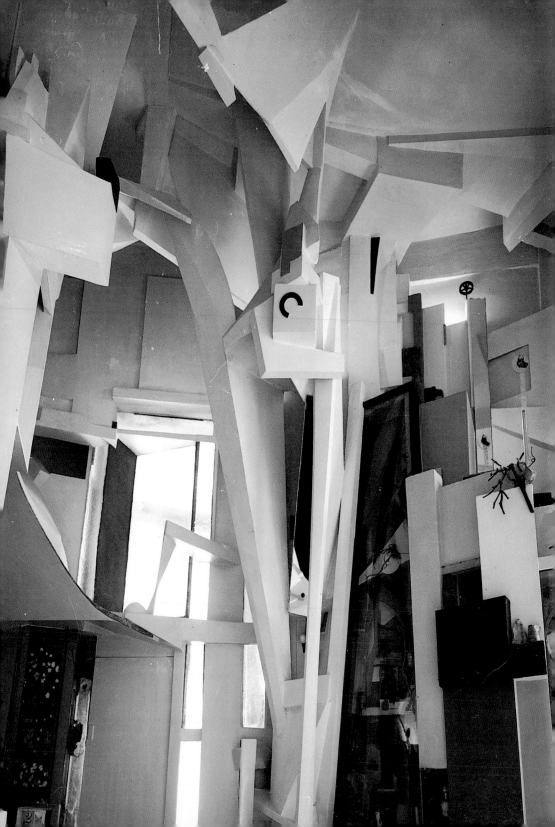

in the early 1920s. In his article 'A and Pangeometry' (*Europa-Almanach*, 1925), Lissitzky cited Suprematism and Dada as dual sources of the revision of the old bourgeois standards of art. He saw Malevich's revolutionary reduction as complementary to Arp's use of chance. It was this common cause in levelling the terrain of art (also shared with Duchamp) that was shared by Constructivists and Dadas.

At least two other Russian groups who inherited the concerns of the prewar Cubo-Futurist poets came to be aware of Dada. In Moscow in 1919–21 a group of younger poets looked to Dada but rejecting the affirmative nature of its name, which means

'yes, yes' in Russian, they called themselves the Nichevoki (Nothingists). Led by Sergei Sadikov, Suzanna Mar and Elena Nikolaeva, they produced only a single publication before being suppressed in the new conformist climate. In Tbilisi, Georgia, where numerous artists had taken refuge from the 1917 Revolution, Kruchenykh joined Ilia Zdanevich in forming the 41° group, and Zdanevich was also instrumental in the H2SO4 group

with Simon Chikovani. Their publications were heavily indebted to 'zaum', but were conceived with radical typography which would become Zdanevich's hallmark. By 1923 he had moved to Paris, where as 'Iliazd' he contributed to Tzara's *Soirée* of the Bearded Heart (*Soirée au Coeur à Barbe*) and published the typographically revolutionary *Le-Dantyu as a Beacon* (100).

A similar blend of Dadaist experimentation was found in the cosmopolitan capitals of the former Austria-Hungary. Already during the war, the most active disseminator of the avant-garde was the Budapest periodical *Ma*, founded by the painter and writer Lajos Kassák in late 1916. His publications and exhibitions of the local avant-garde led to articles on Cubism and Futurism and exchanges with *Der Sturm*. Among his closest collaborators were Béla Uitz, Sándor Bortnyik and Moholy-Nagy, with whom he participated in anti-war protests and welcomed the Bolshevik Revolution in Russia. However, like Schwitters, Kassák would not abdicate what he called the concept of the world (*Weltanschauung*) of art to the exigencies of politics. When the Hungarian Soviet was established in mid-1919, *Ma* was banned as bourgeois; the conservative counter-revolution brought a complementary condemnation, and Kassák removed the periodical to Vienna.

100
Ilia
Zdanevich,
*Le-Dantyu as a
Beacon* (1923)

Exile brought a new outward-looking aspect to *Ma* in 1920, epitomized in November by a Russian Constructivist *soirée* followed by one of phonetic poetry. Work by Tzara was published and read, and the *Ma* artists responded. Kassák's phonetic poems and his abstract collages, which he termed 'Pictorial Architecture' (*Bildarchitektur*; 101), were close to Arp and Schwitters. The role of *Ma* in reconciling Dada's spontaneity with the political commitment of the Constructivists was widely influential in many parts of central Europe. During 1922–3, when Moholy-Nagy was in direct contact with Dada in Germany, he was joined by Bortnyik and László Péri. Although all three produced playful abstract collages (102), these served as a stage towards more severe abstraction. However, Kassák continued to find a balance,

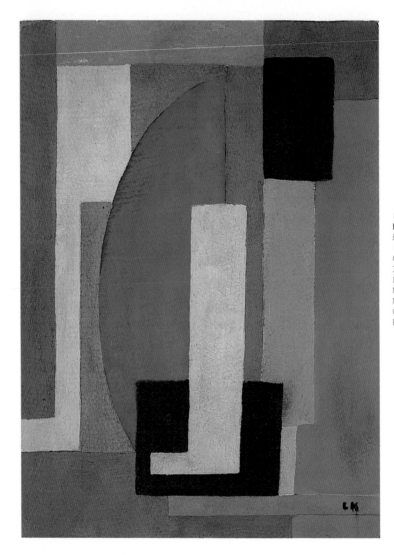

101
Lajos Kassák,
Bildarchitektur,
1920–2.
Oil on card;
28 x 20·5 cm,
11 x 8 in.
Magyar
Nemzeti
Galéria,
Budapest

taking a Dada-inspired *Ma* tour to Prague, Košice, Lučenec and
Bratislava in the spring of 1922, and reviewing the First Russian
Exhibition in the autumn.

Prague was a frequent and convenient goal for Dada tours.
After his 1921 tour with Hausmann and Höch, Schwitters
lectured there again in 1926 and 1927. Kurt Seifert (who had
been at the Düsseldorf Congress) and Karel Teige published
Disk there. As well as including contributions from Parisians such
as Pierre Albert-Birot and Ivan Goll, their writing, especially the
manifesto *Obraz* (May 1923), blended Dada language with the

political commitment of Constructivism. The most immediate response to the Prague tours, however, came from two visiting Yugoslav poets, Virgil Poljanski and Dragan Aleksić, who had helped launch the Zagreb periodical *Zenit* in 1921 edited by Poljanski's brother Ljubomir Micić (103). Dada typography was adopted by *Zenit*, in which Micić proposed the 'Balkanization of Europe'. He broke with Aleksić who made contact with Tzara and Schwitters and organized Dada *soirées* in Osijek and Subotica in 1922. Here as in Moscow, Tbilisi and elsewhere, the gathering of groups whose experiments paralleled those in Zurich or New York once again emphasized Dada's heterogeneous sources. The idea of a *Zeitgeist* or 'spirit of the age' in this context seems to be justified, as such independent and far-flung groups appeared to

102
Lázló
Moholy-
Nagy,
F in the Fields,
1920.
Gouache and
collage on
paper;
22 x 17·7 cm,
8⅝ x 7 in.
Kunsthandel
Wolfgang
Werner,
Bremen

respond in similar ways to similar circumstances. If these – and other – groups shared a quality roughly identifiable with Dada in its widest sense, it was a determination to overturn all values in art, politics and life. These were the targets identified by Huelsenbeck in the *Dada Almanac* (1920):

Dada is the most direct and vivid expression of its times, it turns against everything that strikes it as obsolete, mummified, ingrained. It claims a certain radicalism; it beats a drum, wails, sneers and lashes out; it crystallizes into a single point yet extends over the endless plain; it resembles the mayfly and yet is kin to the eternal colossi of the Nile Valley. Whoever lives for the day, lives forever. That is to say: whoever has made the most of his time has lived for all times.

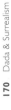
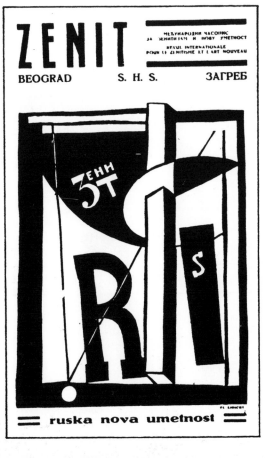

103
Cover of *Zenit*
(1922)

5

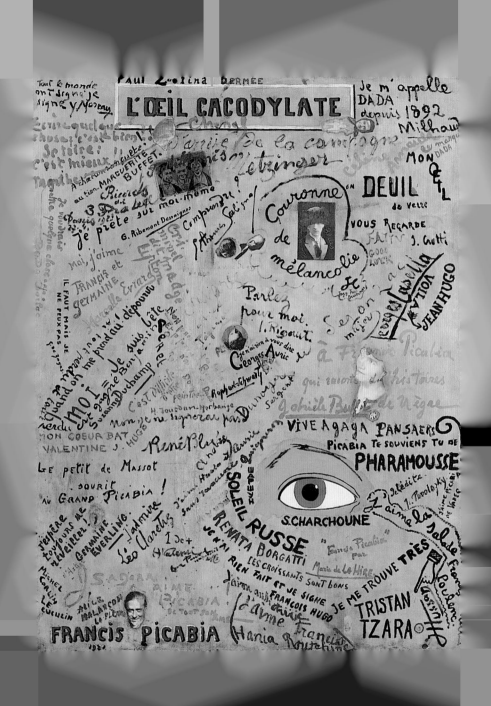

Paris was directly threatened in the war. The Germans came within twenty miles in the first autumn campaign, and the city remained within earshot and range of the big guns. In cultural and political life, jingoistic nationalism swept away the vestiges of liberalism; the attack on France was seen as an attack on civilization as a whole, and the prevailing conservatism particularly tested the position of artists. Even avant-garde publications such as Jean Cocteau's periodical *Le Mot* and Amédée Ozenfant's *L'Elan* joined the struggle in support of the 'French tradition'. Defiant radicalism in the arts persisted, however, for example in Picasso's decision to exhibit *Les Demoiselles d'Avignon* (105) at the Salon d'Antin of July 1916. This work, though unshown for almost a decade, was still shockingly revolutionary and restated Picasso's belief in the validity of experimentation irrespective of the conservative reaction.

It was through Apollinaire's wide-ranging contacts that, in late 1917, Dada began to filter into this charged situation. Tzara sent him poems in the autumn of 1917, which he passed on to Albert-Birot's eclectic periodical *SIC*, and at the same time he received Picabia's *391* from Barcelona. He attended the regular readings at Adrienne Monnier's bookshop Les Amis du Livre, which also attracted Cocteau and the future Dadas Breton, Aragon and Soupault. All four of these young poets cultivated his friendship.

During 1917 Apollinaire was also involved in two avant-garde performances that reached a far wider audience. On 18 May the première of the Ballets Russes's *Parade* presented a collaboration between Cocteau, Satie and Picasso. Apollinaire's programme notes hailed Picasso's designs and Léonide Massine's choreography as a new synthesis of avant-garde styles, which he termed 'sur-réalisme'. However, the ballet's frivolity was ill-suited to the

104
**Francis
Picabia**,
*The Cacodylic
Eye*, 1921.
Oil and collage
on canvas;
148·6 ×
117·5 cm,
58½ × 46¼ in.
Musée
National d'Art
Moderne,
Centre
Georges
Pompidou,
Paris

**105
Pablo
Picasso**,
Les
*Demoiselles
d'Avignon*,
1907.
Oil on canvas;
243·9 x
233·7 cm,
96 x 92 in.
Museum of
Modern Art,
New York

**106
Georges
Ribemont-
Dessaignes**,
Oceanic Spirit,
1918.
Oil on canvas;
100 x 81 cm,
39³⁄₈ x 31⁷⁄₈ in.
Annely Juda
Fine Art,
London

sombre mood of wartime Paris in which Cubism and Germany
had become linked, and the performance was interrupted by
cries of 'Sales boches!' (dirty Boches). In the ensuing scandal,
Satie was sentenced to eight days in prison for insulting a critic.
Undeterred, *SIC* staged Apollinaire's own 'drame surréaliste',
The Breasts of Tiresias (*Les Mamelles de Tirésias*), a month later with
designs by the Cubist Serge Férat. It combined classical mythology
with an unexpected – if Jarryesque – patriotism, as Tirésias
becomes a woman in order to bear children for the war effort!

Apollinaire made a more serious contribution to current
debates in his November lecture 'The New Spirit and the Poets'.
He proposed that what united modernist work was its quality
of 'surprise', which he associated with 'sur-realist' elements.
However, he dismayed younger members of his audience by
asserting the validity of a 'return to order' and the classical values
already found in the work of many poets and painters. Despite
this, some believed that Apollinaire would have participated
in Paris Dada. His death in November 1918 signalled the passing
of an era, but his term 'l'esprit nouveau' ('the new spirit') would

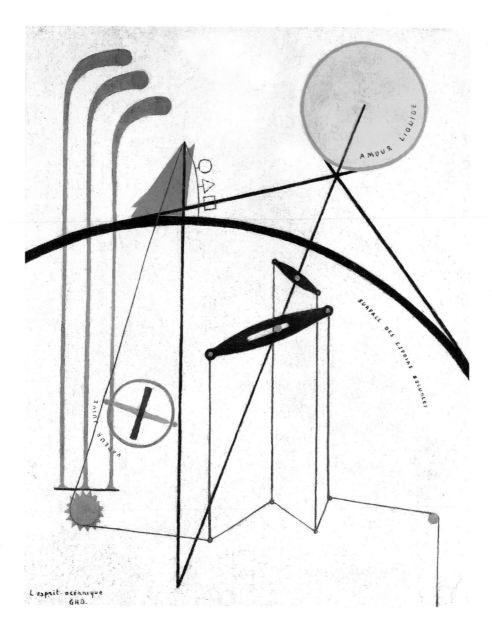

AMOUR LIQUIDE

SURFACE DES ESPOIRS SOLUBLES

VAPEUR SUIVE

L'esprit océanique
GRD.

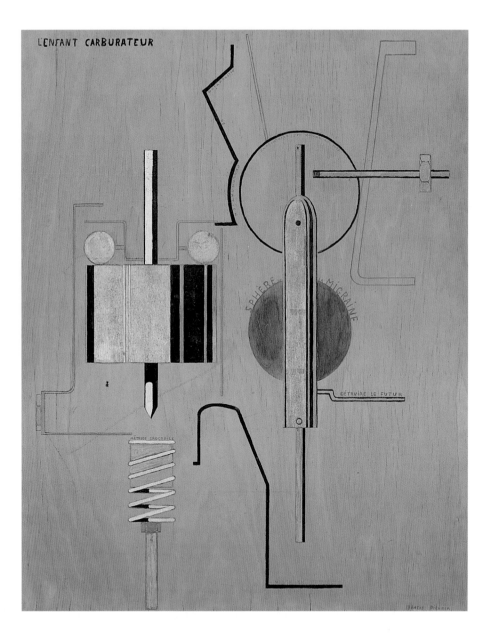

L'ENFANT CARBURATEUR

have long echoes, representing avant-garde aspirations for postwar renewal within which Dada was to serve as a salutary irritant.

The arrival of Dada in Paris was constricted by postwar political realities. In defeat, the German avant-garde, who had largely come to oppose the war of aggression, sought a revolutionary social change; in victory, the French avant-garde, who had generally supported the (supposedly patriotic and defensive) war, were confronted with the triumph of a vindicated conservative culture (see 18). This was confirmed in the general election of late 1919, which returned a massive right-wing majority that became known as the Horizon Blue Chamber (Chambre bleu horizon) after the uniforms of the ex-servicemen. There was a need for physical rebuilding, but this remained closed to the type of utopian modernist architecture found in Russia or Germany. In painting, the reputations of Jean-Auguste-Dominique Ingres, Georges Seurat, Paul Cézanne and other nineteenth-century artists were reassessed in the light of the French tradition of Mediterranean classicism; 'Ingrisme' was especially prevalent, and was sanctioned by Picasso's ambiguous interest in a classical art which ran parallel to his continuing Cubism. Similar values were found in literature, in the novels of Anatole France and Marcel Proust and in the writers associated with the *Nouvelle Revue Française* among whom Jean Paulhan and André Gide briefly balanced between avant-garde and traditional attitudes.

Dada could hardly have been in greater contrast to this 'return to order'. In the place of reconstruction, Dada favoured chaos; in place of tradition, Dada demanded the destruction of all present systems; in the place of national identity, Dada offered political echoes of the Communist International. Interestingly, Dada found support in a dynamic popular culture uncompromised by the French tradition of high art. This included such varied sources as the unexpected narratives of crime novels, American Jazz and, in the new art form of cinema, the slap-stick films of Charlie Chaplin, Buster Keaton and the Keystone Cops, which were greeted enthusiastically

by Soupault and Aragon in their earliest reviews. The immediacy
of these forms masked an underlying assault on bourgeois values.

Among the artists already associated with Dada, it was Picabia
who had made the first impact in Paris, where he arrived on
10 March 1919. He produced astonishing writings, beginning
with *Pensées sans langage* (*Thoughts without Language*) and
returned to painting of the most radical kind, becoming
the focus of a group of friends whom he alerted to Dada.
His most consistent ally was the poet–painter Georges
Ribemont-Dessaignes, who had already contributed to *391*.
Others included Charchoune, Duchamp, his painter sister
Suzanne Duchamp and Jean Crotti, who were married in April.
Their awareness of Dada in Switzerland came through *Dada 3*
(December 1918) and *Dada 4–5* (May 1919) through Tzara's
correspondence and through the visits of both Serner and Janco.

The ironic mechanomorphic style developed in New York
(see Chapter 3) was introduced to Paris in 1919 through
Picabia's and Ribemont-Dessaignes' submissions to the first
postwar Salon d'Automne (106). The diagrammatic nature
of Picabia's *The Carburettor Child* (107) was incomprehensible
to the committee, who displayed it in a stairwell. They were duly
pilloried by Ribemont-Dessaignes in *391*, no. 9 (November 1919),
who managed to insult so many of the exhibitors that Maurice
Denis demanded that he be disciplined by Frantz Jourdain, the
Salon President. At the same time the conservative critic Louis
Vauxcelles took it into his head to challenge Ribemont-Dessaignes
to a duel. While this was avoided, a further controversy erupted
immediately at the 1919 Cirque d'Hiver (Winter Circle) exhibition,
where Picabia's entries included both works executed in gloss
house paint and *Parade amoureuse* (see 1) with its obscene
inscriptions. His paintings were again hidden, and some of the
more scurrilous phrases were covered. Riding the publicity from
the Salon d'Automne, Picabia voiced his complaints to the press.
The simplicity and success of this strategy of assault and
exposure was breathtaking. Dada forced its way into the

Parisian avant-garde scene and captured the public's attention. It made the avant-garde uncomfortably aware that developments elsewhere had outstripped and outwitted them. However, a level of coordinated Dada insurgency was not really achieved until Tzara's arrival the following year.

In a separate development, around the time of Picabia's arrival in March 1919, a group of young poets founded the ironically titled periodical *Littérature*. Its editors Aragon, Breton and Soupault, together with close associates such as Théodore Fraenkel and René Hilsum, were still in their early twenties and had little history of anti-war activity. Under Apollinaire's influence they had begun to contribute to *SIC* and the Cubist periodical *Nord–Sud*, and *Littérature* emerged with the sober appearance of a serious literary journal. To established writers such as Gide and Paul Valéry it gave the impression of a new generation paying homage to their elders, and they and the Cubist poets Salmon, Max Jacob, Reverdy and Cendrars contributed to the opening issue. This facilitated the foundation of the editors' own reputations. Their subsequent radicalism has suggested a deliberate subversion in this, but the contemporary evidence is equivocal.

Some of the most significant work in *Littérature* was the product of those who had died young and were accorded posthumous heroic status. Apollinaire's work featured alongside rediscovered manuscripts by Arthur Rimbaud and his contemporary Isidore Ducasse, who wrote under the pseudonym Comte de Lautréamont. Each offered a revolution in poetic imagery, which was at once unconventional and visionary, macabre and political. *Littérature* also carried Jacques Vaché's war letters. He had published nothing prior to his death on 6 January 1919 (from an opium overdose), but had fashioned a dismissive attitude to the contemporary avant-garde, assuming a distanced Jarryesque humour which he termed 'umour'. Breton was deeply – even disproportionately – impressed and became the guardian of Vaché's posthumous reputation.

The astonishingly public nihilism offered by Tzara's *Dada Manifesto 1918* suggested to the *Littérature* editors that he could fill the gap left by the deaths of Apollinaire and Vaché. Breton was in regular correspondence with him throughout 1919, absorbing and debating the other's 'philosophy of disgust' just as he had with Vaché. Tzara immediately became the most extreme contributor to *Littérature*, although he deliberately offered more lyrical works than the aggressive pieces sent for publication in Italy and Germany. They proved controversial enough and, by the end of the year, the *Littérature* editors had to defend his work from the nationalistic attacks in the *Nouvelle Revue Française*.

Other younger writers, especially Raymond Radiguet and Paul Éluard (who published his own periodical, *Proverbe*), were attracted by the increasing innovation of *Littérature*, evident in its serialization of Breton and Soupault's seminal *Les Champs magnétiques* (*Magnetic Fields*, 1919). These texts resulted from two major techniques that set the tone of their subsequent work: they were collaborative, reducing the importance of the individual; and they were the poets' first exercize in 'automatism', the uncensored outpouring of the imagination which they hoped could tap new poetic imagery. By sustaining their writing sessions for up to ten hours they achieved a free flow comparable with the contemporary 'stream of consciousness' fiction of Gertrude Stein and James Joyce. The results were published uncorrected (in theory), which exaggerated the defiance of orthodox forms. Neither collaboration nor automatism was pioneered in *Les Champs magnétiques* as Picabia and Tzara's text for *391*, no. 8 (February 1919) was familiar to the authors. However, published as a book it was produced on a scale that balanced pretensions towards literature against an assault on its conventions.

Despite their contact with Tzara, the *Littérature* group had no direct contact with Picabia until 4 January 1920. He probably regarded *Littérature* as too conventional, and the poets were

wary of some of his associates, especially Cocteau and Paul Dermée, whom they regarded as opportunists. They were also uncertain of their own visual taste; in early 1919, for instance, Breton favoured Ingres and Derain as well as de Chirico, Braque and Gris. This position probably encouraged Tzara to appoint Dermée, with his extensive avant-garde connections, as official Dada representative in Paris. With Céline Arnauld, Clément Pansaers and Vincente Huidobro, Dermée for a time represented Dada writing in Paris.

The preliminary phase of Paris Dada, represented by the painting and writing of Picabia and his associates, was superseded with the

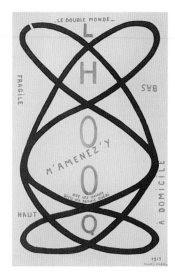

108
Francis
Picabia,
The Double World, 1919.
Enamel and ripolin on canvas;
132 × 85 cm,
52 × 33½ in.
Private collection

arrival of Tzara on 19 January 1920. He initiated a brief season of riotous Zurich-style performances, involving the cooperation of both Picabia's and Breton's groups, the like of which Paris had not seen before. Considerable publicity was whipped up for the first *soirée*: Première Vendredi de Littérature (*Littérature's* First Friday; 23 January 1920). It began acceptably enough with poetry by Salmon, Jacob, Reverdy and Cendrars and a display of works by de Chirico, Lipchitz, Léger and Gris. However, those expecting controversy were not disappointed, as two works by Picabia were presented. The first, *The Double*

BULLETIN

DADA

SALON DES INDEPENDANTS

GRAND PALAIS DES CHAMPS-ÉLYSÉES

(Avenue d'Antin)

Jeudi le 5 Février 4 h 1/2

Matinée

MOUVEMENT DADA

FRANCIS PICABIA

manifeste lu par 10 personnes

GEORGES RIBEMONT-DESSAIGNES

manifeste lu par 9 personnes

Nᵒ 6

ANDRÉ BRETON

manifeste lu par 8 personnes

Prix : 2 fr.

écrire
à
tristan
tzara
32,
Avenue
Charles
Floquet
Paris
(VIIᵉ)

PAUL DERMÉE

manifeste lu par 7 personnes

PAUL ELUARD

manifeste lu par 6 personnes

LOUIS ARAGON

manifeste lu par 5 personnes

TRISTAN TZARA

manifeste lu par 4 personnes et un journaliste

toutes les femmes sont déco-
rées de la Légion d'honneur :
les hommes portent cet
insigne à leur boutonnière.

Francis Picabia le loustic.

PROGRAMME de la **MATINÉE DU**

Mouvement Dada le 5 février 1920

World (108), carried various inscriptions, including 'LHOOQ', within interlocking loops. The disturbance created within the audience was heightened by a second work, in which various insults inscribed on a blackboard were erased just as they were recognized. Rising tension was contained, however, by an interlude of music by Satie, Georges Auric, Darius Milhaud and others, after which the *Littérature* poets read their own work. This was crowned by Tzara's much-heralded appearance: he read a short parliamentary speech by Léon Daudet! Salmon, Gris and other older members of the avant-garde were outraged at the ingratitude of the *Littérature* group in espousing Dada iconoclasm, and the audience was provoked by the obscenities and apparent meaninglessness of the work. Such an eruption immediately took on a political significance in the light of the recent election victory of the right. Dada's internationalism and perceived Germanic origins were a direct challenge to the Horizon Blue Chamber. The ideological divide was confirmed in Dada's subsequent appearance at Socialist and Anarchist venues.

This was a baptism of fire for the participants, since few of the Parisians had any experience of performing. Once established, the tempo was sustained until May. Tzara's *Dada 6* (*Bulletin Dada*; 109) used remarkable typography to serve as the programme for the *soirée* at the Salon des Indépendants (5 February), where it was rumoured that Charlie Chaplin would also appear. Huge crowds turned up to inevitable disappointment. Instead, a series of manifestos was read by decreasing numbers of performers: Picabia's by ten people, Ribemont-Dessaignes' by nine, Breton's by eight, and so on. A typical form was a repeated litany of demands, epitomized by 'No more painters, no more writers' (possibly by Aragon), which ended: 'no more police, no more fatherlands, enough of all these imbecilities, no more, no more, nothing, nothing, nothing, nothing'. A larger crowd gathered two days later at the left-wing Club du Faubourg in Puteaux. There, provoked by Aragon's insults, fighting broke out between rival Anarchists and Socialists.

Paris Dada gained strength from an increasing number of participants. Picabia reworked Duchamp's grafittied *Mona Lisa*, *LHOOQ* (omitting the goatee) for publication in *391*, no. 12 (March 1920), and Crotti and Suzanne Duchamp joined him in submitting mechanomorphic works to the Salon des Indépendants in January. When Gleizes, Gris and Archipenko were planning the Cubist Salon de la Section d'Or, Picabia, who was on the committee, advocated the inclusion of Janco, Arp and Ernst. Gleizes sought to exclude Ernst's collages,

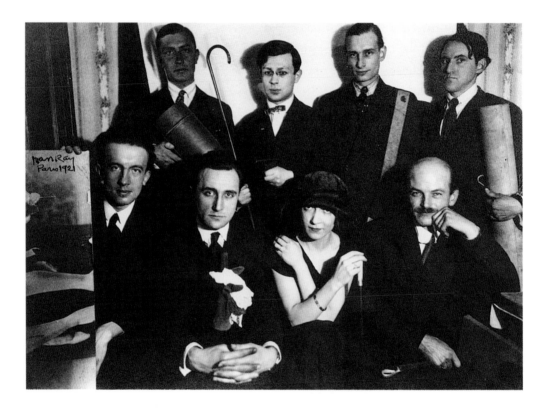

and others became alarmed by the scandals surrounding the concurrent Dada season of performances. At a stormy general meeting at the Closerie des Lilas cafe (25 February 1920) – a destructive end being avoided by the proprietor turning out the lights – Picabia and the Dadas were excluded by a large majority vote. This exclusion both enhanced Dada's reputation for extreme radicalism and confirmed the respectability of Cubism, which became a Dada target (just as Expressionism

was in Berlin). *Littérature*'s editors supported Dada at the Section d'Or vote, and in March 1920 issue no. 13 openly espoused Dada by publishing twenty-three manifestos, while *Dada 7* (*Dadaphone*) acted as an anthology and listed seventy-five Presidents of Dada. New pieces were performed at the Théâtre de l'Oeuvre (where Jarry's *Ubu Roi* had been performed twenty-four years earlier) on 27 March. Ribemont-Dessaignes produced a composition for piano, *Le Pas de la chicorée frisée* (*The Endive's Stride*) by selecting notes at random. Breton, who was distinguished for his admirable sang-froid in the face of an agitated audience, read Picabia's aggressive *Manifeste cannibale* from *Dada 7* (*Dadaphone*). After demanding that the audience should 'Stand up as if for the *Marseillaise* ... Stand up in the presence of **DADA**, which signifies life,' it concluded in stirring fashion:

110
Man Ray,
Dada group
photograph,
1921.
From top left,
standing:
Paul Chadourne,
Tristan Tzara,
Philippe Soupault,
Serge
Charchoune;
seated:
Paul Éluard,
Jacques Rigaut,
Mick Soupault,
Georges
Ribemont-
Dessaignes

DADA alone does not smell: it is nothing, nothing, nothing.

It is like your hopes: nothing.

like your paradise: nothing.

like your idols: nothing.

like your politicians: nothing.

like your heroes: nothing.

like your artists: nothing.

like your religions: nothing.

Hiss, shout, kick my teeth in, so what? I shall still tell you that you are half-wits. In three months my friends and I will sell you our pictures for a few francs.

The savage irony of Picabia's manifesto was matched by the presentation of his work consisting of a stuffed monkey tied to a canvas inscribed 'Portrait de Cézanne, Portrait de Rembrandt, Portrait de Renoir, Natures Mortes.' As well as mocking the 'dead' realism of the 'return to order', it attacked the adoption of heroes of the avant-garde by the establishment. Although stage-fright excused him from performing, Picabia was rarely shy in his artistic assaults, and the canvas was reproduced in *Cannibale*, no. 1 (April 1920), his periodical which temporarily replaced *391*. Despite the instant impact of these pieces, his contemporary

exhibition at Hilsum's Au Sans Pareil gallery failed to live up to the prophetic ending of the *Manifeste cannibale*, 1920.

The culmination of the 1920 season was the *Festival Dada* at the fashionable Salle Gaveau (26 May). The two-month interval was associated with the General Strike which was broken in May, and the Dadas' sympathy with this cause was implicit in the performance. The pieces, including *You Will Forget Me (Vous m'oublierez)* by Breton and Soupault (in which the characters included a dressing gown, an umbrella and a sewing machine), again established an electric atmosphere. Soupault's *Le Célèbre Illusionniste (The Famous Illusionist)*, in which he inflated and popped balloons inscribed with the names of members of the establishment – including the wartime Prime Minister Clemenceau, and the poets Mme Rachilde and Cocteau – offended many of those present. These included Rachilde herself, who had already entered into an ill-judged debate on nationalism with Picabia in the press; the latter's response in *Cannibale*, no. 1, was devastating: 'Wilhelm II and his friends were good patriots, just like you, Madame.' Tzara contributed to the soirée *Monsieur AA the Antiphilosopher Sends us this Manifesto*, a dazzling display of contradiction:

Careful! The moment has come when I should tell you that I have been lying. If there is a system in the lack of system – that of my proportions – I never apply it. In other words, I lie. I lie when I apply it, I lie when I don't apply it. I lie when I write that I lie because I do not lie – because I have lived the mirror of my father – chosen from the profits of baccarat.

Many in the audience, aware of previous disturbances, had come armed with (generally edible) missiles. Fruit, vegetables, even steaks, rained down on the stage. In these curious and gratifying circumstances, one member of the public shouted 'Vive la France et les pommes de terre frites' ('Long live France and fried potatoes'); thus Benjamin Péret made his entry into Dada.

The disruption of the conventional relationship between performer and public matched performances in Zurich and Germany

over the previous two years. For Tzara, Picabia and Ribemont-Dessaignes, this was enough. Their purpose was to shed all programmes and, in the precarious balance between the prepared and the haphazard, the *Soirée* achieved a cathartic liberation experienced by all. This partly explains their more or less indiscriminate inclusion in their activities of such tangential figures as Cocteau, the composers of 'Les Six' (Auric, Milhaud and others), and the toga-clad mystic Raymond Duncan (Isadora's brother).

Breton, who was more concerned with cultural politics, objected to such eclecticism while himself making compromises. In August 1920 he contributed 'Pour Dada' to the *Nouvelle Revue Française* (where he worked as a proof reader). It justified Dada in literary terms associated with the position of *Littérature*: the unorthodox lineage of Rimbaud, Lautréamont and Vaché, and the importance of inspired poetic imagery. Theoretical in tone, it hinted at unspecified possibilities beyond Dada. The editor of the *Nouvelle Revue Française*, Jacques Rivière, added 'Recognition for Dada' as a measured view from outside, which detected a divergence between *Littérature* and the anarchism of Tzara and Picabia. These articles were in themselves divisive. Both Tzara and Picabia were disgusted with the idea that Dada had become the subject of literary investigation, and Breton's role might have proved perilous had other contributors to the *Nouvelle Revue Française* not reacted with exaggerated indignation, thus partially transforming his contribution into a provocation. The fact that the articles appeared in August also neutralized arguments, for the prosaic reason that both Picabia and Tzara were on holiday.

In the summer of 1920, Tzara was in Romania for the first time since 1915. This reflected his interest in drawing attention to Dada's international scope, to be publicized in an ambitious multilingual volume entitled *Dadaglobe*. Probably having Huelsenbeck's *Dada Almanac* (1920) in mind (both as example and rival), he sought contributions from Zurich, New York, Berlin, Cologne and Paris as well as Italian, Spanish and Dutch

pieces. The ambition of the project outstretched its means, and *Dadaglobe* was abandoned at the proof stage in 1921.

Some Londoners were aware of Dada by 1920. By far the most positive response came from Ezra Pound who published a laconic (and bilingual) summary in *Dada 7*:

DADA No.1 Quelques jeunes hommes intelligents stranded in Zurich desire correspondence with other unfortunates similarly situated in other godforsaken corners of the earth.
DADA Bulletin 5 feb. Ils ont échappé. they have got to Paris. La bombe!! La zut – excelsior!!

Pound's tastes, like his writings, were sure but idiosyncratic. He was one of the early promoters of James Joyce's *Ulysses* (1922) but during 1920 he was also attracted by Picabia's writings. He contributed to *Littérature* and, as a foreign editor of *The Little Review* he secured a special Picabia issue in the spring of 1921, which was followed by contributions from William Carlos Williams and von Freytag-Loringhoven. Pound appreciated the sweeping away of the 'imbecilities of our elders' more than Dada's total revolution, but the extent of his own individuality may be gauged by his extraordinary assertion (made during his Fascist period) that Mussolini was the most intelligent man he had met since Picabia!

The suspension of group activities among the Paris Dadas until the end of the 1920 allowed ideas to develop in different directions. Suspicions of Dermée were confirmed when in October he began editing the periodical *L'Esprit Nouveau*, which favoured the cool, functionalist machine aesthetic of the Purists Amédée Ozenfant and Charles-Édouard Jeanneret (the architect Le Corbusier). Despite sharing an internationalist outlook with Dada, *L'Esprit Nouveau* did not provide the opening towards Constructivism experienced in German Dada circles because of a wariness on both sides. Around the same time a divergence between the allies of Picabia and Tzara and those in the *Littérature* circle became more obvious. Hilsum turned down Marie de la Hire's monograph on Picabia, so the painter took his second

show of the year (December 1920) to the Galerie Povolozky.
Although he had published a metro ticket as a *Dada Drawing*
in *391*, no. 14 (November), in this exhibition he countered
expectations by showing saccharinely realistic paintings of Spanish
dancers. However, the opening reception was remarkable for
the cross-section of fashionable figures, including the *Littérature*
poets and a jazz band comprising Auric and Francis Poulenc
conducted by Cocteau. Their relentless interpretation of
contemporary hits was interrupted only for Tzara's sixteen-part
Dada Manifesto on Feeble Love and Bitter Love, which included
the famous recipe for writing a Dada poem (see Chapter 2),
and further defined the nihilistic position shared with Picabia:

Dada places before action and above all: *Doubt.* Dada doubts everything.
Dada is an armadillo. Everything is Dada, too. Beware of Dada. Anti-dadaism
is a disease: selfkleptomania, man's normal condition is DADA. But real dadas
are against DADA.

This was a reaffirmation of a familiar position, but the determi-
nation of Breton and his friends to pursue a more positive
programme was already being felt. As such, the opening of
Picabia's exhibition was a watershed between the Dada activities
of 1920 and the disintegration of 1921–3, when the differing wings
of Parisian Dada began to attack each other. This increasingly
self-destructive process was acted out in publications and on stage.
Its major protagonists were Picabia, Tzara and Breton, and
it reflected both a conflict of personalities seeking dominance,
and a fundamental divergence of ideology. For Picabia, Tzara
and their allies, Dada represented the anarchic shattering of all
constrictions, a state which could be self-perpetuating. This
position was flawed because it was impossible to outrage the
audience continually. For the *Littérature* poets, Dada was a
literary liberation and, as such, was interpreted as a stage
on the road to something else. Their position was weakened both
because its seriousness made it an easy target for satire and
because of their inability to fashion a further step for
themselves.

The *Littérature* poets, gathering at the Café Certa, determined many of the plans for the 1921 season without consulting Tzara. Concerned about the predictability of performances, they proposed two alternative satirical approaches which cast Dada in a quite different light. The first was a series of guided tours to 'unvisited' sites in the city, which was to have included the morgue and the suburban park of Les Buttes-Chaumont. These were abandoned after the failure of the first visit to St Julien le Pauvre, a church on the Left Bank within sight of Notre Dame (14 April), perhaps because opening on to the street diminished the impact of their activities. The second approach was the mock trial of an establishment figure. This had precedents in the May issue of *Littérature* which published several pages of scores, ranging from −25 to +20, placed against selected individuals. The status of figures such as Picasso and Apollinaire was carefully weighed by Breton, Aragon, Éluard and others. Only Tzara (predictably) treated the process with disdain, liberally distributing −25s. It is indicative of the attitude of his colleagues, however, that Breton and Aragon were awarded the highest scores.

The idea of a mock trial followed this approach, but was quite different in practice. The only indictment was of the writer Maurice Barrès, whose youthful revolutionary books, including the appropriately titled *Enemy of Laws* (1893), had given way to rabid nationalism during the war (he was President of the League of Patriots in 1914). Breton and Aragon had been deeply impressed by Barrès's early work and nurtured a personal grievance. The fact that the transcript of the 'Trial' occupied the whole of the August issue of *Littérature* indicates the importance that it held.

Tzara was not the only one who felt the inappropriateness of Dada standing in judicial judgement. Ribemont-Dessaignes would recall: 'Dada could be criminal, coward, ravager, or thief, but not a judge.' Nevertheless, he acted as Prosecutor, while Aragon and Soupault acted for the defence of the stand-in dummy before a tribunal presided over by Breton. The proceedings

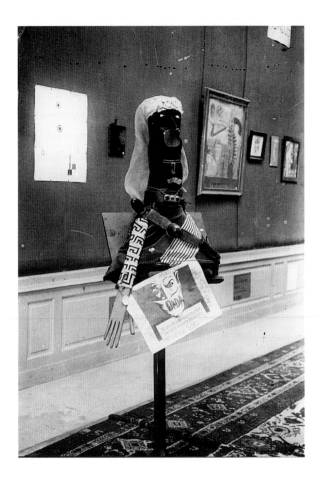

were conducted in front of a paying audience and journalists
and achieved a level of seriousness that nullified their irony.
This was only enlivened by Tzara's defiant mockery when called
as a witness. Péret's role as the 'Unknown Soldier', dressed in
a German uniform and a gas mask, was symptomatic of how
far the trial embodied an attitude to the war which was distinct
from the barbarity and absurdity perceived in Zurich. For the
Littérature poets, the Barrès trial followed Vaché's work as a
stage in their shift towards a political stance towards the war,
which they had not yet confronted publicly.

International connections helped to disguise these conflicting
concerns. The year had begun with the manifesto *Dada Stirs up
Everything* aimed at Marinetti's launch of *Tactilisme* (12 January
1921) and protesting against the Futurists' increasing

nationalism. Shortly before the Barrès trial, Ernst's exhibition opened at Au Sans Pareil (2 May 1921), although the artist himself was still prevented from entering France. The density and inventiveness of his collages (89, 90) made a profound impression on Breton, Simone Kahn and the other organizers. Hailed as the 'Einstein of painting', Ernst proved particularly attractive to the poets because his extended inscriptions opened possibilities for crossing from one art to another. His adoption by the *Littérature* group signalled their growing distance from Picabia, up to that moment the pre-eminent artist.

In any case, Picabia was on the point of withdrawing – an action first mooted in 'Picabia Parts Company with the Dadas' (*Comoedia*, 11 May 1921). His disenchantment had been growing; he did not appreciate the debates on the redistribution of wealth triggered by the appropriation of a waiter's wallet left at the *Littérature* poets' cafe table. More importantly, following a number of visits and contributions to *391*, Schad had written to him from Naples (25 April) levelling accusations of deception against Tzara. He claimed that Ball and Huelsenbeck invented the term 'Dada' in Zurich, and that Serner's manifesto *Letzte Lockerung* (*Final Dissolution*) had been suppressed in France so that Tzara could use its major ideas for his own *Dada Manifesto 1918*. In both these actions, Schad implied, Tzara relied upon being the only witness from Zurich Dada in Paris. Schad was plainly suspicious of Tzara, but his accusations stemmed from a disproportionate loyalty to Serner. Tzara may certainly be accused of overplaying his role in inventing the name 'Dada', but there is no evidence to support his stealing Serner's ideas. The two texts show no more proximity than that to be expected at a time when two writers were working in close collaboration. Serner's silence over this claim adds to the puzzle. In any case, Picabia, made irritable by a protracted eye infection, dissociated himself from Tzara and Dada without attempting to verify the claims. In an antagonistic *391* (no. 15), mysteriously entitled *Pilhaou-Thibaou*, he objected primarily to Tzara's pretensions to leadership.

112
Philippe Soupault, Framed mirror entitled *Portrait of an Imbecile*, exhibited at the Salon Dada, June 1921 (whereabouts unknown)

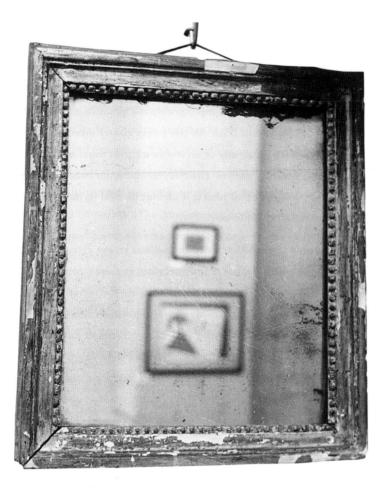

said to have been inspired by a mysterious revelation (114). Picabia, who had shrewdly been elected to the hanging committee, announced that he would show 'an explosive painting'. The Salon officials took him literally, and all the paintings were checked for suspicious devices! Of course, Picabia's announcement proved accurate, as visitors rushed to see – and to be outraged by – his *The Cacodylic Eye* (*L'Oeil cacodylate*; 104). The title derived from the treatment required for his springtime eye infection, and was illustrated by the central disembodied eye. The rest of the canvas bore the signatures of friends. Behind the casual appearance of this work lay a deliberate attack on commercialism. The accepted equation between the artist's signature and the value of the work (irrespective of its merits) was here distilled to its purest form: a canvas on which the valuable signatures excluded the negligible image. The work attracted more comment among critics than all the other submissions put together, and this scandal not only confirmed Picabia's combustive importance but also showed that there was potential in a path independent of Dada. In this he seemed to revert to his position prior to 1920, which he shared with his fluctuating band of friends.

114
Jean Crotti,
*Chainless
Mystery*, 1921.
Oil on canvas;
116·2 × 88·9 cm,
45³⁄₄ × 35 in.
Musée d'Art
Moderne de la
Ville de Paris

Among the others who steered an independent path were a number of old allies. Duchamp and Man Ray had arrived in Paris during the summer of 1921, but Duchamp's dedication to chess kept him on the fringe, a tantalizing prospect for Breton in particular. Photography (and the language barrier) served a similar purpose for Man Ray, allowing him to engage with contemporaries inside and outside Dada. In November he had a solo show at the Galerie Six, a bookshop opened by Soupault. His crisp and ethereal photographs and maliciously witty objects were a revelation comparable with Ernst's collages. The venue placed him within the *Littérature* group, and he later designed the periodical's new cover. However, his most famous object to emerge from the show, a flat iron with steel tacks along the face and entitled *Gift* (116), was a gift for Satie. When Man Ray

developed a technique of camera-less photography, he published a volume entitled *Les Champs délicieux* (*Delicious Fields*; 115). The echo of *Les Champs magnétiques* was balanced by an Introduction by Tzara, who coined the term Rayographs just as he had apparently coined the term Schadographs for Schad's similar invention.

Paris Dada stumbled towards an acrimonious disintegration in 1922. Tzara's split with Picabia was irreparable, but now the strain with Breton came to the fore. The catalyst was Breton's ill-conceived 'Congrès de Paris', a project launched in February 1922. Consistent with his interest in a more positive direction for Dada, its purpose was to debate the possibilities of the avant-garde 'protecting' contemporary culture. Members of other groups served on a committee: Jean Paulhan (for the *Nouvelle Revue Française*), Delaunay, Léger, Ozenfant (for *L'Esprit Nouveau*), Auric (for 'Les Six') and Roger Vitrac (for the periodical *Aventure*). Breton misjudged how far this

115 Left
Man Ray,
*Les Champs
délicieux*, 1922.
Rayograph.
Musée National
d'Art Moderne,
Centre
Georges
Pompidou,
Paris

116 Right
Man Ray,
Gift, 1921. Flat
iron with tacks;
h.15 cm, 6 in.
Private
collection

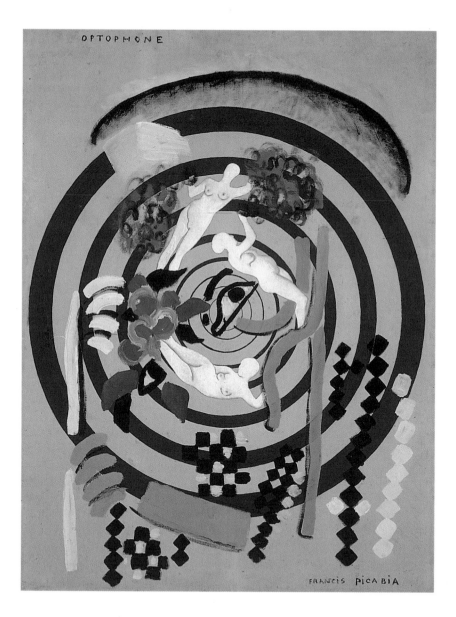

organization exposed him to criticism from his colleagues. Tzara, although invited to participate, highlighted its essentially anti-Dada premise and dubious company. An argument raged in the pages of *Comoedia*, where Breton unwisely characterized Tzara as 'the promoter of a "movement" brought from Zurich'. This recourse to nationalist sentiments rallied Éluard, Ribemont-Dessaignes and Satie behind Tzara; in the ensuing debate at the Closerie de Lilas (17 February), Breton was isolated by all but Aragon. The Congrès never materialized, and further sniping continued until Breton gave a clear indication of his position in 'Leave Everything' in the April issue of *Littérature*:

Leave everything. Leave Dada. Leave your wife. Leave your mistress. Leave your hopes and your fears. Leave your children in the woods. Leave the substance for the shadow. Leave your easy life, leave what you are given for the future. Set off on the roads.

117
Francis Picabia,
Optophone II,
1922–3.
Oil on canvas;
116 × 88·5 cm,
45³⁄₄ × 34⁷⁄₈ in.
Musée d'Art
Moderne de la
Ville de Paris

These messy public disputes had a number of unexpected consequences. The fact that others were sucked into the Congrès débâcle ensured that the final crash of Paris Dada would have a wide impact. Breton had appealed to Picabia (absent on the Côte d'Azur), who supported him against Tzara in the publication *La Pomme de pins* (February). This brought a rebuttal from Tzara and his allies in *La Coeur à barbe* (April), but Breton eventually emerged the stronger. Picabia's backing was manifested on the cover of *Littérature* (new series, no. 5), which carried his black-and-white line drawings. Breton's sole editorship was now of crucial importance, both as a platform for his position and for attracting new recruits seeking publication, such as Vitrac, Max Morise, Robert Desnos and the 17-year-old Jacques Baron. There was a parallel leaching away of support for Tzara; within the *Littérature* group only Soupault, Éluard and the young René Crevel remained close for some time.

These divisions were confirmed in the autumn of 1922. Tzara and the Éluards returned to the Tyrol, where they were again joined by Arp, Taeuber and the Ernsts. Tzara and Arp then travelled to the Dada/Constructivist Congress in Weimar. At the same time,

Picabia's annual assault on the Salon d'Automne took the shape of two large canvases with silhouette figures and romantic-erotic allusions: *La Nuit espagnole* (*Spanish Night*; 118) and *La Feuille de vigne* (*Fig Leaf*). As was his past practice, the works shown in November at Dalmau's in Barcelona – for which Breton delivered an important lecture on contemporary art – were of a rather different nature. They were dominated by geometrical target forms that had some relation to contemporary Constructivism, although in *Optophone II* (117) they had casually superimposed nudes typical of Picabia.

The disintegration of Paris Dada was a significant event in the wider artistic scene. Those who had been targets must have heaved a sigh of relief. Others, such as the Cubists and Purists, sought to benefit from the radical revisions it had set in train. The factional break-up was at the time, and has been subsequently, interpreted as the death of the Dada spirit, but the events of 1922–3 were more in the nature of a split than an annihilation As a result, Breton swung the majority of the poets behind his more deterministic approach, which would lead through the so-called '*époque floue*' ('imprecise period') to the founding of Surrealism. They needed to shed Dada's mockery in order to take matters seriously once more. This need was underlined by contemporary events, as at the beginning of 1923 the nationalist government (with nominal support from Belgium) ordered the invasion of the Ruhr in pursuit of reparation payments from Germany. Dada protest and in-fighting no longer seemed a sufficiently urgent response to resurgent militarism. Twenty years later, Tzara himself acknowledged this process as one of transformation from subjectivism to objectivism, from the anarchic independence of Dada to the communal activity of Surrealism.

Just as it had begun in unconnected strands and unlikely combinations, so Dada returned to that status after 1922. Although some of the *Littérature* poets were later to interpret their passage through Dada as a momentary indisposition, it had a profound impact. For Picabia and for Tzara, as for

118
**Francis
Picabia**,
*La Nuit
espagnole*,
1922.
Ripolin on
canvas;
185·4×127 cm,
73×50 in.
Museum
Ludwig,
Cologne

Ribemont-Dessaignes, Duchamp, the Crottis and others, a line independent of Breton was a necessity. A glimpse of the fluctuating situation may be seen in Breton's attack on Soupault in *Littérature* in May 1923. Four blank pages were published under Soupault's name and reference to *Les Champs magnétiques*, to be taken as a comment on his contribution to the joint text. This reflected a division between the collaborators brought to a head by Soupault's editorship of *La Revue Européenne* launched in March 1923. Although far from hostile (younger associates such as Pierre Drieu de la Rochelle and Joseph Delteil contributed), the new periodical was open to the literary establishment, rather in the style of the early *Littérature*. This was clearly no longer acceptable to Breton; although, astonishingly, the two poets were allied again before the end of 1924.

By the time of Ernst's arrival in Paris in November 1922, the orientation had shifted emphatically towards Breton and *Littérature*. Ernst captured the new position in his peculiar reworking of a Raphael fresco, *Au Rendez-vous des amis* (*At the Rendez-vous of Friends*) shown at the 1923 Salon des Indépendants (119). Here the *Littérature* poets flanking the centrally seated Paulhan introduce Ernst and his absent Cologne allies, Arp and Baargeld. The individuals are identified in two keys. Picabia and Tzara, Man Ray and Duchamp are absent and only three outsiders – Raphael, Dostoyevsky and de Chirico – together with the unidentified Ribemont-Dessaignes (heading the queue behind Morise) represent the input of others.

The painting is laden with esoteric signs that suggest the activities of an arcane sect. The emphasis on poets reflected the consistent literary orientation of the group, although the exploration of trances and dream states which dominated the *époque floue* superseded the orthodox division between artist and writer. The experiments were described in Breton's 'Entry of the Mediums' (*Littérature*, no. 6, November 1922), which evoked Rimbaud's image of the creator as seer and credited Crevel with the introduction of the possibility of voluntarily induced trances.

Breton was enthusiastic, but Aragon and Soupault were openly sceptical that any such state was being experienced by the three specialists, Crevel, Péret and Desnos. Nevertheless, the dreamers' inconsequential responses to questions were occasionally of impressive poetic quality. Drawings (essentially linear cartoons) also attempted to capture the experience of the vision; it is significant that Ernst adopted their amateurish spontaneity in his own drawings. These experiences were subsequently claimed for Surrealism by Breton and, although the term was not yet applicable, they were recognizably of a different order from preceding Dada activities, both in their communal nature and their organization.

By contrast, the last rites of Paris Dada took the form of isolated performances, coincidentally associated with experiments in film. On 6 and 7 July 1923 Tzara attempted to regain the earlier spirit with a Soirée de la Coeur à Barbe, for which tickets went on sale at galleries including Soupault's Galerie Six and Hilsum's Au Sans Pareil. In many ways this was a fascinating pair of performances: Iliazd's poetry and Sonia Delaunay's chromatic costumes for Tzara's Coeur à gaz (Gas-heart, restaged from 1921) were especially notable. The showing of Richter's Rhythm 21 and Man Ray's five-minute Return to Reason apparently constitutes the first inclusion of films within the format of a Dada soirée. Man Ray extended the technique of the Rayograph by scattering sand, pins and nails on the unexposed cine-film, thus returning to chance as a generative method. However, the impact of the evening was muted; the Russians were fund-raising for refugees from the Revolution, and Tzara's audience was increasingly found in the fashionable aristocracy. In fact, the second evening is principally remembered for the battle that brought it to a close, when Breton, Aragon, Péret and Éluard stormed the stage in protest against Tzara and his fellow-performers, Crevel and Pierre de Massot (whose arm was broken). The public nature of this 'blood-letting' – the police were called – brought Paris Dada to the destructive end that they had once envisaged for the establishment.

1 René Crevel
2 Philippe Soupault
3 Arp
4 Max Ernst
5 Max Morise
6 Fëdor Dostoïewski
7 Rafaele Sanzio
8 Théodore Fraenkel
9 Paul Eluard
10 Jean Paulhan

119
Max Ernst,
*At the Rendez-
vous of Friends*,
1922. Oil on
canvas;
130×193 cm,
51¼×76 in.
Ludwig
Museum,
Cologne.
As numbered:
René Crevel,
Philippe
Soupault,
Hans Arp,
Max Ernst,
Max Morise,
Fyodor
Dostoyevsky,
Raphael Sanzio,
Théodore
Fraenkel,
Paul Éluard,
Jean Paulhan,
Benjamin Péret,
Louis Aragon,
André Breton,
Johannes
Baargeld,
Giorgio de
Chirico,
Gala Éluard,
Robert Desnos

With the decline of collaboration came a decline in Paris Dada's radicalism, although partial compromise with the materialist society had allowed for more ambitious projects. Postwar affluence in France and the combination of familiarity and a reputation for outrage coincided in the mid-1920s to allow Dada's acceptance by wealthy patrons. It was in the sponsorship of performing arts, especially theatre, ballet and film, that this new alliance was most evident. Cocteau and Satie had demonstrated this with a number of pieces since *Parade*: the former's *Les Mariés de la Tour Eiffel* and *Le Boeuf sur le toit*, and the latter's more difficult *Socrates*.

Inspired by the Ballets Russes, Rolf de Maré's rival Ballets Suedois staged the notable Milhaud, Cendrars and Léger collaboration, *La Création du monde* (*Creation of the World*), in 1923. Through such works the avant-garde was increasingly integrated into 'society' events, associated with such patrons as the Vicomte and Vicomtesse de Noailles. As well as hiring Man Ray to light one of his parties, the Comte Etienne de Beaumont took the title of Apollinaire's periodical *Les Soirées de Paris* in producing a season of plays in June 1924. This included Tzara's *Mouchoir des nuages* (*Handkerchief of Clouds*) which lacked any definite narrative; the text was interrupted by commentators, while the staging ensured that the actors and stage-hands were visible at all times. Both innovations were related to the 'characters' and the contrasting 'reality' of the actors in Luigi Pirandello's *Six Characters in Search of an Author* (1921) staged by Sylvain Iktine six months earlier.

The purchase of equipment and stock made film (although still silent) relatively expensive, with the result that the innovators within the commercial industry remained dominant. Just as for Eggeling and Richter in Germany (see Chapter 4), so Man Ray found his projects severely limited. However, leading directors such as Abel Gance and Germaine Dulac were open to new possibilities because of the critical debate about the 'seventh art'. Before making his epic *Napoléon* (1925–7), which pioneered

split-screen techniques, Gance had collaborated with Cendrars on *The Wheel* (*La Roue*, 1922). In both cases, the Bergsonian simultaneity of experience encountered in prewar painting and poetry was given new potential.

However, the concern with narrative separated these from films infected with the Dada spirit. Illogicality was characteristic, partially inspired by the substitution of physical acting for narrative in American slapstick comedies. This emerged strongly in three notable films that carried experiments in painting and photography into action. Although last to be finished, Man Ray's mysteriously entitled *Emak Bakia* (Basque for 'leave me alone', 1926) had been in gestation for three years and used *Return to Reason* as a prologue. It combined acting with abstract sequences: the collars taken from a suitcase by Jacques Rigaut proceed to dance, while a garbled sequence was achieved by throwing the running camera over a flock of sheep! Man Ray also commented ironically upon his role: turning upon his reflection and focusing on the camera lens, he superimposed an inverted eye to suggest the machine as the ultimate extension of human activities. In completing *Emak Bakia*, Man Ray had refused to collaborate with the American film maker Douglas Murphy, who turned instead to Léger. Together they made *Ballet mécanique* (*Mechanical Ballet*, 1923–4) with music by the American composer George Antheil. The treatment of the machine was in line with Purist concerns, especially with the concentration on the beauty of manufactured objects. However, there was an enthusiasm shared with Dada for Chaplin (of whom a puppet appears) and for the potential of the city at night.

As so often before, the most startling example came from Picabia. Commissioned to design a ballet for the 1924 winter season of the Ballets Suedois, he had conceived the mischievously entitled *Relâche* (*Performance Suspended*, 1924). For Satie's complex and fragmentary music, the backdrop was filled with light reflectors aimed at the audience, against which the dancers,

choreographed by Jean Borlin, passed as silhouettes. As a filler in the programme, Picabia and Satie added the film *Entr'acte* (*Interval*), for which the young commercial director René Clair was enlisted. Dominated by acted sequences, *Entr'acte* lacked any logical narrative but used technical devices to subvert expectations. Although such effects as Picabia seeming to leap through the screen and the appearance of the Place de la Concorde on Duchamp and Man Ray's chess-board have had their impact blunted by technical crudeness, other images remain fresh. A dancing ballerina is seen provocatively from underneath, but when the camera pans up her body, she is bearded like *LHOOQ*! Most memorable was the long closing sequence of the funeral cortège (120). The hearse is pulled by camels, and the dignified mourners follow with exaggerated leaps and bounds (the actors unable to suppress their smiles at this absurdity). Slipping the camels, the hearse gathers pace, giving rise to a head-long race; an avenue of trees is reflected in split-screen in order to accentuate the plunging perspective of the pursuit. Eventually, the coffin is pitched into a field at a bend, only for Borlin to emerge alive.

120
Francis Picabia and **René Clair**,
A still showing the funeral cortège from the film *Entr'acte* (1924)

The high jinks of *Entr'acte* were deliberately humorous in line with Picabia's Dada work. However, its defiance of expectation carries considerable critical power. The audience was made to laugh at the absurdity of its own conventions. Although Picabia was hardly given to allegory, the structure of *Entr'acte* parallels the whole course of Dada as he experienced it: from its fragmentary origins, through its cavalcade of followers, to their falling away in its race to self-destruction. Even Borlin's emergence at the end parallels its endless potential.

It is appropriate to conclude with Picabia. To the Parisian art world he had been the embodiment of Dada, and his contribution within literary circles was far from negligible. Whatever his intolerance of his collaborators and the chaotic Don Juanism of his private life, his urge to reinvent his work in contradictory and anarchic ways was astonishing and

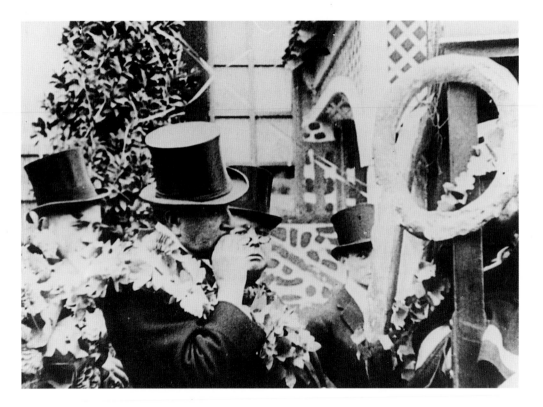

inspired profound respect. These qualities came to seem indistinguishable from those of Dada itself.

Despite the linguistic innovations of automatism, Paris Dada was never deeply concerned with the formal structures of words that characterized the sound poets of Zurich, Berlin or Hanover. Tzara had not attempted to rival Ball and Huelsenbeck in this, reserving the simultaneous poem for himself. Although sounds and non-words did play a part in Paris (Aragon's alphabetical 'Suicide' being a prime example), there was a core of received meanings which carried the impact more directly to the reader. The automatism of Breton and Soupault pursued innovation not by deconstructing language but by loosening the flow of unconscious imagery. This betrayed a need to maintain some relationship with literary antecedents from which the Germans had been willing to free themselves.

This broad definition of the major tendencies within Dada may also serve to suggest something about subsequent developments. The majority of its participants passed into the essentially left-wing avant-garde, but the retention of coherent forms of verbal expression by the Parisians who moved into Surrealism indicates a significant difference from the extreme concrete poetry of Schwitters and Hausmann. For the Parisians, the necessity was to restructure the known in the light of the hitherto ignored subconscious; for those in Germany, the complete collapse of all systems allowed a wholesale restructuring, submitted to Constructivist logic spiced with chaos. One crucial factor that was to set Surrealism apart from Dada was the coherence of group activity in the face of the cultural and political uncertainties of the interwar years. It was much more a movement than Dada ever was or ever aspired to be.

The transfer from Paris Dada to Surrealism around 1924 may
be seen as part of a wider process of transition from a mentality
circumscribed by the war to a realization of the profound change
the war had brought about. Nationalism was vindicated, not least
through the redrawing of the map of Europe. The French
occupation of the Ruhr in 1923 exemplified a determination
to keep Germany subdued and, coincidentally, emphasized
the gulf between the crippled German economy and the postwar
prosperity of France. Communism as promoted by the radical
spirit of the Third Communist International (Comintern)
was initially committed to internationalism, class struggle and
world revolution, but by 1922 this prospect began to recede
as the Soviet Union established relations with its neighbours,
and signed the Treaty of Rapallo with Germany. A simple equation
between cultural innovation and political revolution was no
longer the invariable rule. In Italy, Fascism appeared to be both
culturally revolutionary – accepting Futurism and Arte Metafisica
alongside classical figuration – and politically conservative.
Conversely, the stream of Soviet artists to the West after
the 1922 Russian Art Show in Berlin testified to the decline
of Anatoly Lunacharsky's revolutionary artistic policy. In France,
there was an appreciable shift to the left in the May 1924 elections
as the 'Cartel des Gauches' swept aside the conservative
'Horizon Blue Chamber'.

Such orthodox politics were of little concern to the emerging
Surrealists, who at this date retained the anarchist attitudes
of Dada. Instead, their position was declared in the title of
their new periodical *La Révolution surréaliste* (December 1924).
In Louis Aragon's words this called for a 'new declaration of
the rights of man'. These were to be the rights of the irrational
side of existence, proclaiming Surrealism as a way of life. Its

121
**Giorgio de
Chirico.**
*The Child's
Brain*, 1914.
Oil on canvas;
80 × 65 cm,
31⅛ × 25⅝ in.
Moderna
Museet,
Stockholm

himself demanded and made the term, which he had already used regularly, too restricted for these rivals. This was a masterly demonstration of his power of argument and assertion, which became one of Surrealism's most effective weapons.

Breton's *Manifesto* highlighted the important influences of poetry and psychoanalytic techniques. The most pervasive was Freud's theory of the unconscious. Breton, who had trained as a

122
Assemblage of found objects by an unknown artist;
42·5 x 15·5 cm,
16¾ x 6⅛ in.
Private collection, formerly in the collection of André Breton

doctor, had experience of its associational techniques for the treatment of shell-shock victims. However, he concluded that the investigation of the unconscious should also remain open to poets who could use relational methods in pursuit of what he called the 'marvellous'. His equation was emphatic: 'Once and for all: the marvellous is always beautiful, anything marvellous is beautiful; in fact, it is only the marvellous that is beautiful.'

Breton offered various examples of an alternative to rationality which could serve in its restructuring. His belief in automatism was reinforced by the cumulative power of Desnos's contemporary *Deuil pour deuil* (*Mourning for Mourning*, 1924):

From a molehill at his feet rises a greenish light that surprises him only a little, accustomed as he is to silence, forgetfulness, and murder, and knowing about life only the soft humming that follows the perpendicular fall of the sun when the hands of the clock, pressed against one another and tired of waiting for the night, call in vain with a fateful cry the purple pageant of spectres and phantoms kept far from there in a chance bed between love and mystery, at the feet of liberty, arms wide open against the wall.

In the period leading up to the *Manifesto*, dream accounts (the grounding for Freud's research) were added to automatism. The trance experiments had been curtailed because some participants were finding it difficult to emerge and others were becoming violent. Dreams offered a less dangerous source open to all, which could be understood as glimpses of the workings of a whole alternative world. Thus, they provided Breton with the basis for a subsidiary definition: 'I believe in the future resolution of these two states, dream and reality, which are seemingly so contradictory, into a kind of absolute reality, a surreality.' This dialectical credo confirms the concern with redressing the balance between these two realities. The first issue of *La Révolution surréaliste* opened with unelaborated dream accounts that became a stock type of Surrealist 'evidence'.

Other privileged states were singled out in the *Manifesto*. The undiscriminating fantasy of childhood was held up as a counterpoint to rational adulthood. Less widely appreciable was the example of those declared mad, who 'enjoy their madness sufficiently to endure the thought that its validity does not extend beyond themselves'. The Surrealists were among the first to give value to writings and drawings by those outside the accepted norms of society, publishing examples in their periodicals. This was a recognition of the validity of the magic that the creators themselves had invested in the objects

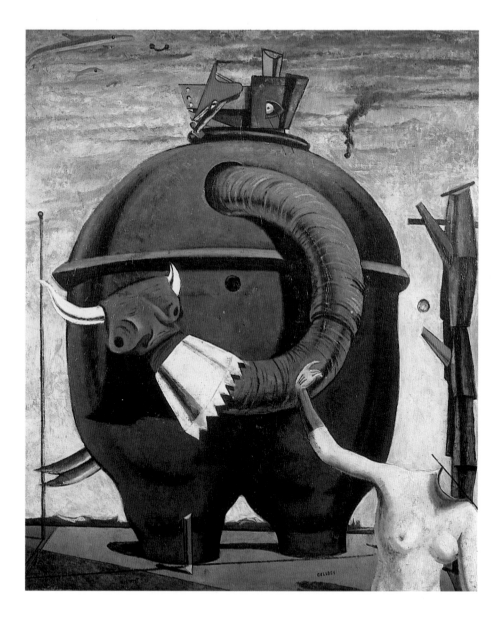

(122). It also distinguished the Surrealists' interest from the interpretations exacted by psychoanalysts.

The influence of Freud was matched by that of Arthur Rimbaud and the Comte de Lautréamont. Among Rimbaud's posthumously published letters was his 'Letter of the Seer' (1871), in which he seemed to anticipate the movement in declaring that 'The poet becomes a *seer* through a long, immense and reasoned *derangement of all the senses.*' Lautréamont (whose *Poésies* had appeared under his real name Isidore Ducasse) offered a different sort of inspiration. His *Chants de Maldoror* (1868–9) enclosed a bizarre narrative within an encrustation of imagery, including the striking simile 'as beautiful as the chance encounter of a sewing machine and an umbrella on an operating table'. In this connection, Pierre Reverdy had recognized that 'The more the relationship between the two juxtaposed realities is distant and true, the stronger the image will be' (*Nord–Sud*, March 1918). This observation was quoted by Breton, establishing juxtaposition – rather than comparison – as the primary poetic means for Surrealism.

The *Manifesto* was not illustrated, but had he chosen to do so Breton would not have had far to search. Man Ray's wrapped object, *The Enigma of Isidore Ducasse*, embodying the famous simile, appeared as the first photograph in *La Révolution surréaliste*. Ernst's work too had been recognized as bringing together distant realities, and he enlarged the unexpected juxtapositions of his collages in a series of astonishing canvases executed in a dry, modified realism. The sky in *Celebes* (123) contains a fish and a fictive hole; the threatening creature at the centre (modelled on an African corn bin) is both organic and machine-like, overshadowing the headless figure. Such works provided a major impetus for the group by seeming to demonstrate the liberation of the unconscious. With his early interest in psychology and Freud's writings, Ernst was well placed to create dream-like situations, although he

123
Max Ernst,
Celebes, 1921.
Oil on canvas;
125·5 × 108 cm,
49 ³⁄₈ × 42 ½ in.
Tate Gallery,
London

avoided simple illustrations of dreams. Instead, in works such as *Two Children are Threatened by a Nightingale* (124), he produced a disturbing atmosphere to which the title added a typically disconcerting view of passive objects.

Breton confined the *Manifesto* to literary examples, mapping an alternative tradition. He traced the roots of Surrealism from the 'gothic' novels of 'Monk' Lewis and the horror of Edgar Allan Poe, to the poetry of Saint Pol Roux, and the satire of Jonathan Swift, Alfred Jarry and Raymond Roussel. He attacked the assumption that the realistic novel was the highest form of literary invention, instead selecting for Surrealism examples of the 'marvellous' from a Romantic–Symbolist tradition. The choice of ancestors was to fluctuate – both Rimbaud and Apollinaire later passed out of favour – but these remained the unifying ingredients.

The *Manifesto* paraded contributions of colleagues, but it is unclear how far it represented a consensus within the group. Years later Aragon would recall Breton's ability to give 'the impression … of always being in the majority', and there is evidence of dissent. Just as Soupault doubted the trances, so Aragon and Éluard were sceptical about automatism. Éluard simply ignored it in favour of his (much admired) poetic inspiration. Aragon pointed to the problem that 'If you write dreary idiocies following a surrealist method they will remain dreary idiocies.' That all three accepted Breton's *Manifesto* attests to their mutual respect and the possibility for flexibility – even contradiction – within the seemingly doctrinaire movement.

Aragon's texts both supported and augmented the *Manifesto*. His article 'A Wave of Dreams' ('Une Vague de rêves', *Commerce*, Autumn 1924) was itself a manifesto and included an alternative definition of Surrealism:

The essence of things is in no way linked to their reality, there are relations other than reality that the mind may grasp and that come first, such as chance, illusion, the fantastic, the dream. These various species are reunited and reconciled in a genus, which is surreality.

124
Max Ernst,
Two Children are Threatened by a Nightingale,
1924.
Oil on wood with wooden additions;
69·9×57·1×11·4 cm,
27½×22½×4½ in.
Museum of Modern Art, New York

In this definition the dream (rather than automatism) took
pride of place alongside another important ingredient: chance.
Although the Surrealists used several of the compositional
methods pioneered by Dada, they pinpointed 'le hazard objectif'
or 'objective chance' as a crucial element. This was epitomized
by the chance encounter, either with an unexpected found object
or with unknown people, and such experiences formed the focus
of a number of important Surrealist books. These took their
lead from Lautréamont in presenting an overwhelming flow of
argument and reportage. In *Paris Peasant* (*Le Paysan de Paris*, 1926),
for example, Aragon documented the establishments of the
Passage de l'Opera threatened with demolition, and revealed
the fantastic aspects of barbers' and cane shops, cafés and
brothels. His exploration was implicitly autobiographical,
and he remarked that he had:

lived a chance existence, in pursuit of chance, which alone among the
divinities had shown itself capable of retaining its authority. No one had
preferred charges against chance, and some were even reinvesting it with
a great charm, going so far as to place a few infinitesimal decisions in its care.
So I let myself go.

While the surrender to chance would later determine key
moments in Breton's book *Nadja* (1928) and Soupault's detective
story *The Last Nights of Paris* (1928), a (paradoxically) systematic
approach to its creative potential quickly surfaced in Surrealist
games. A year after the *Manifesto*, the familiar game of
'consequences' was adapted by André and Simone Breton,
Max Morise, and Jacques Prévert. They constructed sentences
to which each participant contributed in turn without being
able to see the writing of the last, and the game produced the
striking phrase: 'The exquisite corpse will drink the new wine.'
'*Cadavre exquis*' was henceforth adopted as the name for
the visual counterpart, in which figures were developed by
a piecemeal process (125). As well as revealing a 'treasure-trove'
of the imagination, the process of juxtaposition combined
deliberation and chance in equal measure. Furthermore, as a

shared activity it undermined individuality. In this way the *cadavre exquis* typified the Surrealist anti-aesthetic more strictly than the work of any single artist.

The openness to objective chance received its most public manifestation in the Bureau of Surrealist Research (Bureau des Recherches surréalistes), also known as the Centrale Surréaliste, which was open daily between October 1924 and January 1925. It doubled as the office of the periodical, and is seen in Man Ray's cover photographs for *La Révolution surréaliste*, no. 1 (1924; 126), decorated with de Chirico's *The Dream of Tobias* (1916), a plaster nude and a copy of the popular detective novel *Fantômas*. The dramatist Antonin Artaud defined its purpose as applying 'all its forces to the reclassification of life'. To this end the Surrealists welcomed antagonists and potential contributors, such as Georges Bessière and the mysterious Dédé Sunbeam, who introduced aspects of existence pertinent to Surrealism. These had the same quality as the reports of unexplained suicides published in *La Révolution surréaliste* as evidence of the ultimate surrender to the irrational. A reluctance to man the Bureau led to its closure to the public, in part reflecting the practical limitations imposed by the Surrealists' various jobs, until employment was idealistically denounced within the movement.

After its closure the Bureau's activities were placed in Artaud's hands. He was one of the most inventive participants, holding an overtly visionary view of the Surrealist revolution. His open letters in *La Révolution surréaliste* extended the speculations of Breton and Aragon. 'Open the Prisons – Disband the Army' (no. 2, 15 January 1925) attacked two pillars of the establishment, while the 'Letter to the Medical Chiefs of the Asylums' (no. 3, 15 April 1925) demanded the release of mental patients in recognition of their alternative reality. His 'Letter to the Buddhist Schools' turned to oriental philosophy as an opposed to Western rationalism.

Artaud's visionary idealism reflected the interests of a group who had come to Surrealism independently of *Littérature*.

126
Man Ray,
Surrealists in the Bureau of Surrealist Research, 1924.
Collection Lucien Treillard, Paris.
From back left: Charles Baron, Raymond Queneau, André Breton (in front of de Chirico's *The Dream of Tobias*), Jacques-André Boiffard, Giorgio de Chirico, Roger Vitrac, Paul Éluard, Philippe Soupault, Robert Desnos, Louis Aragon; front row: Pierre Naville, Simone Breton, Max Morise, Mick Soupault

During 1922–4, the writers Roland Tual, Georges Limbour
and Michel Leiris had gathered with the painters André Masson
and Joan Miró at 45 rue Blomet; Jean Dubuffet and Ernest
Hemingway were visitors. They discussed Lautréamont and the
Marquis de Sade, Fyodor Dostoyevsky and Friedrich Nietzsche,
and Max Jacob and Juan Gris were influential presences. These
different sources, and the camaraderie evident at the rue Blomet,
discouraged Limbour from bringing them into contact with the
Littérature group. However, during 1924 Desnos and Raymond
Queneau began to visit the rue Blomet, and by the autumn
most of the group was drawn into Surrealism.

Other, smaller groups contributed to the diversity of the vital
early years of the movement. Among them were the former
editors of the periodical *L'Oeuf dur* (1922–4), Jacques-André
Boiffard, Pierre Naville and Francis Gérard, and the rue du

La femme est l'être qui projette la plus grande ombre ou la plus grande lumière dans nos rêves.

Ch. B.

connection with the formation of a visual identity for Surrealism. With the exception of Klee, these artists had been championed by Apollinaire and it was through him that Aragon, Breton and Soupault had first encountered their work. Picabia and Duchamp were significant for their irony, iconoclasm and concentration on sexuality. Their disdain of commercialism and personal reputation – summed-up in Duchamp's abandonment of painting – were considered exemplary.

Picasso was Surrealism's most ambitious quarry. In Dada texts, he was most often treated historically, and was rarely considered a contributor. His simultaneous experimentation with Cubist and classical forms was bewildering, and lacked the irony of Picabia's similarly contradictory styles. However, for Breton the Cubism of the 1920s bore an emotional charge and, by judiciously ignoring Picasso's classicizing works, he read a disjunctive aspect into earlier Cubist paintings which could be claimed as anticipating Surrealism. This would reinforce the impression of Surrealism as the direct inheritor of prewar radicalism. The state of their relationship was indicated by Picasso's contribution of a linear drypoint of Breton as the frontispiece for the poet's *Clair de Terre* (*Earthlight*, 1923), which significantly displaced a drawing by Ernst. Its style indicated the extent of Breton's compromise in order to make public their connection, while for Picasso the attentions of young enthusiasts were invigorating after a period of isolation. His neutrality during the war had fuelled conservative attacks on Cubism, and his marriage to the ballerina Olga Koklova, his role in fashionable society and his classicizing figuration (128) compromised his avant-garde reputation. Although he never formally subscribed to it, Surrealism opened up new territory.

The Surrealists' relationship with de Chirico was rather different, principally because direct contact with the Rome-based painter was delayed almost until 1924. The peculiar atmosphere generated by the modified perspective of his Metaphysical Art had been augmented by his use of mannequin-

127
Man Ray,
Germaine Berton and the Surrealists, from *La Revolution surréaliste*, no. 1 (1 December 1924).
From top left: Louis Aragon, Antonin Artaud, Charles Baron, Jacques Baron, Jacques-André Boiffard, André Breton, Jean Carrive, Giorgio de Chirico, René Crevel, Joseph Delteil, Robert Desnos, Germaine Berton, Paul Éluard, Max Ernst, Sigmund Freud, Francis Gérard, Michel Leiris?, Matthias Lübeck, Georges Malkine, André Masson, Max Morise, Pierre Naville, Georges Neveaux, Benjamin Péret, Pablo Picasso, Man Ray, unknown, Philippe Soupault, Roger Vitrac

type figures, which acted as a surrogate human presence. These paintings did not fit with the abstraction favoured by Zurich Dada, but the *Littérature* editors knew de Chirico's *Portrait of Apollinaire* (1914) and the monograph which had so impressed Ernst in Germany. In March 1922, Paul Guillaume held a decisive de Chirico show. Breton was especially struck by the mysterious personage in *The Child's Brain* (121), later recalling the compulsion to get off a bus in order to gaze at it in the gallery window. It had the same effect on Tanguy, motivating him to become a painter. Breton bought the canvas, immediately reproducing it in *Littérature*, with an appreciation by Roger Vitrac. From this moment, de Chirico's influence was comparable with that of Lautréamont or Freud, as his imagery was interpreted as being inspired by dreams.

De Chirico did not see his Nietzschean work – which questioned the nature of reality – in Freudian terms; indeed it is probable that he was barely aware of Freud's theories. However, he was undoubtedly flattered by the Parisians' attentions, and played down this misunderstanding and his stylistic shifts towards classicism which he considered to be technical refinements of the same inspiration. In November 1924 he visited Paris, where his designs for the ballet *La Giara* appeared in the same programme as Picabia's *Relâche*. He is pictured at the centre of the Man Ray cover photographs for *La Révolution surréaliste* (127), and his specially written dream account opened the issue, apparently lending his support to the movement. The theoretical differences must already have been apparent despite this acquiescence, but they were not made public until 1926, after de Chirico re-established himself in Paris.

Perhaps because he remained outside France, Paul Klee did not have the same attention or difficulties. His importance had been acknowledged in Zurich and Cologne but he was never a contributor to Dada. Although Aragon's letter soliciting illustrations for *La Révolution surréaliste* mentioned both Picasso and de Chirico, Klee was not especially drawn to Surrealism. His work

128
Pablo
Picasso,
*Two Women
Running on
a Beach
(The Race)*,
1922. Oil on
plywood;
32·7 x 41·3 cm,
12⅞ x 16¼ in.
Musée Picasso,
Paris

remained personal (129), even as he taught alongside **Wassily Kandinsky** at the Bauhaus. A monograph showing his free-flowing line was much admired by Masson and Miró, and several of his works appeared in the Surrealists' periodical (no. 3, 15 April 1925). He remained a sympathetic but distant fellow-traveller.

For the artists and writers allied to the movement, *La Révolution surréaliste* was the major joint means of addressing the public. The first issues were edited by Naville and Benjamin Péret,

the most politically astute members, with an opening Preface by Boiffard, Éluard and Vitrac, which proclaimed:

With the investigation into knowledge being closed and intelligence no longer being taken into account, the dream alone grants man all his rights to freedom. Thanks to the dream, death no longer has an obscure meaning and the meaning of life becomes unimportant.

Naville and Péret established the appearance of the periodical which, like *Littérature*, was typographically sober. Dream accounts and Surrealist texts were augmented by open letters and the major *enquête* (literary questionnaire) 'Is Suicide a Solution?', as well as by reviews of films and books. The format included a profusion of illustrations, following the example of the popular scientific journal *La Nature*. The dominant choice of photographs and drawings, while mimicking scientific evidence, reflected Naville's latent doubts about the validity of Surrealist painting. When Breton took over the editorship with the fourth issue, lengthier theoretical texts were illustrated by reproductions of paintings. However, its publication became erratic: eight issues spread over 1924–6, four over 1927–9.

The emphasis on photographs allowed Man Ray a major presence. He introduced the work of Eugène Atget, the street photographer then in his seventies, who had begun documenting Paris in the prewar years. The quality of his searching, somewhat nostalgic works had been overlooked, and his single-mindedness lent him the air of a 'primitive'. It was, in fact, only through Man Ray's judicious selection and placement in a Surrealist context that his works could be 'read' as revealing the unexpected through the ordinary. Atget's image of a crowd looking at the sky appeared on the cover of *La Révolution surréaliste*, no. 7 (15 June 1926); it was captioned 'Les dernières conversions' ('The latest conversions'), disguising the fact that the people shown were observing an eclipse.

Man Ray's photography was also reliant on the actual, which he combined with the 'marvellous'. Aware of a fragmentation in reality, he subverted the medium's apparently factual results through his choice of subjects and an array of transformatory techniques. Ironic titles persisted from his Dada days, so that the ghostly life of washing on a line, *Moving Sculpture* (1920), could appear on the cover of *La Révolution surréaliste*, no. 6 (1 March 1926), with the caption 'La France', suggesting the country's political indecision. He continued to explore

129
Paul Klee,
With Eagle,
1918.
Watercolour
on paper;
17·3 × 25·6 cm,
6⅞ × 10 in.
Kunstmuseum,
Bern

the erotic. The Freudian basis of Surrealism ensured that
the exposure of repressed sexuality was equated with a
liberation from rationalism and the restrictions of convention.
In *Paris Peasant*, Aragon catalogued the sexual activity concealed
behind the city's façades, and Man Ray's nudes in the periodical
provide a photographic equivalent. In the first issue, *Return to
Reason* (130) has the breasts and torso of a model ribbed with
the shadow from a blind. While the body is revealed in a way
approaching abstraction, implications of exposure (the nude
at the window) are present, and the blind provides only the
slightest veil between fantasy and external reality.

The most innovative nudes explored a balance between the
aesthetic qualities of the image and an appreciation of the
form and diversity of the female body. In this, Man Ray's work
set the tone for Boiffard and other photographers linked to
the movement. The results now raise the fundamental problem
of the 'objectification' of the female body – the reduction of
woman to an object – and, in general, the images of eroticized
torsos offer no defence against such accusations. Even the
probability that such images were symptomatic of a liberation
among a certain class of bourgeois artistic woman, and therefore
equivalent to the liberation expressed by the artist himself,
does not explain why the men in the photographs keep their
clothes on. In particular cases, it is often more difficult to
establish whether an image may be declared liberating or
demeaning, and photography is by no means the only aspect
of Surrealism open to such accusations of the 'male gaze'.

In defence of his photography, it may be acknowledged that
Man Ray's subtle technical manipulations consistently served
to enhance the content. To the object-based Rayograph,
the possibilities of the process dubbed 'Solarization' were
added in the late 1920s by his assistant Lee Miller. By exposing
the print prematurely, crisp details could be retained in the
light areas of the image, while the dense blacks were not fixed.
This created a halo effect, which could vary from a mysterious

130
Man Ray,
*Return to
Reason*, 1923.
Silver gelatin
print from a
motion picture
negative.
18·7 x 13·9 cm,
7⅜ x 5½ in.
J Levy
Collection,
Art Institute of
Chicago

132
Max Ernst,
*The Habit of
Leaves*, 1925
(from *Histoire
Naturelle*,
1926). Frottage
with gouache
on paper;
42·2 x 26 cm,
26⅝ x 10¼ in.
Private
collection

131 Previous
Page
Man Ray,
*The Primacy of
Matter over
Thought*, 1929.
Solarization.
Collection
George
Dalsheimer,
Baltimore

veil cast across the whole presence to an aura enhancing
the features (131). Miller and Man Ray limited their use
of Solarization almost exclusively to figure work, locating
in the aura a sense of personality.

It is one of the paradoxes of Surrealism's anti-aesthetic that
the emphasis on personal vision established it as one of the
most technically inventive movements of the century. Through
an exploration of automatism each artist sought his own means
for opening the way to the unconscious. Certainly this combination
of innovative images and techniques was found in the work
of Ernst and Masson.

With misleading precision, Ernst dated the invention of frottage
to 10 August 1925. The technique was simple: paper, laid on
rough floorboards, was rubbed with a soft pencil achieving a
textured drawing. Ernst related this to a childhood memory:
'a false mahogany panel facing my bed played the role of optical
provocateur in a vision of half-sleep'. The original drawings
produced by this method were acknowledged as similar sources,

indicating that they went through a process of clarification before being considered complete. Ernst transformed the texture of the wood-grain into unexpected growths and unnameable beasts for his portfolio *Histoire Naturelle* (*Natural History*) published in 1926. The condensed narrative implied by the thirty-four plates and their titles parodied scientific treatises, and offered instead an untamed vision of the natural world (132). The subtlety of the cycle suggested considerable editing both in the order of frottages and within the structure of each, and the photographic edition allowed Ernst to disguise collaging or masking. Although frottage had some of the qualities of an 'automatic' technique, it is clear that Ernst manipulated the original 'provocation' to draw out its impact.

The search for an equivalent technique for oil paint exercised Ernst in the 1920s. He had already begun to use combing into wet paint, which exposed a contrasting layer of paint below. Results, such as *The North Pole*, were associated with the geological themes of the *Histoire Naturelle*, while *Paris Dream* (1924–5) evoked the abiding concerns of the movement. A series of shells and flowers was made by smearing paint with a knife, and from these experiments grattage emerged.

133
Max Ernst,
The Horde,
1927.
Grattage of oil
paint on canvas;
114·9×146 cm,
45¼×57½ in.
Stedelijk
Museum,
Amsterdam

In this equivalent to frottage, paint was scraped unevenly from a wet canvas pressed against a rough surface. Again, after the initial 'provocation' Ernst tended to repeat the process using masking to achieve a final image. Grattage was particularly associated with the nightmarish threat of the *The Horde* (133) and forest themes, which both drew upon Ernst's childhood fantasies and from which he was protected by his alter ego called 'Loplop'; this bird-like figure became a powerful and ambiguous presence in his work.

Where Man Ray and Ernst came to Surrealism from Dada, Masson had been closer to Cubism. Severely wounded in the war, he read Nietzsche, Dostoyevsky, Lautréamont and others in search for some sense to his harrowing experience. In Paris, he became friendly with Juan Gris and achieved a degree of financial security when taken on by the Cubists' dealer Daniel-Henry Kahnweiler. The claustrophobia and dominance of games, in such paintings as *The Card Trick* (1923), soon indicated a universal purpose to the activities played out with his friends at rue Blomet: man's confrontation with chance and destiny was seen as beyond the control of the individual.

134
André Masson,
The Four Elements,
1923–4.
Oil on canvas;
73 × 60 cm,
28¾ × 23¾ in.
Musée National d'Art Moderne, Centre Georges Pompidou, Paris

Masson's first one-man show at Kahnweiler's Galerie Simon in early 1924 brought him to Breton's attention. The poet bought *The Four Elements* (134), which overlaid Heraclitan references to the classical elements of air, fire, water and earth with an unrequited desire for woman and the primeval creativity of the sea. These concerns probably reminded Breton of André Derain and de Chirico, but he also recognized an intellectual painter of his own generation in whose genius he felt an immediate confidence. This opened the way to the rue Blomet group, with its experiments with language and meaning – such as Michel Leiris's 'Glossary' (*La Révolution surréaliste*, no. 3, 1925) in which phrases were given punning interpretations. Georges Limbour and Leiris were already aware of Breton's and Soupault's automatism, and Masson was quick to grasp its possibilities. Indeed, it seems to have become his mission to develop an

artistic equivalent for automatic writing. His calligraphic ink
line, indebted to Klee, came close to the practice of the poets.
With the minimum of conscious determination, a large number
of works was produced in quick succession and in a trance-like
state in order to eliminate reworking (135). The majority
of his drawings, which began to appear in the first issue
of *La Révolution surréaliste*, conceal recurring themes: fragments
of bodies alongside other elements from his esoteric paintings
(lemons, pomegranates, architecture). These are like the favoured
words or phrases of the poets and, like them, are offered up in
unexpected combinations.

Although contributing only to later issues of the periodical,
two other artists made drawings close in technique to Masson's.
His neighbour at rue Blomet, Joan Miró, had passed through
a hybrid Cubism in Barcelona, and a realism in which details
achieved a bizarre power. His first contact in Paris was Picasso,
who bought Miró's *Self-portrait* (1919). However, Miró is said to
have asked Masson – through the hole in the wall between their
studios – whether he should visit Picabia (whose work he knew

136
Joan Miró,
Maternity,
1924.
Oil on canvas;
91 × 74 cm,
35⅞ × 29⅛ in.
Scottish
National
Gallery of
Modern Art,
Edinburgh

in Barcelona) or Breton. To this choice between anti-painting
and anti-literature, Masson replied: 'Breton ... is the future.'
Miró's aggressive statement about Cubism – 'I will smash their
guitar' – seems at odds with the humorous and erotic cast
of characters which populated such canvases as *The Harlequin's
Carnival* (1924–5) and *Maternity* (136). Signs became familiar
through their repetition: stars, animals, the Catalan peasant's
cap and pipe, the tubular male and almond-shaped female sexes.
In his drawings they achieved an extreme conciseness. A gesture
might determine the whole composition. It could also provoke
sequences in the sketchbook through the simple device of using
the impression on the following page as a starting point for the
next work. During 1925–7 the compositions thus conceived were
reinvented on the larger scale of the canvas. Over thin washes
of colour Miró imposed minimal signs of great calligraphic
elegance. The tentative balance of such works as *Painting* (137)
appears to reinvent painting from first principles.

The openness of Miró's handling had a major impact on the
youngest of the Surrealist painters, Yves Tanguy. Without formal

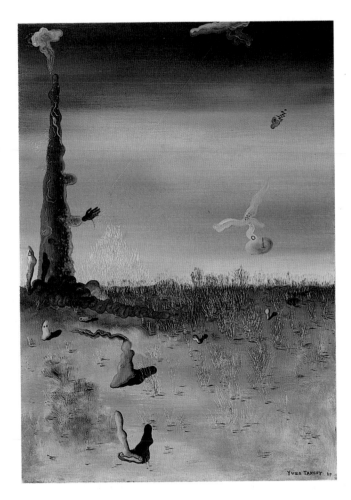

137 Left
Joan Miró,
Painting, 1927.
Oil on canvas;
97 × 130 cm,
38¼ × 51¼ in.
Tate Gallery,
London

138 Right
Yves Tanguy,
Extinction of
Useless Lights,
1927.
Oil on canvas;
92·1 × 65·4 cm,
36¼ × 25¾ in.
Museum of
Modern Art,
New York

(Mme Fondrillon), thus demonstrating his acknowledgement of the possibilities of visual Surrealism and preparing the reader for the first of his series of essays entitled 'Surrealism and Painting'. Major paintings were reproduced, including Miró's *Maternity* and *The Hunter* (1923, both in Breton's collection), Ernst's *Two Children are Threatened by a Nightingale* (124) and *Pietà or Revolution by Night* (*Pietà: La Révolution, la nuit*), Pierre Roy's *Adrienne the Fisher* (*Adrienne pêcheuse*; 139), and Picasso's *Les Demoiselles d'Avignon* (105).

These reproductions were simply a taste of the works available in two exhibitions at the Galerie Pierre. In June, Miró's first Parisian exhibition was mounted as a Surrealist event, and it was claimed (somewhat unconvincingly in retrospect) that his free style could be considered automatic. In November Miró, Masson, Ernst and Picasso formed the core of the exhibition Surrealist Painting, alongside Arp (recently readmitted to France), de Chirico, Klee, Malkine, Man Ray, Dédé Sunbeam, Kristians Tonny and Roy. The exhibition (even its title) was in defiance of the theoretical objections, but by its simple presence it served as a public affirmation of Surrealist painting a year after the movement's foundation. As one of the major trance poets, the involvement of Robert Desnos in its organization reinforced assertions of automatism.

The weight of the defence of visual Surrealism fell upon Breton's 'Surrealism and Painting', which became the movement's major text on painting. The ambiguous relationship embodied in its title was a sign of Breton's difficulty, and he is famous for calling painting 'a lamentable expedient'. However, he valued the inspirational works of Picasso, de Chirico, Ernst and Masson for their provocative imagery, and despite his own interest in group activities he was anxious to insist on the value of individual expression, as opposed to Naville's view of communality. This was not to justify limited aesthetic practice – art for art's sake – but because, Breton believed, these artists exposed alternative realities. So he embarked on a lengthy theoretical discussion

that carried him through most of the associated artists. Like the *Manifesto*, 'Surrealism and Painting' is occasionally obscure. It moves from the opening assertion of the primacy of visual experience – 'The eye exists in a savage stage' – to the seemingly contradictory assertion of automatic writing as a direct trace of that experience. No difference is noted between the direct sensory perception and the intellectual interpretation of it. This is reconcilable only because Breton is not concerned with outer reality, but with tracing the individual's 'internal model'. The practicalities of the intervention of memory are barely addressed; instead the 'marvellous' is isolated in the work of the artists so as to identify the Surrealist element in painting.

In this, the key figures are Picasso, de Chirico and Masson. In Cubism Picasso had achieved, as far as Breton was concerned, the primary break with external reality, which allowed all subsequent explorations. Their friendship brought the publication of both *Les Demoiselles d'Avignon* (105) which, as secretary to Jacques Doucet, Breton had persuaded the collector to buy in 1924, and a new masterpiece, *The Dance* (140). However, the indulgence of Picasso's classicism (128), dismissed as a joke

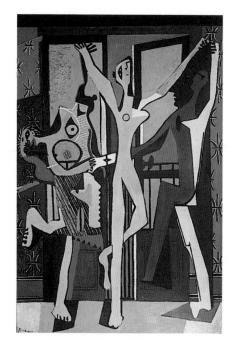

140
Pablo
Picasso,
The Dance,
1925.
Oil on canvas;
215 × 142 cm,
84¾ × 56 in.
Tate Gallery,
London

at the bourgeoisie's expense, was not extended to de Chirico. In *La Révolution surréaliste*, no. 7 (15 June 1926), the Italian was praised for his disconcerting early work (41) but condemned for his recent loss of inspiration and for making copies of his old works in his new style. The public row distracted attention from the fact that Breton was still claiming early de Chiricos for Surrealism irrespective of Morise's objections. The painter's own views were treated in cavalier fashion as he distanced himself from Surrealism and, provocatively, became friendly with the fashionable Jean Cocteau.

This theoretical defence and definition of visual Surrealism elicited further evidence. The collections of Breton and Éluard, and to a lesser extent Aragon, were of growing significance. When Duchamp auctioned his collection of Picabias in March 1926, Breton bought fifteen, including *Parade Amoureuse*. That month also saw two important exhibitions. The first was a large Ernst show at the Galerie van Leer to coincide with the publication of the *Histoire Naturelle*. Despite the success of these experiments, Ernst's position within the movement was somewhat precarious. In May, he and Miró were publicly reprimanded for providing set designs for Serge Diaghilev's *Romeo and Juliet* – an unacceptable compromise with bourgeois commercialism.

The second exhibition in March 1926 was at the Galerie Surréaliste, a new Surrealist venue which remained open until 1928. The opening show combined Man Ray's object-based paintings with Oceanic sculptures; such a juxtaposition of contemporary painting and ethnographic objects was unprecedented and greeted with astonishment. This announced the growing fascination within the movement for non-Western art, which, like interest in oriental philosophy or the art of the insane, was seen to connect to sources outside Western rationalism. The Surrealists favoured Oceanic and Native American work (141) – shown with Tanguy's paintings at the Galerie in 1927 – for a variety of reasons. They were less familiar and commercialized

141
Inuit mask of a bird. Painted wood and feathers; 53 × 27 cm, 20⅞ × 10⅝ in. Collection J J Lebel, Paris

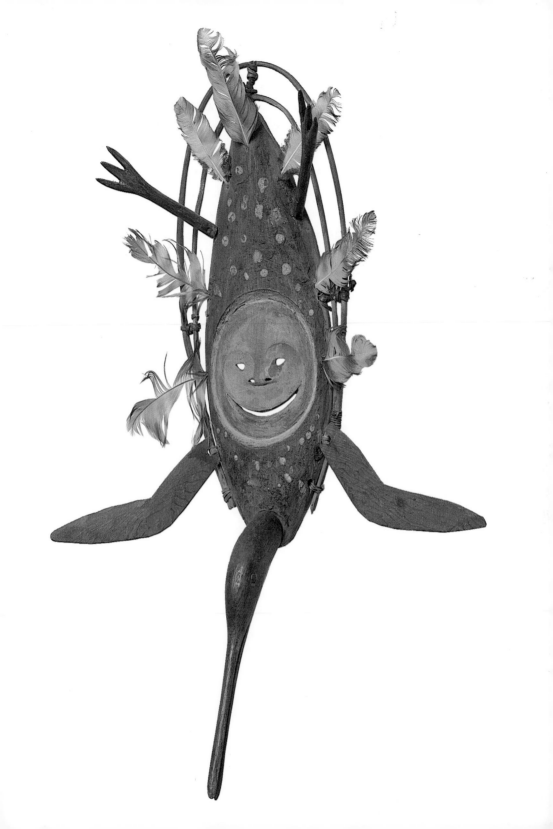

than African sculptures, which were associated with Cubism; they were also more delicate and ephemeral, suggesting the fragility of the spirit world with which they were so often associated.

Although Breton had circumvented Morise's objections and, by 1926, other questions had superseded Naville's, his series of essays, 'Surrealism and Painting', continued. The irregular *La Révolution surréaliste* allowed him to capitalize on developments towards automatic painting, and the turning-point was confirmed in his text in *La Révolution surréaliste*, nos 9–10 (1 October 1927). Concerned with Ernst, it highlighted the hallucinatory origin and effect of frottage and grattage, and one of *The Hordes* was illustrated. Two works reproduced in the same issue demonstrated other possibilities. Miró's *Person Throwing a Stone at a Bird* (142) introduced his whimsical and disconcerting glimpses of mysterious activities: the style, like the title, was deceptively casual. The first reproduction of a Masson 'sand painting' was perhaps more significant, in view of the role allotted to his drawings. Appropriately enough, it illustrated a text by Desnos. The sand paintings (143), begun at the end of 1926, were a breakthrough towards automatic painting. Instead of relying upon line, Masson poured glue and sand on to the canvas, establishing roughly textured areas. These were apparently unforeseen and 'provocative' (in the sense of Ernst's techniques), although there is evidence that the figures were partially drawn in beforehand. In any case, the pouring of sand

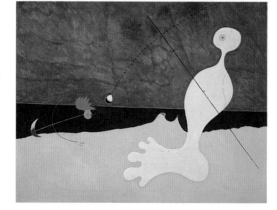

142
Joan Miró,
*Person Throwing
a Stone at a
Bird*, 1926.
Oil on canvas;
73·7×92·1 cm,
29×36¼ in.
Museum of
Modern Art,
New York

and paint was an important liberation for painting. The sand paintings and Miró's parallel experiments met the objections raised by Morise, and set a precedent for the liquid automatic techniques employed over the next two decades by Surrealists and others.

Just as Naville's objections to visual Surrealism provoked internal debate, so it was with their political position. It was a complex issue that would dog the movement, but its fundamental problem was close to that raised over painting: the possibility and consequences of commitment to communal action. Throughout their association with various Communist factions, the Surrealists were confronted with this questioning of their activity – especially their individual activity – within the context of the common desire for a political and social revolution.

The opening phase of the 'Surrealist revolution' had been idealistic. In 1924 Aragon had been able to dismiss the Russian Revolution as 'on the level of ideas ... a vague ministerial crisis', while professing to place 'the spirit of revolt above any politics'. It is hardly surprising that the official Communist Party viewed Surrealism with distrust. However, the need for a political position arose with the French colonial war in Morocco, the 'guerre du Rif', in mid-1925. Disgusted by renewed conflict and impressed by the Moroccan revolutionary leader Abd-el-Krim's demand for equality with the French, the Surrealists were among the signatories of Henri Barbuse's manifesto *Appeal to the Intellectual Workers* (July 1925), which expressed solidarity and condemned the war.

This precipitated the Surrealists towards co-operation with the Communist periodical *Clarté*, edited by Jean Bernier and Marcel Fournier. They looked more directly to the Comintern than the official French Party and wanted to attract radical intellectuals in all fields to the rigours of Marxist–Leninist dialectical materialism and the promise of world revolution. The intellectual and poetic experiments of Surrealism might be accommodated as their 'revolution of the mind' could be seen as parallel to a political and social revolution. A period of

143
André
Masson,
Figure, 1926–7.
Oil and sand
on canvas;
46·1 x 26·9 cm,
18⅛ x 10½ in.
Museum of
Modern Art,
New York

negotiation towards joint action was signalled by the 1925
manifesto *Revolution First and Always*, which was signed by all the
Surrealists and the *Clarté* group as well as by Pierre de Massot,
Raymond Queneau, Ribemont-Dessaignes and the Belgian editors
of the pro-Surrealist periodical *Correspondance*, Camille Goemans
and Paul Nougé. It responded to a conservative manifesto
Intellectuals at the Side of the Fatherland (1925) by citing the
example of Brest Litovsk, the treaty by which Lenin removed
Russia from the war. The signatories refused to be mobilized,
with the unequivocally internationalist declaration: 'for us
France does not exist'. The conclusion was forthright:

We are the revolt of the spirit; we consider a sanguinary Revolution to be
the inescapable revenge of the spirit humiliated by your works. We are not
utopians; we conceive this Revolution only in its social form ... the idea of
revolution is the best and the most effective safeguard of the individual.

Thus, for the first time Surrealist activity was submitted to political theory, although the possibility of individual action was left open. Collaboration between the two groups reached its climax at the end of 1925 with the prospective launch of a periodical, *La Guerre Civile*, with a joint panel of editors. The Surrealists' unwillingness to give up their independent investigations to take up class struggle proved a sticking-point, however, and the publication never appeared. Although the Clartéists understood this 'specialization', the unresolved problem remained, and consequences within Surrealism were profound. Those primarily concerned with artistic pursuits and perceived to be building reputations were expelled during 1926. They included Antonin Artaud and Roger Vitrac, who had formed the Théâtre Alfred Jarry, as well as Soupault, who had been on the panel of *La Guerre Civile*. This showed Breton's determination to pre-empt accusations of being literary and idealistic. It might also have been a necessary sacrifice in the face of Naville's call for more effective political commitment.

Naville's *The Revolution and the Intellectuals (What can the Surrealists do?)* (1926) pointed out that the Surrealists faced a chicken-and-egg situation: should the revolution of the mind anticipate its political equivalent, or 'was the abolition of the bourgeois conditions of material life a necessary condition of the mind's liberation?' He dismissed the consequences of the former option as anarchic and individualistic, favouring the Marxist path of collective activity. While these conclusions were widely acknowledged within the movement, Breton was also aware of the hostility to Surrealism within the Communist Party. His *Legitimate Defence* (September 1926) was a calculated definition of their situation. The piercing attack he launched on Barbuse and the 'cretinizing' official Communist newspaper *L'Humanité* hardly served to win over Party views, but was meant to expose the feebleness of its intellectual adherents. By comparison, the commitment of Surrealism to a proletarian revolution was made with one reservation: 'Meanwhile, it is no less necessary, as we see it, for the experiments of the inner

life to continue and this, of course, without an external check, even a Marxist one.'

Such a defence did not satisfy either Naville, who went over to *Clarté*, or the Communist Party. Nor perhaps was it designed to. It was an assertion of Surrealist independence within a larger view of revolutionary activity. It was, therefore, unexpected when Breton, Aragon, Éluard, Péret and Pierre Unik joined the Party, with the declaration *Au Grand Jour* (1927). This was a decisive step, aimed at defusing the difficulties that had arisen with their natural allies, and it received general support within the movement. The Party – for whom, in any case, Surrealism constituted a fairly minor irritation – remained suspicious, requiring political activists rather than critical intellectuals. Naville had willingly renounced Surrealist experiments. Péret, through his friendship with the Brazilian Communist Mario Pedrosa, became an activist in Rio de Janeiro. For the others, *Au Grand Jour* proved a temporary solution. In 1928, Aragon published *Treatise on Style*, which provided a polemic against literature, while Breton's *Nadja* charted chance encounters with a woman in a perpetual state of trance. These served as confirmation that political commitment was not to diminish the independent concerns of Surrealism.

The debates on art and politics may have been divisive but they served to define Surrealism's position. The commitment to automatism and the 'inner model' set its painters apart from contemporary concerns. Revolutionary aspirations separated them from the nostalgia, mythology and classicism of 'return to order' artists and were an underlying reason for their split with de Chirico. The rejection of rationalism separated them from the Cubism of Gris and Léger, and the Constructivist abstraction of Mondrian and van Doesburg. Although these divides seemed quite unambiguous, this was not quite the case, especially after Surrealist devices began to pass into the mainstream. The Neo-Romanticism of such artists as Pavel Tchelitchev and Christian Bérard would become confused with Surrealism, just as the

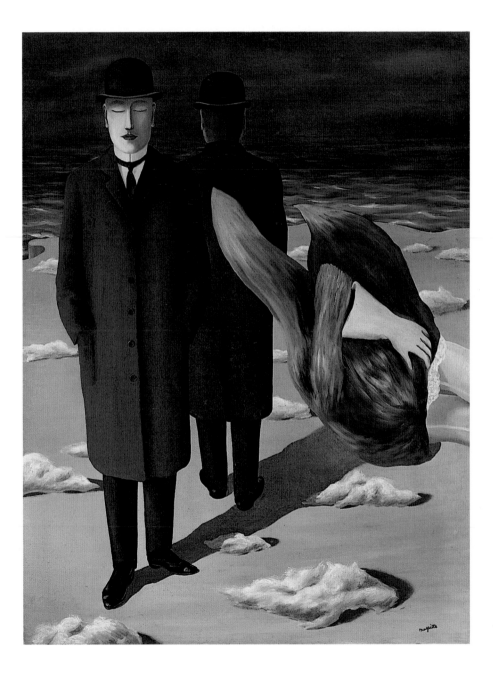

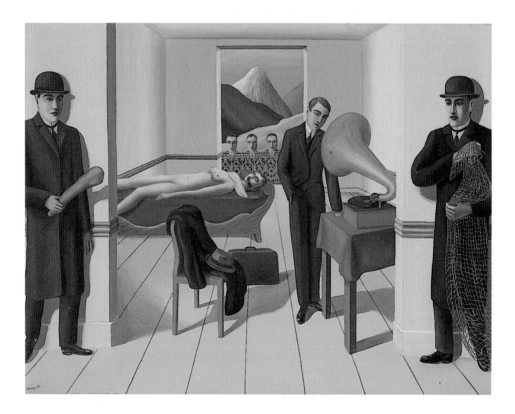

increasingly abstract works of Miró and the organic sculptures of Arp seemed to carry Constructivist echoes.

The definition of terms did bring Surrealism welcome allies, of whom the most important was the independent Belgian Surrealist group. They had first made contact in 1925 and taken common cause with the Parisians in *Revolution First and Always* (1925). This political commitment was not surprising as their main polemicist, Paul Nougé, was also a founder of the Belgian Communist Party. The relationship between poetic and political activity was less problematic for the Belgian Surrealists, partly because they chose to remain invisible in public for long periods. The poets rarely published their work. Instead they engineered, through their bourgeois jobs and appearance, a more insidious subversion of reality. They considered themselves more like conspirators than activists, and though they offered support to the vociferous Parisians they remained fiercely independent.

145
René Magritte,
The Menaced Assassin, 1926.
Oil on canvas;
150·4×195·2 cm,
59¼×76⅞ in.
Museum of Modern Art, New York

The Belgian Surrealist movement was officially formed in 1926 from two sets of friends. One centred on Nougé (a biochemist), Goemans (a civil servant) and Marcel Lecomte (a teacher). They had collaborated on *Correspondance*, which comprised single-page criticisms of the work of individual contemporary poets published fortnightly during 1924–6. Interestingly, Breton and Éluard were among their targets. The other nucleus was around E L T Mesens (a composer, collagist and poet) and René Magritte (144–146). After responding to abstraction, these two had attracted contributions from Picabia for their Dada periodical, *Marie*, before helping to constitute the Surrealist group. They were joined by the composer André Souris, and the writers Louis Scutenaire and Paul Collinet. As a group they were Surrealist by declaration and through their desire for a revolution of the mind as well as of society. Neither automatism nor trances held much interest. Instead, their approach was exemplified by the premeditation characteristic of Magritte's images which lay at the heart of their activities.

Magritte arrived at his perplexing imagery in 1925. He had shared his early abstraction and commercial work with the Constructivist

Victor Servranckx, eventually developing a cool illustrational realism using simplified forms. His encounter with de Chirico's *The Song of Love* (1914) revealed the unforeseen potential in mystery and evocation. His response to the sense of disjunctive narratives may be seen in *The Menaced Assassin* (145). The image, probably devised with suggestions from Nougé, is peculiar and straightforward: the assassin nonchalantly puts on a gramophone record beside the woman's naked corpse; a further twist being the waiting captors visible only to the viewer. As well as the threatening atmosphere of such de Chirico paintings as *Mystery and Melancholy of a Street* (1914), Magritte's points of reference were forms of popular entertainment not usually admitted to high art: the comic book, the covers of detective novels and detective films. The tensions employed in these narratives are complicated by the upsetting of expectations which became central to Magritte's visual investigations.

Both this subversion of the familiar and the Belgian Surrealists' characteristically oblique approach were typified in *Writings and Drawings by Mme Clarisse Juranville* (1927). Here Nougé and Magritte parodied a well-known nineteenth-century school grammar book, infiltrating their work under the cover of its anonymous style. Visually this had some parallels with Ernst's use of images from encyclopaedias and, in fact, Magritte was deeply impressed by his use of juxtaposition. However, the Belgians' work was all the more subversive because of the subtlety of its disguise. Nougé and Magritte offered their work in the place of accepted knowledge so as to take on its authority. This exchange lay at the heart of Magritte's mature images, in which the simple style carries into the world an image of paradox which undermines expectations and, eventually, poses philosophical questions about the nature of existence and of reality.

It is perhaps because of his anonymous pictorial style that Magritte found it difficult to be accepted, even by the Surrealists, during his period in Paris. His arrival in 1927 was inopportune

146
René
Magritte,
*The Treachery of
Images*, 1928.
Oil on canvas;
60×81 cm,
23⅝×31⅞ in.
Los Angeles
County
Museum of Art

in the prevailing trend favouring automatism, and Breton was circumspect, only recognizing the power of the work in the 1930s. Magritte's illustrated text 'Words and Images' appeared in *La Révolution surréaliste*, no. 12 (15 December 1929), and explored the gap between images, inscriptions and titles: 'An object never functions in the same way as its name or its image.' This concern determined the simplicity of his style, which could thus achieve such memorable clashes of images and 'blackboard' script, as in *The Treachery of Images* (146).

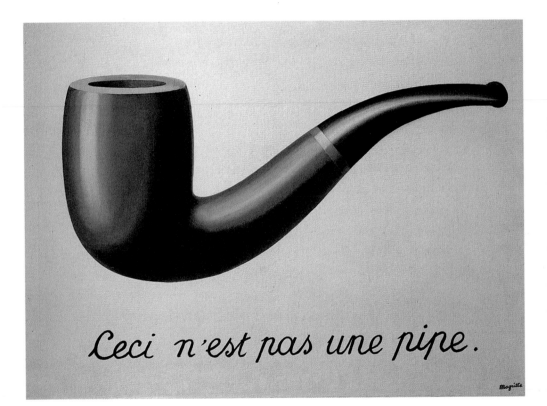

However, it is indicative of his reception in Paris that this was his only article, and that his major show of the period was held in Brussels in 1928, where it constituted a focus for local Surrealist activity. He returned home in 1930.

Goemans, who moved to Paris at about the same time as Magritte, was more successful. He opened a gallery that,

on the closure of the Galerie Surréaliste, became the movement's main outlet. However, Belgian activity remained largely confined to Brussels in pursuit of their independent course. This was evident in their support for de Chirico against the Parisians in 1928, and even in their collaboration with the Parisians in the special Surrealist issue of the local periodical *Variétés* in 1929. At that time, Nougé produced another disguised text, *Géographies*. For both wings of the movement this proved an important step towards a greater internationalism, which would embrace them both in the 1930s.

Breton was enthusiastic enough to place Magritte's painting of a female nude enclosed by 'Je ne vois pas la ... cachée dans la forêt' ('I do not see the ... hidden in the forest') at the centre of the concluding image of *La Révolution surréaliste* (no. 12). As the visual counterpart to the arrangement of portraits around Germaine Berton in the first issue, it showed the Parisian and Belgian members with closed eyes submitting themselves to the power of inner vision. The contrast between the political assassin and the elegant nude is indicative of a period of submission to the power of the female (eroticized) muse already expressed in Breton's *Nadja*.

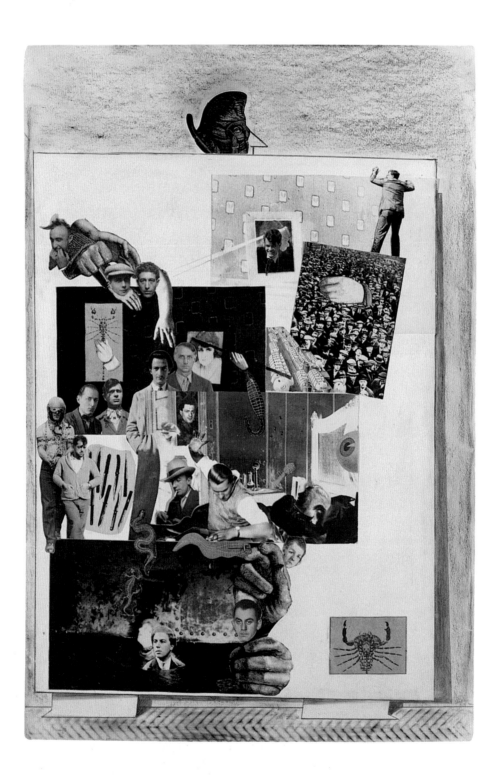

147
Max Ernst,
Loplop
Introduces
Members of the
Surrealist Group,
1931. Collage
of photographs,
pencil and
frottage;
50·1 x 33·6 cm,
19¾ x 13¼ in.
Museum of
Modern Art,
New York.
Upper part,
from left:
Yves Tanguy,
Louis Aragon,
Alberto
Giacometti,
René Crevel,
Georges Sadoul
(from behind
with raised
arms);
Centre, from
left: Luis Buñuel
(before
helmeted
figure),
Benjamin Péret,
Tristan Tzara,
Salvador Dalí,
Max Ernst,
Gala Éluard,
André Thirion
(below Ernst),
Paul Éluard,
René Char (arm
raised), Maxine
Alexandre;
Bottom:
André Breton,
Man Ray

The most urgent question facing Surrealism around 1930
concerned the movement's political commitment as the tension
between its artistic aims and the demands of official Stalinist
Communism became impossible to ignore. The political crisis
in Surrealism in 1926–7 was followed in 1929 by a series of
expulsions that severed links with some of its major writers
and culminated in the defections following the 'Aragon affair'
of 1932. Over the same period the recruitment of the painter
Salvador Dalí and film-maker Luis Buñuel, among others,
served to balance these rifts and to place greater emphasis
on visual activity (147). This process constituted a watershed,
at which the movement's purpose came under scrutiny,
and it is a measure of Breton's personal determination that
fragmentation did not bring total disintegration. It may
even be said that the successful negotiation of this crisis
secured Surrealism's survival into the 1940s and beyond.

On the wider political stage, the late 1920s was a period of
international calm that disguised widespread internal repression.
The Briand–Kellogg Pact (August 1928) was signed in Paris
to 'outlaw war as a solution of international controversies',
but authoritarianism was already resurgent throughout Europe.
In the Soviet Union, Leon Trotsky's anti-nationalist principle of
'permanent revolution' was eclipsed by Joseph Stalin's pragmatic
policy of 'socialism in one country'. The failure of the 1926
General Strike in Britain to become a revolution contributed to
the weakening of Trotsky's position, and in 1927 he was exiled.
Stalin consolidated his power through the Five Year Plan for
industrialization and the collectivization of agriculture instituted
in 1928–9. In Italy Fascism had repressed most opposition and
dictatorships existed in Portugal, Spain, Hungary and Yugoslavia.

The economic volatility of this period also had political consequences. In France, the power of the '200' banking and industrial families paralysed the leftist government and caused a run on the Franc until the return of the right-wing President Raymond Poincaré. More fundamentally, European gold reserves had dwindled through the repayment of American postwar loans. In conjunction with restrictive import controls, designed to protect American produce, it became impossible for European industries to gain the means for further repayments. Other contributing factors included the failure of farming in the 'dust bowl' of the American Midwest, but when New York investors panicked and lost an unprecedented $40 million in the catastrophic Wall Street Crash of October 1929 the effect as loans were called in plunged the world economy into the Depression. Central European nations were hit first, but Britain and France were also profoundly affected.

The international peace of the 1920s also began to look illusory in the face of the political rhetoric accompanying economic despair. Most profoundly disturbing was the meteoric rise of Adolf Hitler's National Socialist Party in Germany, which between 1930 and 1932 doubled its seats in the Reichstag to 230. The Socialists and Communists seemed powerless to halt the flow of support to the nationalist appeal of the Nazis, which was accompanied by violence, terrorism and anti-Semitism. In January 1933 Hitler became Chancellor with the help of right-wing politicians and industrialists. France reacted with understandable nervousness – as early as December 1929 funds were voted for the construction of the fortified Maginot Line in Alsace-Lorraine.

Louis Aragon described Surrealism's unity of purpose in the years covered by *La Révolution surréaliste* as 'une année mentale' (roughly 'a conceptual year'). The movement had successfully maintained a highly disruptive presence, savaging the complacency of an affluent France. Sex, religion and politics were addressed. By 1929 the poetic achievements of Surrealism were considerable, including Paul Éluard's *Capitale de la douler* (*Capital of Sorrows*,

148
Yves Tanguy,
Outside, 1929.
Oil on canvas;
118×91 cm,
46½ × 35⅞ in.
Scottish
National
Gallery of
Modern Art,
Edinburgh

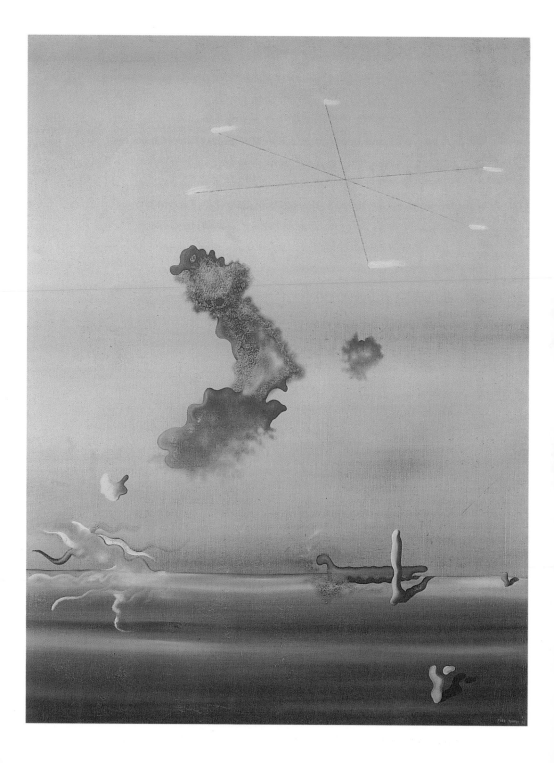

1926) and Robert Desnos's *La Liberté ou l'amour* (*Liberty or Love*, 1927). René Crevel's *Babylon* (1927) offered a curious narrative of bourgeois manners, while Breton's *Nadja* (1928) chronicled his affair with the eponymous heroine and was illustrated by Jacques-André Boiffard's photographs of city squares. Aragon's attack on literature, *Treatise on Style*, and Breton's *Surrealism and Painting* (both 1928) stood out among the theoretical texts. In the visual arts, Masson's sand paintings and Ernst's grattages offered a direct record of the 'inner model', while paintings by Miró and Tanguy (148) achieved floating dreamscapes. In addition to visionary photographs, Man Ray based his third film, *L'Etoile de mer* (*Starfish*, 1928), on a poem by Desnos, and avoided censorship of its nudity by coating the lens in a distorting gel – a suitable metaphor for convention.

Surrealism also became known through periodicals beyond the movement's immediate control. Of these Eugene Jolas's *transition* (1927–38) carried English translations and published *Hands off Love!* (the Surrealists' tract supporting Charlie Chaplin in his divorce) alongside the writing of Gertrude Stein, James Joyce and others whose linguistic experiments constituted what Jolas termed the 'revolution of the word'. Another periodical, *Le Grand Jeu*, brought together a younger generation of artists and writers, including René Daumal, Roger Gilbert-Lecomte, Maurice Henry and the Czech painter Josef Síma, who adapted Surrealism to their own independent purposes. Ribemont-Dessaignes's *Bifur* was a more orthodox literary periodical, but carried the first extracts of de Chirico's novel *Hebdomeros* in 1929. Aragon, who had attacked de Chirico's uninspired paintings of the 1920s, so admired this fictional entry into the marvellous that he suggested the amputation of de Chirico's painting hand so that he could concentrate on writing!

There was a further grey area of works that while loosely considered 'surreal' at the time were not recognized as such either by the movement or by later commentators. Once again, Jean Cocteau heads the list of tangential figures who used the

forms invented by Surrealism for fashionable entertainment. His film *Blood of a Poet* (1930) used devices employed in Man Ray's photographs for its famous animation of the 'marble' Venus played by Lee Miller. It explored the plunge into the subconscious – shown through the striking device of passing through a liquid mirror – but circumscribed it with a self-consciously poetic text. The result was indebted to Artaud's slightly earlier script for *The Seashell and the Clergyman* (1927), filmed by Germaine Dulac, a successful mainstream director. Although Artaud had denounced her lack of understanding, Dulac's involvement reflected the extent to which surrealistic ideas were being accepted. Other artists who gathered around Cocteau – for example, the Neo-Romantic painters Pavel Tchelitchev, Eugène Berman and Christian Bérard – have stood the test of time less well. Their immediately intelligible manipulations of figures were widely considered 'surreal', but although Surrealism undoubtedly contributed to the climate which allowed their work to be accepted they were rejected by Breton for their combination of Catholicism and homosexuality, realism and sentimentality.

This coincided with the first major crisis within the movement. It must be acknowledged that this was manufactured by Breton himself without foreseeing its consequences. His position as 'first among equals', reinforced by his charisma and an unswerving conviction in his interpretation of the movement's direction, gave rise to his title of 'Pope' of Surrealism, and he felt bound to expose those who strayed from his highly moral position. In February 1929, he and Aragon determined to test group commitment, and Surrealists and others in sympathy with the movement were sent a letter asking whether their activity should or should not be confined to their individual work, and to justify their position. A number of important figures did not reply, including Picabia, Duchamp, Ribemont-Dessaignes, Artaud, Vitrac and Naville, as well as those who had begun to follow different paths determined by their pre-Surrealist alliances, notably *L'Oeuf dur* and the rue Blomet group. An extraordinary general meeting was called for 11 March

and, on the basis of their written responses, the rue du Château group (Duhamel, Prévert and Tanguy), as well as Jacques Baron and Man Ray, were expelled because of 'their occupation or their character' (Man Ray and Tanguy were soon reprieved). The commitment to group activity was raised again, and Masson, Michel Leiris and Miró were among those opposed, while Ernst, Georges Malkine and the writer Joë Bosquet declared for pure Surrealist activity. The meeting broke up in disarray as the Surrealists rebuked the periodical *Le Grand Jeu* for its inclusion of religious references and compromises with commercialism (journalism and Artaud's Théâtre Alfred Jarry), which were deemed to indicate a lack of revolutionary resolve.

The March meeting confirmed the increasing remove of a number of important participants, and the antagonism between Surrealism and these dissidents or 'refugees' (as Breton called them) became more pronounced during 1929. This schism was sufficiently complete by the final issue (no. 12) of *La Révolution surréaliste* in December for Breton to launch a blistering attack on Leiris, Georges Limbour and Masson, to whom he added Boiffard, Baron and Desnos (whose defection was openly lamented). He took the opportunity to justify the earlier expulsion of Soupault (for allegedly planting Surrealist gossip in the press), to indicate the paradox of Naville's family wealth (which financed his Communist periodicals) and to revoke links to 'ancestors' such as Arthur Rimbaud, Charles Pierre Baudelaire and Edgar Allan Poe.

This forthright text was Breton's *Second Surrealist Manifesto*, which was published as a volume in 1930, following the republication of the original 1924 *Manifesto*. The *Second Manifesto* demonstrated the reassessment undertaken over the preceding years, and in the Preface to the 1946 edition Breton explained that it had belonged to a period in which 'a few unfettered souls began to perceive the imminent, ineluctable return of world catastrophe'. In response he had undertaken to re-establish Surrealism's fundamental principles. These were addressed in the opening paragraphs:

one must ultimately admit that, more than anything else, Surrealism attempted to provoke, from the intellectual and moral point of view, an attack of conscience of the most general and serious kind, and that the extent to which this was or was not accomplished alone can determine its historical success or failure.

Breton foresaw a reconciliation of opposites open to Surrealism:

Everything tends to make us believe that there exists a certain point of the mind at which life and death, the real and the imagined, past and future, the communicable and the incommunicable, high and low, cease to be perceived as contradictions. Now search as we may one will never find any other motivating force in the activities of the Surrealists than the hope of finding and fixing this point.

These goals are at once more urgent and more abstract than those of the first *Manifesto*. Automatism and dream accounts had been overtaken by Breton's reading of Karl Marx and Friedrich Hegel, reflecting the socio-political circumstances of late 1929. Exposing the abuse of France's motto, 'liberté, fraternité, égalité', he rallied to the total destruction of convention: 'every means must be worth trying in order to lay waste to the ideas of *family, country, religion*'. He also declared:

I do not believe in the present possibility of an art or literature which expresses the aspirations of the working class … because, in any pre-revolutionary period the writer or artist, who of necessity is a product of the bourgeoisie, is by definition incapable of translating these aspirations.

Despite this, the movement's commitment to Communism was another objective of the *Second Manifesto*. Indeed, the assault on many of the dissidents had been circumscribed by the fact that they had renounced Surrealism in order to gain acceptance into the Party. Breton linked his objections to an attack on Naville and Baron, 'whose moral qualities are at best subject to close scrutiny', and who 'thanks to the general confusion rampant within the revolutionary movement, manage to convey some vague impression that they are doing something'.

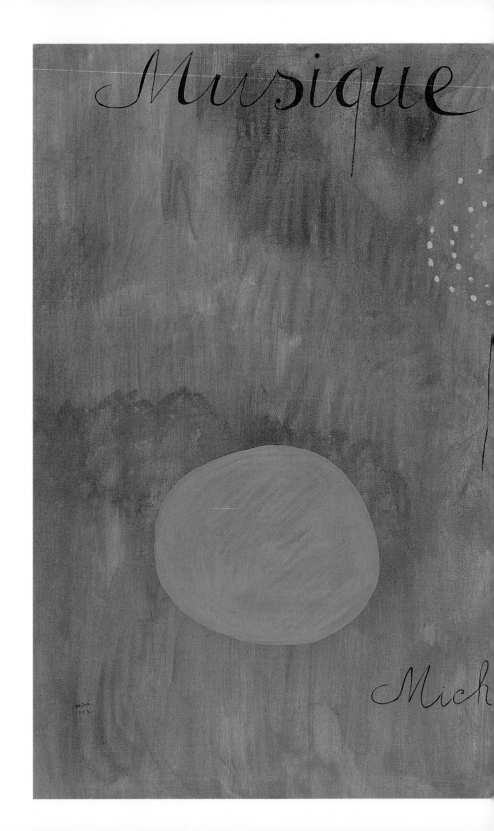

149
Joan Miró,
*Musique Seine,
Michel, Bataille
et moi*, 1927.
Oil on canvas;
79·5 × 100·5 cm,
31³⁄₈ × 39½ in.
Kunstmuseum
Winterthur

275 Rifts within Surrealism 1929–33

While such frankness was hardly likely to be well received by the Party, the first response came from the Surrealist 'dissidents' following the inclusion of the manifesto in *La Révolution surréaliste*. In their joint publication *Un Cadavre* they sought to bury Breton under equally cruel invective; Max Morise, Jacques Prévert and Raymond Queneau protested over the poet's divorce of Simone, while Leiris asserted that Breton had lived on the 'corpses' of Jacques Vaché, Nadja and Jacques Rigaut. The last had shot himself in November 1929, his death seeming a symbolic break with the last vestige of Dada rebellion. When publishing the *Second Manifesto* as a volume, Breton quoted the dissidents' attacks alongside their slightly earlier statements of personal support.

In this aggressive cut and thrust, Breton found time in the *Second Manifesto* to invite Tristan Tzara to join Surrealism, as one of the few producing 'really "situated" poetry'.

During years of individual activity, Tzara had combined provocation with a certain ease, facilitated by his marriage to the painter Greta Knutson, whose wealth financed the building of their Parisian house to designs by the architect Adolf Loos. Tzara had maintained links with Crevel and Aragon (through Nancy Cunard) until the shift in position between him and Breton was complete.

An underlying motive in the *Second Manifesto* was to combine theoretical debates with an intellectual power struggle in which Breton's new rival was the writer Georges Bataille. He had been a visitor to rue Blomet and his selection of '*Fatrasies*', medieval nonsense texts, had appeared in *La Révolution surréaliste*, no. 6, in March 1926. However, his 'obsessive' character made Breton wary, and even his associate Leiris recommended psychoanalysis on reading Bataille's *W.C.* (1927, destroyed unpublished), which the author himself described as 'violently opposed to all dignity'. He actively rejected what he saw as the aestheticism of Surrealism, colourfully refusing the invitation to the general meeting in March 1929 with the phrase 'Too many fucking idealists!' Instead, in his writing of pornography (especially *Story of the Eye* or *L'Histoire de l'oeil*, 1928) and erudite texts he established a theory of 'heterogeneous matter', which focused on the repulsive, linking it to ritual and the communal experience of mankind.

In early 1929 Bataille became an editor of the new cultural periodical *Documents*. Leiris and Limbour became collaborators, later being joined by Boiffard, Baron, Desnos, Masson and Miró – the general defection attacked in Breton's *Second Manifesto*. The work of the *Documents* contributors bore the imprint of a profound pessimism as they moved towards a psychologically informed investigation of society's motivating forces. This tendency, inspired by Lautréamont's reckless blackness, had been welling up for some time. Leiris combined it with an acceptance of contemporary phenomenological notions of existence (based upon the scrutiny of the subject's mental processes) in *Aurora* (1927–8), writing:

I have always found it more difficult than most to express myself other than by using the pronoun 'I' … for me this word 'I' epitomizes the structure of the world. It is only in relation to myself and because I deign to pay them some attention that things exist.

The rivalry between the two groups was soon reflected in the subject matter covered by _Documents_ and Breton's new periodical _Le Surréalisme au Service de la Révolution_ (_Surrealism in the Service of the Revolution_ or _SASDLR_) which associated itself with the

**151
Pablo
Picasso**,
_Nude in an
Armchair_, 1929.
Oil on canvas;
195 × 129,
76¾ × 50¾ in.
Musée Picasso,
Paris

aspirations of the Communist International. It carried Breton and Éluard's joint texts 'Immaculate Conception' (no. 2, 1930), which simulated neurotic and psychotic states through an accumulation of language. These texts, written in parallel over a matter of weeks, were evidence of the 'occultation of Surrealism' called for in the _Second Manifesto_. Further evidence came with articles such as Maurice Heine's consideration of the Marquis de Sade (no. 2, 1930) and Tzara's 'Essay on the Situation of Poetry' (no. 4, 1932).

For a time the tide was in favour of *Documents*. Of the rue Blomet painters, Miró retained an equivocal relationship with Surrealism, protected by his extended stays in Spain following his marriage. As early as 1927 he had celebrated his rue Blomet friendships in the veils of paint overlaid with cursive calligraphy of *Musique Seine, Michel, Bataille et moi (Music Seine, Michel, Bataille and Me; 149)*. In October 1929 he was the subject of an article by Leiris in *Documents*, which

152
Eli Lothar,
Abattoir,
photograph
published in
Documents
(November
1929)

followed a long appreciation of Masson by Carl Einstein in the May issue. Masson's break with Surrealism was an objection to its sycophancy; by his own account, he told Breton:

I can't stand the mimesis that goes on around you. I can't understand how someone who doesn't sleep with the same woman you do, who doesn't eat the same things, doesn't read the same books, can change from one day to the next about a certain person or event just because you do.

153
Jacques-
André
Boiffard,
Untitled (Big Toe),
photograph
published in
Documents,
(November
1929)

This situation brought an end to their collaboration, and in the *Second Manifesto* Masson was condemned for considering himself superior to Picasso. Both Picasso's work and that of Miró reflected the increasing violence of imagery associated with *Documents*. It was already found in Masson's *The Butcher of Horses* (150), in which he sought to capture a transformation in which man, animal and object merge. The livid contortion of Picasso's *Nude in an Armchair* (151) is often associated with the artist's disintegrating marriage, but the echoing pessimism of Masson and Miró provides a wider context. Picasso's new work was featured regularly in *Documents*, culminating in a whole issue (April 1930) which seemed to suggest the loss of the relationship nurtured by Breton.

During the course of its publication (1929–32), *Documents* provided a radical alternative to Bretonian Surrealism. Leiris and Limbour, whose interests lay in anthropology, studied other cultures to investigate latent forces within 'civilization'. This contrasted with Surrealism's relatively superficial interest in non-European artefacts. Above all, a socio-political radicalism was evident in the astonishing texts on apparently incidental subjects which constituted *Documents'* Dictionary. Leiris wrote on the unreliable nature of language (eg 'Metaphor', June 1929), paralleling Magritte's concerns. Bataille's contributions focused on the evidence of

man's literal and metaphorical rise from the animal. His analysis of the attraction and horror of the eye in *Documents* (September 1929) was published alongside Leiris's 'Civilization', and in 'Soleil pourri' ('Putrified sun', *Documents*, April 1930) he linked Picasso's fascination for the bull fight, Mithraic rituals and primitive sun worship. A note resulting from a visit to the Parisian slaughter-houses at La Villette (November 1929) exposed the suppressed element of ritual, made explicit in Eli Lothar's unflinching photographs (152). Increasingly, Bataille relied on the potency of photography to complement his texts. Perhaps most bizarre was his article 'The Big Toe' (November 1929), which was illustrated by Boiffard's disturbing close-ups (153). The text traced the role of the toe from balance – 'a firm foundation to the erection of which man is so proud' – to the foot-binding of the Chinese and foot-fetishism in seventeenth-century Spain. The presence of sexuality and its denial allowed Bataille to read the treatment of the toe as embodying man's attempt to distance himself from his base instincts. 'The meaning of this article',

154
André Masson,
Massacre, 1931.
Oil on canvas;
120×160 cm,
47¼×63 in.
Galerie Louise
Leiris, Paris

155 Left
Max Ernst,
Figure, 1927.
Frottage;
27 × 21 cm,
10½ × 8¼ in.
Kettle's Yard,
Cambridge

156 Right
Max Ernst,
*The Hundred-
headed Woman
Opens Her
August Sleeve*,
1929. Collage;
32·7 × 16·9 cm,
12⅞ × 6⅜ in.
Menil
Collection,
Houston

he concluded, 'lies in its insistence on a direct and explicit questioning of *seductiveness*, without taking into account poetic concoctions that are, ultimately, nothing but a diversion.'

This combination of anthropology and sexuality found echoes in Masson's urgent line drawings and oil paintings. In the *Massacre* (154) his recurring figures and animals took on an explicitly brutal and sexual rage. This violence is characteristically – and most disturbingly – done mercilessly to women, unmasking the frigidity of classical subjects. It also reflected the politically motivated atrocities of the period, which would be highlighted by the outbreak of the Spanish Civil War at the end of Masson's extended stay in Andalucia in 1934–6.

la femme 100 têtes ouvre sa manche auguste

Such controversial and shocking work tended to overshadow Surrealism proper. Beside its charged eroticism, the dialectical musings of Breton's *Nadja* seemed tame, and his *Second Manifesto* was a tacit acceptance of the challenge embodied in *Documents*. More important in ensuring Surrealism's longevity, however, was his faith in group activity and the necessity of political commitment in a time of totalitarianism. Furthermore, there was an eventual realization that the two groups were not mutually exclusive: the focus of discussion in *Documents* on archaeology, anthropology and sexuality in contemporary society expanded the pursuits opened up from an essentially Surrealist standpoint. Whether or not Breton personally found them distasteful, they enriched the movement in areas which it would subsequently make its own. Even Bataille realized the importance of this exchange, describing himself as 'Surrealism's old enemy from within'.

With all the defections and withdrawals, Ernst remained the major 'official' Surrealist artist. In 1927 he eloped with the under-age Marie-Berthe Aurenche, an event curiously mirrored in Crevel's contemporary *Babylon*, for which Ernst made frottage illustrations. Their elegant eroticism is seen in *Figure* (155), which created the effect of lace from chair caning. For publication, Man Ray made negative prints of the frottages by exposing them as Rayograms. The result brought a ghost-like quality to the images.

The propensity for marvellous narratives was carried a step further in Ernst's invention of the 'collage novel'. This reversed the relationship between illustration and text, as the narrative was essentially visual with only minimal commentary. For the cycle *The Hundred-headed Woman* (*La femme 100 têtes*; 156) he returned to his earlier technique of collaging engravings, and his use of photographic reproduction again ensured seamlessness. He transformed melodramatic nineteenth-century illustrations into entanglements of often surreal violence, sexuality and, above all, humour. The form proved so rich that he made two further volumes, *A Little Girl Dreams of Taking the Veil* (*Le Rêve d'une petite fille qui voulut entrer au Carmel*, 1930) and *A Week of*

Kindness (Une Semaine de bonté, 1933), inventing some of the most arresting images to emerge from Surrealism. These encapsulated Ernst's differences from Masson's method based on automatism; although their themes were surprisingly close, the popular source material allowed Ernst to expose disturbances repressed by bourgeois society.

The primacy of Surrealist collage in subverting expectations was explored by Aragon in *La Peinture au défi* (*A Challenge to Painting*, 1930), an extended introduction to an exhibition at the Galerie Goemans. Tracing its use to the Cubism of Picasso and Braque, he identified it as the medium in which all Surrealist artists had made crucial personal explorations. Arp, Duchamp and Picabia were discussed alongside the recent cloth-and-nail guitars of Picasso, Miró's collages and Ernst's collage novels. Recognizing their power, Aragon adapted Isidore Ducasse, claiming 'The marvellous should be made by all.'

157
Salvador Dalí
and **Luis
Buñuel**, A still
from the film
*Un Chien
andalou* (1929)

**158
Salvador
Dalí,**
Little Cinders,
1927.
Oil on panel;
64 × 48 cm,
25⅛ × 18⅞ in.
Museo
Nacional
Centro de Arte
Reina Sofía,
Madrid

Surrealist activities of the early 1930s were epitomized by the movement's new self-declared genius: Salvador Dalí. With the film *Un Chien andalou* ('An Andalusian Dog', 1929), made with Luis Buñuel, he burst upon the Parisian avant-garde seemingly without warning. His arrival flavoured much of the movement's activity over the following years, so much so that in the public domain his name has become almost synonymous with Surrealism. In this respect, he was undoubtedly the most important of the new recruits following the purge of 1929, even though these included Alberto Giacometti and the writers and activists René Char, Georges Sadoul, André Thirion and Georges Hugnet.

Un Chien andalou was self-consciously avant-garde. It capitalized on the potential offered by film for the manipulation of reality to create a dream-like logic. Dalí and Buñuel were well versed

in Surrealist art and theory through such channels as the Catalan periodical *L'Amic de les Arts*, and the technical expertise came from Buñuel's experience as an assistant to the film director Jean Epstein. Buñuel stressed the power of montage, which he called the 'golden key' of cinema and which reflected his enthusiasm for the revolutionary films of Serge Eisenstein. He used the technique to fade between unrelated subjects – a hairy armpit and a sea urchin – so bringing together their visual rhyme to produce a deeper suggestiveness. The impact of *Un Chien andalou* derived from such shock tactics. The prologue showed Buñuel standing on a balcony at night with a girl. As a thin cloud passed across the moon he cut her eye in half with a razor (although a cow's eye was used, Buñuel was sick for a week!). The action had Freudian associations of Oedipal wounding and may be interpreted as a renunciation of reality for a world of inner 'vision' offered by film. Dalí's fixation with putrefaction – evident in the gritty decay in paintings such as *Bird* (1928) – led to the equally notorious scene of the hero attempting to drag across a room a piano laden with rotting donkeys and dead priests (157); this appeared symbolic of the weight of conventions. Perhaps most important was the overall effect of the non-sequential scenario, which Buñuel declared 'anti-plastic and anti-artistic'. The dream-like result remains difficult to grasp and repays repeated viewings, although it lasts only seventeen minutes.

As students, Dalí and Buñuel belonged to a rebellious circle in Madrid that included the poet Federico García Lorca and the painter Maria Mallo. Buñuel abandoned Zoology for film, while Dalí was expelled from Madrid Academy because of his disdain for authority. This disguised his serious experiments with modernism, the results of which were acclaimed by J V Foix of *L'Amic de les Arts* when they were included in Dalí's 1925 show at Galeries Dalmau in Barcelona. After reading Freud, Dalí made knowing use of psychoanalytical methods and symbols, evident in such paintings as *Little Cinders* (158), so that his approach became effectively Surrealist. He was not alone among artists in Barcelona

in moving between the influences of Ernst, de Chirico and Tanguy; Mallo was also producing automatic drawings, while Artur Carbonell adopted the mysterious perspectives of de Chirico.

In his writing for *L'Amic de les Arts*, Dalí blended theory and bizarre lyricism, which traced an increasing proximity to Surrealism. In an appreciation of Miró he wrote (no. 26, June 1928):

Joan Miró's paintings lead us, by a path of automatism and surreality, to appreciate and show approximately reality itself, while thus corroborating André Breton's thought, according to which surreality could be contained in reality and vice versa.

159
Salvador Dalí,
The Lugubrious Game, 1929.
Oil and collage on card;
44·5 × 30 cm,
17½ × 12 in.
Private collection

For Dalí, as for others, Miró's work represented the apogee of local Catalan achievement within the Parisian avant-garde. However, Dalí concentrated on balancing such automatism with an 'automatism of an instant' available through photography. In this he saw the potential for combining reality and transformation in just the way later explored in *Un Chien andalou*. In texts such as 'Photography

pure creation of the mind' (*L'Amic de les Arts*, no. 18, September 1927), he proposed photography as the dominant mode of automatism and set a goal for his oil painting as 'hand-painted photographs'.

If the violent anti-nationalism of his contribution to *Catalan Anti-artistic Manifesto* (1928), also known as the *Yellow Manifesto* – written with Lluis Montanyà and Sebatià Gasch – ostracized Dalí from his Barcelona audience, he was soon caught unwittingly between 'official' Surrealism and the *Documents* group. He was visited at his home in Cadaques by the Éluards, the Magrittes and Goemans in 1929, who were immediately impressed by the power and invention of his paintings. Only Dalí's hysterical behaviour and his apparently 'coprophagic' (literally 'dung-eating') tendencies worried the visitors. He claimed that this state facilitated progress on his canvas *The Lugubrious Game* (159), and his nervous excitement was exacerbated by his sudden love for Gala Éluard. When she left Éluard for him, Dalí poured his energies into his astonishing Parisian début at the Galerie Goemans in November. *The Lugubrious Game* was a central exhibit, displaying Dalí's combination of impressive technique and personal imagery. Fears of father figures and anxieties about impotence were made manifest in the shame-faced figures, softly swollen extremities and accumulated fantasies. Dalí knew his Freudian symbols and exploited them.

When Bataille saw *The Lugubrious Game* at the exhibition he recognized concerns with putrefaction, death and fetishized sex which were close to those explored in *Documents*. He produced one of the first investigations of Dalí's anxious imagery, observing that 'the genesis of emasculation and the contradictory reactions it carries with it are translated with an extraordinary wealth of detail and power of expression'. However, Dalí opted to join Breton's movement, withdrawing rights of reproduction from *Documents* and instead reproducing *The Illuminated Pleasures* (1929) and *The Accommodations of Desires* (160) in *La Révolution surréaliste* (no. 12). This move

reflected his long theoretical engagement with Surrealism, and his concerns with eroticism and decay were combined with his achievement of 'hand-painted photography' evident in these works. To the movement he promised an injection of new ideas.

While Dalí's presence would have a long-term effect, it was the joint achievement with Buñuel of *Un Chien andalou* that proved immediate. It established a potential for film that was taken up in the next two years. Jean Cocteau's *Blood of a Poet* and Buñuel's *L'Age d'or* ('The Golden Age'), both financed by the Vicomte de Noailles in 1930, were the most notable attempts. *L'Age d'or* was much longer than *Un Chien andalou*, technically more sophisticated (one of the first French sound films) and politically polemical. The narrative structure centred on a love forbidden by convention – a Surrealist 'mad love' ('amour fou'). This allowed Buñuel to attack family, politics (the father figure literally attracts flies) and religion, all of which were overthrown in a destructive frenzy when a plough, a giraffe and a bishop are thrown from a bedroom window. Sexuality received its release with the heroine notoriously sucking the toe of a statue, but it was the placement of a religious reliquary on the ground so that an elegant lady could get out of her car which caused a furore. It brought an assault on the Parisian cinema where it was showing by the right-wing League of Patriots and Anti-Jewish League in which canvases in the accompanying Surrealist exhibition were slashed. It says much for the political situation that the authorities withdrew the film's certificate and destroyed all available copies (in fact one or two copies survived). By comparison, *Blood of a Poet* was well received by fashionable society.

If the films associated with Surrealism returned the movement to the limelight, Dalí's contributions altered its relationship with the public. His technical skill was immediately appreciable even to those hostile to his imagery. Although his illusionistic forms owed a greater debt to Tanguy (148) than he acknowledged, Dalí's success also brought a more sustained appreciation of his colleague's work. Similarly, Magritte's rising fortunes

160
Salvador
Dalí,
*The Accommo-
dations of
Desires*, 1929.
Oil on panel;
22 × 35 cm,
8⅝ × 13¾ in.
Private
collection

Dada & Surrealism

within Surrealism in the 1930s can be associated with Dalí's championing of the illusionistic trend. More particularly, through his writings and paintings, Dalí began to promote certain theoretical positions which would briefly hold sway over the movement. The most personal of these was the 'paranoiac-critical method', by which he proposed an objectification of the sort of illusions experienced by paranoids. Already in his 1928 article on Miró, Dalí had explored the possibility of seeing an object in a heightened way. The 'paranoiac-critical method' clarified the approach; in the article 'L'Ane pourri' ('The Putrefied Donkey', *SASDLR*, no. 1) he predicted: 'I believe that the moment is near when, by a process of paranoiac character and activity of thought, it will be possible (simultaneously with automatism and other passive states) to systematize confusion and to contribute towards the total discrediting of the world of reality.'

As evidence, Dalí made such paintings as *The Invisible Sleeping Woman, Horse, Lion, etc.* (161). Depending on which details the observer concentrates on, different objects appear which

are simultaneously present in the painting. **No single image is dominant, so that any notion of its 'reality' is discredited. Perhaps most compelling was a found postcard of an African hut in which Dalí had recognized the simultaneous presence of a Cubist head. The image needed little modification, although such transformations in his paintings were heavily dependent on his virtuoso technique and recalled seventeenth-century Dutch masters whom he greatly admired. That such paintings were immensely laborious to produce but easily dismissed as puzzles may explain their limited number. They did attract the attention of the psychoanalyst Jacques Lacan, who, after publishing his thesis,** *On Paranoiac Psychosis in its Relations with Personality* **(1932), consulted Dalí and became involved with the movement.**

Despite its practical drawbacks the 'paranoiac-critical method' underpinned much of Dalí's subsequent work and, for a time, was a focus for Surrealist activity. Connections may be discerned with Breton and Éluard's poetic simulation of mental states in 'Immaculate Conception' (collected as a volume in 1930). The titles of the divisions had been decided in advance and one part, 'Attempted Simulation of Interpretative Delirium', began:

When that love was done with, I was left like a bird on a branch. I was no longer any use for anything. Nevertheless I observed that the patches of oil on the water reflected my image and I noticed that the Pont du Change, which has the bird market next to it, was becoming more and more curved.

As with automatic texts, it was the poetic rather than the clinical potential of such states that concerned the collaborators.

The common ground between Dalí's 'method' and the poets' 'simulations' disguised a fundamental difference. It was already present in two phrases in 'The Putrefied Donkey'. In calling automatism a 'passive state', Dalí began to claim an 'active' role for the 'paranoiac-critical method' and, by extension, for the power of pictorial illusionism. He simply ignored the debate that had fostered automatism in Surrealist painting, favouring an inducement of the image over its mere recording.

**161
Salvador
Dalí,**
*The Invisible
Sleeping
Woman, Horse,
Lion, etc.,* 1930.
Oil on canvas;
50·2 × 65·2 cm,
19³⁄₄ × 25⅝ in.
Musée National
d'Art Moderne,
Centre
Georges
Pompidou,
Paris

This position is linked to his 'total discrediting of the world of reality', which was quite distinct from the 'fixing' of the point at which 'the real and the imagined ... cease to be perceived as contradictions', foreseen in the *Second Manifesto*. Where Breton had committed the movement to its dialectical reconciliation with the rational, Dalí sought to uphold the irrational. Breton was, however, accommodating in response to this difference, perhaps because Dalí's position was initially defensible under the 'total occultation of Surrealism'.

Certainly, the exposure of the irrational was championed by Dalí in the early 1930s. The theory he developed around the 'symbolically functioning object' and the more general idea of the Surrealist object became his most widely influential. The first objects by Dalí, Gala and Valentine Hugo (162) illustrated his article 'Surrealist Objects' in *SASDLR*, no. 3 (1931). They played on images brought together by juxtaposition, echoing

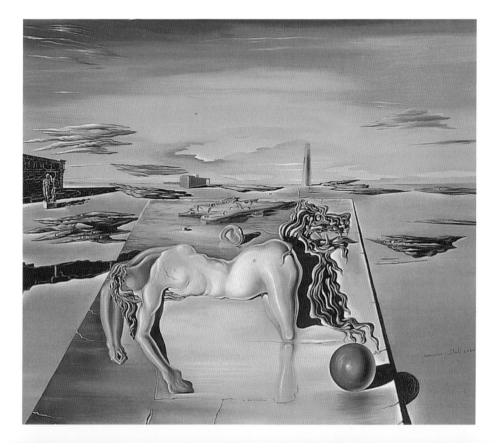

Lautréamont's 'sewing machine and an umbrella on an operating table'. However, the private 'symbolic function' of the assemblies led to an impenetrable complexity; in Dalí's hands this often had a fetishistic aspect. This elaboration was soon abandoned, as it failed to match the simple power of the sources.

These sources were as surprising as they were various. The paintings of de Chirico featured inexplicable elements assuming a threatening irresistibility (41). Tanguy had developed a quite different depiction of unreal objects, squashy or stony in their lumpiness, and the modifications of reality proffered by Magritte and Dalí were different again. Outside the canvas real objects also proved provocative. In L'Amour fou (1937), Breton was to describe the 'objective chance' that led him to discover, in a flea market, a wooden spoon whose handle took the form of a shoe. Not only did the arched handle echo the instep but also the object answered an existing obsession for the poet. Dalí similarly explored chance creations, which he called 'involuntary sculptures', in twisted bus tickets and ends of soap in an article illuminated by Brassaï's photographs (Minotaure, nos 3–4, 1933). While both were associated with the important idea of the release of the irrational into everyday life – already practised by obsessives – Dalí also linked this to the writhing forms of Art Nouveau. These two strands were unexpectedly united in the Surrealists' appreciation of architecture, an art form which up to that point had hardly concerned them. On the one hand, the epitome of obsessive creativity was discovered in the work of the French Postman, le Facteur Cheval, who collected oddly smoothed stones on his daily postal round from which he constructed the marvellous Palais Idéal (1879–1912) in his back garden. On the other hand, Dalí championed the extraordinary inventiveness of Antoni Gaudí, the Barcelona architect of the unfinished church of the Sagrada Familia and the playful Parc Güell.

If there was poetic and artistic inspiration for the Surrealist object, the defining influence came from the sculpture of Alberto Giacometti. After Dalí and Buñuel, Giacometti was the most

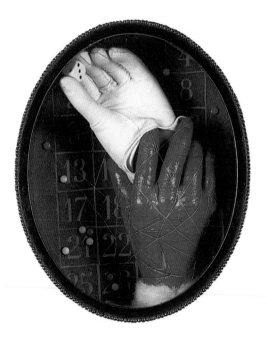

162
**Valentine
Hugo**,
Object, 1931.
Assemblage.
h.32·5 cm,
12¾ in.
Private
collection

important artistic recruit to Surrealism at this time, joining the movement in 1931 after flirting with the *Documents* group. His friendship with Breton was intense, and he was a witness at the poet's marriage to Jacqueline Lamba. Giacometti's impressively charged sculptures, such as *Spoon-Woman* (1926), were developed independently of Surrealism but explored related ideas of sexuality and the dream world.

Giacometti came from an important Swiss artistic family; his uncle Augusto had exhibited his abstract works with the Zurich Dadas (44). Alberto himself introduced psychological qualities into a personal Cubism soon after coming into contact with Arp in Paris. They both explored the suggestive potential of the organic in sculpture. Arp was close to Ernst and Miró, and maintained links with former Dadas and others outside the Surrealist movement. He considered his biomorphic sculptural forms to be 'concrete' works – independent creations rather than abstractions from other entities. As works such as *Head with Annoying Objects* (163) demonstrate, these formal and theoretical propositions did not blunt Arp's quirky humour.

Where Arp maintained a judicious distance from Bretonian orthodoxy, Giacometti was more committed. His organic, occasionally fragile, pieces reflected the inspiration of dreams. *Suspended Ball* (164) was closely associated with the invention of the Surrealist object because of Dalí and Breton's enthusiasm for it. In common with other works, it included moving parts that compelled the participation of the observer and provoked deep-seated fantasies akin to those in dreams. The suspension of the slotted ball over the wedge invited a sliding movement that was deliberately unsatisfactory and unsettling in a way which the Surrealists recognized as implicitly sexual. The delicacy of related works, such as *The Hour of Traces*, evokes the ineffable quality of dream.

In one sense Giacometti's sculptures were antagonistic to the idea of the Surrealist object; their relatively orthodox materials confirmed their position within a Western sculptural tradition. Even his *Disagreeable Object* (165), which could be presented any way up, was carved (though by a craftsman rather than the artist himself). The Surrealist object deliberately broke with this orthodoxy, as the use of heterogeneous materials allowed it to enter into and provoke questions about reality. The peculiarity of many of the objects defied categorization either as functional or artistic pieces. As such they had much in common with the Dada objects of the early 1920s made by Ernst and Man Ray (116).

Like the collage and the *cadavre exquis*, the Surrealist object was democratic – it could be made by anyone. Objects collected by the mentally ill were exhibited (122), and the Surrealist poets participated with Breton introducing words to make the 'poème–objet' (172). It is indicative of the prevailing current that this was one of the unorthodox media in which women were allowed a voice. Indeed, the quintessential Surrealist object must be Meret Oppenheim's sexually charged *Fur Covered Tea Cup, Saucer and Spoon* (see frontispiece). As so often before there were exceptions and exclusions: Breton was never happy with the balance between formalism and chance achieved by

163
Hans Arp,
Head with Annoying Objects,
1930–2.
Plaster;
37×29·5×19 cm,
14½×11½×7½ in.
Kunstmuseum, Silkeborg

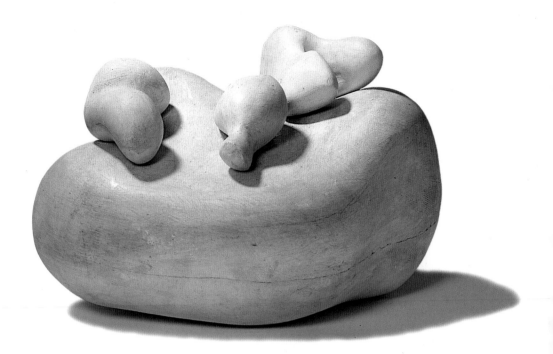

Schwitters, whose work might otherwise seem to embody the requirements of the Surrealist object.

There was no doubting the fertile nature of Dalí's contribution to Surrealism, but his ability to attract attention was not universally acceptable. There was in the painter more than a little of the fashionable dandy (a tendency the Surrealists so vilified in Cocteau). Further evidence was provided by the popularity of his work with the Vicomte de Noailles, who gathered a circle of collectors to support the painter by each buying one painting a year. Although Man Ray's photography brought him into contact with similar society figures, Dalí's position soon began to betray the signs of compromise that were anathema to Surrealists.

The opposing position to Dalí's promotion of Surrealist art was Aragon's championing of political commitment. Although there was no direct conflict, they sought to steer the movement in different directions, and the culmination of this period of schisms came in 1932 with Aragon's withdrawal from Surrealism in

favour of the Communist Party. It is a measure of the profundity of his crisis that this was the solution despite his crucial partnership with Breton. Aragon up to this point had defended Surrealism against all comers; that he left when its fortunes seemed relatively secure may suggest some motives in the otherwise murky details of the 'Aragon affair'.

The catalyst for Aragon's departure was his visit with Georges Sadoul, as official representatives of Surrealism, to the Conference of International Revolutionary Writers at Kharkov in the USSR in late 1930. They were accompanied by Elsa Triolet, the Russian writer who later became Aragon's wife. The Conference highlighted for them a perceived incompatibility between Surrealist activity and official Communism.

Both Breton and Aragon had been shaken by the suicide of the Russian Futurist poet Vladimir Mayakovsky in April 1930. He had been the epitome of the poet–activist, a revolutionary whose 'agit-prop' posters had mobilized support and who had collaborated with some of the great Constructivists. His combination of lyricism and propaganda offered an example to those preparing direct action, and through his words the struggle of the new proletarian nation took on a truly heroic status. This was made more enticing by his romanticism, embodied by his legendary love for Lili Brik, which contributed to his suicide. After his death, Breton wrote a long text entitled 'The Ship of Love has Foundered in the Stream of Life' (*SASDLR*, no. 1), adapting a phrase in Mayakovsky's farewell note, which was published in full. When a French Communist proclaimed that no sane man would commit suicide in the ideal surroundings of the USSR, Aragon went to his house to punch his nose.

Admiration for Mayakovsky chimed with Aragon's move towards the Party in France, and his involvement with Triolet gave him particular authority, as she was Brik's sister and opened up for him the poet's intimate circle. As he sought to reconcile his commitments to writing and politics, he came to embody Surrealism's difficulties over these conflicts. At Kharkov,

however, Aragon and Sadoul found themselves alongside official
Communist delegates from France. The disapproval was mutual,
but Surrealism's independence put them at a disadvantage.
They also found themselves signing the official communiqué which
condemned the psychoanalysis of Freud, Trotskyism and idealism
– all key constituents of Surrealist theory. On their return to Paris
they pleaded duress, and Aragon has subsequently been widely
criticized for this acquiescence (although he might more
justifiably be criticized for going to such a Stalinist conference

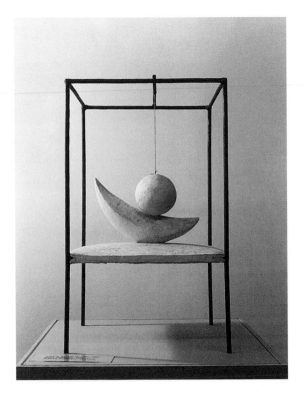

in the first place). It may be said in his defence that, once there,
to have objected to such a statement would have required a
degree of self-importance perhaps only possible for Breton and
would have burnt all bridges between the movement and the
Party. The result was the opposite, providing just the sort of
unequivocal statement that those concerned with Surrealism
within the Party had been seeking for a long time.

The trip had a lasting effect on Aragon. If he was impressed by the progress towards equality in the Soviet Union, he was appalled by the rise of Nazism witnessed on passing through Germany. The September 1930 elections saw Nazi gains despite fervid and imaginative campaigning by artists; John Heartfield tethered two sheep to the Brandenburg Gate bearing a poster inscribed, 'We are voting National Socialist'. Although it is not clear whether Aragon met Heartfield that year, he must have been aware of his photomontages on left-wing magazines and book-covers published by Wieland Herzfelde's Malik Verlag (166). In 1935, Aragon would observe that Heartfield's work constituted a visual equivalent for Mayakovsky's writing and the means required to sell the message of Communism.

165
Alberto
Giacometti,
*Disagreeable
Object*, 1932.
Wood;
h.22 cm,
8⅝ in.
Scottish
National
Gallery of
Modern Art,
Edinburgh

These examples of direct action provided the context for Aragon's move to the Party. He responded to the political climate beyond Parisian Surrealism, acknowledging the crisis in Germany and the apparent solution in the USSR. That it was not a decision taken lightly is confirmed in the long withdrawal during 1931–2, as he tried to shift the movement nearer to the activism he envisaged. The breaking-point came when he was prosecuted for his self-consciously Mayakovskian propaganda poem *Red Front* (1932) because of its exhortation 'Kill the Cops!' Breton defended Aragon, declaring that a poet was no more responsible for the sentiments of a poem than for the content of his dreams. However, in declaring his dislike of *Red Front* itself, he betrayed the fact that he would rather not have had to make the statement. Furthermore, Breton's criticisms of the Party made Aragon unable to sanction the Surrealists' support without jeopardizing his own position. He was forced to choose and, in 1932, chose politics. Interestingly, his abandonment of Surrealism was not unsupported. Sadoul, Pierre Unik and Buñuel shared his move to the Party; all were aware that, for them, the pursuit of the dream had to be set aside for the demands of reality. This was summed up in the difference between the satire of *L'Age d'or* and Buñuel's documentary film of poverty and inbreeding, *Los Hurdes: Land without Bread* (1932).

Aragon embodied the political difficulties of Surrealism in 1931–2, just as Pierre Naville had done in 1926–7. The fact that Surrealism was unable to accommodate his move partly reflected the diversion that Dalí provided, which during the 1930s reinforced the fantastic and dream-based poetics of the movement. Had Surrealism followed Aragon's lead, it would have been dissipated within the mediocrity of official Communist culture; in 1937, he had to defend Stalinist Socialist Realism in terms of the French tradition. In the debate raised by the 'Aragon affair', Breton held the course of Surrealism steady. He foresaw the dangers to the movement in submitting to politicians and – although also momentarily blinded by Dalí's brilliance – he understood that if this meant breaking with his oldest ally, it was a break that he, too, was able to make.

166
John Heartfield,
Millions Stand Behind Me!
Cover of
Arbeiter Illustrierte Zeitung (16 October 1932);
Photomontage;
38 × 27 cm,
15 × 10⅝ in.
Akademie der Kunst, Berlin

The positions established by Dalí and Aragon represented
a polarization within the Surrealist movement in the 1930s.
A gap opened between the commitment to political activism
and the commercially successful face of Surrealism, ensuring
that an integration of politics and art of the type promised
in the 'heroic' 1920s was never achieved. While the political
identity adopted for the movement by Breton robbed it
of effective influence, artistic activity increased appreciably
through new recruits.

At the same time, the polarized politics of the 1930s made the
dictatorships in Italy, Germany and the Soviet Union curiously
indistinguishable. Each concentrated power at the centre in
a party hierarchy which regimented the activities of the general
populace. In return for unquestioning acceptance came
– for some, in the good years – fundamental improvements
in standards of living: mass housing, cheap staple foods, power
and transport. The same concerns were common to all European
states through the pressure of an expanding and demanding
population whose fears were redoubled with the Depression.
While the dictators fought unemployment by having marshes
drained, roads and railways built, democratic governments
struggled to introduce welfare measures in an atmosphere
of industrial discontent. Intransigent bosses (in an employer's
market) clashed with increasingly effective workers' unions;
hunger marches and strikes secured safer conditions, although
the French General Strike of 1933 – like its British predecessor
– was nearly transformed into a violent revolution. Such unrest
found echoes in European colonies. While Mahatma Gandhi
concentrated Indian aspirations for independence in passive
resistance, violence by Communist separatists in French Indo-
China resulted in repressions and executions by the authorities.

167
Lee Miller,
*Nude (Bent
Forward),* 1934.
J Levy
Collection,
Art Institute of
Chicago

War spiralled closer. It was underway in the distant Japanese invasion of China, which took most of the decade. In 1935, the Italians invaded Abyssinia, virtually unopposed by the League of Nations. The following year, Germany remilitarized the Rhineland as part of the Nazis' defiance of the Paris Peace treaties. Lacking the political will to oppose either Mussolini or Hitler, the French and British sought reassurance in increasing their own defence spending. The eruption of the Spanish Civil War in 1936 seemed bound to draw in outside powers, but instead became one of the defining moral and political conflicts of the decade. Artists, writers, political activists and theorists formed an International Brigade; some fought for democracy, most for the liberal ideal of the expression of the will of the people and, in the presence of Italian and German weaponry, against the advance of Fascism. The reluctance of Western governments to commit to the conflict for fear of escalation seemed simply to delay the inevitable. The fall of the Republican government in early 1939 proved to be the prelude to the wider conflict.

The Surrealists negotiated this cultural and political minefield with considerable integrity. Although they lacked the direct activism open to Aragon, Naville and others committed to the Communist Party, they were able to avoid the hypocrisies of official policy. This became especially acute when the Soviet–French Stalin–Laval Pact on a governmental level bypassed the local Party, requiring of its ideologically opposed supporters an unforeseen reconciliation. The price of the Surrealists' independence was high. In 1935 Breton, Éluard and others were expelled from the Party for their continuing refusal to countenance a proletarian art based on 'Socialist Realism'. Three years later, Breton completed a long-incubated political shift by going to Mexico to meet the exiled Trotsky. The gesture served as an acknowledgement of a marginal position beyond mainstream Communism. For some this was too ineffective; finding themselves powerless at the time of the Munich Agreement (1938) and under the German Occupation, both Éluard and Tzara later followed Aragon into the Party.

The changing nature of Surrealism in the 1930s was reflected in the fate of the movement's explicitly ideological periodical *SASDLR*. This proved a financial burden, and its sixth and final issue appeared in May 1933. A replacement was offered in the shape of Albert Skira's new periodical *Minotaure* (1934–9) which had enviably high standards of production. However, *Minotaure* involved two compromises: first, although Breton, Éluard, Crevel, Dalí and Tzara joined the advisory board, Skira also brought in the 'dissidents' Bataille, Masson and Leiris; second, it was aimed at a fashionable and wealthy readership to whom Bretonian Surrealism remained largely unknown. While these readers, therefore, were spared Surrealist politics (which, in any case, Bataille's group did not share in detail), the opulence of the periodical also necessitated the coverage of artists well outside the Surrealist domain, even if, like Matisse and Derain, they were admired. *Minotaure* thus represented a necessary compromise for the Surrealists, but one which they had some success in moulding to their own standards.

Whatever problems the movement faced, the 1930s continued to bring waves of new recruits, not least among women artists and writers. Women had remained almost totally invisible within Surrealism up to then, allotted the roles of companions or inspirational 'muses'. This revealed a profound contradiction between the sexual liberation explored as part of the liberation of the mind and the marginalization of women. The group debates published as 'Investigation of Sexuality' (*La Révolution surréaliste*, no. 11, 15 March 1928), together with further unpublished sessions up to 1932, explored suppressed issues: sexual preferences, fetishism, prostitution. Many of the views expressed were conventional (Breton refused to discuss homosexuality), but the debate was otherwise frank, and the underlying concern was a dialectic between material observation (the evidence of sex) and idealism (the idea of love). However, women were almost totally absent from these discussions (as Aragon was the first to remark), just as they were in the movement's wider activity.

The impression that the women associated with the Surrealists were content not to assert their presence seems to be belied by a consideration of three: Simone Kahn Breton, Gala Éluard and Nancy Cunard. Letters between the Bretons carried a consistent discussion of Surrealist painting, and show Simone's role in collecting and in mounting exhibitions which continued even after their divorce in 1928. That Gala was also active in promoting artists (notably her lovers Ernst and Dalí) suggests that both women were confined to their public position by the men. Nancy Cunard, Aragon's long-time companion, avoided this submissiveness, investing her wealth and dynamism in projects from Aragon's translation of Lewis Carroll's *The Hunting of the Snark* (*La Chasse du Snark*, 1931), which she typeset, to her politically sensitive *Negro Anthology* (1934). Perhaps because of this independence, she remained outside the core of the movement.

In the face of these abilities, the confinement of women to the role of passive muses must be considered one of the greatest theoretical and personal failings of Surrealism in the 1920s. The related political failure was the absence of Surrealist support for the campaign in France demanding votes for women in the interwar period. Some recent commentators have seen in this a cynical acceptance of the anti-clericalism of the state, as it was predicted that devout women would vote for the Catholic parties abhorred by the movement. Other critics have linked the absence of a political voice for women to their 'objectification' in Surrealist images.

Despite this situation, the group around Breton attracted more active women from 1930. The reasons for allying with Surrealism differed with each individual. The majority came through personal relationships, but a community of aims and artistic radicalism added to the attraction even if some, such as the painter of the sexuality charged illusionistic works Leonor Fini, remained on the fringes. There was greater openness as a result of the influence and appreciation of the painter Valentine Hugo and of Jacqueline Lamba, who became Breton's second wife

168
Man Ray,
Facile, 1935.
Collection
Lucien Treillard,
Paris

in 1934. Furthermore, it has been noted by the art historian Dawn Ades that women made their impact in new media – photography, the *cadavre exquis* and the Surrealist object – which were beyond the domination of the men. Both Gala and Hugo were among the earliest object makers, and, before her divorce from Breton, Kahn Breton had contributed to the invention of the *cadavre exquis*. The former circus performer Nusch (who married Éluard in 1934) made photomontages and participated in group debates.

Among the younger women the most dynamic were Lee Miller and Meret Oppenheim. Both posed for Man Ray's photographs but made the crucial transition from model to artist. In this respect the photographs taken of them by men may be contrasted with the elegantly back-lit nudes of Nusch used to illustrate Éluard's book of love poems *Facile* (168); her public exposure suggested that she was seen as a male possession. Man Ray's photographs of Miller carry the same possessiveness, but were made in parallel with her own photographic experiments. Her part in the discovery of solarization has been noted, and some of the prints attributed to Man Ray can now be reascribed to her. Furthermore, his tendency to use Miller's body as an abstracted arena of form was an approach which also appeared in her own work (167). The body is 'objectified' and often eroticized, but in so doing both photographers demonstrated the potential for the medium to transform the recognizable into the 'marvellous'.

Meret Oppenheim also achieved a balance between model and artist. Man Ray's early photographs of her posed nude with an etching press eroticized the machine, but Oppenheim's assured presence indicated her ability to manipulate the image and the result. She came from an intellectual and artistic Swiss family and was introduced into the Surrealist milieu by Alberto Giacometti. She became notorious for the objects she made, using the discarded world of nineteenth-century morality as raw material for subversion. In the trussed-up shoes of *My Governess* (169), contrasting images of mutual dependence and

169
Meret
Oppenheim,
My Governess,
1936. Object;
14 × 21 × 33 cm,
5½ × 8¼ × 13 in.
Moderna
Museet,
Stockholm

disguised perversions are suggested. Equally memorable was the *Fur Covered Tea Cup, Saucer and Spoon* (see frontispiece) that extended the concept of her fur-covered costume jewellery to everyday items. The transformation epitomizes the creative potential in the juxtaposition of unrelated objects. To Breton the sexuality of the fur vessel seemed specifically Freudian and he drew upon the title of Édouard Manet's notorious *Déjeuner sur l'herbe* (1863), a work that had included a naked model surrounded by clothed men, to give an essentially male interpretation of the work, entitling it 'Déjeuner en fourure' (literally 'luncheon in fur'). Breton's reading ignored other possibilities, such as the contradictions presented by the object on a practical level, as well as the suggested transformation of a familiar object into an animal. While women Surrealists did not overcome the subjugation of women found in their male counterparts' work, especially in the Sadean violence of André Masson's paintings (154), they did utilize the liberation offered by the movement to express alternative views. Their efforts did much to transform Surrealism in the 1930s.

Photography remained a central means for the seizure of the surreal, and it became important both to the contribution of women to the movement and to its wider diffusion. Man Ray's elegant language of transformation was extended by Berenice Abbott as well as Miller. They earned their living through fashion photography for *Vogue* and *Harper's Bazaar*, which introduced their combination of 'classically' unblemished outline and surrealizing style to a wider public. Independent photographers such as Maurice Tabard, who made particular use of the overlaying of figures and doubling of exposures, the Hungarians Brassaï and André Kertesz, and the Anglo-German Bill Brandt were also in the orbit of Surrealism. Brandt and Brassaï became renowned for elongating and inflating images of the female body in distorting lenses. This work is more open to accusations of objectifying but, at the same time, it was also part of a wider investigation of the relationship between individuality and reality. The medium was particularly well equipped for this as shown

by Brassaï's photographs of hats for an article by Tristan Tzara in *Minotaure* which exposed their latent sexual symbolism.

More challenging work documented areas in which the marvellous overlapped with the Sadean. Jacques-André Boiffard adopted a quasi-scientific objectivity in his photographs for *Documents* (153), but this contrasted with the intense emotion generated by his subjects. His images of men in carnival masks are disconcerting, those of women in leather masks deeply

170
Hans Bellmer,
The Doll,
1936–49.
Hand-tinted photograph.
Musée National d'Art Moderne,
Centre Georges Pompidou,
Paris

sinister. His work again invites criticism of the unbridling of the male imagination that it represents, but perhaps equally disturbing were the realistic paintings of Balthus (Balthazar Klossowski), who, though only loosely associated with Surrealism, was featured in *Minotaure*. His *Guitar Lesson* (1934) featured vindictive and partially clad pubescent girls. Such suggestiveness was easily overtaken by the weird and, to many, distressing

works of Hans Bellmer, who joined the Surrealists in 1936. His immersion in an all-encompassing world rivalled that of Dalí, but where the Catalan's egocentricity made his work autobiographical and sensationalist, Bellmer worked in isolation on variations of *The Doll* (170), which was the focus of his obsessions. The result exposed an explicit combination of sexuality and manipulation, and the fact that his models were so evidently pre-pubescent and sexually complicit in their construction still remains shocking. That Bellmer did not shrink from these implications is suggested in the livid flesh tones with which he tinted the photographs. They blur distinctions between the perversely personal and fetishistic perversion, and yet they also raise questions of the male gaze and the 'objectification' of the female body. Bellmer's was not an ironic or proto-feminist critique of accepted images of women, but he was aware that his work of transgression only extended many conventional images.

It is perhaps suitable to contrast these imposed views of the female body with the recently rediscovered photographic self-portraits of Claude Cahun (171). Like Miller and Oppenheim, Cahun took control of her own image, bringing about a protean variety of mysterious self-transformations for the camera. On a

171
Claude Cahun,
Untitled (Self-portrait with Whitened Face), c.1929. San Francisco Museum of Modern Art

A l'intersection des lignes de force invisibles
Trouver
Le point de chant vers quoi les arbres se font la courte
échelle
L'épine de silence
Qui veut que le saigneur des navires livre au vent son
hamac de chiens bleus André Breton 12-1-35.

172
André
Breton,
Poem-Object (I
See, I Imagine),
1935.
Assemblage;
15 × 24 cm,
6 × 9½ in.
Scottish
National
Gallery of
Modern Art,
Edinburgh

private scale, her theatricality was comparable with Dalí's and suggests the attraction of Surrealism for some women artists. It offered a curious blend of the ascetic and the luxuriant, of rigour and abandon, group and individual expression but, above all, represented a rejection of established values.

The production of objects was another fruitful area of Surrealist exploration. It had the advantage of equality, as little technical skill was required. Of the earliest examples only perhaps Hugo's enlaced gloves on part of a roulette cloth (162) – with their obvious suggestion of the 'game' of sex – was comparable with Oppenheim's objects. The use of items of clothing may also be seen as a comment on the constriction of women by convention. Cahun too used the unsettling effect of fibrous materials to cover a ball supported by a hand and painted with an eye, entitled *The Marseillaise is a Revolutionary Song* (1936). This and Oppenheim's *Fur Covered Tea Cup, Saucer and Spoon* appeared in the exhibition of Surrealist objects at the Galerie Charles Ratton in May 1936. They were placed alongside a variety of objects

made by Man Ray, Ernst, Miró; sculptures by Tanguy and Giacometti (164); and masks from the Pacific Islands and North America continued the integration of Surrealism and 'tribal' art.

There were other influential contributions to the 1936 exhibition. Of particular importance was Breton's invention of the hybrid 'poème-objet', of which the most successful achieved a fertile play between word and image comparable with Magritte's paintings (172). Dalí took his cue from the collections of items by the insane, some of which were also exhibited. His *Aphrodisiac Jacket* (1936) had glasses attached filled with crème de menthe, while his porcelain *Retrospective Bust* (1933) included an ink-well fixed to a loaf of bread balanced on a woman's head (173). The ink-well was modelled on the figures in Jean-François Millet's *Angelus* of 1858–9 (a painting which particularly haunted Dalí for what he saw as its latent sexuality); the loaf had to be remade in plaster after Picasso's dog ate it at the exhibition opening. The inclusion of Cubist metal guitars by Picasso must have particularly pleased Breton. In 1932–3 the painter had experienced an unprecedented crisis, abandoning painting for eighteen months in response to his parallel relationships with his wife Olga and his young mistress Marie-Thérèse Walther. Friendship with Éluard led Picasso to a period of intense automatic writing by which he returned to a more stable working pattern. Breton welcomed this show of solidarity, and Picasso maintained a position roughly parallel to Surrealism. Another special contribution to the 1936 exhibition was that of Duchamp's readymades. Despite his dedication to chess, he retained links with his artistic friends, and over the next decade contributed by organizing and installing Surrealist exhibitions.

The Galerie Ratton exhibition was the high point of Surrealist object production. It showed both the potential for group activity and how the insertion into reality of quite modest pieces could provide a route to the marvellous. With a number of exceptions, the production of objects waned with the diminishing influence of Dalí within the movement. Having unleashed the painter's

173
Salvador Dalí,
Retrospective Bust, 1933. Plaster, metal, baguette (replaced); h.72 cm, 28³⁄₈ in. M Nellens, Knokke-le-Zoute

talent for self-publicity, Breton found Surrealist positions
undermined by his individuality, and Dalí's unwillingness
to treat politics with due seriousness became counter-productive.
The critical moment came with his painting *The Enigma of
William Tell* (1933), which created a scandal because of the
clear presence of Lenin's face on the distorted and partially
naked body. Called to defend himself, Dalí pleaded illness and
answered his cross-examination with a thermometer in his
mouth! His position was indefensible in the light of the European
political situation, and the case against him – because he was
publicly identified with Surrealism – stronger than any previous
accusation. He was officially expelled; although some
collaborations continued until the end of the decade.

The enthusiastic production of Surrealist objects in the early 1930s
– and the upsurge in internationalism – coincided with the first
considerations of Dada as a historical movement. Georges Hugnet,
who joined Breton's group in 1932, wrote a series of articles on
Dada for *Cahiers d'Art*. Breton had misgivings about this renewed
interest – perhaps because he feared the upsurge of old rivalries
– and particularly disapproved of the text Hugnet supplied
for Alfred Barr's *Fantastic Art, Dada, Surrealism* for the Museum
of Modern Art in New York (1936). At the same moment,
in Germany, where it was less subsumed by Surrealism,
Dada featured in more theoretical texts. Recognizing their
'relentless destruction of the aura of their creations',
the philosopher Walter Benjamin considered Dada within the
wider scope of his important essay on art, film and technology:
'The Work of Art in the Age of Mechanical Reproduction' (1936).

While the Surrealists had long been enthusiastic about other
cultures, the echo found in Tokyo was perhaps the least
predictable international response to the movement.
Japanese intellectuals visiting Europe in the 1920s had absorbed
the prospect of the irrational epitomized by the poetry of
Rimbaud, Lautréamont and their heirs. In the context of the
militaristic and authoritarian empire (engaged in the ferocious

invasion of China throughout the 1930s), the protest in such works was implicitly linked to political opposition and proved an especially brave course of action.

In the late 1920s the poet Junzaburō Nishiwaki introduced translations of Éluard, Aragon and Breton to Tokyo through the periodicals *Ishō no taiyō* (The Dressed Sun) and *Shi to shiron* (Poetry and the Poetic). As a professor of poetry trained at the University of Oxford, Nishiwaki tended to see Surrealism in a critical and historical perspective beyond that approved by the movement itself. The poet Shūzō Takigushi translated Breton's *Surrealism and Painting* in 1930, and the painter Koga Harue, who was only familiar with European developments through illustrations, put his illusionism at the service of an art of juxtapositions. Paintings such as *Bird Cage* (174) are comparable with the contemporary styles of Pierre Roy, Dalí and Magritte. The crucial contact came with the exhibition of the Paris–Tokyo Federation of Avant-garde Artists which toured Japan in 1932. With Salmon and Breton as selectors, it placed major Surrealists (Tanguy, Ernst, Masson, Miró, Man Ray) alongside Picasso, Picabia, Amédée Ozenfant and Jean Lurçat.

Following the exhibition, Takigushi and Chiruo Yamanaka began to correspond with Breton and Éluard and to co-ordinate activities in Tokyo, and their translations constituted an important anthology of French Surrealist writing, *Surrealist Exchange* (1936). The impetus among artists was blunted by the deaths of Harue and his fellow painter Kōtarō Migishi in 1933 and 1934 respectively, but others, such as Seiji Tōgō, made important contributions. In 1937 the Exhibition of Surrealist Works from Abroad was organized by Takigushi and Yamanaka with the help of Éluard, Hugnet and others, but local Surrealist painters were rather passed over.

Few in Europe had direct contact with Tokyo, but the interest in Surrealism there exemplified the movement's internationalization. Attitudes to this had been anticipated in the 1929 Surrealist map of the world (175), in which Oceania was emphasized over Europe, and Paris located in Germany. While this was evidence of

174
Koga Harue,
Bird Cage, 1929.
Oil on canvas;
111·2 × 145 cm,
43⁷⁄₈ × 57�⅛ in.
Ishibashi
Museum of Art,
Kurume

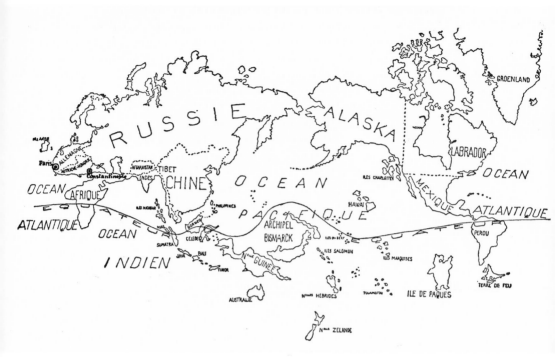

Surrealists turning out towards the world, it was hardly
surprising that the most fruitful responses would be found in
Europe itself.

Paris remained a magnet for artists and writers from across
the continent as intolerant totalitarian regimes forced a migration
of increasing urgency in the 1930s. Hitler's propagandizing of the
'decadence' of modernism – linked by some to his own youthful
failure to get into art school – drove avant-garde experiment
in Germany from the public arena. The Bauhaus was closed
in 1933 and books by leading writers – from Thomas Mann
to Freud – publicly burnt. Paintings by modernists, including
Ernst, Schwitters, Picasso and Kandinsky, were confiscated
from museums and shown in the deliberately derisory Entartete
Kunst (Degenerate Art) exhibitions in 1937–8. That this struck
a cord is confirmed by the 2,009,899 visitors to the Munich leg
of the show alone. Just as in World War I, avant-garde culture
was a soft target for those suppressing all freedom of expression;
its rejection on grounds of racial and mental purity presaged

the terrible persecutions of the concentration camps and the
Holocaust. As this climate grew more intolerant and intolerable,
those German-based artists who were able escaped.

For some, Surrealism beckoned. It provided a focus of cultural
debate for the rejection of Fascism, while at the same time lying
outside the rhetoric of Stalinism. These qualities were not unique,
but they help to explain the influx of new members from
all corners of the continent. This immeasurably enriched
a movement whose artists were already predominantly from
outside France. The power of Dalí's style and juxtapositions
provided a route for the Swiss painter Kurt Seligmann,

**177
Victor
Brauner**,
*The Strange
Case of
Monsieur K*,
1934.
Oil on canvas;
81 × 100 cm,
31⅞ × 39⅜ in.
Private
collection

who adopted a dream-like illusionism in place of his earlier Constructivism (176). German artists such as Bellmer and Richard Oelze also favoured illusionism. The allegiance of another important painter, Wolfgang Paalen, came more through the impact of Ernst. Paalen invented the automatic technique 'fumage', in which smoke was blown across paper to produce amorphous forms from which images emerged. He achieved similar effects in oil paintings that drew on the dark forests of German folklore. Far from the sanitized and heroized vision of the country in Nazi imagery, Paalen showed it as part of a suppressed and violent national myth.

Two Romanians also joined the Parisian movement in the 1930s. The sculptor Jacques Hérold was an assistant to Constantin Brancusi, and through his friendship with Tanguy his own works crossed over from Brancusi's reductivist form to embrace the dream. His compatriot Victor Brauner emerged as one of the most important of this new wave of Surrealist painters. He had been in touch with Marcel Janco's circle in Bucharest and moved to Paris in 1925. There he assumed a naive style that allowed him a satirical and political distance; *The Strange Case of Monsieur K* (177) evoked Franz Kafka's hero Josef K and seems to comment on the transformations undertaken by politicians. So convinced was Brauner of a premonition that he would lose the use of his right eye, that he painted a *Self-portrait* (1931) featuring his eye cut in a way reminiscent of the beginning of *Un Chien andalou*. In 1938 he intervened in an argument and was struck in that eye with a glass, which had exactly the effect anticipated. The works made after this disaster constituted his mature style. Using flat colours and dry techniques (tempera and encaustic), he created a hieratic world of magical figures associated with his immersion in the Tarot.

As artists fleeing from repressive regimes sought out Surrealism in Paris, those elsewhere established their own Surrealist groups. For Breton and his co-founders, Surrealism was inevitably Parisian; they had maintained a tightly co-ordinated programme and had

not sought an evangelizing role. Thus Benjamin Péret spent several years in Rio de Janeiro without establishing a parallel group. This unspoken attitude was questioned by the independent Belgian Surrealist group, and by Marco Ristitch founding a Belgrade group in 1929, which produced the periodical *L'Impossible* before being suppressed by the royalist dictatorship which banned all links with Communism. Despite this failure, the development of other groups constituted a network that could be dubbed the Surrealist International. The political and economic situation did not favour travel, but Surrealism maintained contacts at a time when others were being closed by political bigotry.

The Surrealist group in Prague around Vítězslav Nezval and Karel Teige was especially vibrant. Its proximity to Berlin and Vienna made Prague a centre for opposition to Nazism, and Heartfield and Herzfelde established themselves there. It has been seen as the most important Surrealist centre after Paris, and it served as a conduit for Surrealist activities elsewhere in central Europe. Of fundamental importance was the fact

**178
Jindřich
Styrský,**
Untitled
maquette from
'Emilie Comes
to Me in a
Dream', 1933.
Collage: gelatin
silver print,
halftone
cut-outs;
21 x 17·8 cm,
8¼ x 7 in.
Ubu Gallery,
New York

that those who formed the Surrealist group in Prague had already worked together over an extended period. It emerged directly from Devĕtsil, the group founded by Teige in 1920 which had explored the possibilities opened up between Dada and Constructivism. Teige balanced a lyrical 'Poetism' and a machinist Constructivism in a series of manifestos and periodicals. His approach was strongly influenced by the revolutionary art of the new Soviet Union and the arrival in Prague of the Structuralist theorist Roman Jacobson, a colleague of Vladimir Mayakovsky,

179
Toyen,
*Prometheus
Enchained*,
1934.
Oil on canvas;
145×97 cm,
57⅛×38¼ in.
Private
collection

brought a new rigour. Jacobson introduced the theories of Moscow Structuralists, which rejected any outside reference or knowledge in approaching the absolute structure of a work of literature.

In the mid-1920s Teige had attracted several important allies to Devĕtsil, including Nezval and the painter Josef Síma, who immediately moved to Paris. The artists Jindřich Styřský and Toyen also contributed to the group's early anti-art tendency. During three years in Paris from 1927, when they were in contact with the fringes of Surrealism, the couple devised a lyrical

abstraction called 'Artificialism' which had factors in common with the automatism of Masson. When Styřský became chief designer for Devěstil's Liberated Theatre (Osvobozené Divadlo) in 1930, the couple returned to Prague. The theatrical company favoured plays by the forerunners and by some members of the Surrealist movement, and this literary impetus, supported by the critical writings of Teige, brought the two movements together. The public point of contact was the 1932 Devětsil-sponsored exhibition Poetry 32. This placed work by Giacometti, Ernst, Arp, Dalí, Miró and Masson alongside that of Styřský, Toyen and others, and effectively recognized a convergence. Styřský brought increasing realism to his work, which reflected his interest in dreams (178), while Toyen's muffled 'figure in the forest' of *Prometheus Enchained* (179) anticipated the suggestive imagery of Oppenheim's *Fur-covered Tea Cup, Saucer and Spoon*. Their willingness to analyse dream imagery and develop the work from it showed their subtle difference from the Parisian ideal of the automatically recorded image.

Teige, who was an acute observer and interpreter of European culture, was understandably wary of Parisian Surrealism. As a result it was Nezval, whose writings reflected a surrealizing 'Poetism', who (together with the theatre director Jindřich Honzl) negotiated with Breton in Paris and launched the Surrealist Group in Prague on 21 March 1934. Styřský and Toyen were among those supporting the move, and Teige joined soon after. The alliance was formalized in March 1935 by a lecture tour that brought Éluard, André and Jacqueline Breton to Prague, accompanied by Síma. Nezval had prepared for this by translating Breton's *Les Vases communicants* (*Communicating Vessels*, 1932) and *Nadja* over the intervening year. In response, in the lecture 'The Surrealist Situation of the Object' delivered in Prague on 29 March, Breton called the city 'the magical capital of old Europe'. He also recognized, somewhat belatedly, the international expansion of the movement of which 'a nucleus has already been formed or is in the process of being formed in each country'. For the Parisians, the foundation of the Prague group initiated

an expansion that sought to reaffirm their central aims more than to embrace new adherents or ideas.

The lecture series was an important platform for bringing Surrealist theory to a new audience. Breton quoted Hegel's *Poetics* in 'The Surrealist Situation of the Object', agreeing that 'art and poetry deliberately create a world of shadows, of phantoms, of fictitious likenesses, and yet for all that they cannot be accused of being powerless'. The undermining of rational perceptions of the object in the wake of the production of the Surrealist object relied heavily on Dalí's theories, and on an array of examples taken from 'ancestors' such as Alfred Jarry and Apollinaire as well as Surrealists such as Éluard and Péret. Breton used the opportunity of his second lecture given to the Leftist Front to discuss 'The Political Position of Today's Art'. With a powerful polarity he aligned the Surrealists' investigations with contemporary social realities:

On the one hand the reinforcement of the mechanism of oppression based on the family, religion, and the fatherland, the recognition of a necessity of man to enslave man, the careful underhanded exploitation of the urgent need to transform society for the sole profit of a financial and industrial oligarchy, the need also to silence the great isolated appeals through which the person who up to now has been intellectually privileged manages, sometimes after a long space of time, to rouse his fellow countrymen from their apathy, the whole mechanism of stagnation, of regression, and of wearing down: this is night. On the other hand the destruction of social barriers, the hatred of all servitude (the defence of liberty is never servitude), the prospect of man's right truly to dispose of himself – with all profit to the workers, the assiduous attention to grasping the whole process of dissatisfaction, of moving rapidly forward, of youth, so as to grant it the greatest possible right to grasp the entire range of human demands, from whatever angle it presents itself: this is day.

In establishing this polarity he rehearsed some of the arguments familiar from the preceding years of dispute. Perhaps as clearly as in any other passage he proclaimed, with an eye to the recent difficulties raised by Aragon's defection:

There are still a great many of us in the world who think that putting poetry and art in the exclusive service of any idea, however much that idea moves us to enthusiasm by itself, would be to condemn them in a very short time to being immobilized, and amount to sidetracking them.

The operative word here was 'exclusive'. Again Breton laid claim to the intellectual freedom viewed so suspiciously by the French Communist Party. The implication was that the audience was included in this demand and that the Prague Surrealist group would remain independent but 'of the left'. However, the relationship between the avant-garde and the Party was considerably more co-operative in Czechoslovakia. Breton must have envied the freedom of Teige to edit an official Communist journal in which he regularly discussed Surrealism. Only in 1937–8 did this symbiosis finally disintegrate amid factional splits within Czech Surrealism itself.

However well argued, Breton's political independence on the left must have seemed even more isolated when pronounced within the portentous situation in central Europe in 1935. Moreover, the Parisians' finances had precluded them from bringing paintings with them, and they had already missed the related exhibition of work by Styřský, Toyen and the sculptor Vincenc Makovský. This rather unsatisfactory situation was redressed by the publication of the first *International Bulletin of Surrealism*. Bilingual and with contributions from Breton, Éluard and Nezval, the *Bulletin* became a means by which the leaders of the Parisian movement publicly acknowledged and collaborated with the growing number of satellite Surrealist groups.

Some three months after the lecture tour, the conjunction of Parisian and Prague artists was achieved in the unlikely setting of Santa Cruz de Tenerife, where the Bretons arrived for a make-shift honeymoon, accompanied by Péret and seventy works for an international Surrealist exhibition. The Canary Islands had also seen the development of a sympathetic group around the periodical *La Gaceta de Arte* (1932–6) edited by Eduardo Westerdahl, who had been inspired by the impact made by

Surrealism in Spain through the poetry of Federico García Lorca, Juan Larrea and Rafael Alberti. Together with Domingo López Torres, Augustin Espinosa and Domingo Pérez Minik, he began to produce explicitly pro-Surrealist material in *La Gaceta de Arte* and to make contact with Breton, Éluard and Tzara. In 1934 more regular contact was established when the Tenerife painter Oscar Dominguez joined the Parisian movement. At first he was mesmerized by Dalí's fantastic visions and dream imagery rendered with careful illusionism characterized his work. However, Dalí's waning reputation and ambiguous political interest in Hitler directly affected Dominguez, who looked instead to the resurgent Surrealist interest in automatism. This had acquired new relevance in the mid-1930s because of its politically defiant combination of the release of the individual through techniques open to all, and one of Dominguez's most important contributions was the development of a technique dubbed 'decalcomania' (180), announced by Breton in *Cahiers d'Art* in 1936. The procedure involved the squeezing of thick paint between two sheets of paper to reveal, when prised apart, an unpredictable (but usually symmetrical) pattern. Like frottage, the result acted as a 'provocation' for imagery, which was then drawn out by the artist.

180
Oscar
Dominguez,
Decalcomania
without
Preconceived
Object I, 1936.
Gouache;
35·9 × 29·2 cm,
14⅛ × 11½ in.
Museum of
Modern Art,
New York

Dominguez served as the vital link between Parisian Surrealism and *La Gaceta de Arte* in 1934–5. The arrival of the Bretons and Péret on Tenerife for the 1935 exhibition, and the publication of the second bilingual *International Bulletin of Surrealism* in October, set the seal on the alliance. Momentous though these events were for the participants, they did not have the impact felt in Prague. Perhaps Surrealism was too abstruse for the local audience and the Canary Islands too distant from other sympathizers; Westerdahl and Minik are said to have spent the following fifteen years paying off the debt incurred in holding the exhibition.

Catalan pro-Surrealist activities had to a certain extent given the lead to the Tenerife group. Despite the fact that by 1932 two of the most important promoters of the avant-garde

in Barcelona – *Les Amics de Arts* and the Galerie Dalmau – had closed, a new group, ADLAN (Amics de l'Art Nou or Friends of the New Art), was established to fill this gap. A Surrealist flavour was evident through the participation of Dalí, Miró and Artur Carbonell, who were joined by Maria Mallo, Angel Planells and the three sculptors, Ramon Marinel-lo, Jaume Sans and Eudald Serra, who showed together in 1935. With the exception of Miró and Carbonell, a preoccupation with illusionistic spaces signalled the pervasive influence of Dalí. As with other groupings outside Paris, the ADLAN artists were accommodating towards other sectors of the avant-garde. This ensured ADLAN's official recognition from the Catalan government.

It may be the ambiguities of this official status that kept a distance between ADLAN and Bretonian Surrealism, despite their overlapping concerns. ADLAN organized exhibitions of toys and 'Objects of bad taste' (1934), drawings of children and of the insane (1935). Arp, Man Ray and the American sculptor Alexander Calder had exhibitions under its auspices and two exhibitions in 1936 provided the opportunity to bring the groups together. An exhibition of Picasso's work of 1909–25 created such controversy that Miró, Dalí and the sculptor Julio González joined the organizer Luis Fernández in its public defence; it attracted 8,000 visitors. Picasso's affinities with Surrealism were underlined by readings of his poems and by a lecture given by Éluard. The Barcelona group followed it with the Logicofobista ('Logic-phobiaist') exhibition (May 1936). This was a declaration of identity by those like Carbonell, Mallo, Marinel-lo and Planells who were working in a surrealizing vein. Associated with them were two other artists – Esteban Francès and Remedios Varo – who moved to Paris to join Breton's movement.

The eruption of the Spanish Civil War ensured that the Logicofobista show was ADLAN's last. The victory of the Popular Front of left-wing parties in the 1936 elections provoked a revolt by army officers and neo-Fascist 'Falangists'.

General Francisco Franco launched his attack from Spanish Morocco, pressing north in a series of bitter campaigns characterized by atrocities on both sides. Although riddled with factions (from Socialist and Stalinist to Anarcho-Syndicalist), Catalonia was a Republican stronghold, and the fall of Barcelona in late 1938 was a prelude to the final capitulation of the government in the spring of 1939. Germany and Italy had recognized the Falangist government by the end of 1936 and the conflict allowed these Fascist powers both to test their military equipment and to learn the lengths to which the Western democracies would go to avoid a wider war.

The shocking impact of the Spanish Civil War set the scene for the intellectual struggle abroad. A similar political divide emerged in France in the economic and social confusion of the Depression. Nationalists concentrated in such groups as the Action Française, while strikes and civil unrest in 1934

181
Joan Miró,
Aidez
L'Espagne,
1937.
Lithograph;
31 × 24 cm,
12¼ × 9½ in.
Collection
Eduardo
Arroyo, Paris

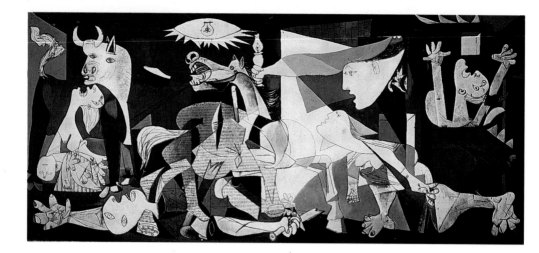

182
Pablo
Picasso,
Guernica, 1937.
Oil on canvas;
351 × 782 cm,
138½ × 308⅛ in.
Museo
Nacional
Centro de Arte
Reina Sofía,
Madrid

and 1936 brought conflict to the streets. Intellectuals who fought for the Republic in Spain warned of the consequences of spreading Fascism, but many establishment figures favoured the restoration of order promised by the right. The acceptance of the polarized political situation ensured that more than ever before all artistic activity was circumscribed by political activity.

The most famous equation of avant-garde art and left-wing politics came with the Spanish Republican Pavilion at the 1937 World Fair in Paris. A defiant gesture, this may also be seen as a result of the developments fostered by ADLAN. Sculptures were by González and Calder; murals by Miró and Picasso. Miró's giant *Reaper* was taken down with the pavilion, but some of its raw anger is appreciable from his contemporary poster *Help Spain* (181). Picasso's contribution was the huge canvas named after the Basque town blanket-bombed by German aircraft that spring. One of the most instantly recognizable images of the century, *Guernica* (182) saw the fragmentation of Cubism put at the service of humanitarian protest. The distortion of the mother and child and the dying horse below the exploding light bulb embody the suffering of a nation, while the black-and-white palette concentrates the intense emotion. This politicized style proved widely influential as an art of resistance in occupied Europe.

The impact of the Spanish Civil War upon Surrealism came from other quarters. Masson lived at Tossa del Mar between 1934 and 1936. While basing his art in the fervid scenes of conflict and of the bullfight, he was one of the first to bring these experiences into the Surrealist milieu. For others there were more tragic consequences. In July 1936, Dalí's friend Lorca was killed by Falangists, probably because of his homosexuality as much as his political views. Dalí made several paintings dealing with the Civil War, notably *Soft Construction in Boiled Beans, Premonition of Civil War* (1936) and *Autumn Cannibalism* (183), as reflections on the brutality of the conflict rather than expressions of support for the Republicans. They came from his own shocked experience of the conflict in Barcelona in 1936. Other Surrealists were more committed; Péret fought for the Republicans, as did the Cuban painter Wifredo Lam.

Even before the outbreak of war in Spain, the Surrealists had been attempting to construct a wide political alliance to oppose

183
Salvador Dalí,
Autumn Cannibalism,
1936.
Oil on canvas;
65 × 65·2 cm,
25⅝ × 25⅝ in.
Tate Gallery,
London

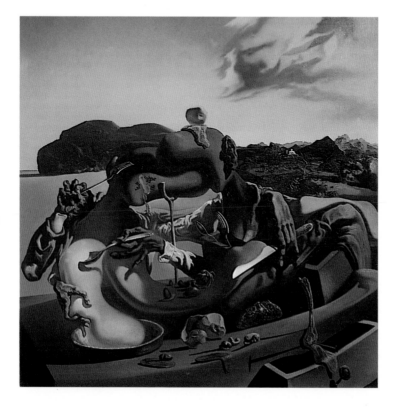

Fascism in Europe. Such alignments proved difficult to secure. In 1933, Breton had been expelled from the Association of Revolutionary Writers and Artists (Association des Ecrivains et Artistes Révolutionaires or AEAR) for his inclination towards Trotskyism. In protest and despair at the movement's continued exclusion from the mainstream of intellectual activism René Crevel committed suicide in June 1935 on the eve of the Paris Congress of Writers in Defence of Culture. Breton had already been forbidden to speak (out of respect for Crevel, Éluard was allowed to read Breton's text) because he had struck the official Soviet delegate, Ilya Ehrenberg, for calling the Surrealists pederasts. In July, the movement published *When the Surrealists Were Right*, which attacked Stalinism and definitively broke with the official Communist Party.

By the end of 1935, Contre-attaque ('counter attack') had been formed as an alternative alliance between the Surrealists, the 'democratic Communists' and Bataille, Leiris and Queneau. It grew out of the collaboration on *Minotaure* but, as he had done successfully with the periodical, Breton sought to dominate by pre-empting the agenda in *The Political Position of Surrealism* (1935). Bataille remained critical, and in 1936 Breton withdrew from Contre-attaque, accusing his rival of 'sur-fascism'. For his part, Bataille's new periodical, *Acéphale* (1936–9), went some way towards justifying this accusation because of its investigations of ritual and crowd psychology. Masson, and the artist brothers Balthus and Pierre Klossowski were associated with the periodical; at the same time, Bataille, Leiris and Roger Caillois founded the College of Sociology as a forum for intellectual debate, which was attended by the anthropologist Claude Lévi-Strauss, and the philosophers Jean-Paul Sartre and Walter Benjamin among others.

In retrospect the political failures of those around Surrealism and their Communist associates appear the result of fruitless squabbling. While personalities often overwhelmed the more profound issues, the confusion of those involved may also be seen as a reflection of the inescapable uncertainty of the world

as they found it. They attempted to reconcile their stated positions with their consciences in each circumstance, but the fact that Breton and Bataille were unable to reach any long-standing agreement is perhaps less important than their willingness to weigh ideological issues carefully and hold a position accordingly. The damaging split between Breton and Éluard that arose at this time developed from the latter's unease about the Surrealists'

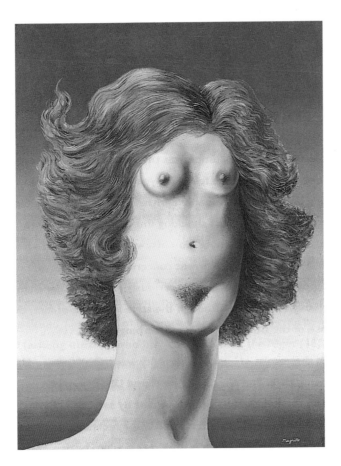

184
René Magritte.
The Rape, 1934.
Oil on canvas;
73·4 × 54·6 cm,
29 × 21½ in.
Menil
Collection,
Houston

move towards Trotsky and consequent political isolation from official Communism. It is significant, in this respect, that Breton was rare among leftist intellectuals in 1936 in condemning the Moscow show trials, by which Stalin was purging the party of opponents. This was a manifestation of his sympathy for Trotsky, but it was undeniably brave to characterize Stalin as 'the principal enemy of the proletarian revolution'.

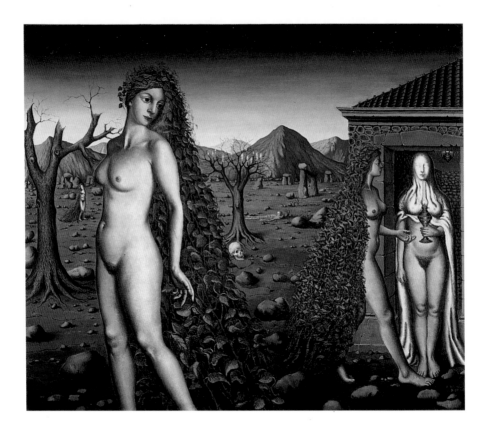

frequented by all the major Surrealists who encouraged Hayter's inclination towards automatism. At that time the painter and writer Roland Penrose became a close friend of Ernst, Éluard and Man Ray. On the strength of owning a dinner jacket, he appeared in a scene in *L'Age d'or*. However, his time in France (1922–36) meant he was out of touch with events in Britain.

The groundwork in England was established through periodicals such as *transition*. In 1930 it carried a manifesto by the Experiment Group of Cambridge University students sympathetic towards what its editor Eugene Jolas proclaimed as a 'revolution of the word'. They included the painter Julian Trevelyan, Hugh Sykes Davies and Humphrey Jennings, all of whom would later become active in British Surrealism. In October 1933, the poet David Gascoyne published 'And the Seventh Dream is the Dream of Isis' (*New Verse*), the first Surrealist poem written in English. At the same period the introduction of Surrealist painting came through a spate of exhibitions of Ernst, Miró and Arp (Mayor Gallery, 1933) and Dalí (Zwemmer Gallery, 1934), which were widely attacked in the press. The painter Paul Nash captured the mood of defiance to this reaction in forming Unit One in June 1933. Although this was not a Surrealist group, Nash's work and that of John Armstrong, Tristram Hillier and Henry Moore had surrealizing elements.

Events moved quickly towards the International Exhibition of 1936. Gascoyne wrote the 'Manifesto of English Surrealism' in May 1935 and translated Breton's *What is Surrealism?* He also published *A Short Survey of Surrealism* (1935) that summarized the movement's achievements in English for the first time. He became committed to the foundation of a London group through a chance encounter with Penrose in Paris, and together they planned the exhibition which drew support from Breton, Éluard, Dalí and Mesens. The collection of Surrealist works from abroad was unprecedented in scale, but the determination to include local contributions raised ambiguities. Moore, Jennings and the critic and theorist Herbert Read were selectors, and a number of arbitrary invitations was issued.

186
Paul Delvaux.
The Call of the Night, 1938.
Oil on canvas:
111 x 131·5 cm,
43¾ x 51⅞ in.
Scottish National Gallery of Modern Art, Edinburgh

**188 Above
Ithell
Colquhoun**,
Scylla, 1938.
Oil on board;
91·4 × 61 cm,
36 × 24 in.
Tate Gallery,
London

**189 Below
Eileen Agar**,
Precious Stones,
1936. Collage;
50 × 43·5 cm,
19¾ × 17⅞ in.
Leeds City Art
Gallery

**190 Right
Leonora
Carrington**,
*Self-Portrait (The
Inn of the Dawn
Horse)*, 1937.
Oil on canvas;
64·5 × 81·2 cm,
25⅜ × 32 in.
Collection of
the artist

McBean. The 1936 exhibition also attracted one of the most significant English Surrealist painters: Leonora Carrington. Her mythologizing autobiographical paintings made extraordinary accommodations for dream imagery (190), but her major work would be made in Mexico.

The period between the exhibition and the outbreak of war saw the consolidation of the London group. From the Continent Magritte arrived in 1938 to paint for Edward James *Time Transfixed* (1938), a smoking railway engine emerging from a

fireplace; Dalí made the same collector a chest of drawers from a stuffed bear. More significantly, Mesens settled in London and became the group's major co-ordinator. With Penrose's help he established the London Gallery and the *London Bulletin* (1938–40). It carried translations of French texts and introduced newcomers, such as the writer Robert Melville and the painter Conroy Maddox. The opening of Peggy Guggenheim's gallery, for which Read acted as adviser, provided a further opportunity to

assaults on all the senses were exaggerated by the darkness against which the visitors were armed with torches. The impact must have been extraordinary. Predictably, none of the torches were returned on the opening night, forcing the introduction of low levels of lighting also demanded by the painters. Despite this technical hitch, the descent into darkness was instructive and revelatory in the uncertain political climate, suggestive of a labyrinthine and psychic space.

The contributors to the exhibition amounted to a rolecall of Surrealists over more than fifteen years of activity. Works by Picasso, de Chirico, Duchamp and Picabia were included, as well as the artists of the first generation: Ernst, Masson, Miró, Man Ray, Tanguy and Arp. Among those prominent in the 1930s were contributions from Brauner, Dominguez, Paalen and Bellmer, as well as Hugnet, Leo Malet and Marcel Jean, and the Belgian, Czech and British artists. Pandering to public expectation, Dalí was included. His *Rainy Taxi* greeted the visitors; an elaborate mechanism allowed it to rain within the vehicle on two mannequins covered in undergrowth and live snails. How far this was a compromise was confirmed by Breton's 'On the Most Recent Tendencies of Surrealist Painting' (*Minotaure*, February 1939), which openly condemned Dalí.

191
Kay Sage,
A Little Later,
1938.
Oil on canvas;
94·4 × 74·2 cm,
37⅛ × 29¼ in.
Denver Art
Museum

The process of estrangement from Dalí had been prolonged but it was most evident within the movement through the gradual abandonment of illusionism. In the same text Breton envisaged a return to automatism, encouraged by renewed contacts with Masson, Paalen and, above all, by the example of Tanguy. Very much the neglected artist of the original generation of Surrealist painters, Tanguy had remained consistent in his exploration of an oneiric or a psychic depth. He had not succumbed to Dalí's influence (arguing that the reverse was the case), instead retaining the suggestive biomorphic forms which linked him to Miró and Arp. In the late 1930s, he came to represent – as Breton saw it – one way forward for younger Surrealist painters coming out of illusionism. A young triumvirate of painters

adopted Tanguy's guidance: the Spaniard Esteban Francès, the British Gordon Onslow-Ford and the Chilean architect-turned-painter Roberto Matta. During a formative summer in 1939 spent painting together with Tanguy, Sage (191) and the Bretons in the French countryside, Matta emerged as the new genius of Surrealist painting. His visionary works in crayon carried some of the charge of Masson's early automatic drawings but were fired with an intense use of colour and psychic concentration (192). They were immediately influential on his young friend, and would set the pace for the ensuing stage of Surrealism in its transatlantic incarnation. Indeed, it is significant that Tanguy, Sage and Matta were among the first Surrealists to arrive in New York and to introduce automatism to America.

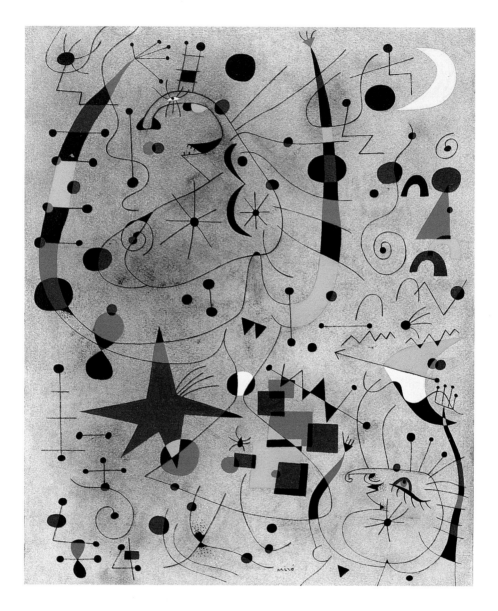

The German annexation of Austria, the 'Anschluss', in March 1938 signalled Nazi plans for territorial expansion. Among the dispossessed, artists and writers – including many Surrealists – were driven across Europe and sought refuge in the New World. Nazi 'order' brought terrible repressions. Most vicious was the extermination of the Jews: the 'Final Solution'. Vienna was the first of the great Jewish communities to be subjected to systematic decimation. Only the adventurous and wealthy found routes into exile to escape the concentration camps; for example, Sigmund Freud fled to London. Shortly after the Anschluss, Nazi agitation began in Sudetenland, a region of Czechoslovakia with a German ethnic minority. Negotiations between Hitler and the British and French Prime Ministers, Neville Chamberlain and Edouard Daladier, resulted in the infamous Munich Agreement (September 1938), which allowed the annexation of Sudetenland to Germany. The Allies did not respond either to Hitler's invasion of Czechoslovakia on 15 March 1939 or to Mussolini's invasion of Albania on 7 April.

Finally, when the Germans invaded Poland on 1 September 1939, Britain and France demanded withdrawal and two days later declared war. As no conflict followed, this period became known as the 'phoney war'. The partition of Poland had been prepared in August, when the German and Soviet Foreign Ministers, Joachim von Ribbentrop and Vyacheslav Molotov, signed a non-aggression pact. The Nazis' restructuring of Europe sought to push their Slav subjects east to enable the expansion of the German population. As the Poles were displaced, so the Jews, a significant presence in Polish cities, were sealed into ghettos or transported 'to the east', a euphemism for the slave and death camps. Stalin's opportunistic collaboration in the division of Poland was underlined in the Red Army's simultaneous attack on

193
Joan Miró,
*Constellations:
Acrobatic
Dancers*, 1940.
Gouache and
oil wash on
paper;
47 x 38·1 cm,
18½ x 15 in.
Wadsworth
Atheneum,
Hartford

194
Paul
Delvaux,
Dawn over the
City, 1940.
Oil on canvas;
175 × 200 cm,
68⁷⁄₈ × 78³⁄₄ in.
Galerie
Christine et Isy
Brachot,
Brussels

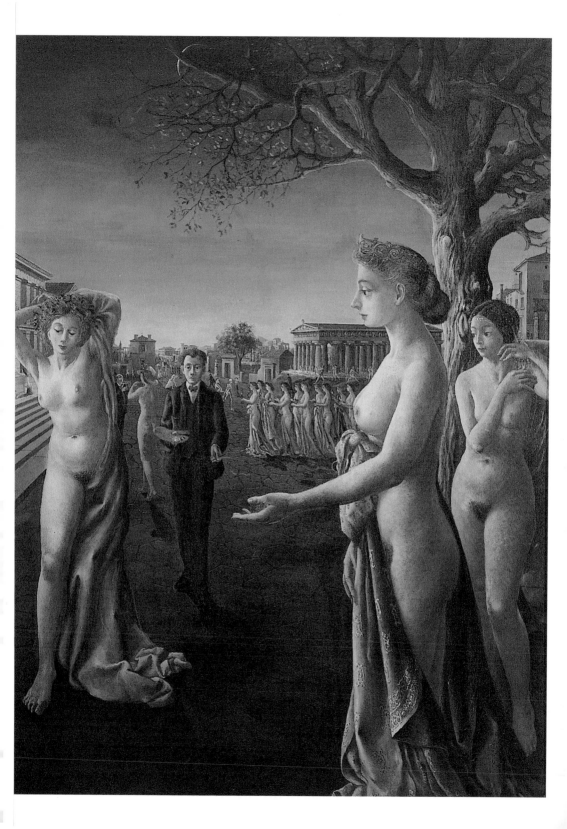

196
Surrealist group in Marseille, *Collective Drawings*, 1940. 22·9 × 29·8 cm, 9 × 11¾ in. Musée National d'Art Moderne, Centre Georges Pompidou, Paris

were released but spent most of the war in hiding, suffering considerable deprivations. Seized at the house he shared with Leonora Carrington, Ernst was eventually able – because his decalcomanias were mistaken for academic realism by an official – to charm his way to Marseille. Lacking any news, Carrington suffered a breakdown, descending into the personal hell described in *Down Below* (1944). Escaping to Spain, she was committed to an asylum against her will. She eventually evaded her captors and married a Mexican diplomat in Portugal to secure immunity and safe passage, but in Lisbon she was shocked to find Ernst involved with Guggenheim. The troubled relationship between the two painters coloured their work throughout the early 1940s.

The journey from Marseille to America involved travelling via Martinique in the West Indies. By late 1940, Seligmann had secured American visas for the Bretons and they finally embarked on 24 March 1941 with the Lams and anthropologist Claude Lévi-Strauss. Mabille had preceded them, and the Massons followed days later. The last to leave was Duchamp who, under the guise of a cheese distributor, had been securing the miniatures of his works which constituted his *Boîte-en-valise* (*Box in a Valise*, from 1941) and who did not reach New York until June 1942.

Martinique provided the first encounter for Surrealism in the New World. The Bretons and Massons were briefly interned in April–May 1941, but after their release Breton chanced upon the local periodical *Tropiques*. It sustained the radical political and cultural aspirations of the black intellectuals from the French colonies which emerged from the 'Négritude' movement promoted in Paris through Etienne Léro's Surrealist-influenced periodical *Légitime Défense*. The poet Aimé Césaire provided the link to *Tropiques*, which was edited by his wife Suzanne and René Ménil, and Breton later wrote glowingly of Césaire and his major work, *Cahier du retour au pays natal* (*Notebook of the Return to the Land of my Birth*, 1939). In it, Breton recognized a ground-breaking political message, not only for the equal rights of colonized peoples, but also for all the repressed in what he called 'an epoch which is witness to the abdication of the mind'. He added: 'he is a black man who is not only a black but is the embodiment of all mankind as well, who expresses all its questions, all its anguish, all its hopes and all its ecstasies, and who, for me, more and more demands recognition as the prototype of dignity'. Breton recognized parallels between Césaire's position and the programme of Surrealism to overthrow the dominance of one part of the mind (reason) over another of equal validity. His enthusiasm was also part of his experience of the Americas and of black culture in particular. This was encouraged by his subsequent encounter with the Spanish painter and political activist Eugenio F Granell in the Dominican Republic, who published the Surrealist periodical *La Poesia Sorprendida* (1943–7). However, Breton's interest was most powerfully reinforced by Wifredo Lam, whose mixed Chinese and black Cuban parentage embodied a striking mélange of non-European cultures.

Lam had studied in Madrid and fought for the Republicans before arriving in Paris with an introduction to Picasso. The latter's use of African sources in his early Cubism proved a revelation and, encouraged by anthropological information from Leiris, Lam adopted the same formal vocabulary. Among the Surrealists in Marseille he had achieved a position

197
**Wifredo
Lam**,
*Light in the
Forest*, 1942.
Gouache on
paper laid on
canvas;
192 x 123·5 cm,
75⅝ x 48⅝ in.
Musée National
d'Art Moderne,
Centre
Georges
Pompidou,
Paris

parallel to Césaire's. For Breton and Mabille, contact with Lam
and Césaire revealed what they perceived as a cultural continuity
with an ancestry associated with Art Nègre. This was something
of a convenient fiction, but Breton bridged this gap through
recognition of the common political and poetic aims. Césaire's
writing was approached on equal terms, although a tendency
remained to emphasize Lam's privileged links to a mysterious
world. This connection was made by the painter himself in order
to construct a modern idiom rooted in this alternative tradition.

From Martinique Lam returned to Havana in 1941, where
he began a series which used his Parisian experience to revise
his approach to his own culture (197). These are among
the most important works associated with Surrealism
to be produced in the early 1940s. Throughout Latin America
'indigenista' ('indigenist') trends proposed locally rooted cultural
renewal, but in the artistic circles of Havana Lam singlemindedly
reimmersed himself in black Cuban traditions. He drew upon
memories of his godmother, who was a priestess in the Santería
religions, which combined Catholic and African rituals and

beliefs. In his paintings, figures blend into the lush undergrowth and are armed with the symbols of African deities and Catholic saints. This use of symbols was as deliberate as, for instance, Masson's use of the classical Minotaur.

In 1945 Lam's major painting, *The Jungle* (198), scandalized New York. It captured the magical integration between the deities and their sacred groves, while in scale and composition it referred to Picasso's *Les Demoiselles d'Avignon* (105), signalling that it lay both within the modernist tradition of revolt and at the birth of a new art for the New World. The North American audience, however, saw it as an image of Voodoo cannibalism, and were outraged when it was bought by the Museum of Modern Art. It may have been these accusations that urged Lam to join Breton on a visit to Mabille in Haiti in early 1946. Mabille had been studying Dahomey-derived Voodoo religions and they attended local ceremonies. While there Lam exhibited a subsequent composition, *The Cardinal Harp* (1944). The three also discovered the untrained Voodoo artist Hector Hyppolite whose work confirmed the free creativity of the people. Breton gave lectures in solidarity with the black cause and drew parallels between political and poetic liberation. This was especially pertinent in the first black republic of the New World. As a consequence, militant students in his audience precipitated strikes which led to the overthrow of the dictator Lescot.

Concerns with indigenous cultures independent of European traditions were instrumental in the transformation of Surrealism when it came into contact with the New World. This coloured the activity of the group who saw out the war in Mexico. Surrealist enthusiasm for Mexico as a cultural and political haven had already been generated by two visits. In 1935–6, Antonin Artaud had lived with the Tarahumara people. His theatrical experience with the Theatre of Cruelty, the successor to the Théâtre Alfred Jarry, made him especially interested in their ceremonies and rituals. By contrast, it was the presence of Trotsky that attracted Breton in 1938. They had a series of productive meetings – with the

exception of their disagreement over the worth of psychoanalysis – resulting in the establishment of **FIARI (Fédération International de l'Art Révolutionaire or International Federation of Revolutionary Art), a new alliance of the left, with the manifesto *Towards an Independent Revolutionary Art*. The text foresaw the collapse of capitalism, and recognized that, for the artist:**

It is only natural that he should turn to the Stalinist organizations which hold out the possibility of escaping from his isolation. But if he is to avoid complete demoralization he cannot remain there, because of the impossibility

of delivering his own message and the degrading servility which these organizations extract from him in exchange for certain material advantages. He must understand that his place is elsewhere, not among those who betray the cause of the revolution, and of mankind, but among those who with unshaken fidelity bear witness to the revolution; among those who, for this reason, are alone able to bring it to fruition, and along with it the ultimate free expression of all forms of human genius.

The manifesto was published in the *London Bulletin* and other periodicals. Although articulating Trotsky's position, he did not sign it for security reasons. Such caution was immaterial as he was assassinated in 1940.

198
**Wifredo
Lam**,
The Jungle,
1943. Gouache
on paper laid
on canvas;
239·4 x
229·9 cm,
94¼ x 90½ in.
Museum of
Modern Art,
New York

Alongside Breton, the manifesto was signed by the muralist Diego Rivera who had taken a similarly serpentine path in relation to Stalinism. His influence was enormous in Mexico and America. Although his didactic pictorial language could never be regarded as in tune with Surrealism, Rivera produced the interior cover for Breton's account of the Mexican visit in the last issue of *Minotaure* (May 1939). Through him and the Peruvian poet César Moro – who had participated in Surrealist activities in Paris – Breton was introduced to sympathetic painters and to the macabre satire of José Guadalupe Posada's prints. A rather different political engagement was found in the photographs of Manuel Alvarez Bravo. These drew on an intimate but questioning knowledge of his country; its permanent state of revolution seemed to be summarized in *Murdered Striker* (199) where reportage, politics and death combine. With other images, such as that of an optician's sign *Parábola Optica* ('optic parabola'), Alvarez Bravo demonstrated his awareness of the unexpected in the everyday in which Breton saw a sympathy with Surrealism.

The most significant of the painters was Frida Kahlo, Rivera's wife. Breton sought to seize her iconic imagery for the movement, and in 1939 he included her in 'On the Most Recent Tendencies of Surrealist Painting' (*Minotaure*, February 1939) and in an exhibition of Mexican art in Paris. Kahlo constructed an autobiographic diary through her paintings in which her suffering

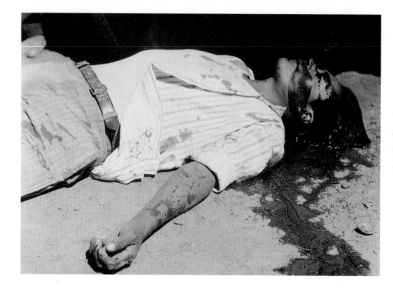

and pleasure paralleled those of the country (200, 201). Coloured by the surgical consequences of a childhood accident, her work nevertheless achieved a universality that has justifiably been interpreted as a feminist critique of the status and treatment of women. She was, as such, the very embodiment of the creative revolutionary envisaged in *Towards an Independent Revolutionary Art*.

Partly because of a sympathy between Surrealism and the local 'fantastic' art, Mexico City became the site of the International Exhibition of Surrealism (January–February 1940), the first show organized by the movement in the Americas. Paalen and his wife Alice Rahon travelled to Mexico to help Rivera and Moro with the organization, taking with them Parisian paintings by Arp, Ernst, Masson and Miró, as well as Dalí, Brauner, Delvaux and Matta. They also gathered contributions from the muralists Roberto Montenegro, Carlos Merida and Guillermo Meza. Kahlo's *The Two Fridas* (200) and Alvarez Bravo's *Parabola Optica* were shown, and Rivera 'surrealized' his painting of a contorted tree and glove (*Symbolic Landscape*, 1940) by changing its title to *Minervegetanimortvida* (roughly 'minervegetanimalstilllife'). While the Mexican work was manifestly rooted in a distinct local tradition, the exhibition was important in inducing an interaction

with European Surrealism. Moro was particularly active, editing the periodical *El Uso del Palabra* in 1939, and publishing two collections of poetry: *Le Château de Grisou* (1943) and *Lettre d'amour* (1944). Through these works he made the theories and practice of the movement known in his native Peru.

Stranded in Mexico by the war, the Paalens became the centre of an exiled Surrealist cell. They had fertile contacts with Rivera, Kahlo and Moro, and were in touch with New York. They were interested in indigenous cultures and in 1939 travelled to British Columbia with the photographer Eva Sulzer to see the totem poles of the Northwest Coast. The power of these images and their position as a path to a rich cultural heritage were an increasingly important source for those associated with Surrealism.

These concerns were visible in the automatist works by Paalen (202) and Rahon publicized through their bilingual (French and English) periodical *Dyn* (1942–4). *Dyn* was open to a wide section of writers and artists from Miguel Covarrubias to Henry Miller, and perhaps this richer blend of influences led Paalen to break

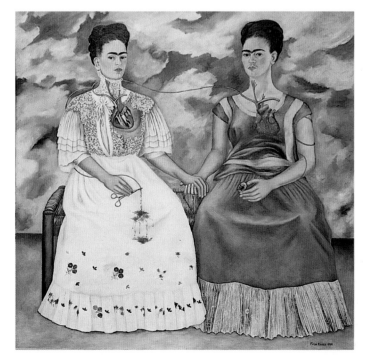

200
Frida Kahlo,
The Two Fridas,
1939. Oil on canvas;
173 x 173 cm,
68⅛ x 68⅛ in.
Museo de Arte Moderna, Mexico

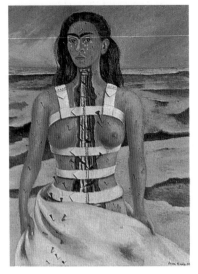

201
Frida Kahlo,
Broken Column,
1944.
Oil on board;
40×31 cm,
15¾×12¼ in.
Museo
Fundación
Dolores
Olmedo Patiño,
Mexico City

with the movement in 'Farewell au surréalisme' (*Dyn*, 1942).
While acknowledging the importance of its collective action, he
aspired to a more scientific and multicultural art. In particular, his
ethnographic interests led him to ascribe a central place to art
in society, one not considered by Marx or sanctioned by Breton.
Onslow-Ford and Matta were persuaded by this programme, but
it brought Paalen's excommunication by Breton.

Another group of Surrealist exiles in Mexico City gathered around
Péret. His Communist activism had prevented him from securing
a visa to the United States, and though maintaining links with
Breton his activities were almost exclusively political. The painter
Remedios Varo, whose work had been included in the 1940
Mexico City exhibition, had joined Péret in late 1941, after
a difficult journey from Casablanca in Morocco. In the following
year Leonora Carrington arrived from New York. This initiated
a remarkable collaboration from which an astonishing body of
almost mystical painting emerged (203). Both were concerned
with the world understood from their position as women.
They drew on the liberation of Surrealism, but pushed beyond
its male-dominated precepts, using an illusionistic technique
to construct a visionary world. Carrington explored childhood
fantasies in which horses and hyenas are both savage and

sophisticated, and in displacing humans opened up a view to the unexpected (204). Varo's work alluded to alchemical experiments in which women embody the knowledge and means of transformation (205). Both painters remained in Mexico City after the war, when they produced some of their most remarkable works.

Mexico was the launching point for the spread of Surrealism into South America. Luis Buñuel arrived to make politically loaded films in Mexico, most notably *Los Olvidados* (*The Forgotten*, 1950).

202
Wolfgang
Paalen,
The Messenger,
1941.
Oil on canvas;
200×76·5 cm,
78⅞×30⅛ in.
Tate Gallery,
London

The poetic and political impetus of the movement was also felt in the writing of Alejo Carpentier, Juan Bréa and Mary Low. In the 1940s the Mandragora group around Braulio Arenas and Enrique Gomez Correa emerged in Santiago de Chile, distinguishing Surrealism from the Stalinism of the poet Pablo Neruda. In Buenos Aires the flavour of the movement was found in the work of Aldo Pellegrini and Jorge Luis Borges.

In the transmission of these ideas, as so often before, they became combined with local concerns and contexts.

For those fleeing Europe, but with no special link to Spanish and Latin American culture, the United States appeared to be the land of opportunity and affluence portrayed by Hollywood. For many this remained true despite the Depression, when strikes saw unions attempting to secure better working conditions and the bootleg market in alcohol during the Prohibition years fostered a murderous gang culture. It was only in the 1940s that these struggles emerged in the cinema with corruption of both the pioneer dream and paternalistic industrialism in John Ford's adaptation of John Steinbeck's *The Grapes of Wrath* (1940) and Orson Welles's *Citizen Kane* (1941).

Despite these discrepancies, President Franklin D Roosevelt's New Deal of 1933 had instituted policies that offered a gradual way out of the Depression. Reliant upon the co-operation of business and industry, it also served the interests of the most deprived in society. Tangible benefits for artists came with schemes such as the Works Progress Administration (WPA): Federal Arts Project, which commissioned instructive and

203
Leonora
Carrington,
Horses, 1941.
Oil on canvas;
66·5 x 81·5 cm,
26¼ x 32 in.
Arturo
Schwarz
Collection,
Milan

204
Leonora
Carrington,
*The Pomps of
the Subsoils*,
1947. Oil on
canvas;
58·5 × 94 cm,
23 × 37 in.
Sainsbury
Collection,
University of
East Anglia,
Norwich

celebratory public murals. As might be expected, avant-garde approaches were rarely encouraged, although responses to Surrealism began to surface in the mid-1930s which filtered into the WPA projects. The murals by Philip Guston and Reuben Kadish in Los Angeles Tubercular Sanatorium (1935–6) demonstrated an awareness of the disjunctive space of Magritte. This interest was encouraged by the Parisian-trained artists Lorser Feitelson and Helen Lundeberg, whose exhibition at the San Francisco Museum of Art in 1935 was called *Post-Surrealism: Subjective Classicism*. The size of objects in their compositions was determined by their psychological importance, with results approaching the illusionism of Dalí or the fantasy of Leonor Fini, but stripped of their sexual or political content. In New York, by contrast, Surrealist illusionism was seen as an alternative to the rhetoric of Socialist Realism by James Guy, Walter Quirt and O Louis Guglielmi, now sometimes called 'Social Surrealists' (206). They adapted it for a manifestly political art.

Neither of these early responses had direct contact with the Parisian movement, nor did they subscribe to its theories. This reflected the relative cultural isolation of America and the dominance of artistic over theoretical exchanges. In the 1920s, only a few Surrealist texts appeared in America (in *Broom* and *transition*), and although the Surrealist issue of *This Quarter* (1932)

205
Remedios
Varo,
The Creation of
Birds, 1957.
Oil on
masonite;
54 × 64 cm,
21¼ × 25¼ in.
Private
collection

carried important texts – including one by Dalí on the Surrealist object – the publishers forbade political discussion. Thus, it was Surrealist painting that made an impact as an excitingly risqué trend. It arrived in New York through the Julien Levy Gallery, which established the American reputations of most of the movement's artists. In 1931–2 Levy organized their first group show with the Wadsworth Athenaeum; the soft watches of Dalí's *The Persistence of Memory* (207) instantly became notorious, and by the time Dalí arrived in 1934 the dealer had shrewdly given the painting to the Museum of Modern Art. Thus, in New York the showman painter was completely synonymous with Surrealism.

Greeting reporters with a baguette, Dalí returned for a one-man show at Levy's in 1936 to coincide with Alfred Barr's *Fantastic Art, Dada and Surrealism* at the Museum of Modern Art. This signalled the institutionalization of Surrealism in America where exhibitions passed outside the control of the movement. It was to establish a pattern, which Breton was unable to reverse, of aesthetic and commercial appreciation which divorced the paintings from their theoretical and experimental roots. Despite Breton's reservations, such exhibitions facilitated the acceptance and the eventual exile of the Surrealists. In this process the bizarre

206
O Louis
Guglielmi.
A Connecticut
Autumn, 1937.
Oil on panel;
160·5 × 76·8 cm,
23⅞ × 30¼ in.
Museum of
Modern Art,
New York

became fashionable and the movement entangled with advertising and fashion. Man Ray and Lee Miller had brought Surrealist style to *Vogue* and *Harper's Bazaar*, but at the heart of this exchange was Dalí who contributed a frisson of controversy. He and Gala organized a 'Bal Oneirique' in 1935 at which socialites displayed wealth and flesh in equal measure. This success was sustained by his collaboration on a 'Tear dress' with the fashion designer Elsa Schiaparelli, who also worked with Fini. Dalí's star status was

unquestionable: he visited the Marx brothers shooting *A Day at the Races* (1937), was arrested for destroying his window design for the Bonnit Teller department store (1939) and had his own *Dream of Venus* pavilion at the New York World's Fair (1939). Breton responded to this profligacy with the withering anagram for the painter's name 'Avida Dollars', but there is little doubt that Dalí's antics brought Surrealism a wider audience.

210
Pavel
Tchelit
Anatomi
Painting,
c.1944—
Oil on c
142·2 × 1
56 × 46 i
Whitney
Museum
America
New Yo

207
Salvador
Dalí,
The Persistence
of Memory,
1931.
Oil on canvas;
24·1 × 33 cm,
9½ × 13 in.
Museum of
Modern Art,
New York

who landed in these years were **Man Ray, Ernst and Guggenheim, Esteban Francés, Enrico Donati and Alexander Calder, as well as Dalí and Gala. Public recognition was afforded by exhibitions at the Museum of Modern Art which, in 1941, included de Chirico, Dalí and Miró. In his absence, Miró's work was seen by James Johnson Sweeney as belonging 'to the youth of the period that is opening, rather than the old age of a closing one'. This sympathetic reception was overshadowed at the end of 1941 by the war. Prolonging the policy of isolationism, the United States had remained neutral in relation both to Axis advances in Europe and Japanese campaigns in Southeast Asia. Partially because the**

211
Artists in Exile,
1942.
Back row, from
left:
André Breton,
Piet Mondrian,
André Masson,
Amédée
Ozenfant,
Jacques Lipchitz,
Pavel
Tchelitchev,
Kurt Seligmann,
Eugene Berman.
Front row:
Roberto Matta,
Ossip Zadkine,
Yves Tanguy,
Max Ernst,
Marc Chagall,
Fernand Léger

Roosevelt government was heeding British calls for intervention, the Japanese launched a pre-emptive strike on the American Pacific fleet at Pearl Harbor in Hawaii in December. Shocked and galvanized, the United States was jolted into the war.

The circumstances of the exiles, however, were not radically changed by the new turn of events. They took up temporary occupations – Breton worked for the French section of the 'Voice of America' radio – in support of the united war effort. Their steadfast opposition to Fascism was well known, and their exhibitions raised funds for the Red Cross and other agencies.

By participating in the *Artists in Exile* exhibition at the Pierre Matisse Gallery (March 1942) they expressed solidarity with other incoming Parisian artists whom they would, in other circumstances, oppose. Ernst, Masson, Tanguy, Seligmann and Matta were placed alongside Léger, Chagall, Tchelitchev and others. Breton joined them for publicity photographs which, perhaps, provided a necessary introduction (211). Two other facts influenced the reception of Surrealism: none of the other Surrealist writers had come, and Breton did not speak English.

In these circumstances it was the younger English-speaking artists who formed bridges to sympathetic American artists. Ernst's son, Jimmy Ernst, also a painter, brought younger artist to the attention of Peggy Guggenheim and other potential patrons, and Stanley William Hayter's transfer of the Parisian print workshop Atelier 17 to New York provided a meeting-point. In late 1940 Gordon Onslow-Ford gave lectures on Surrealist theories and practices at the New York School for Social Research. To an audience that included the painters Arshile Gorky, William Baziotes and Gerome Kamrowski, Onslow-Ford particularly articulated the new possibilities he shared with Matta.

These developments drew upon *Gestalt* psychology and cosmic phenomena as means of extending aspects of vision, and resulted from Matta's and Onslow-Ford's reading of the mystical and scientific theories of Ouspensky's *Tertium Organum* (1911). The tangible results were found in Matta's *Psychological Morphologies*, which derived their title from the methodology for the study of growth. In texts such as *Pulse of Life* (1939) he explained his goal:

I depict phenomena to try and make a morphology of essence. For the deed, the action and the intention are not what we think they are: unrelated happenings occurring in a vacuum. They occur within a constant, and it is within the structure of this constant that I wish to use this morphology to integrate the picture of the world … If I can take the first steps in depicting the workings of essence, we may have something from which to derive particular happenings. I believe that we need for this knowledge of ourselves a creative imagination, a creative attention and a creative will … If we had

212
Roberto Matta,
Fabulous Race-Track of Death,
1939.
Oil on canvas;
68·7 × 88·7 cm,
27½ × 35½ in.
Yale University
Art Gallery,
New Haven

a real picture of ourselves, we might begin to realize the possibilities of exercising our creative will.

Psychological states were the 'essences' with which Matta was concerned, hence one of the earliest in the series: *Morphology of Desire* (213). A more turbulent work suggestive of responses to world-wide disruption was *Fabulous Race-Track of Death (Instrument Very Dangerous for the Eye)* (212). Matta's new space was adapted from that of Tanguy's paintings and responded to Paalen's quasi-scientific proposals in *Dyn*. The fluid handling was associated with organic and mucous forms, as if inside the body – an anatomical aspect shared with Tchelitchev. The painter also drew parallels between the 'essences' of man and the turbulence of the earth, giving the term 'Inscape' to works in which the organic becomes volcanic.

213
Roberto
Matta,
*Morphology of
Desire*, 1938.
Oil on canvas;
45·7 × 66 cm,
18 × 26 in.
San Francisco
Museum of
Modern Art

In New York the *Psychological Morphologies* seemed astonishingly abstract, irrespective of these allusions. They influenced the work of Kamrowski, Baziotes and Peter Busa, who were experimenting with collaborative paintings and other surrealistic techniques in their search for a new abstract art. During 1940–2, Matta's enthusiasm galvanized them into an unofficial group. The writer and painter Robert Motherwell also participated in the discussions, and the making of *cadavres exquis* and 'doodles' (Motherwell's neutral term for automatic drawings). Less frequently, Gorky, Jackson Pollock and Lee Krasner joined them, recognizing Matta as a messenger of modernism for their generation.

The approach formulated by these painters accommodated two current interests: Carl Jung's psychoanalytical theory and the art of Native American peoples. Jung posited a 'collective unconscious' which revealed itself in archetypes, symbolic embodiments of ideas which persisted in myth and ritual, religion and art across many cultures. The artist John Graham elaborated on these theories in *System and Dialectics of Art* (1937) which had circulated among painter friends including Gorky and Pollock. Graham stressed the spiritual transformation of society accessible through the collective unconscious. His ideas were

also associated with an enthusiasm for the art of Native American peoples that – from the totems of the Northwest Coast to the sand painting demonstrated by Navaho medicine men at the 1941 Art of the American Indian exhibition at the Museum of Modern Art – seemed to be proof of this timeless manifestation. Also, they were symbolic and often abstract, offering a precedent for the new American abstract art.

Matta's automatism provided a means for the realization of these ideas, while the privileged position of the artist in Jungian thought circumvented Breton's objections to a purely aesthetic reading of Surrealist work. With these differences and Matta's pivotal position, an alternative movement seemed to be in the making. However, a concern with the erotic led Matta to the symbolic 'great invisible ones' ('grands transparents'). These were explained by Breton in his 'Prolegomena to a Third Surrealist Manifesto or Not' (*VVV*, no. 1, June 1942) as undetected 'beings whose behaviour is as strange to [man] as his may be to the mayfly'. Matta was thus accommodated and, in 1942–3, Motherwell, Baziotes, Kamrowski and Gorky all exhibited as Surrealists.

Pollock was more hesitant, although it was through the movement that he came to the attention of Peggy Guggenheim, who helped to launch him as 'America's greatest living painter' (214).

The second half of 1942 was a crucial period for Surrealism in New York. In the space of six months the Bretonian identity of the movement was confirmed in a new periodical, two texts and two concurrent exhibitions. The periodical *VVV* was launched in June 1942 and carried articles in French and English; the triple V for victory proclaimed Surrealism's opposition to Fascism. *VVV* highlighted the commitment to the movement among Americans: the editor was the sculptor David Hare, who was Sage's cousin. It featured Calder, the painter Dorothea Tanning and the photographer James Laughlin, and there were texts by Motherwell and the 15-year-old poet Philip Lamantia. However, the contributions of the exiled Surrealists and fellow-travellers, such as the anthropologist Claude Lévi-Strauss, tended to dominate. This remoteness was maintained by its bilingual publication and by the editorial board of Breton, Ernst and subsequently Duchamp. Only two further issues appeared: in March 1943 and February 1944.

Breton's residence permit forbade political activity, thereby constricting any Surrealist publication. The effect was apparent in his 'Prolegomena' in *VVV*. Even so, he laid out his position, dominating the text with a lyrical condemnation of the state of existence:

So long as men have not become aware of their condition – and I mean not only their social condition but also their condition as men and its extreme precariousness … so long as men stubbornly insist on lying to themselves; so long as they will not take into account the ephemeral and the eternal, the unreasonable and the reasonable that possess them, the unique that is jealously preserved within them and its enthusiastic diffusion in the crowd … it isn't worth the trouble to speak out, and still less worth the trouble for people to oppose each other, and still less worth the trouble to love without contradicting everything that is not love, and still less worth the trouble of dying and … still less worth the trouble of living.

To this litany Breton opposed an optimism derived from opposition to established systems, from the poetry of Apollinaire and Aimé Césaire to the masks of New Guinea. He warned the establishment: 'If this war and the many chances that it offers you to live up to your promise were to be *in vain*, I should be forced to admit that there is ... something basically wrong with you that I cannot hide from myself.' Muted, but not gagged, Breton could only propose a 'Third Manifesto', whose content had to remain latent in the expression allowed him.

In December 1942, Breton lectured at Yale University on the 'Situation of Surrealism Between the Two Wars' (*VVV*, nos 2–3, 1943), defining the movement in relation to war. Youth was a major theme, as his audience was the same age as he had been in World War I. He concluded with a summary of beliefs:

A persistent faith in *automatism* as a sounding device; a persistent hope in the *dialectic* ... for the resolution of the antinomies which overwhelm man; recognition of *objective chance* as an indication of the possible reconciliation between the ends of nature and the ends of man ... a will to the permanent incorporation in the psychic apparatus of *black humour* which ... alone can play the role of a safety valve; preparation in a practical way for an *intervention*

**215
Marcel
Duchamp**,
Exhibition
installation for
First Papers of
Surrealism,
New York,
1942

in mythical life ... in such contexts are to be found the fundamental watchwords of surrealism today.

Breton was also active in organizing the exhibitions that established Surrealism in the public eye. *First Papers of Surrealism* opened on 14 October 1942 at the Whitelaw Reid Mansion. It effectively continued the series of recent international exhibitions of Surrealism. The work of members, including Ernst, Masson, Tanguy, Seligmann, Carrington and Matta, was integrated with that of local sympathizers, combining Matta's group with those in *VVV* – Sage, Calder, Jimmy Ernst, Hare, Baziotes and Motherwell. The setting was contrived as a disconcerting environment. Duchamp webbed a mile of string across the works, at once preventing their appreciation and alluding to the labyrinth as a parallel for the exploration of the subconscious (215). Together with the title, named after immigration papers, the string referred to the difficulties of exile. These witty allusions and the catalogue's 'compensation portraits' (images of people who looked like the artists) gave the impression of Surrealism as a closed circle.

The second exhibition was not exclusively dedicated to the movement. Art of this Century was the name Guggenheim gave to the gallery displaying her collection, which she had hidden from the Nazis in Grenoble and which reflected her crucial help for the artists and writers themselves. Her marriage to Ernst ensured that she was seen as Surrealist by extension. Her collection was dominated by the movement including Ernst's recent decalcomania *Europe after the Rain* (216), a nightmarish vision of decayed civilization. Breton's Preface, 'Genesis and Perspective of Surrealism', shrewdly saw even the Cubist paintings in Surrealist terms. However misleading, this progression was particularly apposite at a moment when avant-garde New York artists were making a stylistic transition from one to the other. It provided the sculptor David Smith, for example, with an opportunity to see the Giacomettis that inspired his surrealizing pieces (217). The organic environment

was designed by the Austrian architect Friedrich Kiesler. Along with curved walls and plywood seats (which could stand any way up), his spotlighting of unframed canvases on cantilevered arms made the paintings glow and float in darkness.

These shows, reinforced by the exhibition of Lam's work at Pierre Matisse's gallery in November 1942, constituted the

most vibrant moment of Surrealism in New York. Kamrowski was not alone in admiring the display of optimism and freedom together with 'a certain aspect of humanism'. Impetus was sustained in 1943 through the individual exhibitions of Matta, Lam, Ernst, Masson and Donati, and the recruitment of the writers Charles Duits and Patrick Waldberg. However, the movement could not maintain the cohesion that it had in Paris.

216
Max Ernst,
Europe after the Rain, 1940–2.
Oil on canvas
(decalcomania);
55 × 148 cm,
21⅝ × 58¼ in.
Wadsworth
Atheneum,
Hartford

This was supposedly for lack of café meeting-places, but more probably because of the restrictions on political activity and the independence of the senior artists. Many of them sought the tranquillity of the country. Masson, Calder, Tanguy and Sage went to New England. Tanguy reflected the clear light in heightening the intensity and colour of his work, while Sage began to transmute her response to his work and to de Chirico

into her own view of disquieting isolation. Masson reinvigorated automatism, publishing drawings in *The Anatomy of My Universe* (1943), which proved extremely influential on Gorky, Pollock and others. Although his relations with Breton cooled, such paintings as *Leonardo da Vinci and Isabella d'Este* (1942), bought by the Museum of Modern Art, exemplified his energetic gesturalism.

paralysis in his painting arm following a car crash; under the weight of these events Gorky committed suicide in July 1948.

Breton followed the news of the Normandy landings by the Allies during his summer in Quebec and, in 1945, perversely celebrated the end of war in Europe in a German restaurant in New York with Duchamp and Man Ray. In the intervening period, exchanges with Europe swung back towards normality. Miró's *Constellation* watercolours were some of the first works to cross the Atlantic and were exhibited to great acclaim (January 1945). Exiles began to lay plans for the return home. Masson left as soon as possible in October 1945; Breton, travelling via Haiti and the Dominican Republic, did not arrive in Paris until May 1946. Tanguy and Sage, and Ernst and Tanning had set down sufficient roots to remain.

Should confirmation be needed, the urge to return showed how difficult exile had been. If Surrealism, in the shape of Breton, was never at home in America, it nevertheless left important traces there. Besides recruiting such differing allies as Cornell and Gorky, and having a direct impact on the Abstract Expression-ists, its influence was pervasive. Surrealist works provided a stimulus for others, among whom the sculptors Noguchi and Smith were prominent. However, for the vast majority of those who had heard of it, Dalí – who designed the dream sequences for Alfred Hitchcock's psychoanalytic thriller *Spellbound* (1945) – continued to embody Surrealism.

With peace, the results of the destruction of Europe brought
by six years of war had to be confronted. Cities from Stalingrad
to Rotterdam had been decimated, and the survivors were forced
– physically, psychologically, politically – to come to terms with
the past. In 1945 the extent of the Nazis' concentration camps
began to be quantified; the names of Auschwitz and Buchenwald
became bywords for the incomparable inhumanity of the
Holocaust. Hardly less appalling – though more distant – were
the terrors of the Pacific war, ended by the unprecedented destruc-
tive power of the atom bombs dropped in the name of peace on
the civilians of Hiroshima and Nagasaki in August 1945. The work
of reconstruction, too, was fraught with pitfalls. Postwar socialism
in eastern Europe was shaped by forced 'alliances' with the Soviet
Union. Winston Churchill, who had negotiated directly with Stalin
over spheres of influence, spoke of the 'Iron Curtain' dividing
Europe into the tense armed peace of the 'Cold War'. Caught
between the opposing superpowers of the USA and USSR,
western Europe experienced a period of crisis, witnessed in the
division of Berlin and Germany, and the enfeeblement of Britain
and France with the loss of their former status as colonial powers.

In Paris, both Catholicism and Communism attempted to secure
the legacy of the Resistance. On one level, the imperious General
Charles de Gaulle – wartime hero of the Free French – restored
national morale and establishment values. On another level,
Picasso's presence in the city during the war made his move
to the Communist Party in the autumn of 1945 highly symbolic.
In America, where Senator Joseph McCarthy's 'witch hunts'
of Communist sympathizers were gathering pace, the Federal
Bureau of Investigation (FBI) opened a file on Picasso. Picasso
was close to Éluard, Aragon and Elsa Triolet, who were among
the leaders of the Communist National Committee of Writers

220
Enrico Baj,
Angry General,
1960. Oil with
various
materials;
130×97 cm,
51⅛×31⅛ in.
Private
collection

221
Wols,
Untitled,
1946–7. Oil on
canvas;
81×81 cm,
31⅞×31⅞ in.
Menil
Collection,
Houston

(Comité National des Ecrivains), and he became head of the
related National Front of Arts (Front National des Arts), as both
organizations instituted purges of Nazi collaborators, resulting
in victimization and suicides. The Resistance poetry of Aragon,
Éluard and others was celebrated in the volume *Honneur des poètes*
(*Honour of the Poets*, 1945); only Péret, in *Le Déshonneur des poètes*
(*Dishonour of the Poets*) written in Mexico in 1945, exposed their
manipulative nationalism. Similar values were represented by
Socialist Realism in painting, which was reasserted by Moscow
as the only style untainted by bourgeois concerns. The debate
about realism and propaganda was thereby revived.

Picasso's move to the Communist Party was also encouraged by
his contact with Existentialist philosophers and writers.
Committed to political and social revolution, Existentialism
became an increasingly accepted intellectual currency by which
the absurd divorce of the experience of the individual from the

222
Jean
Dubuffet,
M Plume with
Creases in his
Trousers
(Portrait of
Henri Michaux),
1947.
Oil on canvas;
130·2 x 96·5 cm,
51¼ x 38 in.
Tate Gallery,
London

outside world of objects could only be bridged by acts of pure
will. It was diffused through the periodical *Les Temps Modernes,*
through philosophical tracts such as Jean-Paul Sartre's *Being and*
Nothingness (1943) and Simone de Beauvoir's manifesto for
women *The Second Sex* (1950), and such novels as Albert Camus'
The Outsider (*L'Etranger,* 1947). The perception of the isolation of
the individual within society became a pervasive image of
Existential writing, stimulating the violent sexuality of Jean
Genet's novels and the anxious inactivity of Samuel Beckett's
plays and Eugène Ionesco's Theatre of the Absurd. The sense of
the 'outsider' chimed with the isolation of artists during the war.
The searching analytic surface of the almost immaterial figures
made by Giacometti in Switzerland seemed to embody the
phenomenological dilemma of interaction between individuals
identified by Existentialism. Physical disruption also served to
record anxiety in the different fraught surfaces of the paintings
of Wols (221), Jean Dubuffet (222) and Jean Fautrier. Above all, it
was Antonin Artaud who established an artistic equivalent for
Existential writing. His treatment for insanity with electric shock
therapy resulted in temporary amnesia. The drawings and texts
he made provide a diary of this loss of identity, paralleling the
destruction of human dignity in the war (223).

225
Simon
Hantaï.
Untitled, 1952.
Oil on canvas;
106 × 122 cm,
41¾ × 48 in.
Musée National
d'Art Moderne,
Centre
Georges
Pompidou,
Paris

Connections had already been established with another group of painters and writers. Taking letters from their cities – Copenhagen, Brussels and Amsterdam – Asger Jorn, Dotrement, Pierre Alechinsky, Karel Appel and Constant coined the name Cobra in 1948 for their specifically non-Parisian conjunction of Surrealism and Expressionism and its eponymous periodical. From collaborative and automatic techniques emerged spontaneous animalistic imagery executed in intense colours. Lam was close to Jorn, and Alechinsky became allied to Surrealism after Cobra's collapse.

A fertile source was found in the work of untrained artists, which Dubuffet dubbed Art Brut ('raw art') and which had long been an area of interest to the Surrealists. In 1947, Dubuffet – whose own painting was indebted to the example of his friend Gaston Chaissac (227) – established the Société de L'Art Brut, enlisting Breton, Jean Paulhan and others in the steering committee. Inspired by Hans Prinzhorn's *Artistry of the Mentally Ill* (1922), Dubuffet began to collect and exhibit work by 'outsiders'. In *L'Art Brut préféré aux arts culturels* (*Art Brut Preferred to Cultural Arts*, 1949) he sought to secure for this work a place at least on a level with orthodox art. The Art Brut collection went on show at the Musée des Arts Décoratifs.

Breton lent considerable support to the cause. He wrote 'L'Art des fous' ('Art of the Mad', 1948) and collected works by Chaissac, Aloïse, Adolf Wölfli, and the animal painter Aloys Zötl. In London, Mesens and George Melly championed Scottie Wilson. In each case, the peculiarity of the artist's biography was used to reflect upon his or her work. It was an art of compulsion. Interest in it fitted with a wider view outside the mainstream, which encompassed ritual and magic. Breton and Gérard Legrand published the fruits of their research in that area in *L'Art magique* (*Magical Art*, 1957).

The first of the postwar Surrealist periodicals was *Néon* (1948–9) launched by Sarane Alexandrian, Vera Hérold and others. It immediately became the site of controversy when Breton

227
Gaston
Chaissac.
The Last Supper.
c.1956–7.
Ripolin on
wood;
140 × 101 cm,
55⅛ × 39¾ in.
Musée des
Beaux-Arts de
Nantes

excommunicated Matta (for divisive tendencies) in October
1948. Brauner and most of the editorial board were expelled for
defending him, and when Breton and Péret seized control of the
periodical Surrealism seemed to have returned to its prewar
pattern. *Néon* attracted Adrien Dax and Jean Schuster to the
movement, before the latter's *Médium* was transformed into the
official organ (1951–5). Between these two periodicals came the
Surrealist Mid-century Almanac (1950), which included Breton
and Péret's collaborative 'Calendar of Tolerable Inventions
from Around the World', a bizarre and witty list of inventions
from the carnival mask to the toboggan. The periodicals were
planned for short runs, each reinventing the movement's
message. In 1956 Schuster's increasingly influential role was
acknowledged when he shared with Breton the editorship of *Le
Surréalisme, même* (1956–9). This became a substantial annual
publication, comprising over 150 pages for each of its five issues.

painters came into the group's orbit, notably Jean Gaverol and Félix Labisse, both of whom worked with illusionistic and eroticized images. Younger poets were also inspired to form the satellite group of Walloon Surrealists in the 1950s.

More fragile groups had emerged in all corners of Europe, although few were sustained for long. In Sweden in 1946 Karl Hulten and Max-Walter Svanberg founded the Imagist group, which combined Surrealism and mystical fantasy; Svanberg's works were received enthusiastically in Paris in 1953. A short-lived Portuguese Surrealist group was formed by the painter Antonio Pedro in 1947. In Athens in the 1950s the Greek group around the poets Andréas Embiricos and Odysseus Elytis renewed activities begun in the 1930s with encouragement from expatriates like Nicholas Calas and Gisèle Prassinos. Among the painters the most important was Nicos Engonopoulos, whose work had long been indebted to de Chirico. The activities of these groups – and others – were rather disparate and lacked the interconnections achieved in the 1930s.

None of the shows that followed EROS (1959), the eighth of the series of international Surrealist exhibitions, went to cities with strong local groups. The ninth exhibition, entitled Surrealist Intrusion in the Enchanter's Domain, was co-ordinated in New York (d'Arcy Galleries, 1960) by Duchamp. Although Breton, José Pierre and Edouard Jaguer were instrumental in the selection, Duchamp's role was evident in the presence of younger artists, such as Oyvind Fählström, the Cobra painter Corneille and the Italian maker of object paintings Enrico Baj (220). Dalí – still the epitome of Surrealism for most Americans – was also included, to Breton's anger. This broader approach seems to have encouraged new adherents. Most notable were the Cuban Jorge Camacho, whose paintings used cartoons, and the Mexican Alberto Gironella, who combined objects with painting in his parodies of the seventeenth-century painter Velásquez.

In 1961, following the tenth exhibition (Galleria Schwarz, Milan), Breton launched what was to be his last periodical, the aptly

228
Jan
Svankmajer.
A still from the
animated film
Punch and Judy,
1966

named *La Brèche* (*The Breach*, 1961–5) with Robert Benayoun,
Gérard Legrand, José Pierre and Schuster on the editorial board.
It featured Gironella and Camacho, and the writers Radovan Isvic
and Vincente Bounoure. A feature on erotic images ran alongside
discussions of film and Pop Art, and the pressing difficulties
of Cold War politics. The German painter Konrad Klaphek
was welcomed for his disconcertingly erotic images of domestic
machines – typically the sewing machine so evocative of
Lautréamont's classic simile (229). In the hands of the co-editors,
the future of the movement appeared assured; significantly,
Breton's last article, 'Cavalier Perspective' (*La Brèche*, no. 5,
October 1963), dealt with issues of the movement's continuity
and drew parallels with the long maturity of Romanticism.
He defined Surrealism as a similar continuum, 'obedient
to an irresistible impulse and projecting towards an unlimited
objective'. Asserting the importance of the present, he concluded:
'Surrealism is a dynamic of which today the vector should not be
sought in *La Révolution surréaliste* but in *La Brèche*.'

In this exhortation Breton attempted to counter the tendency to see Surrealism as a thing of the past. This was an unrealistic effort; in the 1950s many of the central figures of the movement had died, including Mabille, Picabia, Heisler and Tanguy. Between 1957 and 1962 Dominguez, Paalen, Kay Sage and Seligmann all committed suicide, and the death of Péret in 1959 robbed Breton of his longest-standing ally. With typical defiance, however, he organized an eleventh international exhibition, L'Ecart absolu (Absolute Distance) in 1965 (Galerie l'Oeil). Klapheck, Hervé Télémaque and Pierre Alechinsky were included alongside the major exponents, and a revised edition of Surrealism and Painting appeared. In 1966, however, in the same year as Arp, Brauner and Giacometti, Breton himself died. An attempt to perpetuate his legacy in the periodical Archibras (1967–9) was short-lived. Breton's magnetism was missed and, with acknowledgement that more could be achieved by individual than collective endeavour, Surrealism passed into history.

Individuals and groups continued to work along the directions established by Surrealism. By far the most internationally influential was Luis Buñuel whose films, from Viridiana (1961) to The Discreet Charm of the Bourgeoisie (1972), demonstrated a pungent assault on class sensibilities, religion and politics. The absurd was combined with the bizarre in narratives that embodied Surrealism for a wide audience. Outside France, individual Surrealist activities continued. Conroy Maddox was among the most active, and John Lyle's Transformaction served as the voice of British Surrealism in the 1970s. Receiving the blessing of Breton and the support of Kamrowski, Franklin Rosemont established the Chicago Surrealist group in 1966. His monograph André Breton and Surrealism (1978) accompanied translations of important Surrealist tracts entitled What is Surrealism? (1978). However, these efforts – which continue – seem a shadow of the former successes, not only perhaps because time has not yet placed them in perspective, but also because Surrealist strategies have been so widely adopted by others.

With the ageing of its survivors and its decline as an intellectual force came the establishment acceptance which Surrealism had so long avoided. Individual artists were the subject of monographs, often by fellow Surrealists – such as Patrick Waldberg's on Ernst or Penrose's on Man Ray. The poets, including Breton himself, issued revised editions of their earlier works, and former members (such as Pierre Naville) published memoirs of their fervid youth. Radio interviews – by Breton (1952), Masson (1958) and Duchamp (1967) – retold the past, repaying scores and debts alike. Interest in Surrealism made it public property, but the postwar audience was passive, perhaps more fearful of nuclear attack than intellectual assault. This audience relied upon assessments from those outside the control of the movement, a process begun with Maurice Nadeau's *History of Surrealism* (1944) and leading to William Rubin's *Dada and Surrealist Art* (1968). The wider context for this change was the loss of cultural ground to the United States. Abstract Expressionism came to dominate in the 1950s as exemplary of Western freedom of individual expression – a cultural weapon in the Cold War. A significant accompanying change was the linguistic dominance of English, which hastened the decline of Paris as the intellectual capital of the world.

The Surrealists' impact on politics was more transitory, although their ideas may be seen to have infiltrated all levels of social exchange. The radical idealism propounded by the movement surfaced in popular culture in the 1960s and – above all – in the search for a greater liberty. After the 'Prague Spring' of 1968, the Surrealist animator Jan Svankmajer used the subversive potential of the unexpected to undermine the impediment of freedom by the authorities (228). In France, dissatisfaction with postwar order was concentrated into contemporary 'events' of 1968, the strikes and student occupations of university campuses. The barricades on the streets of Paris and students and workers fighting the riot police side by side suggested that revolution was imminent. Significantly, the former Surrealist André Thirion recorded

229
Konrad
Klaphek,
*The Logic of
Women*, 1965.
Oil on canvas;
110×90 cm,
43³⁄₈×35³⁄₈ in.
Louisiana
Museum of
Modern Art,
Humblebaek

that the slogans painted in the streets were more frequently
drawn from Breton's writings than from those of Marx or Lenin.
The liberation of the mind engendered works of protest.

Epilogue

Epilogue

It is impossible to trace all the routes by which Surrealism and – emerging from its shadow – Dada have filtered into the cultural mainstream. Their influence, dilute but present, is to be found in much of the ensuing art, literature and cultural debate.

Beyond Antonin Artaud's Theatre of Cruelty and Eugène Ionesco's Theatre of the Absurd, the questioning of logic and the nature of reality raised by the two movements continued to be addressed. This found echoes in the work of such writers as Henry Miller and William Burroughs, and in Georges Perec's peculiar achievement of writing *La Disparition* (1969, translated as *The Void*) without using the letter 'E'. With many others, the stories of Jorge Luis Borges and the novels of Milan Kundera show the impact of Surrealism. A whole generation of radical philosophers, psychoanalysts and literary critics grew up alongside and contributed to their experimentation. Among these, Jacques Lacan revitalized Freudian psychoanalytic approaches, Roland Barthes applied semiological methods to mass culture, and Michel Foucault addressed madness and history in his *Histoire de la Folie* (*Madness and Civilization*, 1961) and *Les Mots et les Chose* (*The Order of Things*, 1966). The overturning of philosophical and literary discourses by reference to psychoanalysis shared sources with Surrealist experiments.

The impact remains profound in visual culture. Echoes of the combined examples of Kurt Schwitters and Salvador Dalí may be found in the work of those who espoused assemblage and 'bricollage' – the gathering of objects. The use of chance and of juxtaposition became standard devices, as did the unleashing of the erotic. Marcel Duchamp was a pivotal figure in this process of diffusion, not least for his openness to new developments. In New York in the 1950s he provided a counterpoint to the

230
Jean
Tinguely,
*Homage to
New York (Self-
destroying
Assemblage)*,
1960.
Museum of
Modern Art,
New York

of Dada and Surrealist work – was again the predominant medium, speaking eloquently for the consumer society of the Margaret Thatcher years. The work of Tony Cragg and Bill Woodrow, for instance, took the use of bricollage to an unprecedented scale, gathering objects less in Surrealist juxtaposition than in a taxonomy of consumerism. The wittily entitled and knowingly shocking pickled animals of Damien Hirst take this tendency further, while veering towards the showmanship of Koons, Warhol and Dalí, whose notoriety Hirst has quickly come to rival. This is the alliance with money and fashion which Breton, in another time, had feared for ideological reasons but which, amid the shifting ideologies of Postmodern culture, is knowingly embraced.

With Dada and Surrealism now the common language of advertising and fashion, the link between artistic experimentation and political liberation has been uncoupled by the expedient of commercialism. In so doing, the potency of the imagery is diminished. At the same time, like the operatic arias used for television commercials, the repeated use of the language of the 'marvellous' has enriched these aspects of popular visual culture and facilitated an acceptance of the irrational in everyday life.

231
'Fish on a Bicycle', 1996. A still from a television commercial produced for Guinness plc by Ogilvy & Mather and directed by Tony Kaye

Glossary

Abstract Expressionism New York painters of the late 1940s and 1950s (especially Jackson Pollock, Robert Motherwell and Willem de Kooning), whose use of colour and gesture was **Expressionistic** and indebted to Surrealist **automatism**.

L'Amour fou (French, 'mad love') Intoxication of love recounted in Luis Buñuel's film *L'Age d'or* (1930) and **André Breton**'s book *L'Amour fou* (1937).

Art Brut (French, 'raw art') Term coined by Jean Dubuffet in 1945 to designate the art made by those outside conventional culture, often mental patients.

Art Deco Abbreviation from the Exposition des Arts Décoratifs (Paris, 1925), associated with 1920s design loosely derived from **Cubism**.

Arte Metafisica (Italian, 'metaphysical art') Enigmatic imagery of art developed by Giorgio de Chirico in Ferrara (1915–18) with Carlo Carrà and Giorgio Morandi.

Art Nègre (French, 'Negro art') Widely applied in the first half of the century to art of non-European tribal peoples; increasingly it was restricted to African art.

Assemblage Three-dimensional work, often made from 'found' material, without either the modelling or carving of traditional sculpture. See also **collage**.

Automatic writing 'Direct dictation of the unconscious mind', derived from Freudian associational techniques and used as a means towards a reinvigorated imagery, especially by **André Breton** and Philippe Soupault for *Les Champs Magnétiques* (1919). Presented without editing or correction.

Automatism Pictorial equivalent of **automatic writing**, aiming to liberate the composition from conscious control; doodling and more personal techniques (compare with **decalcomania**). **André Breton** defined Surrealism as 'pure psychic automatism'.

Avant-garde (French, 'advance guard') Term applied to writers and artists whose work proposed a formal and artistic change in defiance of convention. This was often associated with aspirations towards revolutionary philosophical and political change in society.

Bildarchitektur (German, 'painting-architecture') Lajos Kassák's term for hybrid constructivist collages made by members of the Ma group (1921).

Der Blaue Reiter (German, 'the blue rider') Munich-based **Expressionist** painters and writers around Wassily Kandinsky and Franz Marc. Their spiritual outlook is evident in their influential *Der Blaue Reiter Almanach* (1912).

Die Brücke (German, 'the bridge') Dresden- and Berlin-based group of **Expressionist** painters around Ernst Ludwig Kirchner and Karl Schmidt-Rottluff (1906–14).

Bruitisme (French, 'noise-ism') Music created by a co-ordination of noises; pioneered by Luigi Russolo's manifesto *Arte dei Rumori* (1913).

Cadavre exquis (French, 'exquisite corpse') Surrealist communal visual game in which different parts of a body are drawn by different participants.

Calligramme Term coined by Guillaume Apollinaire in 1914 for poems with a visual form – often literally depicting the subject. Compare with **parole in libertà**.

Cobra Post-World War II alignment of post-Surrealist artists from Copenhagen, Brussels and Amsterdam.

Collage (French, 'gluing') Work made of glued paper and often including found material. Compare with **assemblage** and **photomontage**.

Constructivism Form of predominantly geometrical abstraction, with an underlying social idealism associated with the Russian Revolution and wider social change in Europe.

Cubism Term (at first dismissive) applied to the work of Georges Braque, Pablo Picasso and others to characterize their fragmentation of objects, influenced by Paul Cézanne. Theoretical justification was offered in *Du Cubisme* (1912) by Albert Gleizes and Jean Metzinger.

Decalcomania Automatic Surrealist technique invented by Oscar Dominguez in 1935 in which wet paint is squeezed between sheets of paper which are then prized apart. **Max Ernst** adapted it for use with oil paint.

Époque floue (French, 'imprecise period') also called **époque de sommeils** (French, 'period of dreams') Pre-Surrealist period (1922–4) in which the *Littérature* group experimented with trances, gathering their verbal and visual results.

L'Esprit nouveau (French, 'the new spirit') Term coined by Guillaume Apollinaire (1917) to describe the postwar **avant-garde**; name adopted by a Purist periodical edited by Paul Dermée.

Expressionism Painting and writing, generally associated with Germany and central Europe, manifesting a heightened personal emotional

response. In painting, unmixed colours and gestural handling were often used especially by the artists of **Der Blaue Reiter** and **Die Brücke**.

Fauvism (from the French for *fauve*, 'wild beast') Name applied to works of Henri Matisse, André Derain and others at the 1905 Salon d'Automne; it became associated with and influential on **Expressionism**.

Found object Element from everyday life incorporated into or wholly constituting a work. Compare with **assemblage** and **readymade**.

Frottage (French, 'rubbing') Automatic Surrealist technique adapted by **Max Ernst** that involves taking a rubbing on paper from a textured surface.

Fumage (French, 'smoking') Automatic Surrealist technique invented by **Wolfgang Paalen** whereby paper is stained with blown smoke.

Futurism Milan-based movement launched by the poet Filippo Tommaso Marinetti in 1909. The painters (especially Umberto Boccioni and Carlo Carrà) were influenced by **Cubism**, but emphasized simultaneity, technology and urbanism.

Gesamtkunstwerk (German, 'total art work') An ideal synthesis of all the arts in a single experience.

Grattage (French, 'scrapping') Automatic Surrealist technique invented by **Max Ernst** as an equivalent to **frottage**. A freshly painted canvas is laid on a rough surface and the paint scraped off; the process is usually repeated or combined with **decalcomania**.

Humour noir (French, 'black humour') Term coined by **André Breton** for his book *L'Anthologie de l'humour noir* (1939) for writings characterized by a distanced or macabre humour.

Lautgedichte (German, 'sound poem') Poem in which sounds are the fundamental element.

Mechanomorphic Work in which machine parts assume human functions.

Montage (French, 'mounting') Cinema technique of fading from one image to the next.

Neo-Romantics Fashionable group of painters (especially Pavel Tchelitchev and Christian Bérard) identified by Jean Cocteau in 1926; their distortions of the figure offered a more widely acceptable version of Dalían illusionism.

Neue Sachlichkeit (German, 'new objectivity') Exacting, often critical, realism of the 1920s, especially in the painting of **George Grosz**, Christian Schad, Otto Dix and others.

Orphism or **Orphic Cubism** A term coined by Guillaume Apollinaire (derived from the Greek poet Orpheus) for the colouristic and psychological **Cubism** of Robert Delaunay, Fernand Léger, **Marcel Duchamp** and **Francis Picabia** of 1911–13.

Paranoiac critical method A theory proposed by **Salvador Dalí** for the simultaneous apprehension of two or more realities.

Parole in libertà (Italian, 'words in freedom') Onomatopoeic Futurist poetry freed of syntax and set in dynamic typography.

Phonetic poem Poem in which letters are pronounced individually. See also **Lautgedichte**

Photogram see **Schadograph**

Photomontage Collage of photographic images.

Purism Paris-based post-**Cubist** painting associated with Amédée Ozenfant and Charles-Édouard Jeanneret (Le Corbusier) that retained references to observed reality while evoking classical and machined forms.

Rappel à l'ordre (French, 'recall to order' or 'return to order') Renewal of interest in the human figure and Classicism after World War I.

Rayograph see **Schadograph**

Readymade A term coined by **Marcel Duchamp** for unaesthetic manufactured objects selected and exhibited with minimal intervention.

Schadograph also **Rayograph** and **photogram** Camera-less photograph achieved by placing objects on light-sensitive paper and exposing them to light. Discovered independently by Christian Schad in Geneva in 1919, **Man Ray** in Paris and László Moholy-Nagy in Berlin in 1921.

Simultaneity The multiplicity of urban experience associated with Henri Bergson's theory of 'L'Elan vital' (vital energy). Used to describe paintings presenting several different aspects of reality simultaneously.

Simultaneous poem Poem in which several parts are spoken at once.

Socialist Realism Optimistic realistic painting following dictates of Stalinist cultural policies.

Solarization Photographic technique discovered by **Lee Miller** in which premature exposure creates an outlining aura.

Sound poem see **Lautgedichte**

Surrealist object Objects produced from 1929 by **Salvador Dalí** and others that function symbolically or provocatively in the real world.

Brief Biographies

Louis Aragon (1897–1982) Poet and polemicist. Having served as a medical auxiliary in World War I, he co-founded *Littérature* (1919–24) with **André Breton** and Philippe Soupault: it became a mouthpiece for Dada. He helped to define Surrealism. He attacked orthodox literature in *Traité du style* (1928) and defended **collage** in *La Peinture au défi* (1930). He moved to the Stalinist Communist Party in 1932. In 1934 he began a cycle of ten novels, *Le Monde réel*. His poetry of resistance won him acclaim, and his editorship of *Les Lettres françaises* ensured his postwar importance.

Hans/Jean Arp (1887–1966) Painter, sculptor and poet. By 1912 he embraced the new abstract art. In Zurich in 1915 he met **Sophie Taeuber** (they married in 1921) and in the following year he joined the Cabaret Voltaire, playing a central part in Zurich Dada. He collaborated with **Max Ernst**, **Kurt Schwitters** and El Lissitzky in postwar Germany. In Paris, from 1925, he collaborated both with Surrealist and Constructivist groups and his organic sculptures established a world-wide reputation.

Hugo Ball (1886–1927) Poet. Active in .**Expressionist** theatre (1912–14), he was familiar with Wassily Kandinsky's abstraction in Munich. After participating in anti-war protests with **Richard Huelsenbeck**, Ball and Emmy Hennings fled to Zurich where they founded the Cabaret Voltaire (February 1916). Ball conceived the **Lautgedichte** as a return to the fundamentals of language; co-director with **Tristan Tzara** of the Galerie Dada (1917), he then distanced himself from Dada. With the support of Hennings, Ball composed his retrospective diary of Dada, *Die Flucht aus der Zeit* (1946), in conditions of extreme austerity.

André Breton (1896–1966) Poet and polemicist. After serving as a wartime medical auxiliary, he co-founded the periodical *Littérature* (1919–24) with **Louis Aragon** and Philippe Soupault, which became a mouthpiece for Dada. He was married to Simone Kahn in 1921–9. Breton established Surrealist theory through his *Manifeste du surréalisme* (1924) and the *Seconde Manifeste du surréalisme* (1930) in which the ideas of the Comte de Lautréamont, Sigmund Freud and Karl Marx were combined towards a revolution of the mind. He edited the periodical *La Révolution surréaliste* (1925–9) and published *Le Surréalisme et la peinture* (1928) and narratives of love (*Nadja*, 1928; *L'Amour fou*, 1938). His gravitation towards Leon Trotsky, whom he visited in Mexico in 1938, deprived him of close allies. He went into wartime exile in New York (1941–6). He married Jacqueline Lamba in 1934, separating in 1942. He married Elisa Claro in 1945. On returning to Paris, Breton's polemics were sustained through *Le Surréalisme, même* (1956–9) and other periodicals.

Leonora Carrington (b.1917) Painter and writer. She lived with **Max Ernst** at Saint-Martin d'Ardèche (1938). On Ernst's wartime internment, Carrington crossed to Spain and was committed to an asylum – described in *Down Below* (1944). She reached Mexico (via New York) in 1942 where she joined Benjamin Péret and Remedios Varo, and married the photographer Imre Weisz. In 1985 she moved to New York.

Salvador Dalí (1904–89) Painter. He adopted **Cubist** and Surrealist styles for his debut at the Galerie Dalmau, Barcelona (1925). Following the film *Un Chien andalou* (1929), made with **Luis Buñuel**, he joined Surrealism. His '**paranoiac-critical method**', **Surrealist object** and pictorial illusionism revitalized the movement in the 1930s. He was expelled in 1936 for political ambivalence. Supported by his wife Gala, he exploited his fame in America during the war. Dalí's provocations reached new heights in the 1960s when he conceived his museum in Figueres, completed shortly before his death.

Marcel Duchamp (1887–1968) Artist and chess master. He abandoned **Cubism** in 1912 and with **Guillaume Apollinaire** and **Francis Picabia** he opened the possibilities of conceptual forms, such as the '**readymade**'. In New York he made *The Large Glass* (1915–23) and coordinated Dadaistic activities. In the 1920s he become a French chess international. He designed Surrealist exhibitions (from 1938) and issued the miniaturized compendium of his works, *Le Boite-en-valise* (from 1941). His ironic and intellectual art established Duchamp's postwar influence.

Paul Éluard (1895–1952; pseudonym of Eugène Grindel) Poet. Served in World War I and met his future wife Gala while recuperating. He joined Paris Dada and Surrealism. He was acknowledged as the movement's greatest lyrical poet, publishing *Capitale de la douleur* (1926), *L'Amour la poésie* (1929) and *Facile* (1935). Gala left him for **Salvador Dalí** in 1930; Éluard married Nusch in 1934. He broke with **André Breton** to join the Communist Party (1938). Active in the Resistance, the popularity of his poetry made him an important Party figure.

Max Ernst (1891–1976) Artist. Following war service he formed Cologne Dada (1919) with Johannes Baargeld and showed collages at their notorious Dada Vorfrühling exhibition (April 1920). Ernst participated in Paris Dada through his friendship with **Paul Éluard** and joined Surrealism. He invented the 'automatic' techniques of **frottage** and **grattage**, and experimented with **collage** novels (from 1929) and **decalcomania** oil painting (from 1938). With the war, internment separated him from **Leonora Carrington**, but in 1941 he reached New York with Peggy Guggenheim, to whom he was briefly married. Ernst settled with Dorothea Tanning in Arizona in 1946, but they returned to France in 1953.

George Grosz (1893–1959) Painter and satirist. Fellow anti-war protester with **John Heartfield**, he joined Club Dada (1918) and the German Communist Party (1919). His drawings satirizing the establishment achieved a wide audience. Disillusioned by the Soviet Union in 1924, his depiction of decadent Berlin was associated with **Neue Sachlichkeit**. Fleeing the Nazis, Grosz emigrated to America in 1933 and became increasingly conservative in his view of new art.

Raoul Hausmann (1886–1971) Photo-monteur and poet. With the self-publicist Johannes Baader he joined Club Dada in 1918. Hausmann became a leading figure, publishing the periodical *Der Dada*. With **Hannah Höch** he was one of the inventors of **photomontage**; with **Kurt Schwitters** he developed the phonetic poem. On the rise of the Nazis he moved to Ibiza (1933–6) and then established himself reclusively in France.

John Heartfield (1891–1968; pseudonym of Helmut Herzfeld) Photomonteur. With his brother Wieland Herzfelde and **George Grosz** he undertook anti-war protests manifested in his Anglicized pseudonym. He joined Club Dada (1918) and the German Communist Party (1919), producing **photomontages** for his brother's publishing house Malik Verlag. Because of his anti-Nazi work, the brothers fled to Prague in 1933 and London in 1938. He moved to Leipzig in 1950 and East Berlin in 1957.

Hannah Höch (1889–1978) Photomonteur and painter. Joined Club Dada with **Raoul Hausmann**, developing **photomontage**. She collaborated with **Hans Arp** and **Kurt Schwitters** and Theo van Doesburg after leaving Hausmann in 1922. In The Hague with Til Brugmann (1926–9) she was in contact with De Stijl. She returned to Berlin in 1929 and survived Nazism and postwar partition.

Richard Huelsenbeck (1892–1974) Poet. After anti-war protests with **Hugo Ball** in Berlin he joined the Cabaret Voltaire in Zurich (February 1916) and performed sound poems (*Phantastische Gebete*, 1916). Establishing the Club Dada in Berlin (1918) he attracted **Raoul Hausmann**, **John Heartfield** and others to more directly political aims. In 1920 he published *Dada*

Almanach and *En Avant Dada*. He served as a ship's doctor (1922–33) before practising as a Jungian analyst in New York (1936–69) as Dr Charles Hulbeck. In *Mit Witz, Licht und Grütze* (1957) he de-politicized his memories of Dada in response to the Cold War.

Marcel Janco (1895–1984) Painter and architect. Studying architecture in Zurich he was encouraged in his painting by **Tristan Tzara** and performed at the Cabaret Voltaire (February 1916). His designs epitomized Dada's use of the ephemeral. With **Hans Arp** and Hans Richter he established groups favouring abstraction (Das Neue Leben, 1917; Groupe des Artists radicaux, 1919). In Bucharest he founded the periodical *Contimporanul* (1920–30) and practised as an architect. On the coming of war he emigrated to Israel and founded the Ein Hod artist's community.

Frida Kahlo (1907–54) Affected by childhood polio and a bus crash (1925), she began to paint. She joined the Communist Party in 1928 and married the muralist Diego Rivera in 1929. Supporting Leon Trotsky during his Mexican exile (1936–40), she met **André Breton** in 1938. Kahlo contributed to the Surrealist exhibition in Mexico City (1940) but remained independent. Illness and invalidity restricted her work; her home became the Museo Frida Kahlo.

Wifredo Lam (1902–82) Painter. After studies in Havana he lived in Spain (1923–38) and fought in the Civil War. He met Pablo Picasso in Paris (1938) and the Surrealists in Marseille (1940–1). With Hélène Holzer he returned to Cuba where local religious mysteries informed *The Jungle* (1942). Maintaining contact with Cuba and Paris he settled in Albisola, Italy (1960).

René Magritte (1898–1967) Painter. Through contact with Paul Nougé's *Correspondance* group he formed the Belgian Surrealists (1926) and was its best-known artist. He collaborated with E L T Mesens on the publication of *Marie* (1926). Magritte lived in Paris in 1927–30 without fully integrating with **André Breton**'s movement. Appreciation for his exposure of the disjunction between image and meaning grew in the 1930s. He introduced Marcel Mariën to the Brussels group in 1937. Magritte temporarily adopted a looser style during the war. Subsequently he returned to more surreal imagery rivalling **Salvador Dalí** in popularity.

Man Ray (1890–1976; pseudonym of Emmanuel Radnitsky) Painter and photographer. In 1915 in New York he encountered **Francis Picabia** and **Marcel Duchamp**, with whom he collaborated. In Paris from 1921 he moved to Dada and then Surrealism establishing himself as an innovative photographer. He invented **Rayographs** and **solarization** with his assistant **Lee Miller**. He made several short films. Man Ray spent a decade in Hollywood but returned to Paris in 1951.

André Masson (1896–1987) Painter. He was associated with **Cubism**. At rue Blomet he

was a neighbour of **Joan Miró** and the centre of the intellectual group which joined Surrealism. He pioneered automatic drawing and sand painting (1926–7). Distancing himself from **André Breton**, he contributed to Georges Batalle's periodical *Documents* and then moved to Spain (1934–7). His friendship with Breton revived in 1937–41, and he moved to New York where his **automatism** influenced the **Abstract Expressionists**. On his return to France in 1945 Masson assumed a course independent of Surrealism.

Matta (Roberto Matta Echaurren; b.1911) Painter. Trained as an architect before joining the Surrealists in 1937 and developing the 'psychological morphologies'. In New York in 1941–2 he explored **automatism** with the young American painters who would form **Abstract Expressionism**. **André Breton** expelled him from the Surrealists in 1947, although he was reintegrated a decade later. In Paris, London and Rome since the 1960s Matta has remained an indefatigable activist.

Lee Miller (1907–77) Photographer. She was a New York model before becoming **Man Ray**'s assistant in Paris (1929–32), where she discovered **solarization**. She established her own photographic studio in New York in 1932–4. After periods in Cairo and Paris she settled with Roland Penrose in wartime London. Miller documented the Blitz and the Allied advance into Germany (1944–6). Her reputation was only re-established posthumously.

Joan Miró (1893–1983) Painter and sculptor. He developed a colourful **Cubist** style before going to Paris late in 1919. A neighbour of **André Masson**, he participated in the rue Blomet group which joined Surrealism in 1924. Close to **Hans Arp**, his calligraphic style was influential on **Yves Tanguy** and **Salvador Dalí**, but he gravitated to the *Documents* group in 1929. He supported the Republicans in the Spanish Civil War but settled in Mallorca. Success in the postwar years allowed him to establish Foundations in both Barcelona and Palma.

Meret Oppenheim (1913–85) Painter and object maker. Introduced into Parisian Surrealism by Alberto Giacometti and **Hans Arp** (1932), she made the quintessential Surrealist object, *Fur Covered Tea Cup, Saucer and Spoon* (1936). In Basel from 1937 she entered a period of artistic uncertainty returning to academic drawing and Jungian analysis. Resuming painting in Bern in 1954, Oppenheim contributed to the Surrealists' EROS exhibition in Paris (1959).

Wolfgang Paalen (1905–59) Painter. While studying in Munich he discovered Cycladic art. In Paris he joined the Surrealists in 1936. He invented **fumage** in 1937. With Alice Rahon he visited Alaska and Mexico in 1939 where they organized the 1940 Surrealist exhibition with César Moro. In Mexico during the war he broke with **André Breton** and launched the periodical *Dyn* (1942–4). Paalen was reconciled with Surrealism in postwar Paris (1950–4); he committed suicide in Mexico.

Francis Picabia (1879–1953) Painter, poet and polemicist. Rejecting his Post-Impressionism, he embraced abstraction through contact with Guillaume Apollinaire and **Marcel Duchamp**. With Gabrielle Buffet he visited New York for the Armory Show (1913) and returned in wartime (1915 and 1917). There, and in intervening stays in Barcelona, he made scurrilous and critical works and published the itinerant periodical *391* (1917–24). After encountering **Tristan Tzara** he became the major Dada artist in Paris until its disintegration in 1921. In the South of France in the 1920s and 1930s he painted overlaid 'transparencies' and nudes before returning to abstraction in the 1940s.

Kurt Schwitters (1887–1949) Collagist and poet. Assembling **found objects** and **collages** from discarded papers he was nevertheless prevented from joining Berlin Dada for lack of political commitment. He founded Merz in 1920 and collaborated with **Raoul Hausmann**, **Hannah Höch**, **Hans Arp** and Theo van Doesburg. He launched the periodical *Merz* (1923–32) which reflected his commercial design work; he also began constructing the *Merzbau* in his house. Fleeing the Nazis, Schwitters moved to Norway in 1937 and then England in 1940, making a *Merzbau* in each place; only the beginnings of the last survive.

Sophie Taeuber (1889–1943) Painter and designer. She became a member of the craft Zurich Werkbunde (1915–32) and taught textile design at the Kunstgewerbeschule (1916–29). She met **Hans Arp** in 1915 and was associated with Dada and the Laban dancers. She and Arp built a house at Meudon, Paris, and were active in Abstraction-Création. Avoiding the German occupation they moved to Grasse but Taeuber died in an accident in Zurich.

Yves Tanguy (1900–55) Painter. With Marcel Duhamel and Jacques Prévert he joined Surrealism in 1925. Encouraged by **André Breton** and the example of **Joan Miró** his paintings reflecting amorphous space became more desert-like after a trip to North Africa in 1930. They influenced **Matta**'s automatism in 1938–40. Tanguy and Kay Sage moved to America in 1939, preparing for the Surrealist exile, and remained there after the war.

Tristan Tzara (1896–1963; pseudonym of Sami Rosenstock) Poet and polemicist. After inclining towards Symbolism, he went to study in Zurich. With **Marcel Janco** he performed at the Cabaret Voltaire (February 1916) and succeeded **Hugo Ball** – with whom he co-directed the Galerie Dada (1917) – as the chief promoter of Dada, editing the periodical *Dada* (1917–22). Contact with **Francis Picabia** and **André Breton** in 1918 led to the chaotic period of Paris Dada (1919–24). After a period of independence, Tzara aligned with Surrealism in the 1930s, but chose the Communist Party and the Resistance in occupied France. He remained vocal in postwar cultural politics.

Key Dates

Dada & Surrealism

1912 Munich: Hans Arp contributes to *Der Blaue Reiter Almanach*. Hugo Ball director at Kammerspiele theatre. Marcel Duchamp visits. Paris: Guillaume Apollinaire's *Les Peintres cubistes* and *Méditations éstetiques*

1913 Milan: Luigi Russolo's manifesto *Arte dei rumori*; Marinetti's Balkan War book *Zang Tuum Tumb*. New York: Armory Show (February–March). Paris: Apollinaire publishes *Alcools*; Duchamp selects *Bicycle Wheel*, the first readymade

1914 Paris: Apollinaire publishes 'calligrammes' in *Les Soirées de Paris*; Arp meets Pablo Picasso. Zurich: Walter Serner and Conrad Milo found Cabaret Pantagruel and periodical *Sirius*

1915 New York: Alfred Stieglitz's and Marius De Zayas's periodical *291*. Arriving exiles include Duchamp, Francis Picabia and Gabrielle Buffet, Jean Crotti, Alfred Gleizes and Juliette Roche. Man Ray publishes *The Ridgefield Gazook*. Duchamp begins *The Large Glass* (1915–23). Zurich: Arp, Otto and Adya van Rees exhibit together (November)

1916 Budapest: Lajos Kassák establishes periodical *Ma*. Paris: Establishment of Pierre Albert-Birot's periodical *SIC* (January) and Pierre Reverdy's *Nord–Sud* (March). Zurich: Ball and Emmy Hennings open Cabaret Voltaire (February) with Arp, Richard Huelsenbeck, Marcel Janco and Tristan Tzara. Term 'Dada' coined (April). *Cabaret Voltaire* published (June). Contact with Sophie Taeuber and Laban dancers. Hans Richter arrives (September)

1917 Barcelona: Picabia's periodical *391*; visits New York (March). New York: Duchamp's *Fountain* causes controversy at Society of Independent Artists (April), publicized through *The Blind Man* and *391*. Paris: Jean Cocteau, Eric Satie and Picasso collaborate on ballet *Parade* (May); Apollinaire's play *Les Mamelles de Tirésias* (June). Rome: Enrico Prampolini launches *Noi* (June). Zurich: Dada exhibition (January), followed by Galerie Dada (March–May); six soirées and Tzara's periodical *Dada* (July and December)

1918 Berlin: Huelsenbeck's *Dadaistiche Manifesto* launches Club Dada (April), joined by Raoul Hausmann, Hannah Höch, John Heartfield, George Grosz and Johannes Baader.

A Context of Events

1912 Atlantic: Sinking of the Titanic (April). Balkan War: Greece, Bulgaria, Montenegro and Serbia unite in attack on Ottoman Empire

1913 Balkans: Second Balkan War: Greece, Romania, Montenegro and Serbia unite to curb Bulgarian expansion. Mexico: Revolutionary Pancho Villa controls the north

1914 Sarajevo: Assasination of Archduke Franz Ferdinand of Austria (June) sparks World War (August). Austria-Hungary and Germany confronted by Russia, France and Britain. Germans invade France through Belgium and rout Russians at Tannenberg

1915 Gallipoli: British land ANZAC troops at Dardanelles (April); retreat (December). Lemburg, Galicia: Austrians defeat Russians (June); further defeat at Brest-Litovsk (August). Ypres: 69,000 British soldiers killed or captured. Rome: Italy declares war on Austria-Hungary (May). Zimmerwald: Socialist Peace Congress. Zurich: Lenin in exile, planning Russian Revolution

1916 Bucharest: Romania declares war on Austria-Hungary (August), but overrun by December. Kienthal, Switzerland: Socialist Peace Congress. Somme: Combined British and French attack (July–November). Verdun: Six months of sustained assault by German army (February–July). Vienna: Death of Emperor Franz Josef

1917 Caporetto: Heavy defeat (October) results in Italian retreat. Petrograd: February Revolution and abdication of Tzar (March) followed by Lenin's Bolshevik Revolution (October). Washington: United States enters war (April) in response to German unrestricted submarine warfare. Ypres: Third battle of Ypres (Passchendaele)

1918 Berlin: Armistice (November), abdication of Kaiser and Republic declared. Communist Spartacist Revolution. Peace settlement establishes Poland, Latvia, Estonia

Paris: Apollinaire publishes *Calligrammes*; dies of influenza (November).
Tbilisi: Aleksei Kruchenykh and Ilia Zdanevich form 41° group.
Zurich: Arp, Taeuber and Janco found Das Neue Leben (April). Tzara publishes *Vingt-cinq poèmes* and *Dada 3* (December)

and Lithuania.
London: Women get the vote (December).
Moscow: Peace of Brest-Litovsk removes Russia from war (March); Leon Trotsky organizes Red Army in Civil War.
Vienna: Peace settlement establishes Czechoslovakia and Yugoslavia, allotting Trento to Italy and forming republics of Austria and of Hungary

1919 Berlin: Heartfield's photomontages in *Jedermann sein eigner Fussball* (February).
Cologne: Max Ernst and Baargeld publish *Der Ventilator* and *Bulletin D*. Formation of 'Stupid' group.
Paris: André Breton, Louis Aragon and Philippe Soupault found *Littérature* (1919–24). Picabia scandalizes Salon d'Automne. Breton and Soupault's *Les Champs Magnétiques*.
Zurich: *Dada 4–5* (May) marks convergence of Zurich, New York and Barcelona activities. Arp, Janco and Richter establish Radikalen Künstler (May)

1919 Berlin: Murder of Communist leaders Karl Liebknecht and Rosa Luxemburg (January); Weimar Republic established (July).
Budapest: Hungarian Soviet (March); conservative backlash enforced by Romanian invasion.
Cologne: French, British and Belgian troops establish de-militarized Rhineland.
Paris: Victory of right in election of Chambre Bleu Horizon

1920 Berlin: Hausmann publishes periodical *Der Dada* (April). Erste International Dada-Messe exhibition (June) accompanied by Huelsenbeck's *Dada Almanach* and *En Avant Dada*.
Cologne: *Die Schammade* (February); Ernst and Baargeld exhibition Dada Vorfühling (April).
Hanover: Kurt Schwitters establishes Merz.
Paris: Première Vendredi de Litérature (23 January) marks Tzara's arrival. Picabia exhibition at Galerie Povolozky (December).
Prague: Baader, Huelsenbeck and Hausmann Dada tour. Karel Teige founds Devětsil group

1920 Dublin: Bloody Sunday killing of British officials (November).
London: League of Nations established (February) without participation of America.
Washington: Prohibition.
Moscow: End of Civil War (November).
Tours: Founding of French Communist Party

1921 Mexico City: Manuel Maples Arce manifesto *Actual* (December) launches Estridentismo.
Paris: Ernst exhibition at Galerie Au Sans Pareil (May). Barrès trial (13 May); Picabia breaks with Dada. Salon Dada at Galerie Montaigne (June). Duchamp and Man Ray arrive from New York. Crotti and Duchamp-Crotti launch 'Tabu'. Man Ray exhibition (November).
Prague: Schwitters, Hausmann and Höch on Anti-Dada Merz Tour.
Zagreb: Ljubomir Micić establishes *Zenit*

1921 Dublin: Truce (July) followed by establishment of Irish Free State (December)

1922 Düsseldorf: Theo van Doesburg, Richter, Prampolini and Hausmann at Internationalen Kongress für fortschrittliche Kunst (May).
Paris: Congrès de Paris (February) divides Breton and Tzara. Georgio De Chirico exhibition (April).
Weimar: Schwitters, Arp, Tzara and van Doesburg at Konstructivisten-Dadaisten Kongress (September)

1922 Berlin: Rapid inflation.
Rapallo: Germany and Soviet Union sign treaty.
Rome: Fascists seize power in March on Rome, Mussolini forms government (October)

1923 The Hague: van Doesburg and Schwitters on tour of Holland.
Paris: Tzara's 'Soirée de la Coeur à Barbe' (July)

1923 Ruhr: French invade over German failure to pay reparations (January); inflation and unemployment (2·6 million) spiral

1924 Brussels: Camille Goemans and Paul Nougé edit *Correspondance*.
Paris: Aragon 'Une Vague de rêves' and Breton's *Manifeste du surréaliste* establish new movement; *La Révolution surréaliste* (1924–5). Picabia and Satie *Relâche* for Ballets Suedois (November) and René Clair's film *Entr'acte*

1924 Moscow: Death of Lenin (January) leads to power struggle between Trotsky and Joseph Stalin.
Paris: Victory of left in election of 'cartel des gauches' (May).
Rome: Fascists murder Socialist Deputy, Giacomo Matteoti (June)

1925 Berlin: Experimental films by Viking Eggeling and Richter shown by November Group (May). Paris: Breton editor of *La Révolution surréaliste* (1925–9). *La peinture surréaliste* exhibition (June). Surrealists and *Clarté* joint manifesto 'La Révolution d'abord et toujours!' (October)

1925 Berlin: Paul von Hindenburg elected President. Morocco: Colonial revolt of 'Guerre du Rif'. Paris: French withdrawal from Ruhr. Exposition des Arts Décoratifs

1926 Brussels: Goemans, Nougé, E L T Mesens and René Magritte form Belgian Surrealist group. Paris: Aragon publishes *Le Paysan de Paris*; Éluard, *Capitale de la douleur*. Ernst publishes *Histoire Naturelle*; has a solo exhibition (March). Christian Zervos publishes *Cahiers d'Art*. Galerie Surréaliste (1926–8) opens with Man Ray exhibition. Independence from Communists signalled in *Légitime Défense* (September)

1926 London: British General Strike (May)

1927 Paris: Antonin Artaud's *Le Coquille et le Clergyman* made into a film; Robert Desnos publishes *La Liberté ou l'amour*; René Crevel publishes *Babylone*. Breton, Aragon, Éluard, Benjamin Péret and Pierre Unik join Communist Party with manifesto *Au Grand Jour*. Prague: Teige's periodical *Red* (1927–9)

1928 Barcelona: Salvador Dalí, Lluis Montanyà and Sebatià Gasch publish *El Manifiesto antiartistico Catalán*. Paris: Breton publishes *Nadja* and *Le Surréalisme et la peinture*; Aragon publishes *Traité du style*

1928 Moscow: Stalin's Five Year Plan for industrialization; Trotsky expelled from party. Paris: Briand–Kellogg Pact (August)

1929 Paris: *Seconde Manifeste du surréalisme* expels Artaud, Soupault, André Masson, Desnos and others associated with *Documents*. Luis Buñuel's and Dalí's film *Un Chien andalou*. Ernst's first collage novel, *La Femme 100 têtes*

1929 Moscow: Trotsky banished. New York: Wall Street Crash (October) leads to Depression. Paris: Construction ordered of Maginot Line of defences in East

1930 Brussels: Magritte returns from Paris; collaboration with Parisian group on *Variétés*. Kharkov: Aragon represents Surrealism at Conference of Revolutionary Writers. Paris: Aragon *La Peinture au défi*, Breton *Seconde Manifeste du surréalisme* (1930); Tzara joins Surrealists. New periodical *Le Surréalisme au service de la révolution* (1930–3). Buñuel's film *L'Age d'or* banned

1930 Berlin: Allied troops leave Rhineland (June); parliamentary gains for Hitler's National Socialist Party (September). 4·4 million unemployed. Jalapur: Mahatma Gandhi, salt march. Moscow: Suicide of Vladimir Mayakovsky (April)

1931 Paris: Dalí develops 'symbolically functioning object'; Alberto Giacometti joins Surrealism

1931 Berlin: Financial crisis. 5·7 million unemployed. London: Government of National Unity. Madrid: Establishment of Spanish Republic

1932 Paris: Aragon moves to the Communist Party, and Georges Sadoul, Unik and Buñuel follow. Prague: Devětsil Poesie 32 exhibition includes Surrealist work. Tokyo: Conféderation des artistes d'avant-garde Paris–Tokyo exhibition

1932 Berlin: Hindenburg wins Presidential election; National Socialist gains in local elections. Paris: President Paul Doumer assassinated (May). Port Arthur: Japanese seize Manchuria (February). Washington: Franklin D Roosevelt elected President

1933 Paris: Victor Brauner joins Surrealists. Ernst's collage novel, *Une Semaine de bonté*. Dalí expelled by Surrealists

1933 Berlin: Adolf Hitler becomes Chancellor (January). Reichstag fire (February). Washington: President Roosevelt's New Deal to combat the Depression

1934 Brussels: Mesens coordinates Documents 34 and Minotaure exhibition. Paris: Surrealists contribute to *Minotaure*

1934 Paris: French General Strike

(1934–9).
Prague: Vítězslav Nezval establishes Prague
Surrealist group (March)

	Dada & Surrealism	A Context of Events
1935	Brussels: Third *Bulletin International du surréalisme* (August). Paul Delvaux exhibits with Surrealists. Paris: Breton and Éluard expelled from Communist Party; Crevel commits suicide (June). Prague: Éluard and the Bretons on lecture tour; first *Bulletin International du surréalisme* (May). Santa Cruz de Tenerife: Péret and the Bretons open International Surrealist exhibition organized with *Gaceta de Arte*; second *Bulletin International du surréalisme*	**1935** Abyssinia: Italian invasion
1936	London: David Gascoyne's *A Short Survey of Surrealism*; with Roland Penrose plans International Exhibition of Surrealism (June). Fourth *Bulletin International du surréalisme*. New York: Museum of Modern Art exhibition *Fantastic Art Dada and Surrealism*. Paris: Exhibition of Surrealist objects at Galerie Charles Ratton. Georges Bataille founds periodical *Acéphale* (1936–9)	**1936** London: Edward VIII abdication crisis (December) Madrid: Election of Popular Front sparks right-wing mutiny and Spanish Civil War. Federico García Lorca killed by Falangists (July). Moscow: Show trials purging party of opponents to Stalin. Paris: Election victory of Popular Front. Rhineland: Re-militarized. Berlin Olympic Games
1937	Paris: Breton publishes *L'Amour fou*. Short-lived Surrealist Galerie Gradiva	**1937** Munich: Nazis' Entartete Kunst exhibition. Paris: Exposition International, Picasso's *Guernica* in Spanish Republican Pavilion
1938	London: London Gallery and *London Bulletin* coordinated by Mesens. Penrose buys Éluard's collection. Mexico City: Breton visits Trotsky, meets Diego Rivera, Frida Kahlo and establishes Trotskyist FIARI. Paris: Exposition Internationale du Surréalisme. Éluard joins Communist Party	**1938** Barcelona: Fall of city to General Franco's Falangists. Munich: Daladier and Neville Chamberlain acquiesce in Hitler's annexation of Sudetenland from Czechoslovakia (September). Vienna: German annexation of Austria, the Anschluss (March); Sigmund Freud escapes to London
1939	Mexico City: Wolfgang Paalen and Alice Rahon arrive; César Moro edits *El Uso del Palabra*. Paris: With war, German Surrealists interned	**1939** Prague: Hitler invades Czechoslovakia (March). Spain: Capitulation of Republican Government. Tirana: Benito Mussolini invades Albania (April). Warsaw: Hitler invades Poland (September), divided with Stalin by non-aggression pact (August). Britain and France declare war on Germany; lack of conflict in 'Phoney war'
1940	Marseille: Protected by American Committee for Aid to Intellectuals, the Surrealists gather for exile. Ernst, Hans Bellmer and Wols interned by Germans. Mexico City: Paalen, Rivera and Moro co-ordinate Surrealist Exhibition (January). New York: Charles Henry Ford and Parker Tyler establish *View*; Gordon Onslow-Ford lectures on Surrealism. Paris: Aragon, Éluard, Desnos and Tzara join Resistance	**1940** Copenhagen: Germans take Denmark and invade Norway (April). London: Winston Churchill becomes Prime Minister (May). Blitz (September–December). Paris: Germans take Luxembourg, The Netherlands and Begium, and invade France (May). Evacuation of Dunkirk; Hitler in Paris (June), divides France into occupied zone and Vichy Republic under Marshal Pétain. Vilnius: Soviet invasion of Baltic states, Lithuania, Latvia and Estonia (June)
1941	Havana: Wifredo Lam returns to Cuba. New York: Massons and Bretons arrive. Group around Matta includes Gerome Kamrowski, William Baziotes and Robert Motherwell	**1941** Moscow: German surprise invasion, follows occupation of Yugoslavia and Greece. Washington: United States enters war following Japanese attack on Pearl Harbor (December)
1942	London: Surrealists split between Mesens and Toni del Renzio.	**1942** El Alamein: Allied Victory in North Africa (October).

Dada & Surrealism

Mexico City: Paalen establishes *Dyn* (1942–4), breaking with Surrealism. Breton establishes *VVV* (June) publishing 'Prolegomena to a Third Surrealist Manifesto or Not'. First Papers of Surrealism and Art of this Century exhibitions (October).
Prague: Death of Jindřich Styřský

1943 New York: Masson publishes *Anatomy of my Universe*. Duchamp's *Large Glass* shown at Museum of Modern Art

1944 New York: Richter's film *Dreams that Money Can Buy*. Breton *Arcane 17*

1945 Paris: Picasso joins Communist Party.
New York: Lam's *La Jungla* bought by Museum of Modern Art.
Terezin: Desnos dies in concentration camp

1946 Paris: Breton returns (May); Artaud released from asylum (June)

1947 New York: Nicholas Calas organizes Bloodflames exhibition, including Matta and Arshile Gorky.
Paris: Breton relocates Surrealism in *Rupture inaugural* (June) and Surréalisme en 1947 exhibition (July). Jean Dubuffet establishes Société de l'Art Brut

1948 Paris: Galerie Solution Surréaliste opened. Breton expels Matta and supporters including Brauner and editors of *Néon* (1948–9). Death of Artaud

1949 Paris: Dubuffet *L'Art Brut préféré aux arts culturels*

1950 Paris: Breton and Péret *Almanach surréaliste du demi-siècle*

1951 Paris: Jean Schuster's periodical *Médium*

1952 Paris: Galerie L'Etoile scellée opened.
Prague: Teige commits suicide on facing arrest

1954 Brussels: Marcel Mariën launches *Les Lèvres nues* (1954–60)

1956 Paris: Breton edits *Le Surréalisme, même* (1956–9). Protests against Algerian War and suppression of Hungarian uprising

1959 Paris: *EROS* exhibition

1960 New York: *Surrealist Intrusion in the Enchanter's Domain* exhibition

1961 Milan: Tenth International Exhibition, Galleria Schwarz.
Paris: Breton founds *La Brèche* (1961–5)

1966 Chicago: Franklin Rosemont founds Chicago Surrealist group.
Paris: Deaths of Breton, Brauner and Arp

A Context of Events

Midway, Pacific: US defeat Japanese fleet (June).
Singapore: Japanese invade (February).
Stalingrad: Pivotal siege (to 1943) in reversing German advances

1943 Sicily: Allied landings (July); Mussolini deposed; Italian armistice (September).
Stalingrad: German defeat

1944 Paris: Allied Normandy landings; Paris liberated (August).
Rome: Anzio landings; Rome liberated (June)

1945 Berlin: Armistice, end of War in Europe (May). Revelation of 'Death Camps'. Germany partitioned between four allies.
Hiroshima and Nagasaki: H-bombs dropped on civilians (August) and end of Pacific War.
San Francisco: United Nations established (February)

1946 Nuremburg: Nazi War Criminal Trials

1947 Budapest: Communist coup (June).
Delhi: Partition and Independence of India (August)

1948 Delhi: Mahatma Gandhi assassinated (January).
Prague: Communist coup (February)

1949 Bonn: Establishment of Federal Republic from zones of three western occupiers

1950 Pyongyang: Korean War (June)

1951 Korea: UN troops intervene against Chinese (January)

1956 Budapest: Hungarian uprising crushed by Russians (November).
Suez: French and British abort seizure of canal (November)

1961 Berlin: Building of Wall dividing West Berlin from East Germany.
Washington: John F Kennedy inaugurated President (January)

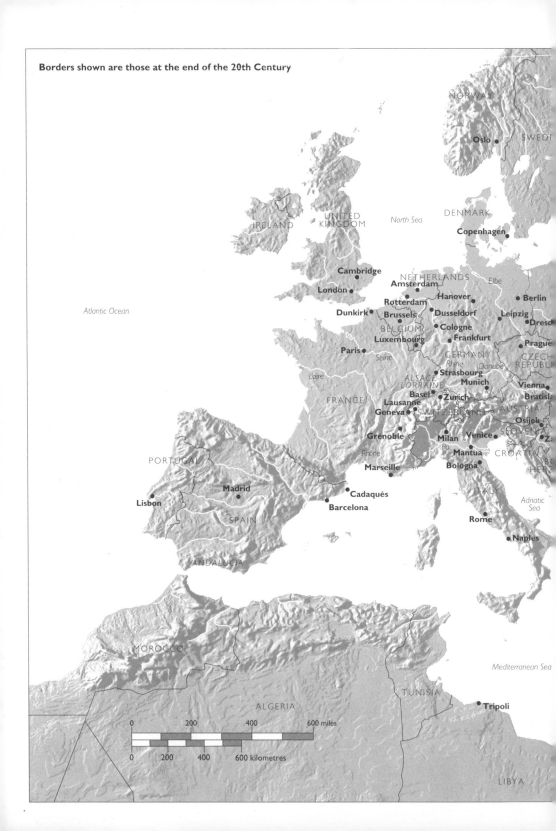

Borders shown are those at the end of the 20th Century

Further Reading

Periodicals

Facsimilies of Dada periodicals are in the following:

Marc Giroud (ed.), *Dada, Zurich Paris, 1916–1922* (Paris, 1981)

Arturo Schwarz (ed.), *Documenti e periodici Dada* (Milan, 1970)

Writings

Louis Aragon, *Écrits sur l'art moderne*, ed. Jacques Leenhardt (Paris, 1981)

—, *Le Paysan de Paris* (Paris, 1926), trans. as *Paris Peasant* (London, 1971 and 1980)

Jean Arp, *Jours Effeuilles*, ed. Marcel Jean (Paris, 1966), trans. as *Arp on Arp* (New York, 1969 and 1972), and *Collected French Writings, Poems, Essays, Memories* (London, 1974)

Hugo Ball, *Die Flucht aus der Zeit* (Munich, 1927; Lucerne, 1946), trans. as *Flight Out of Time* (New York, 1974, 2nd edn, Berkeley, Los Angeles and London, 1996)

Georges Bataille, *Visions of Excess: Selected Writings, 1927–1939*, ed. Allan Stoekl (Minnesota and Manchester, 1985)

André Breton, *Entretiens* (Paris, 1956 and 1969), trans. as *Conversations: The Autobiography of Surrealism* (New York, 1993)

—, *Le Surréalisme et la peinture* (Paris, 1928; revised New York, 1945; revised Paris, 1965) trans. as *Surrealism and Painting* (London and New York, 1972)

—, *Manifestes du Surréalisme* (Paris, 1962), trans. as *Manifestoes of Surrealism* (Ann Arbor, 1969)

—, *Nadja* (Paris, 1928 and 1964; trans. New York, 1960)

—, *What is Surrealism?*, ed. Franklin Rosemont (London and New York, 1978)

— and Philippe Soupault, *Les Champs Magnétiques* (Paris, 1919), trans. by David Gascoyne as *Magnetic Fields* (London, 1985)

David Gascoyne, *A Short Survey of Surrealism* (London, 1935 and 1970)

Richard Huelsenbeck (ed.), *Dada Almanach* (Berlin, 1920; facsimile New York, 1966; Paris, 1980) trans. as *Dada Almanac* (London, 1993)

—, *Memoirs of a Dada Drummer* (Berkeley, Los Angeles and Oxford, 1974, 2nd edn, 1991)

José Pierre (ed.), *Tracts Surréalistes et déclarations collectives, 1922–1982*, 2 vols (Paris, 1980 and 1982)

Hans Richter, *Dada Art and Anti-Art* (Cologne and London, 1965)

Tristan Tzara, *Sept Manifestes Dada, lampisteries* (Paris, 1963), trans. as *Seven Dada Manifestos and Lampisteries* (London, 1977)

General

Dawn Ades, *Dada and Surrealism* (London, 1974)

—, *Photomontage* (London, 1986)

Ruth Brandon, *Surreal Lives: The Surrealists 1917–1945* (London, 1999)

Marc Dachy, *The Dada Movement 1915–1923* (Geneva and New York, 1990)

Lucy Lippard (ed.), *Dadas on Art* (Englewood Cliffs, 1971)

Robert Motherwell (ed.), *The Dada Painters and Poets: An Anthology* (Cambridge and London, 1951 and 1981)

Maurice Nadeau, *Histoire du Surréalisme* (Paris, 1945 and 1964), trans. as *The History of Surrealism* (New York, 1965; London, 1968 and 1973)

Gaëtan Picon, *Surréalisme 1919–1939* (Geneva, 1977; London 1977), trans. as *Surrealists and Surrealism, 1919–1939* (London 1983)

William Rubin, *Dada and Surrealist Art* (New York and London, 1969)

Specialist Studies

Hans Bolliger, Guido Magnaguagno and Raimund Meyer, *Dada in Zurich* (Zurich, 1985)

Marguerite Bonnet, *André Breton: Naissance de l'Aventure Surréaliste* (Paris, 1975 and 1988)

Maria L Borràs, *Francis Picabia* (Barcelona and London, 1985)

William Camfield, *Francis Picabia* (Princeton, 1979)

—, *Max Ernst, Dada and the Dawn of Surrealism* (Munich and Houston, 1993)

Mary A Caws, *The Poetry of Dada and Surrealism* (Princeton, 1970)

—, Rudolf Kuenzli and Gwen Raaberg (eds), *Surrealism and Women* (Cambridge, MA and London, 1991)

Whitney Chadwick, *Women Artists and the Surrealist Movement* (London, 1985)

Anne d'Harnoncourt and Kynaston McShine (eds), *Marcel Duchamp* (New York and London, 1973)

Jacques Dupin, *Joan Miró: Life and Work* (London, 1962)

Briony Fer, David Batchelor and Paul Wood, *Realism, Rationalism, Surrealism: Art Between the Wars* (New Haven and London, 1993)

Haim Finkelstein (ed.), *The Collected Writings of Salvador Dalí* (Cambridge, 1998)

Hal Foster, *Compulsive Beauty* (Cambridge, MA and London, 1993)

Stephen C Foster (ed.), *Dada/Dimensions* (Ann Arbor, 1985)

– and Rudolf Kuenzli (eds), *Dada Spectrum: The Dialectics of Revolt* (Iowa City, 1979)

Jean-Charles Gateau, *Paul Éluard et la peinture Surréaliste 1910–1939* (Geneva, 1982)

Christopher Green, *Cubism and its Enemies: Modern Movements and Reaction in French Art, 1916–1928* (New Haven and London, 1987)

Marcel Jean (ed.), *Autobiographie du Surréalisme* (Paris, 1978), trans. as *The Autobiography of Surrealism* (New York, 1980)

Rudolf Kuenzli (ed.), *New York Dada* (New York, 1986)

Ileana B Leavens, *From 291 to Zurich: The Birth of Dada* (Ann Arbor, 1983)

Julian Levy (ed.), *Surrealism* (New York, 1936 and 1996)

Annabelle Melzer, *Latest Rage: The Big Drum: Dada and Surrealist Performance* (Ann Arbor, 1980)

Francis Naumann, *New York Dada, 1915–23* (New York, 1994)

Kristina Passuth, *Les Avant-gardes de l'Europe Centrale, 1907–27* (Paris, 1988)

José Pierre (ed.), *Recherches sur la sexualité* (Paris, 1990), trans. as *Investigating Sex: Surrealist Discussions, 1929–1932* (London, 1992)

Ida Rodriguez-Prampolini, *El Arte Fantastico y el Surrealismo en Mexico* (Mexico City, 1969)

Franklin Rosemont, *André Breton and the First Principles of Surrealism* (London and New York, 1978)

Michel Sanouillet, *Dada à Paris* (Paris, 1965)

Martica Sawin, *Surrealism in Exile and the Beginning of the New York School* (Cambridge, MA and London, 1995)

Richard Sheppard (ed.), *Dada: Studies of a Movement* (Chalfont St Giles, 1979)

Kenneth Silver, *Esprit de Corps: The Art of the Parisian Avant-garde and the First World War, 1914–1925* (London, 1989)

Virginia Spate, *Orphism: The Evolution of Non-Figurative Painting in Paris 1910–1914* (Oxford, 1979)

Werner Spies, Sigrid Metken and Günter Metken (eds), *Max Ernst, Oeuvre Katalog*, 5 vols (Cologne, 1975–87)

David Sylvester (ed.), *René Magritte, Catalogue raisonné*, 4 vols (London, 1992–4)

Dichran Tashjian, *A Boatload of Madmen: Surrealism and the American Avant-garde, 1920–1950* (London and New York, 1995)

–, *Skyscraper Primitives: Dada and the American Avant-garde, 1910–1925* (Middletown, 1975)

José Vovelle, *Le Surréalisme en Belgique* (Brussels, 1972)

Harriet A Watts, *Chance: A Perspective on Dada* (Ann Arbor, 1980)

John Willet, *The New Sobriety: Art and Politics in the Weimar Period, 1917–33* (London, 1978)

Exhibition Catalogues

L'Amour fou: Photography and Surrealism, eds Rosalind Krauss, Jane Livingstone and Dawn Ades (Corcoran Museum, Washington; Hayward Gallery, London; Musée National d'Art Moderne, Centre Pompidou, Paris, 1985)

Angels of Anarchy and Machines for Making Clouds: Surrealism in Britain in the 1930s, eds Andrew Robertson, Michel Remy, Mel Gooding and Terry Friedman (City Art Galleries, Leeds, 1986)

Anxious Visions, Surrealist Art, ed. Sidra Stich (University Art Museum, Berkeley, 1990)

André Breton, La Beauté Convulsive, eds Agnes Angliviel de la Beaumelle and Isabelle Monod-Fontaine (Musée National d'Art Moderne, Centre Georges Pompidou, Paris, 1991)

Dada, Surrealism and their Heritage, ed. William Rubin (Museum of Modern Art, New York; County Museum of Art, Los Angeles; Art Institute, Chicago, 1968)

Fantastic Art, Dada and Surrealism, ed. Alfred Barr (Museum of Modern Art, New York, 1936)

Dada and Surrealism Reviewed, ed. Dawn Ades (Hayward Gallery, Arts Council of Great Britain, London, 1978)

In the Mind's Eye: Dada and Surrealism, ed. T A Neff (Museum of Contemporary Art, Chicago, 1985)

La Planete Affolée – Surréalisme – Dispersion et influences 1938-1947, ed. Germaine Viatte (Centre de la Vielle Charité, Marseille, 1986)

Paris Post War: Art and Existentialism, ed. Frances Morris (Tate Gallery, London, 1993)

Salvador Dalí 1904–1989, ed. Karin v Maur (Staatsgalerie, Stuttgart; Kuntshaus, Zurich, 1989)

Surrealism: Desire Unbound, ed. Jennifer Mundy (Tate Modern, London; Metropolitan Museum of Art, New York, 2001–2)

Surrealism: Revolution by Night, eds Michael Lloyd, Ted Gott and Christopher Chapman (National Gallery of Art, Canberra; Queensland Art Gallery, Brisbane; Art Gallery of New South Wales, Sydney, 1993)

Index

Numbers in **bold** refer to illustrations

Acknowledgements

In common with most authors, I cannot claim the sole credit for a survey which necessarily relies upon the original work and current research of others; however, both the synthesis and the shortcomings are mine. My approach is indebted to the authors listed in the bibliography, and to tutors, colleagues and students over the years. Of these, I should single out Professor Dawn Ades (who read an early draft) and Professor Christopher Green both of whom supervised my thesis and whose ideas have guided my own. I should also like to thank Dr Michael White, who commented upon the Dada chapters at an early stage. Much of the text was written during long winter evenings in Cambridge. I would like to thank my former colleagues at Kettle's Yard for their support; the same is true of my present colleagues at the Tate, and especially the ever resourceful Librarians. The Series Editor at Phaidon, Pat Barylski, has been patient and encouraging during the whole process; I should also like to thank Marc Jordan who initiated the book, Cristiano Ratti, Senior Editor, and Giulia Hetherington, Picture Research Manager, who were especially helpful during the critical final stages. Finally, I should thank my parents and my wife, Rowena Fuller, who has had to relive the elation and bitterness of Dada and Surrealism.

Permission to quote the passages on the following pages is gratefully acknowledged:

Hans Arp (pp.48, 50) from Jean Arp, *Collective French Writings, Poems, Essays, Memories*, trans. Joachim Nevgroschel, John Calder and Boyars (London, 1974), used by permission of Calder Publications Ltd.

Hugo Ball, (pp.45, 53, 61) from *Flight Out of Time*, ed. John Elderfield, trans. Ann Raimes (New York, 1974; Berkeley, Los Angeles and London, 1996), translation copyright © 1974 by Viking Press Inc., used by permission of Viking Penguin, a division of Penguin Books USA Inc.

André Breton (pp.217, 229, 273, 330–1, 389, 390–1) from *Manifestoes of Surrealism*, trans. Richard Seaver and Helen R Lane (Ann Arbor, 1972), used by permission of the University of Michigan Press.

Tristan Tzara (pp.46, 54, 63–4, 73, 186, 189) from *Seven Dada Manifestos and Lampisteries*, trans. Barbara Wright and John Calder (London, 1977), used by permission of Calder Publications Ltd.

Photographic Credits

AKG, London: 58, 82, 88, 119, 125, 174, 182, 200, 214; Annely Juda Fine Art, London: 106; Art Institute of Chicago: 130, The Lindy and Edwin Bergman Collection 192, 208, 209; Arturo Schwarz Collection, Milan: 203; Biblioteca General d'Historia de l'Art, Barcelona: 66; Bibliothèque Littéraire Jacques Doucet, Paris: 110; Bridgeman Art Library, London: 1, 89, 206; British Film Institute, London: 228; Centraal Museum, Utrecht: 21, 97; Denver Art Museum: 191; Hamburger Kunsthalle: photo Elke Walford 150; Kettle's Yard, Fitzwilliam Museum, Cambridge: 155; Foundation Arp, Musée de Sculpture, Clamart: 24; Fundación Colección Thyssen-Bornemisza, Madrid: 53; David Gahr, New York: 230; Galerie Christine et Isy Brachot, Brussels: 194; Galerie Louise Leiris, Paris: 154; Galleria Nazionale d'Arte Moderna, Rome: 46; Giraudon, Paris: 2, 181, 223; Guinness plc/Ogilvy & Mather, London: 231; Guggenheim Museum, New York: photo David Heald 107; Hans Arp and Sophie Taeuber Arp Foundation, Rolandseck: 22; Heartfield Archiv, Berlin: 166; Imperial War Museum, London: 20; Index, Florence: photo L Carrà 220; Israel Museum, Jerusalem: 29; Karl Ernst Osthaus-Museum der stadt Hagan: photo Rosenstiel 9; Kunsthandel Wolfgang Werner KG, Berlin: 102; Kunsthaus, Zürich: 19, 25, 30, 32, 33, 37, 38, 39, 40, 42, 43, 85; Kunstmuseum, Bern: 129, 176; Kunstmuseum, Winterthur: 149; Jean-Jacques Lebel, Paris: photo Marcel Lannoy 141; Lee Miller Archives, East Sussex: 167, 195, photo Anthony Penrose 116; Leeds Museum and Galleries: 189; Los Angeles County Museum of Art: purchased with funds provided by Mr and Mrs Norton Simon, The Junior Arts Council, Mr and Mrs Frederick R Weisman, Mr and Mrs Taft Schreiber, Hans de Schulthess, Mr and Mrs Edwin Janss, and Mr and Mrs Gifford Phillips 95; Louisiana Museum of Modern Art, Humlebaek: donation Celia Ascher 229; Magyar Nemzeti Galéria, Budapest: 101; McNay Art Museum, San Antonio: bequest of Marian Koogler McNay 12; Menil Collection: Houston: photo P Hester 221, Hickey-Robertson 184, photo photo A Mewbourn 156, photo J Woodard 144; Metropolitan Museum of Art, New York: Alfred Stieglitz Collection 55; Moderna Museet, SKM, Stockholm: 83, 121, 169, 224; Mountain High Maps, © 1995 Digital Wisdom Inc.: pp.436–7; Musée Comunale d'Arte Moderna, Ascona: 28; Musée d'Histoire Contemporaine, Paris: 18; Musée des Beaux Arts de Nantes: 139, 227; Musée National d'Art Moderne, Centre Georges Pompidou, Paris: 8, 16, 23, 31, 34, 50, 73, 78, 81, 104, 134, 170, 177, 196, 197, 225; Museo Civico di Torino: 87; Museum Folkwang, Essen: 10; Museum Ludwig, Cologne: 118; Museum of Modern Art, New York: frontis-piece, 14, 45, 70, 92, 124, 138, 142, 147, 180, 207, 41, 67, 135, Katherine S Dreier Bequest 61,

gift of A Conger Goodyear 62, Hillman Periodicals Fund 51, Inter American Fund 198, Sidney and Harriet Janis Collection Fund 219, Eugene and Agnes E Meyer Collection, given by their family 47, Abby Aldrich Rockefeller Fund 96, gift of Nelson A Rockefeller 11, gift of William Rubin 143, Sage Tanguy Fund 145, gift of G David Thompson 57; Offentliche Kunstsammlung Basel, Martin Bühler: 35, 36, 44, 164; Peggy Guggenheim Collection, Venice: photo David Heald 86; Philadelphia Museum of Art: Louise and Walter Arensberg Collection 7, 48, 59, bequest of Katherine S Drier 49, Duchamp Archives 215; Photothèque des Musées de la ville de Paris: 54, 114, 117; RMN, Paris: 17, 128, 151; Roger-Viollet, Paris: 111, 112; Eva-Maria und Heinrich Rössner, Tübingen: 76; Sainsbury Centre for The Visual Arts, University of East Anglia, Norwich: photo James Austin 204; Scottish National Gallery of Modern Art, Edinburgh: 90, 136, 165, 172, 186; Silkeborg Kunstmuseum: photo Lars Bay 163; Sprengel Museum, Hanover: 13, 93, 99; Staatsgalerie Moderner Kunst, Munich: 68; Staatsgalerie, Stuttgart: 69; Städtische Galerie im Lenbachhaus, Munich: 15; Stedelijk Museum, Amsterdam: 133; Tate Gallery, London: 5, 137, 140, 183, 187, 188, 202, 222; Telimage, Paris: 115, 131, 168; Ubu Gallery, New York: 178; University of Hawaii, Honolulu: 64; by courtesy of the Board of Trustees of the Victoria and Albert Museum, London: 4, 199; Visual Arts Library, London: 94, 213; Wadsworth Atheneum, Hartford: Ella Gallup Sumner and Mary Catlin Sumner Collection Fund 216, Philip L Goodwin Collection: 193; Washburn Gallery, New York: 218; Whitney Museum of American Art, New York: photo Geoffrey Clements 217, gift of Lincoln Kirstein, photo Jerry L Thompson 210; Yale University Art Gallery, New Haven: Gift of Collection of Sociéte Anonyme 52, 56, 212

447 Acknowledgements

Phaidon Press Limited
Regent's Wharf
All Saints Street
London N1 9PA

Phaidon Press Inc.
180 Varick Street
New York, NY 10014

www.phaidon.com

First published 1997
Reprinted 1999, 2002, 2004, 2006, 2011
© 1997 Phaidon Press Limited

ISBN 978 0 7148 3261 6

A CIP catalogue record for this book is
available from the British Library.

Text typeset in Gill Sans

Printed in Singapore

Cover illustration Raoul Hausmann,
Mechanical Head (Spirit of the Age), c.1920
(see p.137)